The Greenwood Encyclopedia of
Homes through American History

The Greenwood Encyclopedia of Homes through American History

Volume 1
1492–1820

1492–1780, Melissa Wells Duffes, William Burns, and Olivia Graf

1781–1820, Melissa Wells Duffes

Thomas W. Paradis, General Editor

GREENWOOD PRESS
Westport, Connecticut • London

Library of Congress Cataloging-in-Publication Data

The Greenwood encyclopedia of homes through American history.
 v. cm.
 Includes bibliographical references and index.
 Contents: v. 1. 1492–1820 / Melissa Wells Duffes, William Burns, and Olivia Graf ; 1781–1820 / Melissa Wells Duffes ; Thomas W. Paradis, general editor—v. 2. 1821–1900—v. 3. 1901–1945—v. 4. 1946–present.
 ISBN 978–0–313–33496–2 (set : alk. paper)—ISBN 978–0–313–33747–5 (v. 1 : alk. paper)—ISBN 978–0–313–33694–2 (v. 2 : alk. paper)—ISBN 978–0–313–33748–2 (v. 3 : alk. paper)—ISBN 978–0–313–33604–1 (v. 4 : alk. paper)
 1. Architecture, Domestic—United States—Encyclopedias. 2. Decorative arts—United States—Encyclopedias. 3. Dwellings—United States—Encyclopedias.
I. Greenwood Press (Westport, Conn.) II. Title: Encyclopedia of homes through American history.
 NA7205.G745 2008
 728.0973'03—dc22 2008002946

British Library Cataloguing in Publication Data is available.

Copyright © 2008 by Melissa Wells Duffes

Library of Congress Catalog Card Number: 2008002946
ISBN-13: 978–0–313–33496–2 (set)
 978–0–313–33747–5 (vol. 1)
 978–0–313–33694–2 (vol. 2)
 978–0–313–33748–2 (vol. 3)
 978–0–313–33604–1 (vol. 4)

First published in 2008

Greenwood Press, 88 Post Road West, Westport, CT 06881
An imprint of Greenwood Publishing Group, Inc.
www.greenwood.com

Printed in the United States of America

The paper used in this book complies with the Permanent Paper Standard issued by the National Information Standards Organization (Z39.48–1984).

10 9 8 7 6 5 4 3 2 1

Contents

HOMES IN THE FEDERAL ERA, 1781–1820

Foreword

What if the walls of our homes could talk? Though perhaps a frightening thought for some, our walls would certainly relate countless happy memories and events throughout our lives and past generations. They might also tell us of their own origins—their own past, explaining their history of construction; materials; positioning within the home—their relationship to doors, windows, rooflines, and basements; and all the special ways in which they have been decorated or altered by their owners. In a sense, this unprecedented series of volumes on the history of the American home will allow our walls to talk to the extent possible through the written word. The physical structures of our homes today—whether condominium, townhouse, farmhouse, apartment house, free-standing house, mansion or log cabin—all have a story to tell, and the authors of this set have been determined to tell it.

It is easy to take our homes for granted; we do not often recognize the decades and centuries of historical development that have shaped and informed the construction of our own walls that shelter us. Our homes' room layouts, construction materials, interior furnishings, outdoor landscaping, and exterior styles are all contingent upon the past—a past comprising individual innovators, large and small companies, cultural influences from far-away places, political and economic decisions, inspirational writers, technological inventions, and generations of American families of diverse backgrounds who have all contributed to how our homes look and function. This set, titled *The Greenwood Encyclopedia of Homes through American History,* treats the American home as a symbolic portal to an historical account rarely viewed from this perspective.

This set focuses just as much on the interrelated past of American culture, politics, economy, geography, transportation, technology and demographics as on the home itself. By twisting the title a bit, we could easily justify renaming it to an *American History through the Home.* Given that most of us find history more meaningful if connected tangibly to our own lives, the American home perhaps serves as the ideal vehicle for relating the fascinating and engaging aspects of American history to students of any age and educational background. Our homes today are in large part a product of our past, and what better way than to use our own dwellings as veritable gateways to understanding American history—and for better understanding ourselves?

The volumes herein take us on an introductory though comprehensive tour through the dynamic developmental process of the American home from the earliest colonial cabins and Native-American precedents to present-day suburbs and downtown loft condominiums. Though treated as a historical account, this collection constitutes a multi-disciplinary approach that weaves together the influences of geography, urban and rural development, cultural studies, demographics, politics, and national and global economy. Each book in the set considers regional developments, relevant historical issues, and multicultural perspectives throughout the current-day contiguous 48 United States. Further, because most of us do not live in grand, *high-style* estates or mansions designed by professional architects, our authors devote more than the typical amount of space on common, or *vernacular,* architecture of the home. It is nonetheless vital to recognize the vast amount of past and contemporary research from which this set has borrowed and showcased. More than the latest write-up on architectural history, these volumes also provide an extensive overview of the more significant resources on this topic that will lead enthusiasts well beyond these specific pages. This set is perhaps best interpreted as a beginning on the journey of life-long learning.

Those interested in the American home—whether student, professional, layperson, or a combination—can approach the *Greenwood Encyclopedia of Homes through American History* in various ways. The set is divided into parts, or time periods, each written by a different scholar. Thus, each volume is divided into two or more chronological segments, and each can be read as a narrative, moving in the order presented by the sequence of chapters. Others will find an encyclopedic approach to be useful, allowing those searching for specific information to quickly access the volume and topic of choice through the volumes' contents pages and through the comprehensive index. Every chronological part of each volume includes a glossary and lengthy recommended list of resources to enhance the reader's search for clarity and to provide further sources of information. While impossible to scour the Internet for all relevant resources on the topic, this set has included a commendable listing of reliable and informative Web resources, all of which can potentially lead in new directions.

Like scaffolding that enables a building's construction, the sequence of chapters found in each chronological segment of the volumes progresses logically through major topics relevant to the home. With a few exceptions, each part takes us on a veritable tour, beginning first with a chapter devoted to relevant history and contextual background. From there, we tour the American home's exterior treatments, referred to as architectural styling, perhaps the most visible and public feature of our dwellings. The tour then continues to

the inner workings and construction of the home, highlighting the important building materials and manufacturing techniques available during that period of time. The home's interior serves as the next stop on the tour, with two successive chapters devoted to floor plans, room layouts and uses, topics on lighting, heating, and ventilation, and a full chapter devoted to furniture and interior design.

Completing most segment's tour is a final chapter taking us back outside to consider the approaches to landscaping around the home, its site on the lot, its situation in the local or regional environment, its relationship to the streets and neighborhood, and any outbuildings that may have contributed to the homestead.

Organized a bit differently from the rest, the final segment, from 1986 to the present, provides a sort of conclusion to the entire set, interpreting the most current trends in contemporary housing and society, with which we can all directly relate as we progress through the early part of the twenty-first century. As the series editor, I speak for all of our authors by inviting you to explore the endless fascination provided by our cherished American home through history, and to discover for yourself how, indeed, our walls can talk to us.

Thomas W. Paradis
Series Editor

PART ONE

Homes in the Colonial Era, 1492–1780

Melissa Wells Duffes, William Burns, and Olivia Graf

Introductory Note

The years of early settlement in North America, which was already inhabited by cultures of Native Americans, were a difficult time indeed. It seems miraculous that as many people survived as did in the years of the early seventeenth-century settlements in the colonies. Their homes were rough, for the most part, with some early settlers even living in caves. Some lived in wigwams or in shacks, which often collapsed or more likely burned down. The new world in New England, however, offered many things that were not as abundant in England, among them, heavy forests and a large supply of trees. Soon immigrant houses and towns in the new world were being built. In other parts of North America, stone and tabby (a mixture of sand, lime, and crushed oyster shells to form a concrete) were also used. By the middle of the seventeenth century, however, structures were beginning to be made of brick, sometimes even entirely of brick. Although some brick was imported from England, most was made in America.

The first chapter, "Settling in the New Land" by Olivia Graf, discusses the four main groups of Europeans who immigrated to the New World: the Spanish, the French, the Dutch, and the English; and the three regions that they settled in: New England, the middle colonies, and the South. Although many cultures of Native Americans already had settled the Eastern United States, eventually, these European settlers, including craftspeople, merchants, farmers, and plantation owners—with the work of slaves—created a thriving and prosperous economy that allowed them to gain their independence from British colonial rule. A new cultural identity developed, one that was based on groups of diverse settlers (but only whites), who shared living and building traditions.

The second chapter, "Styles of Domestic Architecture around the Colonies" by Olivia Graf, discusses the types of homes that the immigrants built, which evolved from crude wooden structures, wigwams, and tents through the gracious Georgian and Palladian style multistory homes of the later eighteenth century. Other styles that developed and exist to this day include Dutch colonial, New England saltbox, Swedish and German log houses, clapboard houses throughout the colonies, and adobe houses in the Southwest. Slaves lived in wooden huts with dirt floors, close to where they worked in the fields, or they might sleep in barns or eventually dormitories.

The third chapter, "Building Materials and Manufacturing" by William Burns, looks at building materials and manufacturing in the Colonial period and the changes that occurred in construction, design, and services. American colonial housing developed from primitive structures and techniques going back to medieval Europe, but evolving to a range of styles and materials, which varied by class, ethnic group, and region. Immigrants from Europe and Africa brought the building traditions of their native lands with them and then changed them under new conditions. The vast majority of builders drew on locally available materials, so housing varied tremendously between regions. New England developed wooden housing, taking advantage of the plentiful wood from forests in most of the region, while other areas were more likely to use stone, brick, or adobe. Coastal areas in the southeastern colonies often used mortar created from crushed shells.

The fourth chapter, "Home Layout and Design" by Melissa Wells Duffes, examines the interior spaces of the colonial home, the room arrangements, and layouts of various types of homes. Influences, such as the use of builders' guides and pattern books, changed how homes were built and began to impose more conformity on home building. Houses changed from one- or two-room structures, where the fireplace and hearth were the focal points, to those with more rooms for sleeping or entertaining and more floors. The gentry sought to impose classical ideas of symmetry and proportion to their rooms, layouts, and exteriors.

The fifth chapter, "Furniture and Decoration" by Melissa Wells Duffes, discusses colonial interior furnishings and decoration, including furniture, metals, ceramics, glass, and textiles, as well as some Native American decorative objects. For the settlers, their furnishings were influenced by Europe and England. The English, Dutch, Spanish, French, Germans, Swedes, and others brought their styles with them when creating objects for everyday living. Furnishings brought by the early colonists served as prototypes for the new forms that craftspeople created. Until pattern books became more available and influential, furniture makers, or cabinet makers as they later came to be called, used foreign examples to build upon and then created new forms from older ideas. Colonial craftspeople eventually began to produce styles that were not seen in Europe.

The final chapter, "Landscaping and Outbuildings" by Melissa Wells Duffes, describes colonial gardens, which initially were grown strictly for food or other household uses. Before the arrival of European immigrants, Native Americans had used the land for sustenance, and the early settlers had to do the same for many years. Eventually, gardens were planted for pleasure and decoration as well as for food. Farms and large plantations had a combination

of working and pleasure gardens, with slaves working the land and gardens. Colonists continued the English practice of establishing and protecting property by enclosing it, usually with fences.

As with all the books in *The Greenwood Encyclopedia of Homes through American History,* there is a timeline to put prominent event dates of this period into context, a glossary for terms that may be unfamiliar, and a resource guide, which provides recommended information for readers from a wide variety of resources, including books and Web sites.

Timeline

1492	Genoese mariner Cristoforo Colombo, in the employ of the Spanish government, encounters the islands of the Caribbean.
1565	Founding of St. Augustine, the oldest continuously inhabited European settlement in the United States.
1607	Founding of Jamestown, the first permanent British settlement in America.
1610	Founding of Santa Fe in New Mexico. The Palace of the Governors, an adobe building started soon after the founding of the city as a residence for the governor and an administrative headquarters, is the oldest public building in the United States.
1611	Sir Thomas Gates brings three English brickmakers over to make bricks for the new settlement of Henricopolis in Virginia.
1620	The *Mayflower* lands at Plymouth Rock, Massachusetts.
1625	Founding of New Amsterdam.
1630	Founding of Boston.
1631	A chimney fire in Boston leads to the destruction of two houses and an ineffective ban on wooden chimneys and thatch roofs.
1638	The beginnings of Swedish settlement in Delaware. The Swedes will introduce the log cabin to America.
	Founding of Newport, Rhode Island.

1652	Unsuccessful attempt to set up a central water system in Boston.
1662	Virginia Assembly enacts the Act for Building a Towne, requiring each county support building a brick house in Jamestown, as part of an attempt to revive the city. The law also provides for the building of other towns and forbids wooden buildings in towns.
1664	New Amsterdam, a Dutch town, is taken over by the English and renamed New York City after James, Duke of York.
1672	Spanish authorities in St. Augustine require that all stone workers be devoted to building the Castillo San Marcos, a great fortress. This leads to greatly increased use of tabby as a building material for homes and other private buildings.
1675–76	King Phillip's War devastates much of New England.
1676	Jamestown destroyed by fire in Bacon's rebellion. Subsequent attempt to revive the town will be unsuccessful.
1679	Calamitous fire in Boston.
1680	Founding of Charles Town, South Carolina, later known as Charleston.
1682	Founding of Philadelphia. Thomas Holme surveys the site, setting a new British American standard of precision in laying out a city's streets.
1692	Salem Witchcraft Trials.
1699	Founding of Williamsburg as the new capital of Virginia.
1706	Work begins on the Governor's Palace in Williamsburg, Virginia.
1711	Major fire in Boston, still a wooden town, leads to rebuilding of some of the city in brick.
1713	Destructive hurricane in Charleston leads the South Carolina Assembly to decree that subsequent buildings be in brick.
1718	Founding of New Orleans.
1722	White Pines Act, intended to reserve trees for masts for the Royal Navy, requires a permit to fell white pines with a diameter over 24 inches unless on private land.
	The Governor's Palace at Williamsburg is finally completed. It will become the model for the great houses of Virginia planters.
1724	Founding of the Carpenters's Company of the City and County of Philadelphia, an association of master carpenters and house builders who establish uniform rates for their work.
1726	Establishment of the first brickyard serving New Orleans, at Bayou St. John.
1729	Founding of Baltimore.
1734	The founding of the Library of the Carpenters's Company of Philadelphia, a repository of works on building design, mostly printed in England.

1735	First American fire insurance company, the Friendly Society for the Mutual Insurance of Houses Against Fire, founded in Charleston.
1737	Building of Thomas Hancock's great house on Beacon Hill in Boston.
1739	German immigrant Caspar Wistar builds the most successful colonial glass factory, using German workers, in Alloway, New Jersey.
1740	Fire in Charleston leads to destruction of much of the city and the collapse of the Friendly Society for the Mutual Insurance of Houses Against Fire.
	Around this time, Benjamin Franklin devises the Pennsylvania Fire Place or Franklin stove, a device for heating rooms more efficiently by minimizing the escape of heated air.
1742	Publication of a pirated edition of Eliza Smith's English manual *The Compleat Housewife* in Williamsburg, Virginia. This is the first cookbook and domestic guide published in British America.
1744	Franklin gives a model Franklin stove to the iron founder Robert Grace, and helps publicize them.
1752	Franklin takes the leading role in founding the Philadelphia Contributorship for the Insurance of Houses from Loss by Fire.
1753	Obadiah Brown, a leading businessman of Providence, Rhode Island, establishes a spermaceti candleworks at Tockwotton.
1754	The first system in North America for providing water for household use to an entire community through pumps is built in the Moravian community of Bethlehem, Pennsylvania.
	Beginning of the French and Indian War.
1760	Formation of the Cordwainer's Fire Company, a Philadelphia group of master shoemakers combining the functions of a trade group and a volunteer fire company.
	Construction begins on Thomas Jefferson's house Monticello.
1761	Formation of the Association of Spermaceti Candlers, an association of candlemakers in Boston, Providence, Newport, New York, and Philadelphia to fix the price for spermaceti and allocate it among its members.
	Public street lighting, using whale-oil lamps, begins in New York City.
1763	The French and Indian War, which had become merged with the global conflict between France and Britain known as the Seven Years War, ends with a conclusive British victory and the expulsion of France from mainland North America.
1769	Disagreements over fees and other matters in the Carpenter's Company of Philadelphia lead to a split and the creation of a new

group, the Friendship Carpenter's Company, with a much lower entrance fee.

1775 The first architectural book published in British America, a reprint of Abraham Swan's *British Architect,* appears in Philadelphia with 60 copperplate engravings by the American engraver John Norman.

American Revolution begins.

1776 Around this time, Jeremiah Wilkinson of Cumberland, Rhode Island, devises a technique for making nails out of cold iron rather than forging them.

1781 Founding of Los Angeles.

Governor's Palace at Williamsburg, then in use as a hospital for wounded American soldiers, is destroyed by fire.

Battle of Yorktown ends American revolution with victory for the colonial insurgents and their European allies.

Settling in the New Land

Olivia Graf

The Colonial period begins in the fifteenth century with the European endeavor to expand territories and their own economic wealth to the New World, and ends with the declaration of independence of a growing nation. America's colonies were architecturally as diverse as the nations that founded them, supplanting traditions from the Old World to the New and transferring familiar domestic building styles to adapt to the untamed colonies. Melding traditions and influences as various European colonies became neighbors and shared the common experience of living and surviving in the New World, in addition to following some Native American building traditions, affected the blending of architectural styles to eventually form the "New Style."

This chapter primarily discusses the four main groups of Europeans who immigrated to the New World, which was already occupied by Native Americans. The Spanish, the French, the Dutch, and the English settled in three regions of the New World: New England, the middle colonies, and the South. This chapter will also discuss political and cultural influences on colonial architecture.

The themes central to life in colonial America included these: (1) religious beliefs were so diverse in the New World that support for an established church eroded, and religious tolerance was instead promoted; (2) wealthy merchants, farmers, and plantation owners eventually created a thriving and prosperous economy, increasing their potential for independence from British colonial rule; and (3) a new cultural identity rooted in the English language developed as a result of diverse settlers sharing traditions of living and building.

European nations established colonies mainly to generate income. The colonies provided them with raw materials for trade, which stimulated the European economy and pushed forward a commercial revolution that expanded European trade and wealth. As the colony prospered, residential architecture, first built for protection and shelter, began to translate to a visual and outward symbol of class distinction. Houses of the Colonial era are "reminders of the richness and diversity of the people who settled the colonies of the New World" (Larkin, Sprigg, and Johnson 1995, 14).

Settlers were also drawn to the New World because of the political systems that were instituted, including religious tolerance, a certain amount of cultural diversity, prospects for economic growth, and representative government. With these freedoms, many people were able to build their own houses, often keeping their cultural identity and a sense of pride, as well as learning from other cultures.

SHAPING COLONIAL AMERICA

In 1492, Christopher Columbus (Cristoforo Colombo), a sea explorer from Genoa, while on a voyage for Spain in search of a direct sea route from Europe to Asia, unintentionally stumbled upon the Americas. First arriving on islands in the Caribbean, the adventurers noticed that the native peoples of the island (which they quickly claimed for Spain) were wearing gold, and they immediately thought of the wealth this territory could provide. The Spaniards, believing that they had arrived in the Indies, soon called all islanders Indians.

As French, Dutch, and English colonists began arriving in the New World in the early seventeenth century, the Spanish colonies of New Spain (Mexico), New Granada (Colombia), and the Caribbean were nearly 100 years old. A source of power and means of lucrative trade for Spain, the idea of acquiring colonies became attractive to many other European nations.

SPAIN AND ITS RIVALS

When Henry VII came to the throne in 1485, the typical English person cared only of the world consisting of the local village, the fields, and the nearest market town. With the success of Spanish explorations, however, "Englishmen first saw the New World through Spanish eyes: the New World was the Caribbean and New Spain, a warm and languid land, rich in tropical fruits, and of course, gold and silver" (Larkin et al. 1995, 6). From afar, the Americas seemed to satisfy an ideal of Utopia, where a new life and wealth awaited all who made the journey. As Portugal established trade routes in the Americas, their Spanish rivals decided to focus on colonization and missionary activities as well as increasing ventures of trade. When the Spanish landed in Tampa Bay, Florida, in 1528, the climate required an adapted architectural response to building shelter. However, it was not until 1565 that the first permanent settlement of the New World was established in St. Augustine, Florida, by the Spaniards. The Royal Ordinances for the Laying Out of New Cities, Towns, or Villages declared by Philip II in 1573 imposed instructions for "a plaza with quarters for merchants, a town hall, hospital, other public buildings, and the church nearby if it was for a harbor town, at some distance and on a hill if for an inland town" (Donnelly

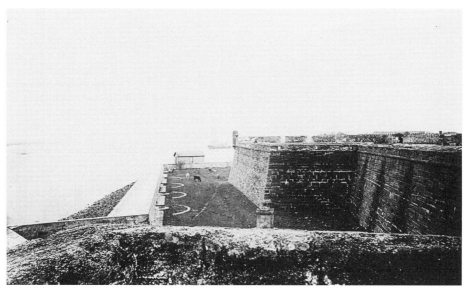

The Fort of Castillo de San Marcos, where construction began in 1672 to help defend the settlement of St. Augustine, Florida. From 1821–1942, it was known as Fort Marion. Courtesy of the Library of Congress.

2003, 1). Based on Spanish precedents and the writings of Vitruvius, a grid plan was established for individual properties. Thus, the Spanish settlement pattern was extremely orderly and regular, successfully shown in St. Augustine.

In the early part of the seventeenth century, the Spanish and French were still exploring; however, by 1715, two great forts emerged: Castillo de San Marcos in what is now Florida, and the Louisbourg Fortress, in what is now Nova Scotia, Canada (Donnelly 2003, 95). Spain occupied colonies in eastern Texas, New Mexico, and Arizona. The town of Santa Fe was founded by Spain in approximately 1610 in what is now New Mexico. The Palace of the Governors, an adobe building built soon after the city's founding as a residence for the Spanish governor and as administrative headquarters and fortress against the Pueblo Indians, is the oldest public building in the United States. France conquered the St. Lawrence Valley in what is now Canada and the Mississippi Valley in what is now the United States. Both Spain and France were more interested in trading furs and finding gold than in developing agriculturally and commercially. However, when other European nations emerged in the quest to colonize the New World, they had much different interests.

The Netherlands

Upon independence from the Spanish in the late 1500s, unlike Spain and France, The Netherlands sought to extend their empire through commerce and trade (Blackburn 2002, 23). In 1609, Henry Hudson, a British captain under the employ of the Dutch West India Company, explored the river later named after him (Kennedy 1985, 52). Following Hudson's discoveries, the Dutch set up trading outposts in this region up and down the river and called it New

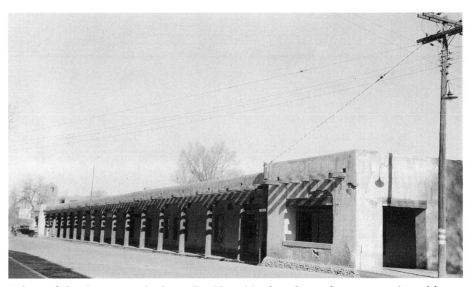

Palace of the Governors in Santa Fe, New Mexico. Once the governor's residence and now a museum, it is the oldest public building in the United States. Courtesy of the Library of Congress.

Netherland. When the Dutch West India Company tried to recruit settlers to inhabit the new settlement in 1624, it was difficult to persuade even the poorest people in Holland to move to the wilderness; a new, feared place. Hence, when people from other nations, which were less tolerant and less economically successful than Holland, offered to immigrate to a Dutch colony, they were readily accepted. The consequence was that the colonial population was as much foreign as it was Dutch (Blackburn 2002, 23). The consequence for Dutch architecture? It was influenced by other indigenous styles, causing traditional buildings to adapt to the New World, creating a truly colonial architecture.

Since the early 1600s, the Dutch had introduced the sugar and slave trade to the colonists, supplying the settlers with credit, technology, and other manufactured goods to sustain the trade. In the 1650s, the Dutch began to lose control of much of the New Netherland settlement as English settlers started to outnumber the Dutch. In September 1664, the English succeeded in capturing the town of New Amsterdam without much of a fight, renaming it New York (Blackburn 2002, 25). Therefore, by 1665, the now English-controlled colony of New Netherlands had a higher number of slaves than Virginia, Maryland, or any of the other northern British colonies (Kennedy 1985, 53). The wealth that these industries produced, afforded plantation owners the financial success to build classically based mansions—the latest trend in Europe—in order to flaunt their opulence.

England

Some of the earliest, as well as some of the last-settled colonies, were the ones on the southeastern coast of the current United States. In 1607, the Virginia Company in London sent 105 men and 3 ships to explore along the

James River. They named their landing site Jamestown, and so began the history of the colony of Virginia, which was named for Queen Elizabeth I, the "Virgin Queen."

When Captain Christopher Newport brought a group of English immigrants to Virginia, these settlers were only interested in exploring the country, setting up a fort, securing a sizeable wealth, and then hurrying home. Largely comprising city people from London, these settlers lacked the ability to adapt to the wilderness and difficult winter conditions. After Newport returned to England, Captain John Smith took control, trading with the Indians for corn so that the Virginian settlers could survive their first winter. Although the colony survived, they found no gold to strike it rich. Virginia was slow to progress because its migrants were ravished by disease, starvation, and Indian attack. Only 60 of the first 800 settlers survived the first three years. However, through trading with the Indians, they came across a most lucrative discovery: tobacco. This crop was easy to grow and sell at high prices back in England.

As the English settled in Virginia, despite the disappointment of the true nature of this colony (compared to what they had heard back home), they found tobacco to be an enormously prosperous undertaking. In 1618, Virginia exported 50,000 pounds of tobacco; this number increased six-fold within another eight years. Large plantations were established that grew *sotweed,* or tobacco, and these plantations acted as a residence, a place of manufacturing, and as a self-sustaining farm.

In the seventeenth century planters used indentured servants, who were poor young men and women from England, to work their land. In exchange for their transport to America, along with food and shelter, and sometimes the promise of land, these immigrants had to agree to work for a certain period, usually four years. Most of the servants, however, were never able to claim the land, as they died either on the voyage, or during their service.

By 1700, a reduction in England's population growth meant an end to indentured servitude as the primary labor system, because there weren't as many servants to send over. In response, planters, who had emerged as the most powerful political and economic figures in the southern colonies, began purchasing slaves from Africa that were supplied by the Dutch. By 1776, nearly 250,000 African slaves were in the colonies. This created a large disparity between the mansions of planters and the one-room hovels of their slaves, leaving little or no mercantile middle class in between.

A very different group of British colonists settled in the northern parts of the New World. Unlike the British that landed in the southern colonies looking for wealth, this group of Puritans came to America seeking religious freedom. In 1620, a small group of English nonconformists to the established British religion set sail on the *Mayflower* to find religious freedom and be free of persecution from the Old World. They landed in Plymouth and drew up the Mayflower Compact, which promised "just and equal laws"; the American ideal. Before the end of the 1620s, another religious group, the Congregationalists, who were also considered Puritans, initiated the Massachusetts Bay Company, which would come to dominate New England. These Puritans, however, were not driven out of England because of persecution; they simply believed that the New World was a place of opportunity. Between the Separatist colonists, who were trying to create a better political and social environment,

and the Congregationalist settlers, who were trying to create a better economic environment, New England was sure to prosper.

REGIONAL SETTLEMENTS

The aforementioned major European nations were the primary colonists of the New World. However, the Scots, Irish, Welsh, Germans, Swiss, Swedes, and Finns were among many other groups of settlers to journey to America. There were three main regions for the settlement of European peoples. New England, settled mainly by the British seeking religious freedom; the middle colonies, settled by the Dutch and some Germans and Scandinavians; and the South, settled by both British loyalists and Spaniards. Each region produced a varied response to architecture based on homeland traditions, new topographical surroundings, climatic differences, and sharing building techniques.

New England

Most settlers came to America to practice their separatist faith away from persecution in England. Nearly half of them died that first winter of 1620. However, the next year, new ships arrived with more settlers to establish new communities along the Massachusetts coastline. With the help of Squanto, also known as Tisquantum, an English-speaking member of the Wampanoag tribe confederation, the settlers learned the skills necessary to survive their second winter. (Squanto had been earlier captured by English Captain John Weymouth, taken as a slave to England, and made to be an interpreter so that the English immigrants could trade and live in New England.) Squanto was a guide and interpreter, and he taught them how to farm, hunt, and fish in the New World (Johansen 2005).

Twenty years after the *Mayflower* landed, over 20,000 settlers had made Massachusetts Bay Colony home. This diverse group of people included university graduates, farmers, clergy, and fisherman. Established in 1630, Boston soon became a crucial trading center and the heart of New England. In 1636, Thomas Hooker led 100 followers and over 160 livestock along Indian trails to present-day Connecticut. Roger Williams established a community called Providence for the settlers to live by their own beliefs, which included the separation of church and state. Williams also learned native languages and established friendships with various Native American leaders, promoting their rights to their native land and to their religions.

The American colonists brought their familiar traditions from England and Europe, including how they lived, worked, and worshipped. The look of the familiar provided a necessary link to the Old World, which caused colonists to recreate the traditional ways of building houses, barns, and fences. "Shelter was the immediate need. Doing what they had done back home was the quickest, most practical way to establish themselves and provide for their needs" (Larkin et al. 1995, 10). Many English families initially lived in crudely built huts, or caves dug into hills; others copied the Native Americans and built a form of wigwam, called the English wigwam (Johnson 2002, 74).

At first, the church was the center of every community. The austere and simple nature of these rough, wooden buildings contrasted with the ornamental

and elaborate cathedrals in Europe. But life in the New World was meant to be free of that, with settlers free to worship as they pleased. However, "life in New England was highly ordered" (Larkin et al. 1995, 17), probably because of the familiarity of the ordered life back home. Typically towns were organized around a common green, with fields and pastures around the outskirts. The reason for this layout was two-fold; colonists reproduced the familiar from their English villages and clustered to keep safe from possible Indian attack. Along with the Church, the meetinghouse and schoolhouse became the focus of town life. Education was important in order to teach colonists how to read the Bible.

Shipping and commerce thrived along the coast, and by 1671, "colonial seaports were exporting shiploads of boards, staves, masts, cod, and beaver pelts. With the success of every new enterprise, the New England colonies were a step closer to economic self-sufficiency" (Larkin et al. 1995, 18). The abundance of New England forests and raw materials gave the new colonists a quick means to build their familiar type of shelter.

The Middle Colonies

New York, New Jersey, Pennsylvania, Delaware, and Maryland constituted the middle colonies or Mid-Atlantic states, which unlike New England, was an area of much cultural diversity.

The colony or settlement of New Netherland was established in 1623, with outposts along the Hudson River, when the Dutch West India Company "sent 30 families led by Cornelius May to an island inhabited by the Manahatta tribe in the harbor of the Hudson River" (Larkin et al. 1995, 138). The Dutch West India Company had but one objective: to develop trade with the Indians, obtaining furs to sell in Europe. In order to persuade settlers to make the move to the New World, the Dutch West India Company developed patroonships. These were tracts of land of up to 200,000 acres for those to own tax-free for 10 years if they could persuade 50 or more settlers to come to this new colony. In contrast to New England, where colonists settled to seek religious freedom, the Dutch-controlled colony became a "magnet for commerce-minded colonists" (Larkin et al. 1995, 138).

The colony of Pennsylvania began in 1681, when three ships of Quakers, mostly Germans, made the trip to America to escape persecution from the Old World. The colony was created when King Charles of England gave William Penn 40,000 square miles of land as a favor to Penn's father, the admiral of the English fleet. Four years later, over 72,000 people had made the move. The colony's success was due to "Penn's commitment to peace with the natives, religious tolerance and a fair chance for all" (Larkin et al. 1995, 141).

In 1633, 140 colonists landed on the coast of what was to become Maryland. Led by George Calvert, the colonists renamed the pre-existing Indian village St. Mary's, which became the colony's capital for over 61 years. Immediately the settlers built a guardhouse and a storehouse, while they lived in tents until the first dwellings could be constructed.

Maryland and Virginia developed similar architectural styles through proximity and therefore ease of the settlers' travel and communication. "No where is the spirit of our colonial past better preserved than in the Tidewater country

of Maryland and Virginia. A good life was lived and traditions of urbanity and hospitality wove themselves in the fabric of its buildings (Whitehead and Brown 1997, 159).

The settlers were at once well adapted, building with native materials and incorporating their dwellings into the landscape, even if it comprised their traditional and familiar domestic styles of the Old World. Land was abundant, and unlike the towns of New England, houses in colonial Maryland were usually built in the country, the owners taking on "almost feudal living conditions of authority" (Whitehead and Brown 1997, 159). This isolation in the country, however, meant that houses in the countryside needed to be self-sufficient. Thus, the house included wings; one for servants, and on the other side, a place for business and schooling.

By the end of the seventeenth century, over 30,000 colonists had settled in Maryland. However, unlike in the northern colonies of New England, the English Civil War brought Maryland closer together with England, as many wealthy Englishmen came to the colony seeking refuge. As England seized control of the colony in 1689 from Calvert, they imposed the Anglican Church as a means for controlled transference of British government and culture. As German settlers immigrated to Maryland in 1730, they brought with them "a tradition of stone construction and a fondness for highly functional plans built around central chimneys" (Lane 1991, 28). As Maryland grew more prosperous and increased in population, a taste for fine architecture flourished, creating brick mansions that we now recognize as typical of the Mid-Atlantic states (Lane 1991, 32).

The South

The southern colonies included Virginia, North Carolina, South Carolina, and Georgia. Virginia was one of the most successful colonies of the South. Chesapeake society began to move west of Virginia, establishing 21 new counties between 1732 and the outbreak of the Revolution. In the mid-1750s, economic expansion and gain as a result of the tobacco industry and the exploitation of slaves led to what can be called a golden age of Chesapeake society for white residents. This plantation system was carried into the furthest reaches of the southern colonies. The wealthy Americans admired the traditional English culture of the time, which rested solely upon social hierarchy. The plantation mansion in the New World became an expression of this power and status, as well as a symbol of the owners' intellectual prowess for being up to date with European ideals set forth by the Enlightenment. However, most fashions and styles took between 10 to 20 years to reach the colonies after they peaked in Britain. With few roads and towns, Virginia colonists were much more self-sustained than their northern neighbors. This meant the people on plantations, that is, the slaves working under the control of white plantation managers and owners, grew most of their own food and made their own clothes. The southern colonies thus avoided the New England revolution against Britain for the most part, continuing their thriving plantation society for another 100 years (Larkin et al. 1995, 216).

Charles Town, now Charleston, founded in 1680 and called "the only metropolis south of Philadelphia," became the social and commercial center of the

South. Planters of various colonies moved to Charleston for the summer, the epitome of refinement, "to their elegant townhouses with lacy iron gates and balconies, where they could enjoy cool sea breezes" (Larkin et al. 1995, 194).

The last colony to be settled was that of Georgia. In 1733, about 40 families "landed at the sandy bluff overlooking the Savannah River" (Lane 1986, 11). Parliamentary reformers, or trustees, received a charter from George II of England to settle poor and persecuted people in this new colony. However, despite these seemingly virtuous and moral intentions, the colony was actually intended to defend North Carolina from the Spanish in Florida and to raise crops to export back to England (Lane 1986, 11).

The primary founder of the colony, James Oglethorpe, imposed a military style of planning on the settlement of Savannah. Each Ward was laid out with a central square and four public-use buildings, or *Trust* lots, in gird-form on either side. To the north and south of these were four *Tythings* with 10 lots each for the colonist's houses (Lane 1986, 12, picture). These wards were repeated within an overall grid, forming an organized and easily defendable town. In time, the central squares became areas of social activity and havens of landscaped parks with monuments and fountains. Oglethorpe repeated the layout of these towns throughout Georgia. Despite tumultuous times in Georgia in the mid-1700s, Savannah began to prosper once more when slave labor and plantations were introduced, and Spain ceded Florida to the British in 1763.

A NEW STYLE IN THE NEW WORLD

Every new generation of American-born colonists led to weaker connections to the Old World. The main difference between American and English styles was simplification, initially caused by the lack of skilled craftsmen in the early stages of settlement in America, then becoming a somewhat enduring style in New England and reflecting the differing ideals from the homeland that the colonists brought with them. By the end of the Colonial period in 1763, Americans lived in a new economic, social, and political world. As a result of sustained population growth, the mainland colonies had approximately 2 million residents and a dynamic economy.

Starting in the 1750s, signs of a cultural awakening began to show as well. As an architecturally varied style arose from bits and pieces taken from different European traditions, the cultural backgrounds of the settlers became less apparent and less important. Colonists began to realize the potential power of the New World. Expansionist John Adams began to speak of a unified destiny of the colonies "to dominate the continent," and that God had chosen America "as the instrument of bringing happiness to humankind" (Larkin et al. 1995, 24). This set the stage for American nationalism, which began only as a desire to exist independently within the context of the British Empire, but soon grew to yearn for a revolution. The 13 British colonies were soon to become one nation. Patrick Henry described the new American attitude best when he passionately cried, "The distinction between Virginians, Pennsylvanians, New Yorkers, and New Englanders are no more. I am not a Virginian, but an American" (Larkin et al. 1995, 24).

Reference List

Blackburn, Roderic. 2002. *Dutch Colonial Homes in America.* New York: Rizzoli.

Donnelly, Marion. 2003. *Architecture in Colonial America.* Eugene: University of Oregon Press.

Johansen, Bruce E. 2005. *The Native Peoples of North America: A History,* vol. 1. Westport, Conn.: Greenwood Press.

Johnson, Claudia Durst. 2002. *Daily Life in Colonial New England.* Westport, Conn.: Greenwood Press.

Kennedy, Roger. 1985. *Architecture, Men, Women, and Money in America.* New York: Random House.

Lane, Mills. 1986. *Architecture of the Old South; Georgia.* New York: Beehive Press.

Lane, Mills. 1991. *Architecture of the Old South; Maryland.* New York: Beehive Press.

Larkin, David, June Sprigg, and James Johnson. 1988. *Colonial Design in the New World.* New York: Stewart, Tabori & Chang.

Whitehead, Russell, and Frank Choteau Brown. 1997. *Early Homes of New York and the Mid-Atlantic States.* New York: Arno Press.

Styles of Domestic Architecture around the Colonies

Olivia Graf

The Colonial era cultivated the transference of cultural, social, and political ideals from the Old World to the New, such as architectural styles, construction methods, religion, and the structure of "hereditary class distinction" (Gowans 1992, 15). Spanish, French, Dutch, Swedish, and English colonists were the first to promote this transference. Many other immigrants made the journey to the New World seeking independence as well, including those from southern and eastern Europe, the Far East, India, and Malaysia.

After the urgency of temporary shelters, the colonists quickly began to transplant their traditions from the Old World, including familiar architecture and furniture. "They wanted to recreate the environment they had known, the environment that told them who they were, what their place in the world was" (Gowans 1992, 15). Therefore, it became routine to name their towns after familiar places in Europe; after home.

Depending on the agenda of the various colonizing nations, whether it be for commerce, or political and religious persecution, the architectural styles of the colonies differed accordingly. "Colonial Spanish architecture predominantly served a missionary effort. Colonial French architecture served the interests of an aggressively authoritarian state. Colonial North European architecture served the predominantly mercantile interests of New Netherlands and New Sweden. Colonial German architecture in the beginning was largely made by and for refugees, or small individualistic religious groups" (Gowans 1992, 21).

The European-derived house types brought into the New World were based on medieval building methods and traditions. In the early seventeenth century,

*Living in Caves and Other Early
New England Shelters*

Among the first settlers in the Massachusetts Bay Colony in 1630 (which became Boston), the quickest way to make shelters against the late summer rain was by digging caves into the sides of Boston's hills. A family might do this, using the crude hoes and spades they were able to fashion from the tin cups they brought with them. The small opening of their cave might be covered with a dried animal skin that they found abandoned by a native. A few other settlers might find teepees made of skins that had been discarded by the natives. These had holes in the top that allowed them to build internal fires. Some modified the teepee style for a semi-permanent structure, which was called the New England teepee. Other better-off settlers to the Massachusetts Bay Colony and all the wealthy gentry, who comprised the colony's leaders, were able to bring tents over with them on the ship for use as shelter. Some of the more important members of the colony were lucky enough to continue fairly comfortably at night in houses built by earlier settlers.

Source: From *Daily Life in Colonial New England* by Claudia Durst Johnson. Copyright © 2002 by Claudia Durst Johnson. Reproduced with permission of Greenwood Publishing Group, Inc.

tent and cabin structures with thatched roofs and wood board floors served as the first temporary shelter for the colonists. Sometimes a hole was dug that was walled with timber, floored with planks, and given a roof. These were built in both Virginia and New England in the early seventeenth century. Eighteenth-century pioneer settlers on the frontier also built temporary structures based on Native American homes, sometimes called English teepees or English wigwams, built from branches, animal skins, bark, or sod. Slowly, the colonists began to build houses. These were familiar forms, both out of ease because of the need for quick shelter and a comforting connection to the Old World. Rooms had low ceilings, were dimly lit, and had small casement windows and heavy block-like rectangular furniture with painted and carved decorations that made it "delightful to look at" (Larkin, Sprigg, & Johnson 1988, 11). More urban housing butted narrow end to narrow end to conserve space within the fortified walls. Rural houses, however, had the luxury of open space to work with, taking advantage of orienting the house to natural light and breezes. Although the rural houses and urban houses might look different, they essentially were built on the same principles.

THE EVOLUTION OF DOMESTIC ARCHITECTURE IN THE COLONIES

Once these styles were transplanted into the various colonies, all house types developed into more than one room with a central hallway separating them and multiple floors. As the notion of democracy evolved, so did the practice of individualistic freedoms, shown by the start of separate bedrooms for each or groups of inhabitants of the home (Blackburn 2002, 36). This "new style" house was often called the Georgian house style; however, Georgian refers more to the period than to the style. The Georgian period extends from 1714 to about 1800, or from the beginning of the reign of George I to half way through the reign of George III. Georgian architecture peaked by the time of the American Revolution. The work of the Italian architect Andrea Palladio was a key component and influence of Georgian architecture.

Only the more affluent could afford the larger houses of Georgian design. Known for its symmetry, balance, and the proportions of classical architecture, which were influenced some by the Greeks but primarily by the Romans, the

Georgian style became fashionable in the 1700s. Importance was now placed on the exterior of the house, with ornament on the interior and exterior. It became an era of embellishment beyond utility. Interiors became more spacious with larger windows. With more rooms, levels, and flexibility in the placement of multiples fireplaces, it became more expensive to operate the house. More rooms meant more servants, and more fireplaces meant more firewood. Therefore, the Georgian Period meant an emphasis on status in an emerging societal shift. The colonial house became a merchants' expression of newly gained affluence through self-made means; it became a social space, no longer simply a means of shelter.

The domestic architectural styles of each region of the New World—New England, the middle colonies, and the South—developed first in Europe, were then introduced and transferred from the Old World to the New, and lastly, the familiar styles adapted to form a new American vernacular based on available local materials, climate, and melding cultures with frontier living.

Palladio's Influence on Georgian Design

Andrea Palladio, an Italian architect in the early sixteenth century known as one of the most influential architects in European history, built his villas between 1530 and 1570. By 1600, his influential designs had crossed the ocean to the New World.

Pre-Palladian (in Italy) or proto-Georgian (America) are styles that define fortified houses with turrets at the corners, which were derived from the medieval castle. These building types were found in areas where there was fear, common in the Middle Ages. Palladio was able to open up the design of his villas because of a less threatening environment. When at first settlers moved from Europe to the colonies, the architecture of fear was again repeated. However, by the end of the eighteenth century, plantations in the colonial South and mansions in the middle colonies that were influenced by Palladio showed an "implied control of the landscape" and an elaborate, unutilitarian ornament. The entrances were exposed and glorified: "its embracing colonnades extended a proclamation of confident control" (Kennedy 1985, 30).

Georgian colonial architecture became more academic because of the increasing number of architecture books in circulation. Based on the principles of Palladio in his *Four Books of Architecture* (first published in Italian in 1570), the change in attitude from construction to theory was known as the Palladian movement. The style these theories preached was more readily adopted in the South than in New England, for example, Thomas Jefferson, in his designs for his own house, Monticello, and for the University of Virginia, was heavily influenced by Palladio.

THE HOMES OF NEW ENGLAND

During the first century of settlement, most houses eventually resembled those in England. "The settlers raised structures with massive timber frames, then filled the walls with *wattle and daub,* a combination of clay and interwoven saplings" (Larkin et al. 1988, 12). When dry, wattle-and-daub walls were durable and provided surprisingly warm shelter in cold weather. Thatched roofs shed rain and reminded the settlers of buildings back home (Larkin et al. 1988, 24).

"After European colonists had established themselves on the east coast of North America, their approaches to more permanent housing were varied, as had been their first temporary shelters" (Donnelly 2003, 31). Their more permanent houses paralleled English *earthfast* buildings, which were constructed with timbers placed directly in the ground, either set in holes, on the surface, or in shallow trenches (Donnelly 2003, 32). Although the framed house was the most predominant dwelling type in the New England colonies, brick and sometimes stone were also employed.

Early New England Houses

The New England climate prompted colonists to choose boards, called clapboards, instead of plaster for the exterior of their homes. Individual boards of oak, pine, or cedar measured about four feet long by five inches wide, each overlapping the other, and were also called weather boards.

Windows were small and few, to conserve heat and to keep out dangerous animals. Open to the outside in warm weather, they were covered with oiled linen or paper in cold weather to keep out drafts but still bring in light. "At night and in the worst weather, interior shutters brought maximum warmth" (Larkin et al. 1988, 26).

These English house styles were well-suited to the New England climate. The steep pitched roof, a building tradition brought from the Old World, was well adapted to shed snow. In spite of the risk of fire, most roofs were either thatched, which was well known in England, or shingled, with shingles being slightly more fireproof, but more expensive and harder to install.

The vernacular English house consisting of the two-room *hall and parlor* with a centralized fireplace was transplanted into New England. "Following English usage, the term "hall" is generally interpreted as the room having a fireplace in which the cooking was done" (Donnelly 2003, 35). In a one-room house, the bed was either in this room as well, or in a room above, commonly called the chamber. In a two-room house with central chimney, as was customary in New England, the second room was called the parlor and contained the nicer furnishings.

The basic human necessity of the hearth, existing since the Paleolithic era, had—by the time of the Colonial era—transformed into the fireplace; the hallmark

of the colonial home. Up to 7 feet wide and 10 feet tall with a massive oak lintel and rising 6 feet above the ridgeline, the fireplace represented the most dominating element within the dwelling's interior. Houses in New England were based on British yeoman housing from medieval times. Their fireplaces were located centrally in the room, with multiple flues supplying each room around it.

A stone-ender was a house type prevalent in Rhode Island in the late 1600s. It was a wooden house that featured a massive stone chimney on one end, perhaps comprising the entire wall, and it was influenced by similar houses seen or lived in by settlers from western England (Historic New England 2007). Unlike the other New England colonies, Rhode Island had access to good stone for building and limestone for mortaring. Many of these houses are still standing.

> ### The First Houses Built with Clapboarding
>
> Eventually, people built sawmills in New England, which provided planks from the logs, but settlers prepared the boards themselves by painstakingly planing one edge of each plank so that the boards they secured to a log structure, inside and out, could overlap. This process, which many settlers knew from their home areas in England, was called *clapboarding*. The clapboards usually had to be secured onto the framing posts with home-crafted pegs, as nails were still a rare commodity.
>
> *Source*: From *Daily Life in Colonial New England* by Claudia Durst Johnson. Copyright © 2002 by Claudia Durst Johnson. Reproduced with permission of Greenwood Publishing Group, Inc.

Developing a New Home Style in New England

As the first groups of English colonists were arriving in the New World, another group of Englishmen, including Inigo Jones, went to study the Italian

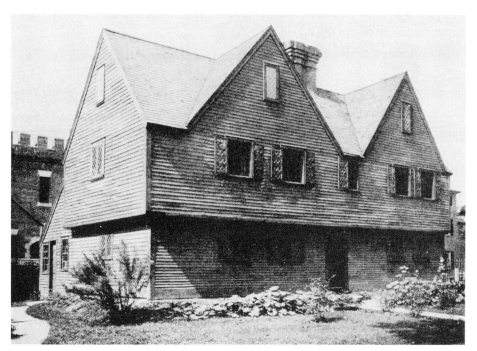

The John Ward House, built in 1684, features a clapboard exterior and gables.
Courtesy of the Library of Congress.

Renaissance in Italy. They brought to England ideas on proportion and detail of the classical architecture of Andrea Palladio. Although translated in England far differently than its Italian counterpart, this style was further altered upon entrance to New England as the "double-pile house." Double pile meant that it was two rooms deep, in other words, one room behind another, but it could be any number of rooms wide. In colonial New England, it came to mean a house of a square plan, usually with five sashed windows, two and a half stories high. It also had proportions and details of classical architecture: a pediment above the doorway to emphasize it and symmetrical windows on either side of the entrance. This style became the most common in New England, from the early eighteenth century until the Revolution and beyond.

In 1652, Christopher Wren became a dominant force in English architecture. The Wren baroque-style detached house, popular in New England in the eighteenth century, concerned itself with "extravagant taste and pretentious elegance" (Larkin 1995, 20). Decorative mantels, paneling throughout the public areas of the house, and sculptural carpentry attest to the opulence of this style. With the advent of higher ceilings, larger windows, and architectural detailing in the early eighteenth century, rooms began to feel more spacious. Whereas structure was once exposed to plain view, plaster and moldings started to cover it, refining the space. Function was now not so

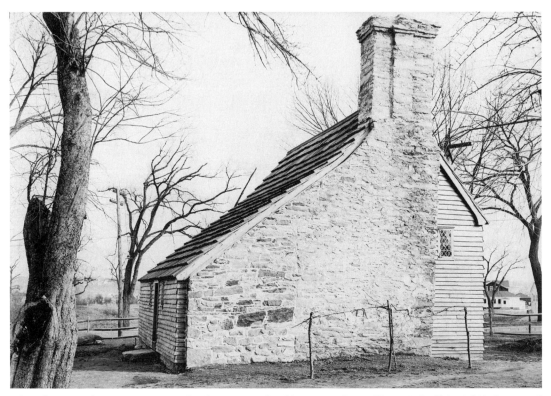

The Thomas Clemence House (also known as the Clemence-Irons House), built in 1679, is a good example of a colonial "stone-ender" house from Rhode Island. Courtesy of the Library of Congress.

important as formal and decorative appearance.

Saltbox Houses

Massachusetts Bay Colony settlers started to build cellars beneath their two-room houses in order to store food. Stairs located in the hall provided access to the basement. At the same time, the saltbox house was developing in Massachusetts. The saltbox is characterized by an asymmetrical roof, created when settlers began to add lean-tos used for the bedroom, kitchen, or dairy. The addition of the lean-to shed was integrated with the original structure. The sloping roof of the saltbox either extended from the original structure at the same

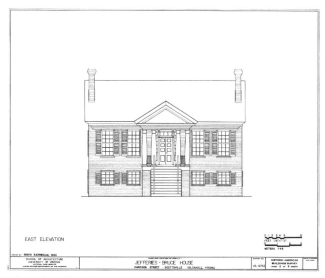

The double-pile style is shown in the Jeffries-Bruce House of Scottsville, Virginia. Courtesy of the Library of Congress.

angle as the original roof, or had contiguous roof lines and angles, as it was part of the original framing. The latter method was more common in the late seventeenth century. Unlike the styles from the Old World, this was uniquely

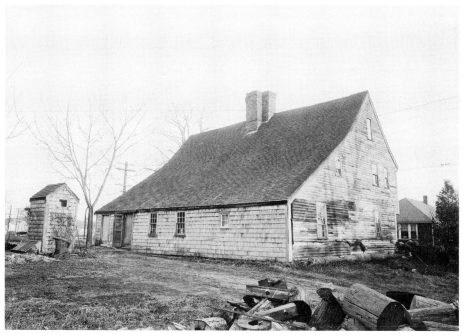

The Boardman house of Saugus, Massachusetts, built in 1651, is a classic saltbox design. Courtesy of the Library of Congress.

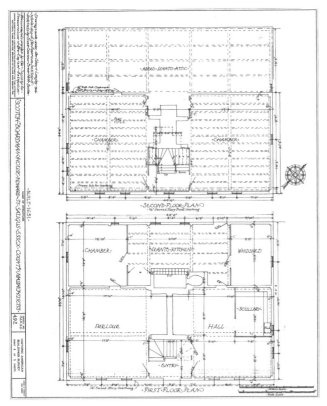

The Boardman house floorplan. Courtesy of the Library of Congress.

American (Larkin et al. 1988, 12). Houses that still survive today all around New England are, therefore, the culmination of additions throughout the Colonial period.

New England was shaped by its abundance of forests. This wood was used for the colonists' most immediate need—shelter. Seventeenth-century houses were small, with a common living area beneath a space for sleeping. As households grew, colonists added a parlor and more sleeping chambers around the central chimney and hearth. "These houses were built on post-and-beam frames, raised into place and then covered with clapboards or sheathing. The very first roofs at Plymouth were thatched, but within a few years wooden shingles came into use" (Larkin et al. 1988, 19). By the late seventeenth century, the New England house was expanded to include a central staircase, which gave individual access to each of the four rooms on the second story and created the ability to have back-to-back fireplaces in every room.

Unlike the medieval appearance of houses in the seventeenth century, the eighteenth-century floor plan evolved to include a central hallway flanked by two smaller chimneys with large windows framing the entrance and included interior ornamental woodwork showing complex stylistic intent. This was very unlike the simple, dimly lit rooms with small windows and exposed beams.

THE HOMES OF THE MIDDLE COLONIES

Unlike the predominantly English-settled New England, the middle colonies were more diverse, including the French in the two great continental river systems—from the St. Lawrence River by the now Canadian border to the Mississippi; the Dutch in New Netherland (Hudson River Valley, now New York and New Jersey); the Swedish in Delaware; the Germans in Pennsylvania; and the British in Maryland.

French, Dutch, Swedish, German, and English Influences

New France's main architectural impact on the Colonial era was the rural homestead. Instead of centralizing the fireplace in the home, the French began—in the eighteenth century—to locate chimneys on the gable ends of the rural farmhouses.

In the seventeenth and eighteenth centuries, the tradition of stone building along the St. Lawrence River resulted in many villages with the types of stone houses seen in France (Donnelly 2003, 100).

Unlike the French, who were concerned mainly with transplanting the monarchy and their class structure to the New World, the Dutch were concerned with commercial enterprises. Therefore, governmental buildings were for the most part unimportant. Even the town house was merely modeled after a typical merchant's home. Holland's high style of Renaissance architectural elements thus never needed to be transferred to the New Netherlands colony.

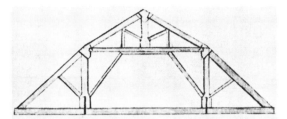

A "low curb" roof gable structural drawing, from William Pain's *Practical Builder*. Dover Pictorial Archives.

As had been their custom in Holland, Dutch houses were typically made of brick, tall and narrow, two or three stories high, with common walls and gable end (the end with the triangle formed by both sides of a sloping roof) to the streets (Donnelly 2003, 40). In rural New Netherlands, the Dutch followed their traditional stone-built houses.

In Holland, dry land was so limited that instead of storing food in warehouses, merchants stored their goods in the attic. Acting much like a barn, pullies lifted the goods directly from barges on the canal through the frontal attic door. With walls built of brick and stone, their narrow elevation, the gable end, faced the street. In comparison with New England and developing *Yankee* framed houses, the Dutch house "presented a hard face to the world…Like their

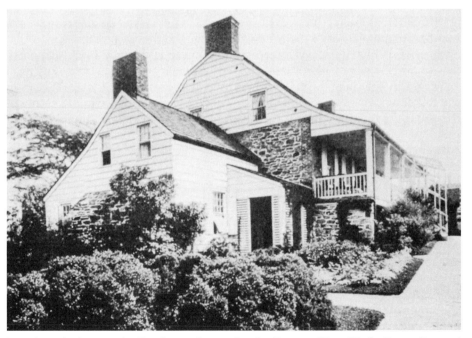

Dutch style is seen in Dyckman house in the Bronx, New York. Dover Pictorial Archives.

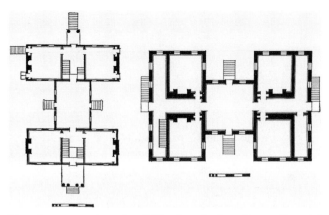

Two houses using the "H" plan design. Dover Pictorial Archives.

ancestors along the North Sea—like their cousins in the West Indies or at Charleston—they were not just residential in origin. The door on the narrow, street side was for commercial entry. The master of the house did his business in the reception rooms on the ground floor, and family rooms were often a story above" (Kennedy 1985, 50–51).

In each full-sized room, Dutch houses had a unique fireplace placed against a wall. Unlike the complex series of joists and large supporting beams of the English house, the Dutch house had a simple H structural frame. "Dutch interiors were enlivened by colorful tiles, textiles, brass, copper, and other furnishings popular in the Netherlands" (Larkin et al. 1988, 144).

In the Netherlands, a lack of wood for roofing shingles developed the use of thatch and fired clay pan tiles, which were laid loosely on a steep roof to shed rain and snow. Fifty-six degrees was determined the ideal roof angle so that the pan tiles would not be blown off by too steep of an angle, but steep enough so that the rain would shed quickly and not soak through the reed thatching.

The Swedish colony in the Delaware Valley of western New Jersey and eastern Pennsylvania brought their traditional log home with them from the Old World. More cabin-like in appearance, one account from the Journal of Jasper Danckaerts, a Dutchman traveling in 1680, described Swedish houses "which are [like] block houses, being nothing else than entire trees, split through the middle, or squared out of the rough, and placed in the form of a square, upon each other, as high as they wish to have the house" (Donnelly 2003, 43). These logs or timbers were laid horizontally, without nails or spikes, comprising both walls and roof. Unlike the English and the Dutch, who built their fireplaces in the center of the home, the Swedes placed their stone fireplace in the corner of the room. As most Swedish colonists did not bring glass with them, they left little holes for windows with movable boards fastened to the wall to act as a type of shutter. Cracks between the logs were filled with clay, on both the exterior and interior. Finns and Germans tended to use these customary building techniques as well.

Although colonial German domestic architecture is similar in many ways to colonial northern European in general, it should be considered separately because of the scale and diversity of German immigration. Germans arrived in the New World in two waves: the first in the eighteenth century in Pennsylvania, and the second in the nineteenth century in the then expanding Midwest. Most immigrants to Pennsylvania were either peasant or religious refugees who built homes, outbuildings, and furniture with medieval traditions and origins. These traditions included "flat dormers, hall-kitchens focused on wide hearths with great summer beams, and plain plastered walls so thick that small windows are set in deep splayed reveals" (Gowans 1992, 40).

"The first settlers built log cabins in the northern European style. These quickly gave way to substantial houses of fieldstone" (Larkin et al. 1988, 143). The Germans brought with them yet another house type to Pennsylvania. Stemming from the Palatinate region of the Rhine Valley, the cove eave and pent roof (basically a type of shed roof over the first story) followed them to America. These elements are projections of the roof beyond the exterior wall and were used into the eighteenth century by the Quakers. The traditional German house was separated in half by a partition wall where the fireplace was located, adjacent to and servicing the large kitchen or main living area, with a staircase to the second floor positioned in the corner of that room. On the other side of the partition wall, the space was divided into two: one square room and its remainder.

Thomas Cornwallis, who supervised the building of the fort at St. Mary's, Maryland, described the dwellings there as cottages similar to those of the yeoman farmers from England, with dirt floors and thatched roofs with a hole to let out smoke from the central hearth (Lane 1991, 12). Two Dutch travelers visiting colonial Maryland in 1680 remarked, "The dwellings are so wretchedly constructed that if you are not so close to the fire as almost to burn yourself, you cannot keep warm, for the wind blows through them everywhere" (Lane 1991, 14). At this time, colonists did not have the skilled labor, money, or time to construct well-built brick or stone houses.

Developing a New Home Style in the Middle Colonies

French Settlements

In the St. Lawrence Valley, cottages were normally built into the hillside to protect from the cold climate, rather than raised above the ground on stilts as in the South. However, traders introduced the verandah to the stone cottages. In the Mississippi Valley, the cottage was built at ground level. Most were simple one-level houses, but sometimes, in more urban areas, they were two- or three-level stone cottages. Raised basements developed as well, accentuating the second story and thus giving it a more grand appearance. A typical and distinctive characteristic of French colonial houses was the *galerie* or *portico*. The hot and humid climate of Mississippi made porches a necessity to block the sun's rays from beating against the walls of the house, thus keeping the interior cool; to prevent rain from striking the walls, which prolonged the life and ornamentation of the exterior; and to provide a cooler area to eat, entertain, and even sleep beneath. The visual connection of the porch to the southern plantation home makes it a distinctive element of the French colonial residence.

Much like towns of New England were organized around the meetinghouse, St. Lawrence villages were organized by its churches. Not only did this affect the various colonies socially, it also governed them architecturally. Because the French were mainly settling areas in order to convert the Indians to Christianity and concentrated on building defensive military posts, domestic construction suffered. Eventually, in 1763, this culminated in France losing her territories. Today, little remains of French colonial building in America.

Dutch Styles

Although some mimicked the traditional building styles, others modified it to turn the gable end away from the street, giving their houses a more typical appearance of what one thinks of as a New England house.

While the clients of Palladio showed their status through an extravagant entrance or ornamental doorway, Dutch merchants enhanced the gables of their homes as they gained wealth and prospered. Whether patterned brickwork was added or stepped or curved edges and spiked finials, these architectural elements symbolized a shift in Dutch colonial society.

At the turn of the twentieth century, colonial revivalists rediscovered the Dutch colonial cottage and tried to find its origin in the Netherlands. This "prototype" was never found because it was a New World development, "a response to New World conditions and specifically to conditions in the old territories of New Netherlands" (Gowans 1992, 37). This house type represents one of many variations of the Georgian style, with additions of a second or third room and rebuilt stonewalls.

The verandah-girt cottage was an alternative, indigenous colonial Dutch house. As the Dutch masonry cottage was transplanted to the New World, it adapted to include a verandah around the perimeter of the original building. This became known as the Dutch Colonial style. Within 25 years of the verandah's introduction around 1725, it became very common in many of the colonies, including French, English, and Spanish—wherever the West Indian traders made contact.

As houses became larger, higher, and deeper, the roof had to change to accommodate this new structure. The traditional Dutch home had one room with a very steep pitched roof. Because the roof would become steeper and taller with a large house, and the wind stress would be too strong, the roof was adapted to the *gambrel,* a style picked up in New England, possibly influenced by the Huguenots. The gambrel roof had two slants to a side, the upper slant being quite low (Blackburn 2002, 32). This lowered the roof, yet preserved the same usable attic space.

However, when the Dutch came to America, where there were plenty of forests and therefore ample opportunity to use wood shingles, it reluctantly took them until the mid-seventeenth century to start adopting a new way of building. Continuing to build their traditional houses was also a way for the Dutch to hold onto their cultural identity and oppose being under control of the British government.

Gambrel roof framing allowed for a lowered roof while preserving attic space. The Tufts house, shown, achieved this by having two slants to a side. Dover Pictorial Archives.

At the beginning of the eighteenth century, casement windows (hinged at the jamb) were widely used, however, soon colonists started to use sash windows (slides

along the jamb) developed in the Netherlands in 1700. This shows that colonists were sharing ideas and traditions, adapting to what the New World required of them.

A Combination of Cultures Becomes Colonial Style

These colonial adaptations began to meld various cultures of the Dutch with the Swedes and Germans, and eventually culminated under an umbrella of the British colonies by 1763.

In 1730, Germans from Pennsylvania migrated to Maryland, bringing with them both their traditional stone building methods and those new vernacular styles that had been developing in Pennsylvania. By the late 1700s, Maryland had grown more secure and was prospering in the tobacco trade. As Palladio's influence reached the colony, houses were built symmetrical, with two wings on either side of the main, hierarchal part of the house (Lane 1991, 33). A grand staircase comprised a stately entrance to the home. Rooms included a small parlor, reading room, kitchen, library, and two or more chambers (bedrooms) on the second floor. These elaborate and ornamental plans, furnishing and woodworking details around the trim, moldings, chair rails, and especially fireplaces became commonplace throughout the middle colonies and the South.

THE HOMES OF THE SOUTH AND OTHER COLONIES

The South was largely under British control, as was New England. Unlike the commerce-minded colonists in New England towns and cities, southern houses were centered around planting and selling cash crops as a commodity for direct sale and not primarily for personal use. Therefore, the early dwellings of the southern colonies varied widely from elegant plantation mansions to one-room dwellings as a simple means for shelter, inhabited by the business owner and the worker, respectively. "The typical house of the dirt farmer was dark and drafty and had a dirt floor. It was commonly not maintained, because it was a temporary shelter, to be abandoned when tobacco exhausted the soil" (Larkin et al. 1988, 194). Scattered throughout the region were large plantation houses, modeled on the vast country houses on estates in England.

In Virginia, some farmers "rose from the yeoman's ranks through hard work and the acquisition of land" while others arrived already possessing wealth (Larkin 1995, 207). The planters (or owners of plantations) settled sites along the riverfronts, building their houses where they had landed. The yeomen and tenants of more modest means built their homes away from the main waterways and instead among the fields, trees, and creeks. The affluent colonists were able to build their homes of stone, whereas the poorer colonists built their houses of timber. Once slaves were brought over, they lived in small cottages, called quarters, with about six or more slaves each.

In less rural areas, the typical house in Virginia was one or one and a half stories with a sometimes brick chimney at one or both gable ends. Charles Town was truly the ideal urban center. The city grew rapidly during the Colonial period, probably because of the large population of Jews and Huguenots, who felt most at home and familiar with city life. The seaport was larger than New York, Boston, or Philadelphia.

From its conception, North Carolina was divided into north and south. The north consisted of mainly tobacco farmers from Virginia, while rice farmers from South Carolina populated the southern part. South Carolina was considered a buffer province, bordered on the south by the Spanish and on the north by the Indians. As Georgia was established in 1733, this new colony created a new buffer against the Spanish, providing the opportunity for South Carolina's economy to improve. Charles Town (which became Charleston in 1783) supplied the colony with its commercial link to the rest of the world with its three main crops: rice, indigo, and cotton. The emerging prosperous merchants began building two types of dwellings: the single house and the double house. The single house gets its name from having one room, thus being able to keep the house cool. The house was oriented with its gable end to the street side and had a covered *piazza* or porch running along the west or south side of the house. This sheltered from the sun and provided an outdoor living area, both in the summer evenings and during the winter, when the low sun filled the house to keep it warm. The double house was copied from an architect's pattern book, usually English in nature, but sometimes adopted by the wealthy to accommodate the site and local topographic and climatic conditions. Both of these styles created elegant houses, and along with "wide streets and fine gardens" (Larkin 1995, 212). evoked a feeling of beauty and dignity to all who came to visit and settle in these colonies.

Houses in Oglethorpe's Savannah, which was based on military town planning principles, began as clapboard construction. These were huts built with puncheons, or upright logs buried in the ground, and the gaps were filled with wattle and daub and protected on the exterior by clapboards. In Oglethorpe's frontier garrison at Frederica, Georgia, a village of thatched huts was created with Palmetto leaves covering the roofs. These primitive dwellings are proof that Georgia was, at this time, the poorest British colony.

The Spanish established St. Augustine, Florida, in 1565, and they built shelters from wood and thatch, which were frequently destroyed by fires and invaders. In the eighteenth century, architects and engineers trained in Europe were brought to St. Augustine to build a fort that would protect the new colony. Organized much like the temporary dwellings, stone *casas* "lined the edges of narrow streets or footpaths to conserve as much of the lot as possible for detached kitchen houses, wells, storehouses and kitchen gardens" (Gordon 2002, 141). The small porous stones were covered with white plaster and then whitewashed to protect and seal the exterior, gleaming a brilliant white. The typical house in this colony was one level of one or two rooms, with a flat roof and parapet. A *loggia* opened onto a courtyard, and as the style developed, it provided a protected access to a second story and verandah. Suspended, cantilevered wood balconies became characteristic of the charm of the St. Augustine style. The adaptive vernacular architecture focused outward, with a strong indoor–outdoor relationship, instead of focusing inward, as the cold climates of England and the northern colonies required.

Developing a New Home Style in the South and Other Colonies

In Jamestown, although many building methods were brought to the New World from the Old, settlers did assimilate some Indian building techniques.

These included wide, large chimneys and houses covered with tree bark to protect against the heat of the summer sun and the cold winter weather (Donnelly 2003, 10).

In eighteenth-century Williamsburg, an orderly town plan was developed of half-acre lots. To protect the gardens—usually built in front of the residence—from stray livestock, legislation required that each lot be fenced, creating the well-known elevational appearance of the Colonial period.

Similar to the other southern colonies, Charles Town's merchant class was diverging from the merchant class in the middle colonies and in the North, which was adopting a much more balanced structure. A middle class was thus almost nonexistent, causing Charles Town merchants to look to the past for an architecture that had already been established as elegant. A society in the pursuit of pleasure, constant balls, parties, and private clubs created a culture of luxury. This affected domestic architecture in that homeowners desired bigger and better homes to impress, increasing ornament to both the exterior and interior of the house.

The West Indies were colonized by the major European nations. As the West Indies reverted to slavery and a society of fear and violence, its architecture followed. The sugar plantations on the islands proved to be extremely profitable, pushing out the poorer whites and increasing the hostility between wealthy master and slave. In the seventeenth century, Barbados' population was as large as Massachusetts or Virginia (Kennedy 1985, 32). Houses on the islands were much more massive in size and used more permanent materials. However, although the wealthy plantation owners had ample money to build in the Palladian style, they chose to build defensive architecture until the late eighteenth century.

In the Spanish colony of Santa Fe, New Mexico, adobe structures had been built by the Pueblo Indians who lived there when the Spanish conquerors arrived, first in 1540, with the arrival of Coronado. Adobe, consisting of a mixture of earth, sand, and straw then dried in the sun, is still used today in many houses built in Santa Fe and throughout the Southwest.

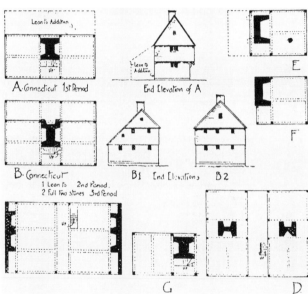

Drawings of typical early Colonial New England houses from Norman Morrison Isham's and Albert Frederic Brown's *Early Connecticut Houses* (Providence, Rhode Island; Preston & Rounds, 1900). Drawings show (A) the chimney and the overhang, from what Isham and Brown call the first period (up to 1675); (B, B1, B2) the larger houses of the second period (1675–1700), and the third period (1700–1750), which show the lean-to design as a more deliberate element, which became known as the saltbox design; (D) in the later period, homes might have a central passage with 2 rooms on either side, with a chimney between; (E and F) show chimneys at the end of a house, including the "stone end" design, prevalent in Rhode Island. (G) shows two rooms with a central chimney. Dover Pictorial Archives.

Georgia, like all other colonies, adapted its architecture as a result of changing conditions and the realization that their traditional building technologies did not prove as appropriate to the New World. Thus, by 1741, tabby construction was widely used throughout colonial Georgia. This building method consisted of a mixture of lime and oyster shells framed in square boxes, which quickly dried and created sturdy and long lasting walls. Not only was this a cheaper method than building in brick, but it also took advantage of the plentiful source of local materials, especially copious amounts of oyster shells. As the economy flourished, soon houses began to include brick in the foundation or as an entire first story, with a timber-framed second story, showing that, once again, yet another colony could adapt its building techniques and architectural styles.

Reference List

Blackburn, Roderic. 2002. *Dutch Colonial Homes in America.* New York: Rizzoli.

Donnelly, Marion. 2003. *Architecture in Colonial America.* Eugene: University of Oregon Press.

Gordon, Elsbeth. 2002. *Florida's Colonial Architectural Heritage.* Gainesville: University Press of Florida.

Gowans, Alan. 1992. *Styles and Types of North American Architecture.* New York: Icon Editions.

Historic New England. 2007. "Clemence-Irons House." Available at: http://www.historic newengland.org/visit/homes/clemence.htm.

Johnson, Claudia Durst. 2002. *Daily Life in Colonial New England.* Westport, Conn.: Greenwood Press.

Kennedy, Roger. 1985. *Architecture, Men, Women, and Money in America.* New York: Random House.

Lane, Mills. 1991. *Architecture of the Old South; Maryland.* New York: Beehive Press.

Larkin, David, June Sprigg, and James Johnson. 1988. *Colonial Design in the New World.* New York: Stewart, Tabori & Chang.

Building Materials and Manufacturing

William Burns

American colonial housing developed from primitive temporary structures to buildings in a wide range of styles and materials differentiated by ethnicity, economic class, and region. Immigrants from Europe and Africa brought the building traditions of their native lands with them and then modified them under new conditions. The vast majority of builders drew on locally available materials, so housing varied tremendously between regions. Wood-rich areas, such as New England, developed wooden housing, while other areas were more likely to use stone, brick, or adobe.

WOOD CONSTRUCTION

In the early days of English colonization, Native Americans speculating on the motivations of their strange and dangerous new neighbors suspected that the newcomers had come to the American shores because they had cut down all the trees in their own countries. This suspicion was not very far from the truth. One characteristic of North America that amazed its early English settlers was its wealth of trees. Heavy demand for wood over the centuries had deforested much of Europe and the British Isles, and the bountiful forests of eastern North America were ripe for exploitation.

In 1622, the Virginia Company, the London-based group of investors in the first permanent Virginia colony, recommended that each immigrant family come equipped with two broad axes, two felling axes, two steel hand saws, one whip saw, two hammers, two augurs, six chisels, two stocked braces, three gimlets (a small tool with a pointed screw end to make small holes), two hatchets, two froes (used to split wood), nails, and a grindstone. If all this equipment had

actually been brought along, it would have represented a huge expense for a family of settlers. The Virginia Company was often disconnected from the reality of colonial life, but it was right about one thing—American settlers would need to fell trees and shape lumber.

The Axe and Other Tools

No woodworking tool was more important to the development of America than the axe. Axes appeared very early in the European invasion of North America, because Europeans, whether Spanish, French, or English, frequently exchanged small axes and hatchets for Native American goods. These small axes were known as "Biscayan axes" to the Spanish, and "Hudson Bay axes" to the English. Given the Native American lack of sharp metal tools, the axes were quite valuable to them.

The felling axe was a larger axe made for chopping down trees, and it was one of the most commonly used axes. British colonists improved on the European original to make the American felling axe by shortening the blade and creating a heavier (and sometimes steel-reinforced) poll, on the opposite side of the handle to the blade, to counterbalance the weight of the blade and make the axe easier to swing. It also made the reverse of the blade a more effective hammer. The body of the blade of the American felling axe was iron with a steel cutting wedge as wide as one and one half inches welded on. When the edge dulled, it was replaced by welding a sheet of steel on one side of the axe, a process known as *steeling* the axe. Another common axe was the hewing or goosewing axe, which had the handle bent away from the blade to enable the user to chop wood lengthwise without his or her hand striking the wood. Goosewing and other broadaxes were used to transform round logs into square beams suitable for building. Goosewing axes often had the makers name inscribed, while felling axes did not. The mortising or posthole axe, with the blade at right angles to the haft, was used to chop square mortises into wood for making a mortise and tenon joint, commonly used in house construction.

Another commonly used hand tool was the froe, which was used to split wood. A froe was a long metal wedge extending at right angles to a short wooden handle. The woodworker set the froe where he desired to split off a layer of wood from a block, and then struck it with a one-handed wooden hammer or froe club. The operator twisted the froe to break off the wood. Froes had many uses. Builders used froes to split off clapboards for siding houses and shingles for roofing. For smoothing a beam, an adze, a tool with a wooden handle leading to an arched metal blade, was used.

The first commonly practiced technique to turn logs into boards, the pit saw, was drawn from Europe. The log to be sawed was laid over a pit about as deep as the height of a man. One man on top and another man in the pit used a long vertical saw to cut the log into boards. Pit sawing was exhausting, particularly because the bottom man (the two sawyers changed positions often) was constantly showered with sawdust, even though he protected himself with a wide-brimmed hat. It was also relatively inefficient because it took a long time to turn a whole tree into boards. The abundance of wood in America meant that hand tools and muscle power were not sufficient for exploiting it, particularly because labor was relatively expensive.

Sawmills

Shortly after the first British colonies were planted, water-powered sawmills were introduced. Anglo-American workers themselves could not build them, because England, which had been consuming its wood avidly for centuries, had become a wood-poor country and lacked sawmills. Experts from the European continent built the first sawmills in Anglo-America using straight saws rather than the later circular saw. Germans built the first sawmill in the Chesapeake, and Danish workers built the first in the Massachusetts Bay colony. The Dutch settlers of New Netherland used windmills, familiar technology from their own country, to cut wood. However powered, mills wasted considerably more wood than did sawyers or axemen cutting lumber by hand. They more than compensated by being much faster. The abundance of wood in early America and the ravenous demand for boards for houses and buildings made speed far more important than efficiency.

The fact that the water-powered sawmills of Anglo-America had to be situated by a stream was an advantage in that softwood logs could be floated to the mill. (Hardwoods sank in water, and had to be carried to the mill.) Streams also provided a deceptively easy solution to one problem sawmills created, a problem that would recur many times in the history of America and the world: disposing of toxic waste. The waste sawmills generated took the form of sawdust. Up to one-fifth of the wood a sawmill processed ended up as useless sawdust. The most common solution of the problem of how to dispose of these mountains of dust was for the miller to dump all of it back into the millstream to be carried downstream. This habit, along with overfishing, eventually killed off the abundant fresh-water fish life that had greeted the first settlers.

Some woods were common, such as oak and pine; others were luxuries and served to show off the user's wealth and status. Sometimes a builder would accentuate the door of a rich family's house by making it out of a special wood not used for walls or roofs, such as apple, sassafrass, or mahogany, one of the rare woods in use that was not of local origin and had to be imported to North America from the Caribbean or Central America. Cherrywood, which could be polished to a rich red, was used for doors and also prized for furniture. Other woods had special properties that were useful to builders. Red cedar, chestnut, sassafras, and especially black locust were water-resistant and therefore well suited to be foundation blocks.

The First Settlers' Dwellings

The earliest colonial housing was very simple in its design and sparing in its demands on labor and natural resources in keeping with the poverty of the early colonists. The first dwellings erected in a colony were often planned merely to provide basic shelter while the colony was established, and then to be abandoned in favor of more sturdy housing. One common temporary solution to the housing problem in both Virginia and New England in the early seventeenth century was digging a rectangular hole in the ground about seven feet deep, walling it with timber, flooring it with planks and putting a wooden roof over the whole. During the first settlement of Philadelphia, which was founded in 1682, some people lived in caves dug into the banks of the Delaware. Caves

were also dug into the hills of Boston in its early settlement in 1630. (These persisted as homes for the very poor or the criminal into the eighteenth century.) This phenomenon of cheap temporary shelters was repeated in subsequent expansion of the colonial frontier. Eighteenth-century pioneer settlers of the back country also built temporary structures, huts, or English wigwams, as they came to be known, constructed of animal skins, bark, or sod. (Despite their name, these structures had European as well as Native American precursors.) On Dauphin Island, near Mobile, Alabama, early French lower-class colonists lived in huts made of wooden stakes covered by reeds.

The Early American House

Even when more permanent structures began to be built, many colonists did not put much effort into them, perhaps believing that they would have the opportunity to better themselves by moving again. Whereas the earliest houses were built mostly by those who planned to dwell in them, houses became increasingly likely to be built by specialist craftsmen, although many of the specialists were not particularly competent by European standards. The most common construction material in the seventeenth-century English colonies was wood, particularly oak. The wattle and daub method was highly popular. Known in England since medieval times, and probably used as far back as the Iron Age, this technique used vertical stakes of wood, woven together with smaller pieces of branches, and bound with a mixture of clay, sand, and possibly straw. It could be plastered over for a smoother finish.

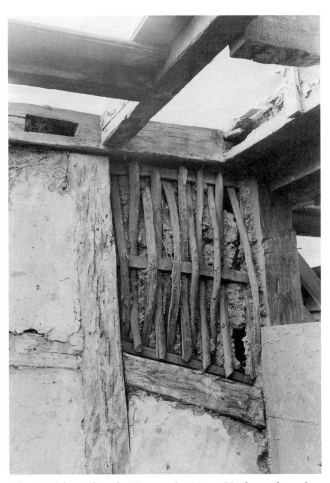

The Golden Plough Tavern in New York undergoing renovations. A detail of the original wattle and daub construction can be seen in an inner partition. Courtesy of the Library of Congress.

Timber-frame clapboard houses, common in English-settled areas, were built around four wooden posts pounded into the ground or resting on a brick or stone foundation at the corners. Smaller vertical beams were placed between the corner beams, and horizontal beams held them together. To avoid the expense of iron nails, many houses were held together with dried wooden pegs known as *treenails* (pronounced *trunnels*) usually made from locust wood. Iron

nails were so valuable that when a building was demolished, the nails were carefully recovered and preserved. The spaces between the beams were filled with a clay daub, a mix of clay, sand, and sometimes straw. Outer walls were short planks, about five or six feet long, called clapboards, placed horizontally. The common use of clapboards distinguished Anglo-American architecture from that of England, where wood was scarce. Even a small house could easily require over a ton of wood.

Jaspar Danckaerts, a seventeenth-century Dutch visitor to America, described the shoddy clapboard houses in Delaware:

> They first make a wooden frame, the same as they do in Westphalia and Altona, but not so strong; they then split the boards of clapwood, so that they are like cooper's pipe staves, except they are not bent. These are made very thin, with a large knife, so that the thickest end is about a *pinck* (little finger) thick, and the other is made sharp, like the edge of a knife. They are about five or six feet long, and are nailed on the outside of the frame, with the ends lapped over each other. They are not usually laid so close together, as to prevent you from sticking a finger between them, in consequence either of their not being well joined, or the boards being crooked. When it is cold and windy the best people plaster them with clay. (Dankers and Sluyter 1966, 173)

Many people envision the early English settlers in America living in log cabins. As it happened, this much snugger and better-built alternative to the clapboard house was introduced to America by the Swedish colonists of Delaware and for several decades had little influence on Anglo-American houses. Swedish settlers, coming from a part of Europe that was still heavily wooded, also made churches and other buildings out of logs. Danckaerts found the log houses far superior to clapboard:

> The house, although not much larger than where we were the last night, was somewhat better and tighter, being made according to the Swedish mode, and as they usually build their houses here, which are block-houses, being nothing more than entire trees, split through the middle, or squared out of the rough, and placed in the form of a square, upon each other, as high as they wish to have the house; the ends of the timbers are let into each other, about a foot from the ends, half of one into half of the other. The whole structure is thus made, without a nail or a spike. (Dankers and Sluyter 1966, 175)

The log cabin design began to spread with the settlement of Pennsylvania, when German and British settlers copied the houses of their new Swedish neighbors. From there the log cabin diffused through the settlement of the back country in the eighteenth century. By the middle of the century, Virginia planters were constructing log houses for their slaves.

Another local variation in housing was the stone-ender, a form of wooden house common in Rhode Island, which, unlike the other New England colonies, had access to good stone for building and lime suitable for mortaring. The stone-ender featured a massive stone chimney that furnished most of the wall on the north end of the building, suited for protecting the inhabitants from the

cold north wind. The greater separation of the chimney from the wooden part of the house meant that stone-enders had considerably less risk of burning than all-wooden buildings.

French colonists in the Mississippi Valley and Mobile, Alabama, used wood, mostly cedar, to build their houses, although a few houses in Mobile had brick or stone foundations. Foundations, whether of wood or more durable material, were necessary to raise Mobile houses above the flood line. Clay was used for plastering.

In the early stages of colonization people often roofed their houses with thatch or sod, but eventually shingles, which lessened the danger of fire, became common. (Thatch roofs disappeared by about 1670.) Cedar, due to its lightness and durability, was the most popular material for shingles—so popular as to rapidly deplete the stock of cedar trees. White pine and fir were also used for shingles. The lightness of cedar shingle roofing contributed to the American tendency to build houses with very thin walls without much load-bearing capacity. Baked clay tiles nailed to the roof were also used, and in the eighteenth century, they replaced shingles in many areas. They offered still better protection from fire. Benjamin Franklin was among those recommending tile roofing for fire protection, and he was also intrigued by the idea of covering roofs with copper. Copper never caught on, but slate roofs were also used for fire prevention. The windows of early colonial houses were slits designed to minimize the loss of heat, and sometimes covered with cheap translucent paper or cloth rather than expensive glass. (Early Swedish settlers in the Delaware valley made windows out of the transparent mineral mica.)

Wood, coated with a heavy layer of clay, was initially used in New England for the upper portion of chimneys. The lower portion was brick or stone to protect from fire, but many lacked the money to build an all-brick or all-stone chimney. Because the clay could fall off the wood, even well-protected wooden chimneys were dangerous, and chimneys made entirely of brick became more and more popular over the Colonial period.

Houses for Slaves

Some of the shoddiest housing in the British colonies was built for slaves, particularly those field workers on plantations who lived in small groups in simple wooden huts with dirt floors close to where they worked. Many slaves, particularly on small farms and in the early days of settlement, lacked any dedicated housing and slept in barns, tobacco houses, or kitchens. Slaves also slept in large dormitories in some outlying plantations. Where African Americans, whether free or enslaved, were able to build their own houses, they

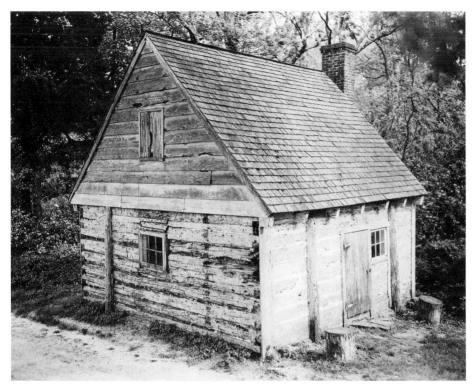

Early stone slave quarters in Bethesda, Maryland. Courtesy of the Library of Congress.

often incorporated African features, such as small rooms around 12 by 12 feet, pounded dirt floors, mud construction, and palmetto-leaf thatching. African housing materials and technologies, like other features of African culture, were particularly marked in South Carolina, where the high death rate of slaves meant that masters continued importing slaves from Africa in large numbers throughout the Colonial period. In the other great center of slavery, the Chesapeake tobacco-planting region, the slave population was more self-sustaining, and African cultural survivals were fewer.

Slave housing in South Carolina improved somewhat in the eighteenth century, with sturdier buildings with foundations and plank floors. In Virginia, slave housing (including the miserable huts George Washington provided for his slaves at Mount Vernon) was usually temporary and poorly made because slave tobacco workers had to follow the crop as fields became exhausted and new ones were planted. South Carolina rice growers, cultivating the same fields year after year, were willing to provide better, more permanent housing for their enslaved workers.

STONE AND BRICK CONSTRUCTION

Wood's great rivals as construction materials were brick and stone. Although wood, by far the cheapest material, was also the most common, particularly for

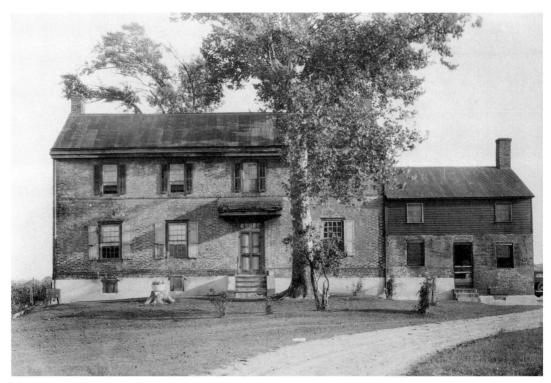

The Flemish bond method of brick laying patterns is found in the Huguenot House, a plantation house built in approximately 1711 in New Castle County, Delaware. Courtesy of the Library of Congress.

the poor, stone and brick housing was an increasing presence on the American scene in the eighteenth century.

Quarries for sandstone and granite were established early in America. Sandstone was mostly quarried in Connecticut and Pennsylvania, while granite was mostly quarried in New England. Building stone was a difficult and expensive material to extract, shape and transport, and its principal uses were for public buildings and churches rather than residences. Like brick, it was also used for purposes where wood would be unsuitable, to lay foundations or to serve in fireplaces and chimneys, to protect against the spread of fire.

Bricks were cheaper and more common than building stone. They were made of clay and other ingredients, including sand and water, shaped in rectangular wooden molds, dried for several days, and fired in a kiln for many hours. Although some bricks, particularly by the eighteenth century, were imported from England, most bricks used in English colonial buildings were American-made. Brickmaking began early in the American colonies. In 1611, only a few years after the founding of Jamestown, Sir Thomas Gates brought brickmakers from England to make bricks for the new settlement of Henricopolis. Buildings made entirely of brick began to appear around the middle of the seventeenth century. Whether a colony adopted brick in its early years was largely dependent on whether their immediate territory offered good clay for brickmaking. Some

areas, such as Tidewater Virginia, boasted clay deposits that made excellent bricks, and Jamestown even exported bricks to the Caribbean. Bricks were also recycled as old buildings fell into ruin or were demolished. Ivor Noel Hume, an archeologist specializing in colonial Virginia, has estimated that the average eighteenth-century, Anglo-American colonial brick was 8 3/4" by 4" by 2 5/8." Seventeenth-century bricks were slightly larger (Hume n.d., 81–82). The color of the brick was determined by the impurities of the clay of which it was made and the firing process. Some areas, such as Charleston in the late eighteenth century, preferred to build with bricks as close to uniform in color as possible. Others, such as the Chesapeake, preferred variegated bricks.

Once bricks were made, they had to be laid into walls. Mortar was used to bind bricks or stones together in a wall, while plasters were used to provide a smooth and in some cases water-resistant surface. The two principal types of mortars and plasters used in colonial America were clay-based and lime-based. Clay-based mortars and plasters were cheaper, but not as durable or water resistant. They were most common in areas where lime was unavailable.

A detail of the Flemish bond method of brick laying patterns in Davidson County, Tennessee, shows that the long side of the brick (the stretcher) alternates with the short end of the brick (the header). Courtesy of the Library of Congress.

Lime mortars and plasters were made from lime, sand, and water. Sand and water were common, but lime had to be manufactured. The most common source of lime was from burning limestone, marble, or seashells, particularly oyster shells. Native Americans had thrown away oyster shells for centuries, in heaps called *middens,* and these became valuable sources for colonial lime-makers. (Fragments of shell can sometimes be seen in remaining plasters from the Colonial era.) Mixing the ingredients together into a strong mortar was a skill and a large portion of the knowledge of an expert bricklayer. The area between bricks filled with mortar was known as the *joint.*

Load-bearing brick walls had to be more than one brick thick. In order to make strong brick walls, bricks laid lengthwise and endwise *(stretchers* and *headers)* were arranged in different patterns called *bonds.* Bonds were often identified ethnically, such as English bond or Flemish bond, and went in and out of

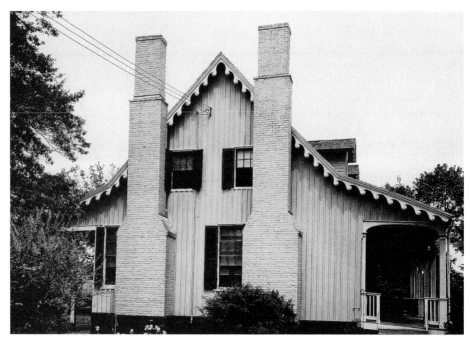

English bond method of brick laying is used in Sasscer's House, Upper Marlboro, Maryland, originally constructed before 1730. Courtesy of the Library of Congress.

fashion. Bricklaying at the highest level was a skilled profession. Expert bricklayers, many of them coming directly from England, were expected not just to know different bonds and prepare mortars and plasters, but also how to lay bricks for tricky domestic features, such as brick gables.

Brick was the basis of the eighteenth-century Georgian house, which became characteristic of the American elite. Georgian houses were marked by brick construction, painted clapboards, and large, symmetrically arranged sash windows with ornamental wooden frames and crown glass rather than inferior broad glass. The huge central fireplaces of the seventeenth century were abandoned in favor of smaller, more efficient fireplaces. Seventeenth-century features, such as tall gables, broad glass windows with lead casements, and overhanging second floors, disappeared, sometimes through remodeling of existing structures.

Despite the rise of Georgian and other brick country houses, brick was most characteristic of cities. Brick offered better protection from fire than wood. Fire was a constant danger, particularly in large cities. The Virginia Assembly, prompted by governor William Berkeley, enacted in 1662 a requirement that each county support the building of a brick house in Jamestown as part of a program to expand and modernize the capital of the province. The program was unsuccessful due to the general indifference of Virginia planters to urban centers. It was not Jamestown but Philadelphia that set the pattern for subsequent Anglo-American brick cities. From its founding in 1682, it broke with the Anglo-American tradition of timber houses and built its middle-class dwellings and other buildings mostly of brick. (Many Quakers came from the

North of England, with a tradition of building in stone.) Brick houses in Philadelphia were both taller—some extending to three stories—and more cramped than wooden houses in New England. Although wooden houses predominated at first, the Dutch also built much of their housing in New Amsterdam in brick or stone. The French in New Orleans (founded in 1718) also began with wooden buildings, but after a brickyard was established in 1726, they incorporated brick basements to raise their living quarters above the flood lines. (Little is known of original New Orleans dwellings, as nearly all of the early city was destroyed in a great fire in 1788.) New England, on the other hand, with its abundance of forest, stuck much more stubbornly to wooden housing. There were only a dozen or so brick houses in seventeenth-century New England.

A calamitous fire, such as the one that swept Boston in 1711 or New Orleans in 1788, sometimes led a town to replace its destroyed wooden housing stock and other buildings with brick. Severe weather damage could have the same effect. In Charleston, which was founded in 1680 as Charles Town, houses were originally wooden and built in the manner of the West Indies, where many of the city's first colonists originated. The city suffered a severe hurricane in 1713 with much damage to its housing stock. The South Carolina Assembly then ordered that subsequent buildings be in brick, although this requirement was frequently ignored. Charleston also had a distinctive, French-influenced style of brickwork, a contribution of the town's large French Protestant, or Huguenot population.

A detail of the English bond method of brick laying pattern in Sasscer's House, Upper Marlboro, Maryland, shows that one row of the long side of the brick; the stretcher alternates with one row of the short head (the header). Courtesy of the Library of Congress.

Urban housing was not all brick. Brick was far too expensive for the poor, who were housed in crowded wooden buildings in back alleys, vulnerable to epidemic disease and fire. As brick and stone houses advanced, cheaper wooden housing continued to drop in status. The mid-eighteenth-century Swedish traveler Peter Kalm, describing the New Jersey town of New Brunswick, pointed out that many of the houses had only one brick wall, facing the street, while the rest of the building was of wood. Someone passing through rapidly, he

A brick house of the period, the Robert Brewton House in Charleston, South Carolina, original construction between 1701 and 1715. Courtesy of the Library of Congress.

claimed, might think most of the town brick—exactly what the passing stranger was intended to think (Kalm 1966, 121).

ADOBE AND OTHER BUILDING MATERIALS IN SPANISH AMERICA

Spanish housing in the Southwest (which was to Spanish and Mexican colonists the far north) was shaped by the isolation of this remote frontier of the Spanish Empire. Unable to import building materials, and having few timber resources, the Spanish adopted the Native American tradition of construction with a mixture of clay and sand, dried in the sun rather than fired in a kiln like brick. This material is known as *adobe.* (Wooden buildings began to appear more frequently in Spanish America once Spain had worked its way up to California and its forests in the eighteenth century.) Adobe was sometimes used in English colonies, particularly New Jersey, but its most important center was the Spanish territory in the Southwest.

The Spanish were already familiar with adobe by the time they arrived in the American Southwest. It had been introduced into Spain by the Islamic invaders of the Middle ages. (The word *adobe* was originally Arabic.) The Spanish transformed Native American adobe technology by introducing the technique to make adobe into bricklike forms. Native Americans had puddled mud into large pieces, which were then used as layers in the building of a wall. Spanish construction also differed from Native American in that the Spanish used stone foundations for their buildings rather than laying them directly on the earth. Although adobe is considerably easier to manufacture than baked brick, it has the disadvantage of being much more subject to erosion from wind and particularly water. An adobe wall was initially covered with a protective layer of clay plaster and required constant upkeep and replastering to keep the building from literally falling apart. (Restricted to clay mortars and plasters in the Southeast, the Spanish were able to use lime mortars on the California coast, burning abalone shells for the lime.)

Wood was incorporated into adobe houses as materials for doors and doorframes and as supports for the adobe roof. Planks were laid on top of the house, then covered with saplings or twigs. Then the whole mass was covered with

watertight adobe. The wood used for roofing was subject to decay and had to be replaced about once a century. Floors were of packed earth, sometimes mixed with animal blood and ashes for a harder surface. There was no window glass and few windows. Wood was used to bar windows, due to the scarcity of iron in the area. Mica panes were also sometimes used as windows.

Tabby and Coquina

The building materials in Spanish Florida and other southeastern settlements were unique and drew upon the resources of the seacoast. One was a kind of sedimentary limestone known as *coquina,* produced by the buildup of shells over many thousands

A detail of a house in Florida showing coquina blocks in mortar, original construction ca. 1710. Courtesy of the Library of Congress.

of years. Coquina had to be dried for several years before it was hard enough to be used in building. Another Spanish building material in the Southeast was *tabby,* a mixture of sand, lime, and crushed shells to form a concrete. Tabby was poured into wooden molds to harden into blocks over two or three days. Poured directly into a pit dug in the ground, it could form a foundation, or, poured on load-bearing timbers, it could make a roof. Tabby was plastered or stuccoed for protection, particularly where it might be exposed to the weather. Its origins may have been in the Iberian Peninsula or in West Africa. In Florida, where all stone in 1672 was required for use in building the Castillo San Marcos, a great fortress to protect Spaniards against the English, tabby came to be used for building homes and other buildings. It then spread to the British colonies in Georgia and coastal South Carolina. In Georgia, tabby was promoted by the founder of the colony, James Oglethorpe, for its cheapness and durability.

CRAFTSPEOPLE AND WORKERS

Particularly in the early days of settlement, people and communities built their own houses. This naturally led to poor construction, as most lacked the skills of carpenters and joiners. People who had only a smattering of knowledge could market themselves as skilled builders, which led to houses of only slightly greater quality. Eventually the profession of the master builder, or *housewright,* developed in the eighteenth century. Master builders supervised the construction of entire houses, often working from design books imported from England. They were most important in the construction of large houses belonging to planters and other members of the colonial elite. Some master builders, such as Henry Carey who supervised the construction of the Governor's House at Williamsburg, then the new capital of Virginia, attained a considerable reputation.

Anglo-American colonial promoters were eager to import technically knowledgeable people from different areas of Europe. This began as early as the first colonies in Massachusetts and the Chesapeake bay in the opening

decades of the seventeenth century. The desirability of attracting European immigrants knowledgeable in specific industries continued into the eighteenth century and beyond. Skilled workers emigrated from England and Europe in pursuit of the greater professional mobility and higher wages America offered. However, the need for housing in the settled areas of the colonies led to the development of a native construction industry of carpenters, joiners, bricklayers, and stonecutters. The most expert of these workers, foreign or native-born, found their services in high demand, as towns or individuals actively recruited them.

Paradoxically, the low cost of land in America actually posed a problem for the colonial homebuilding industry. Many colonial builders hoped to use the profits earned by their skill to buy land and become farmers. Landed property was associated with independence and security, as opposed to the precarious existence of the craftsman who could only earn if others hired him. After entering farming, craftspeople might have used their skills to build for themselves, but farming took too much time for them to continue building for others. American social mobility also made it difficult either to control the wages paid to workers by government decree, although it was tried, or to set up and maintain an institutionalized system of apprenticeship like Europe's. In an apprenticeship system, a young worker was legally bound to a master worker for a period of years, learning the trade and receiving room and board in exchange for an initial payment. However, in America it was relatively easy to set out on one's own without fulfilling the full term of the apprenticeship contract.

Both skilled and unskilled construction work was also performed by slaves, particularly in the South where the slave population was greatest. Slave builders not only worked on plantation and other rural housing, but also on urban houses. Although the work was hard and the hours longer than those worked by the free, skilled slave builders had higher status and better living conditions than most slaves who were agricultural laborers. Slaveowners sometimes hired free carpenters for a building job with the expectation that the carpenters would train the slave laborers. Free artisans in the South were aware of the danger of slave competition, but they were helpless to do much about it in the slaveowner-dominated society.

HEATING THE HOME

A great problem for dwellers in early colonial houses in the North was heating them, a problem exacerbated by the coldness of the winters compared with those in Britain and Europe. Early English colonists took advantage of the bountiful supply of wood to build large, centrally located fireplaces, twice the size of those they had known in England. In addition to the standard tendency of fireplaces to send much of their heat up the chimney, heat also escaped through the many cracks and openings in wooden walls, although stone and brick homes, if well plastered, retained heat better. If a person was not close to the fire, he or she often derived little warmth from it, and fireplaces and open hearths were also dangerous for children. The fireplace's insatiable hunger for wood contributed to deforestation and meant that people spent much of their daily labor chopping down trees, preparing wood for the fire, and tending the flames. A supply of firewood was also a common perquisite of ministers. The

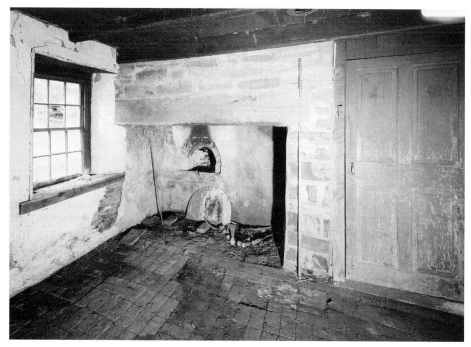

A large fireplace both for cooking food and for heating the house at the High Farm in Pennsylvania, built ca. 1710. Courtesy of the Library of Congress.

Reverend Samuel Parris, later to become infamous as a leader of the Salem witch hunt, had bitter disputes with his parishioners for years over what he alleged was their failure to keep his house adequately supplied with firewood.

Finding and preparing firewood grew more demanding with the decades, as people exhausted the timber resources close to their dwellings and had to go farther and farther afield for wood. Much of the early expansion of New England to the north was driven by the need to find new forests for timber. Many Anglo-American colonial leaders of the eighteenth century were acutely aware of the looming shortage of wood and what it portended. Benjamin Franklin claimed, "Wood, our common fewel, which within these 100 years might be had at every man's door, must now be fetch'd near 100 miles to some towns, and makes a very considerable article in the expence of families" (1931, 64). The demands of the cold winter of 1770 drove the Virginia planter Landon Carter to fear for the future:

> I must wonder what succeeding years will do for firewood. We now have full 3/4 of the year in which we are obliged to keep constant fires; we must fence our ground in with rails build and repair our houses with timber and every cooking room must have its fire the year through. Add to this the natural death of trees and the violence of gusts that blows them down and I must think that in a few years the lower parts of this Country will be without firewood but pines have a quick growth and we must find out a way of burning them unless we shall be happy in discovering mines of coal (Carter 1965, 382).

Finding an adequate supply of firewood was a particularly pressing problem for cities, given their population concentrations. Boston, which had no native timber, was perpetually bedeviled by a shortage of wood and eventually turned, after 1730, to importing coal from Britain. (Some Bostonians still depended on firewood, however, because coal had to be burned in a grate, and not everyone could afford one.) New York City had to pass strict laws regulating the fees that could be charged for hauling wood to prevent exploitation by haulers during the winter. America's firewood situation improved with the development of snugger houses that did a better job of retaining heat and eventually the introduction of the stove, a more efficient means of heating than the fireplace. German colonists are often credited with bringing heating stoves to America, but they spread slowly through the Anglo-American population.

Although stoves were introduced from Europe, they were capable of further improvement in America. Two great physicists produced by colonial America, Benjamin Franklin and Benjamin Thompson (best known by his later title as Count Rumford), were fascinated with the problem of efficiency in fireplaces and stoves and originated stove designs. Franklin pointed out that one reason why stoves had not become more popular is that, unlike fireplaces, they did not allow people to actually see the flames. He combined a visible fire with the heating advantage of the stove in his "Pennsylvania Fire Place," which he hoped would help conserve America's wood.

Of course, heat was not always a blessing. Because a fire was necessary for cooking even on hot days, early colonists in the South faced the problem of dissipating heat during the summer. One solution was to put the fireplace at the end of the house rather than at the central location common in northerly climes. Eventually, many southerners physically separated the kitchen from the rest of the house.

LIGHTING THE HOME

The problem of lighting the home was solved in many ways. The most common source of light, of course, was the sun, and many adapted to it simply by going to bed when the sun set. One of the advantages of the shift from seventeenth-century domestic architecture to the eighteenth-century Georgian house was that the latter's larger windows let in more light. The domestic fire, particularly when in an open fireplace rather than an enclosed stove, also provided some

light. Dedicated light sources were rarer. Anglo-American settlers seized on the Native American practice of using pine-knots, which could burn in a corner of the fireplace and light the room. The pine-knots were also called candlewood or pine-torches.

Candles were too expensive to be a source of light for the poor, and they were more often used by the middle class and rich. The wealthiest Americans sought to dazzle visitors to their homes with rooms illuminated by dozens of candles. Candles could be made of many substances, but the two most common were animal fat, or tallow, and wax. Tallow, which was also used for soap-making, was most commonly made from the fat of domestic cattle, but all kinds of animal fat could be used. In the fall, tallow was melted in great vessels and skimmed. Tallow candles were made either by dipping, repeatedly lowering the wicks in the tallow and allowing each layer to cool before dipping again, or in candle molds.

Vegetable fat tallows were unusual, but not unknown. Peter Kalm described how, in Pennsylvania, tallow for candles was made from the bayberry, or candleberry, bush: "The berries grow abundantly on the female shrub, and look as if flour had been strewn upon them. They are gathered late in autumn, being ripe about that time, and are then thrown into a kettle or pot full of boiling water. By this means their fat melts out, floats at the top of the water, and is skimmed off into a vessel. The skimming is continued until there is no tallow left. The latter, as soon as it is congealed, looks like common tallow or wax, but has a dirty green color. It is for that reason melted over again and refined, by which means it acquires a fine and rather transparent green color: this tallow is dearer than common tallow, but cheaper than wax" (Kalm 1966, 102.) The bayberry candles also had the advantage of giving off a pleasant aroma when snuffed. Myrtle-berries were also used for candle wax, and valued for their scent.

Wax candles burned with a clearer, steadier flame than tallow candles and, given their greater expense, carried more social status. The best and most expensive candles, however, were made from *spermaceti*. Spermaceti, found in the heads of sperm whales, produced a hard candle that did not melt in the hands and burned cleanly and brightly. The profitability of the spermaceti trade made candlemaking and deep-sea whaling boom industries of the mid-eighteenth century.

External lighting was another problem, particularly in cities. In the eighteenth century, cities shifted from a system whereby individuals were required to keep lights in front of their dwellings to publicly maintained night lighting systems. Whale-oil lamps were used for public lighting in Boston and Philadelphia.

WATER IN THE HOME

Next to air, there is nothing human beings require more than water. Although many shunned water as a drink, it was necessary as the base for other drinks, such as tea, as well as for cooking, washing, and firefighting. Every household required water, but getting it could be a formidable challenge. Sources varied from streams, which had water in profusion although it was often dirty; to wells, which were more work but produced purer water that many preferred. Despite the proximity of the Delaware River, Philadelphia drew most of its

water for domestic use from wells. Springs and cisterns for catching rain were also commonly used, but presented many difficulties in getting water from one place to another. Cities had neighborhood pumps in some areas, but not central water. A centralized system set up in Boston in 1652 combined a small, gravity fed reservoir with pipes made from hollow logs to carry water for household and firefighting use, but this early attempt at centralizing water for a city proved to be a failure.

The first American town that had a system pumping water to every household was the German Moravian town of Bethlehem, Pennsylvania. Bethlehemers had depended on a single well at the bottom of a hill near the town gate. Water for household use had to be carried by hand up the hill. The new system was completed in 1755 under the direction of Hans Christopher Christensen, a Danish immigrant millwright, with some help designing the pump from John Boenher, a missionary stationed in the West Indies but visiting Bethlehem. The completed system used a water-powered wheel to pump water from a cistern fed by a local stream. The water was conveyed through a system of hemlock logs bored to form pipes to a water tower constructed in the middle of town. The water was then carried by gravity to Bethlehem homes. The system attracted notice outside of the town itself, and Bethlehem became a destination for curious visitors, including George Washington. Moravians also spread the idea for this system to their other American communities. The Bethlehem system was later upgraded with multiple iron pumps and pine pipes.

TRASH AND SEWAGE DISPOSAL

Another huge problem was disposing of waste. Like other people before the twentieth century, colonial Americans generated far less trash than people do today (for one thing, packaging had not become the ubiquitous source of stuff to be thrown away that it is in the twenty-first century), but they did generate much, and it all had to be disposed of somehow. The most common solution was a trash pit, dug in the ground in the land surrounding the house. Trash pits took all kinds of refuse, including human and animal waste, garbage, and broken crockery (making them, once centuries had passed, an excellent source for archeologists). People urinated and defecated in outhouses, often called privies or necessaries, sometimes with a pit dug below to hold wastes, sometimes not. In either case, the outhouse had to be moved after a period. The presence of all this trash and waste generated horrible odors, particularly in areas of concentrated population. Two of the major cities of northern North America, Boston and New York, began building public sewers around 1700, although Philadelphia was a laggard. New York and Boston in the eighteenth century built their streets with a slight concavity, so that water would run down the middle, while Philadelphia built convex streets, creating gutters on the side.

Reference List

Carter, Landon. 1965. *The Diary of Colonel Landon Carter of Sabine Hall, 1752–1778*. Edited with an introduction by Jack P. Greene. Charlottesville: University Press of Virginia.

Dankers, Jaspar, and Peter Sluyter. 1966. *Journal of a Voyage to New York and a Tour in Several of the American Colonies in 1679–80*. Trans. and ed. Henry C. Murphy. Reprint. New York: Readex Microprint.

Franklin, Benjamin. 1931. *The Ingenious Dr. Franklin: Selected Scientific Letters of Benjamin Franklin.* Ed. Nathan G. Goodman. Philadelphia: University of Pennsylvania Press.

Franklin, Benjamin. 1987. *Writings.* New York: Library of America.

Hume, Ivor Noel. n.d. *A Guide to the Artifacts of Colonial America.* 2nd ed. Philadelphia: University of Pennsylvania Press.

Jefferson, Thomas. 1984. *Writings.* New York: Library of America.

Kalm, Peter. 1966. *Peter Kalm's Travels in North America: The English Version of 1770.* Rev. and ed. Adolph B. Benson. New York: Dover Publications.

Home Layout and Design

Melissa Duffes

This chapter will look at the various dwellings built by the Native Americans and the early colonists of the North American continent. While the earliest explorers might have noticed the structures inhabited by the natives, few actually built their own homes similarly; and if they did, they were only of a very impermanent nature. As Roth (1979) states, the native dwellings viewed by the early colonists were quite alien: "It countered all their traditions…and in no way provided the immigrants with the emotional and symbolic security needed" (13). Instead, they built their homes as they had been being built for centuries in their homeland—with varying results.

NATIVE AMERICAN DWELLINGS DURING THE COLONIAL PERIOD

When the first European explorers arrived in North America, the dwellings of the natives had been in the process of evolution for thousands of years. Through trial and error, each tribe had developed their own unique structures, dependent on the climate as well as on their style of living. Some descriptions of their dwellings by the earliest settlers showed their fascination with the natives' construction techniques:

> The Natives of New England are accustomed to build them houses much like the wild Irish; they gather Poles in the woodes and put the great end of them in the ground, placing them in forme of a circle or circumference, and, bendinge

the topps of them in forme of an Arch, they bind them together with the Barke of Walnut trees, which is wondrous tough, so that they make the same round on the Topp for the smoke of their fire to ascend and pass through;…The fire is always made in the midst of the house, with winde falls commonly: yet some times they fell a tree that groweth near the house, and, by drawing in the end thereof, maintaine the fire on both sides, burning the tree by Degrees shorter and shorter, untill it be all consumed; for it burneth night and day. Their lodging is made in three places of the house about the fire; they lie upon plankes, commonly about a foote or 18 inches above the ground, raised upon railes that are borne up upon forks; they lay mats under them, and Coats of Deares skinnes, otters, beavers, Racoons, and of Beares hides, all which they have dressed and converted into good leather, with the haire on, for their coverings: and in this manner they liee as warme as they desire. (Morton 1637)

The Wigwam

The dwellings of the Eastern Woodlands Indians were indeed warm, and quite substantial, able to withstand the harsh winters. A structure common to many tribes, particularly those of the Northeast, was the wigwam. As was described by Morton (1637), wigwams were domed dwellings made from young saplings, bent over and lashed together and covered with bark, hides, or woven mats. The domed shape was useful in deflecting cold winds during the winter. There was a single door opening in the side, as well as an opening on the roof for smoke. Usually 10–16 feet in diameter and 10 feet high, a single wigwam could house two or three families at a time (Roth 1979, 8).

Wigwams were found further down the eastern coast as well. A late sixteenth-century explorer described the dwellings of natives in the North Carolina region as, "constructed of poles fixed in the ground, bound together and covered with mats, which are thrown off at pleasure, to admit as much light and air as they may require" (Roth 1979, 9). And Captain John Smith observed houses of Virginia

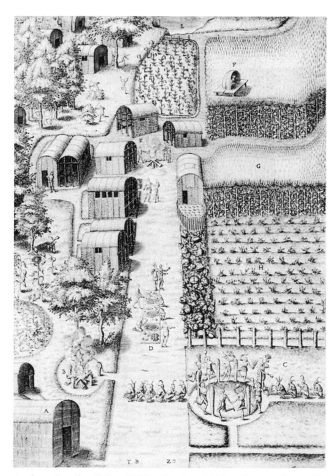

A drawing by John White in the 1580s shows the well-ordered Algonquin village of Secotan, located on the Pamlico river estuary (North Carolina). Courtesy of the Library of Congress.

natives from 1624 as, "so close covered with mats, or the bark of trees, very handsomely, that notwithstanding either wind, rain, or weather, they are as warm as stoves" (Roth 1979, 9).

Other Native Dwellings

A variation of the wigwam was the longhouse, built mainly by Northeastern tribes such as the Iroquois. These structures were essentially elongated wigwams with arched roofs and sides covered in bark, thatch, or hides. Measuring up to 100 feet in length, with multiple smoke holes in the roof, the longhouse could hold up to 14 families at once, along with additional storage space (Roth 1979, 8).

Many of these dwellings, unlike those of tribes further west, were of a semipermanent nature. The Eastern Woodlands tribes were based on more agricultural traditions and tended to stay in one location until the soil and other resources were used up. While some more northern tribes might move further into the forest during the winter months for protection against harsh winds, many of the longhouse communities were quite stable and would stand for a decade or more before being taken down and moved.

The further south explorers traveled, the more the climate changed and, with it, the native dwellings. Southern tribes also constructed wigwams and longhouses, but without the harsh climate to worry about, their dwellings took on a different shape. Many of the tribes built structures with gable roofs that were thatched rather than covered in hides. Woven mats would be used for the walls, as well as a form of half-timbering with woven grasses and clay (McAlester and McAlester 1991, 70). In the farthest South, in the Florida regions, many dwellings were raised up on poles to keep dry and often were built only with a gable thatched-roof covering and no walls.

Indoor activities that took place in Native American dwellings were much like those of the early colonists. Eating, sleeping, and working would all be performed indoors by some tribes, particularly those living communally in Northeast

Pomeiock, a fortified sixteenth-century Native American village, located in present-day North Carolina. The longhouses, though meant to be temporary, could last more than a decade. Courtesy of the Library of Congress.

longhouses, and certainly during the winter months for many tribes. The Iroquois longhouses allowed multiple activities to take place, while those living in smaller structures might only sleep and eat within. Religious ceremonies and other socializing would often take place outside of the dwelling at larger centrally built structures.

EARLY COLONIAL HOMES IN THE NORTHEAST

The very earliest homes of English and European settlers of the New World were built quickly, without much thought to style. Immediate shelter was of the utmost importance; crops had to be planted for survival, and extra time spent on architectural styles was not spared. Cornelis van Tienhoven, a later visitor to the English colonies, described how the first settlers constructed their dwellings:

> Those in New Netherland and especially in New England, who have no means to build farm houses at first according to their wishes, dig a square pit in the ground, cellar fashion, 6 or 7 feet deep, as long and as broad as they think proper, case the earth inside with wood all round the wall, and line the wood with the bark of trees or something else to prevent the caving in of the earth; floor this cellar with plank and wainscot it overhead for a ceiling, raise a roof of spars clear up and cover the spars with bark or green sods, so that they can live dry and warm in these houses with their entire families for two, three and four years, it being understood that partitions are run through those cellars which are adapted to the size of the family. The wealthy and principal men in New England, in the beginning of the Colonies, commenced their first dwelling houses in this fashion for two reasons; firstly, in order not to waste time building and not to want food the next season; secondly, in order not to discourage poorer laboring people whom they brought over in numbers from Fatherland. In the course of 3

Life Inside a House in the Massachusetts Bay Colony

Inside a house of an average, not wealthy, family, in the Massachusetts Bay Colony in the 1630s, people covered their log walls with different materials. Some used hides; some used cloth; some used sod, that is, dirt to which grass and other hardy vegetation was still attached (and what frontiersmen on the nineteenth-century plains would use); some used tree bark. Some families used deerskins. These skins and some large pieces of bark might cover all but the fireplace wall. Settlers made roofs of logs covered with bark, heavily daubed with clay to keep water out. Although the clay-daubed fireplace was an obvious fire hazard, early settlers (except for the wealthy) had no choice but to make the fireplace of wood and clay.

Poor New Englanders were unable to afford the heavy metal hinges that the wealthier people imported or had fashioned for them by local blacksmiths from imported metal, so their doors and shutters were tied on with leather thongs.

Early immigrants often planned their doorways not with the aim of admitting light and sun, but rather to keep out bad weather and dangerous animals. They reasoned that a small, low doorway would mean they at least would have some momentary warning if unfriendly people tried to enter their house. Doorways often ended up being so low and small that even the shortest adults or young people were forced to bend over to enter.

Despite the addition of windows, house interiors were still dark and gloomy. Viewing such a house today, we might wonder why the builder had not made more and larger windows and more and larger doors to bring in the beauty of this pristine landscape for a light, cheerful, handsome interior. But for most settlers, typical of the time and place, their views of nature were altogether different from a twenty-first-century view. To settlers, nature was not synonymous with beauty and grace; it was instead a hostile enemy. Nature to them meant chilling cold, ice, snow, brutal winds, predatory animals, and the baffling natives. They did not want to bring nature into their houses; they wanted to keep it out.

Source: From *Daily Life in Colonial New England* by Claudia Durst Johnson. Copyright © 2002 by Claudia Durst Johnson. Reproduced with permission of Greenwood Publishing Group, Inc.

or 4 years, when the country became adapted to agriculture, they built themselves handsome houses, spending on them several thousands." (De Wolf 1992, 5–6)

Early homes of the colonial settlers were built in much the same way as they were in England, though the climates were quite different, and first attempts did not stand up well to the harsh New England weather. Half-timbered homes common to the West Country in England, from where many colonists emigrated, proved to be an ineffective barrier. The wattle-and-daub method of construction (wood frame with woven twigs and mud and a thatched roof) was not impermeable, and cracks developed in the walls and at the joins. Colonists soon began to replace the half-timbered exterior with a covering of clapboard walls and a split shingle roof, which was an effective wind barrier.

Home Layouts

The layout of the early colonial home in the Northeast was either based on a single-cell or two-room interior (both one room deep) with a half story above. Often the smallest of homes would have a central door, two window openings on either side, and a large masonry fireplace on one end. The half story, which would be a floor laid underneath the eaves, might only reach halfway across the length of the dwelling and be reached by a ladder. Half stories of other homes might cover the floor space entirely and be accessed by a tightly turned corner staircase. The one-and-a-half-story home of William Oakford was built in

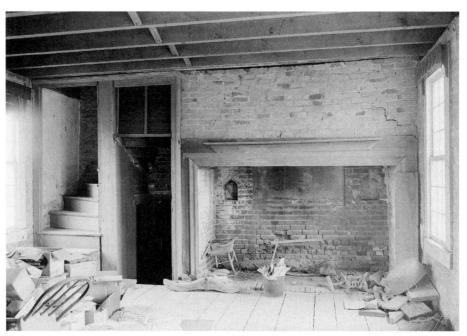

A hearth and staircase in the William Oakford House of Salem County, New Jersey, shown in great disrepair, probably in the 1930s. The house was built in 1736.
Courtesy of the Library of Congress.

Salem County, New Jersey, in 1736. Brick exterior and a shingle roof enclosed a single room downstairs with two fireplaces, one at each end. Next to the larger of the two fireplaces was a small staircase that led to a half-story above, which was partitioned into three rooms.

For early colonial homes with a two-room layout, the door opening faced a massive central chimney with hearth openings to either side, one room serving as a main workroom, kitchen, and living space, and the other room used for more private activities, possibly containing the "best bed" of the homeowner. A staircase built into a chimney niche would save space in cramped quarters, and the upper story could double as a storage area as well as additional sleeping space. Later, larger homes developed a stair hall, which was an anteroom just beyond the front door that contained a staircase leading to a full second story. The second story might still be a single room or, in larger or more affluent households, could be divided into two rooms, each with a fireplace opening.

Another variation on the central chimney plan was a layout referred to as a saltbox (also known as a cat slide in the South; Rifkind 1980, 4). In a saltbox configuration, additional rooms, some for storage or sleeping, or often as a kitchen, would be built on the backside of the dwelling, running the length of the house. Because of the longer winters, more interior space was much desired, and the extra rooms, even small ones, would be a welcome addition. The side-gabled roof would extend in the rear to cover the added rooms, resulting in the saltbox shape. Colonial saltbox houses could be both one and two sto-

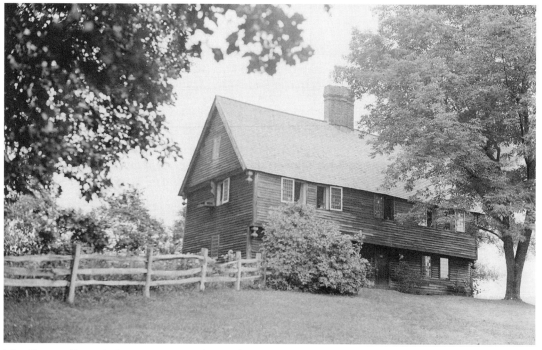

The Parson Joseph Capen House of Topsfield, Massachusetts, built in 1683 is an excellent example of a New England central chimney plan. Courtesy of the Library of Congress.

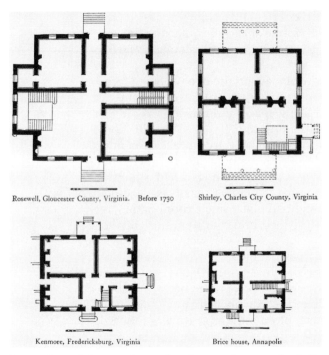

Rosewell, Gloucester County, Virginia. Before 1730

Shirley, Charles City County, Virginia

Kenmore, Fredericksburg, Virginia

Brice house, Annapolis

Examples of houseplans showing various stair halls (1730). Dover Pictorial Archives.

ries high and were not commonly seen until after 1700 (McAlester and McAlester 1991, 105). Built in the second half of the seventeenth century, the Boardman, or Scotch house, located in Saugus, Massachusetts, was built in a classical saltbox shape. Beyond the hall and parlor configuration of the two downstairs rooms (with a stair hall located just inside the front door), the additional lean-to added a further chamber, kitchen, and woodshed on the first floor and extra storage space behind the two bedrooms on the second.

Early colonial homes with the central chimney plan were located mainly in the New England areas, though they could be found in other parts of the English colony as well. The layout was ideally suited for harsher climates, however, because the large masonry chimney located in the middle of these dwellings would store heat and radiate it out over a period of time, which was most useful for the long winters. The Parson Joseph Capen House in Topsfield, Massachusetts, was built in 1683 and is another excellent example of a New England central chimney plan. Larger than others of its time, the Capen house had a small turned staircase in a modified stair hall with two rooms on either side of the central chimney. Instead of a smaller half story, the dwelling had a full second story.

EARLY COLONIAL HOMES IN THE SOUTH

The smallest early colonial homes in the southern colonies also featured single-room layouts, the major difference being in the placement of the chimney to the side of the room. As the winters were quite mild in the South, a central masonry chimney with its radiating heat properties was not a priority. The single room usage, however, was much the same as in the northern colonies—work activities and most family life were pursued in the downstairs room, while the half or full story above would contain sleeping areas and extra storage space. A variation on the one-room layout, seen in larger or more affluent southern dwellings, was the hall-and-parlor configuration. Much like the central chimney layouts of northern dwellings, the southern hall-and-parlor was divided into two rooms downstairs, separated by a central staircase leading to the upper story. The hall side, with the chimney, functioned as the kitchen, workspace, and main living area, while the parlor contained the "best bed" of the homeowner. The Keeling house, in Princess Anne County, Virginia, near Norfolk, was probably constructed in the late seventeenth or early eighteenth century. A center

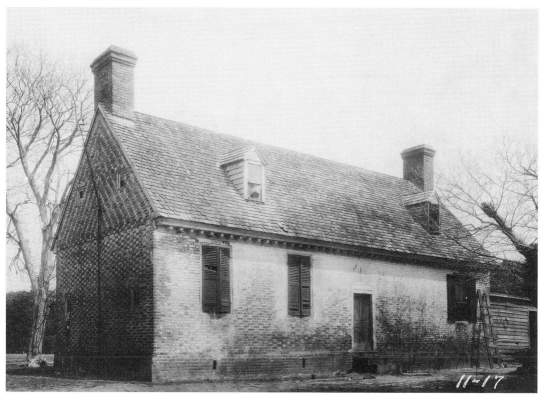

Adam Keeling House (ca. 1700), with paired chimneys, in the London Bridge vicinity, Virginia.
Courtesy of the Library of Congress.

hall and staircase separated two rooms downstairs, each with fireplace openings on the outside walls. These paired chimneys were also a feature particular to early southern colonial homes. As heat was not needed as much in the interior of the dwellings, chimneys were placed on the sides of the house (on the outside, rather than inside walls) and heat was better controlled. Southern homes originally built with a single end chimney might later add a second when finances permitted. Also, a single-room dwelling with an end chimney could be enlarged with another room and paired chimney on the end for symmetry. Built in the middle of the seventeenth century, the Adam Thoroughgood House in Virginia Beach, Virginia, is another

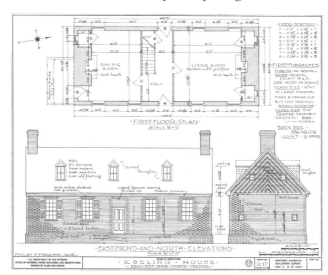

The Keeling house floorplan. Courtesy of the Library of Congress.

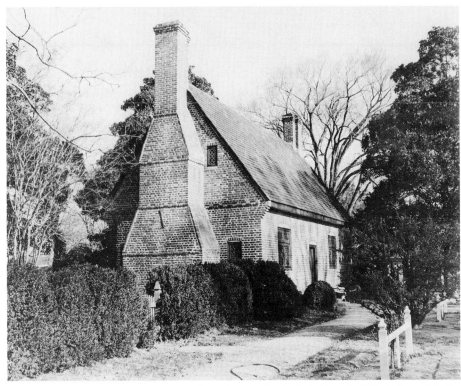

Adam Thoroughgood House (mid-17th c.) of Virginia Beach, Virginia, with its stately chimneys. It is one of the oldest surviving houses on the East Coast. Courtesy of the Library of Congress.

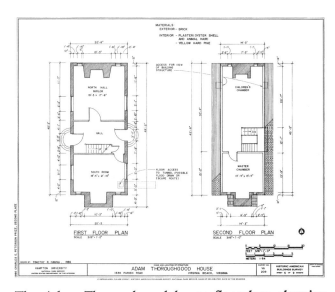

The Adam Thoroughgood house floorplans showing the early Colonial central stair hall plan. Courtesy of the Library of Congress.

excellent example of the early colonial central hall plan. The one-and-a-half story dwelling with paired end chimneys had a center stair hall in between two rooms downstairs and two rooms upstairs.

Later Colonial Homes

As Cornelis van Tienhoven observed in 1650, the earliest settlers to the North American colonies did not have the means, or the time, to build dwellings to their liking. But, toward the end of the seventeenth century, colonists began to rethink their homes, and some were able to fashion new and grander houses that they hoped would compare with the large estate homes in England. The increased trade with England

guaranteed that the colonists would be aware of changing styles in architecture in that country, and they did their best to keep up with it.

The Palladian style homes built by the British elite in the early seventeenth century stressed an adherence to a strict classical order, with symmetry and proportion inside and out. Andrea Palladio was an Italian architect of the Renaissance whose *Four Books of Architecture* (1570) influenced architectural styles in England and, later, in the colonies. The first English edition of Palladio's treatise appeared in 1715 and led to a spate of architectural books being published in England during the first half of the eighteenth century. Colin Campbell's *Vitruvius Britannicus* (1715) and Robert Castell's *Villas of the Ancients* (1728) joined reprints of Palladio and Vitruvius's *Ten Books of Architecture* (30 B.C.), the only complete architectural treatise to survive from the ancient world. Architectural treatises had long since been a part of a wealthy English gentleman's library. Obtained while abroad in Europe on the Grand Tour, or imported at great expense back home, these books showed his good taste in the ancient arts. This rediscovery of classical architecture was led by men such as Inigo Jones and Williams Kent, who designed houses for England's wealthiest landowners in the seventeenth century.

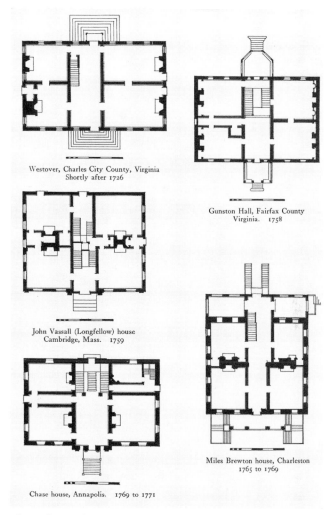

Westover, Charles City County, Virginia
Shortly after 1726

Gunston Hall, Fairfax County
Virginia. 1758

John Vassall (Longfellow) house
Cambridge, Mass. 1759

Miles Brewton house, Charleston
1765 to 1769

Chase house, Annapolis. 1769 to 1771

Floorplans of Westover, Gunston Hall, and other period houses. Dover Pictorial Archives.

News of the style, along with the architectural books themselves, slowly made its way to the British colonies during the late seventeenth and early eighteenth centuries. The College of William and Mary (1695–1702) is an early example of the style, while Westover, in Charles City County, Virginia, and Sabine Hall, in Richmond County, Virginia, both epitomize a high-style classical structure built for a private homeowner. Though much of what was new about this style could be found on the exterior, changes were taking place in the interior layout, especially in homes of the colonial elite. Outward expressions of gentility and wealth were important. Houses on the whole became larger, now two rooms deep and two full stories high, often with a basement level as well (sometimes containing the kitchen in more northern areas). The central chimney plan gave way to paired chimneys, and the hall-and-parlor plan was

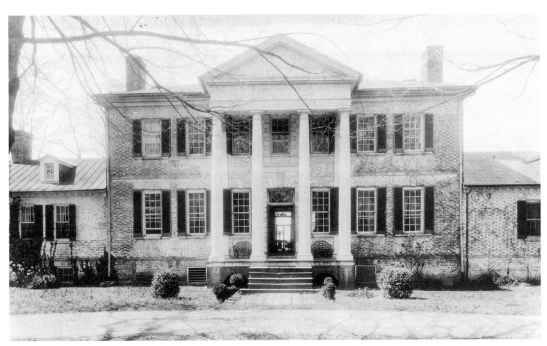

Palladio's influence is seen in Richmond, Virginia's Sabine Hall, built in 1750. Courtesy of the Library of Congress.

expanded. The hall itself was widened to become a room of its own, and it was set off on both sides by four symmetrically balanced rooms. "Best beds" began to be moved out of sight of the visitor, relegated to upstairs chambers, while the notion of the parlor as a room for entertainment became very important to the later colonial homeowner. Sabine Hall had four rooms around a center hall, including a library and a drawing room, for entertaining guests. Derby House in Salem, Massachusetts, also had a central hall with four rooms surrounding it (including the kitchen).

The center stair hall layout with paired end chimneys became common throughout the colonies during the eighteenth century, though some central chimney versions did continue in the northeastern areas, especially for middle- and lower-class homes. Wealthy colonists could easily build new dwellings, while others made do with older layouts or merely added on rooms (such as saltbox examples) as needs and finances changed. As usual, the poorest home-owners continued to live in old structures that were common to the earliest part of the Colonial period.

As cities grew during the eighteenth century, townhouses became more common and developed an interior layout all their own. As space was an issue, the common two-rooms-deep plan with central hall and staircase was revised. Townhouses were usually one room deep, with a staircase hall, or, depending on space, simply a staircase located on one side. Additional rooms fell in behind the front room, which was the most public room—a parlor or drawing room. The Van Bidder House (1763), located in the Fell's Point area of Baltimore, Maryland, had a cellar, three stories, and an attic, but it was just one-and-a-half

rooms wide at the front and one room wide at the rear. Two public rooms, one behind the other, ran alongside a narrow stair case hall, with other rooms built directly behind the staircase in back.

Reference List

De Wolf, Gordon. 1992. "The Beginnings." In *Keeping Eden: A History of Gardening in America*, ed. Walter T. Punch, 1–11. Boston: Little, Brown and Company.

Johnson, Claudia Durst. 2002. *Daily Life in Colonial New England*. Westport, Conn.: Greenwood Press.

McAlester, Virginia, and Lee McAlester. 1991. *A Field Guild to American Houses*. New York: Alfred A. Knopf.

Morton, Thomas. 1637. "Description of the Indians in New England." In *New English Canaan*. The American Colonies, Swarthmore University History Department, Bruce Dorsey, 1999. Available at: http://www.swarthmore.edu/SocSci/bdorsey1/41docs/08-mor.html.

Rifkind, Carole. 1980. *A Field Guide to American Architecture*. New York: Plume.

Roth, Leland M. 1979. *A Concise History of American Architecture*. New York: Harper & Row.

Elevation of a town house from Joseph Moxon's *Mechanick Exercises* (1700). Dover Pictorial Archives.

Furniture and Decoration

Melissa Duffes

Colonial interior furnishings and decoration were chiefly influenced by the settlers from Europe and England. The English, who settled mainly in New England and the South; the Dutch, who colonized the Hudson River Valley area of New York; and the German and Swedish settlers, who made their home in Pennsylvania and the Delaware Valley, all brought their respective styles to play when creating objects for everyday living. Furnishings that were brought to the New World by the early colonists served as prototypes for the new forms that were created by craftsmen. Far away from large centers of culture, and with cabinetmaker's pattern books scarce to nonexistent, craftsmen used these foreign examples to build upon, creating new forms from older ideas. While many objects could be traced to a main source, other forms were wholly unique creations, not made by contemporary craftsmen abroad. This chapter will discuss objects and furnishings made and used by early American colonists in the sixteenth through the eighteenth centuries: furniture, metals, ceramics, glass, and textiles, as well as the influence of pattern books on furniture design. Some Native American decorative objects will also be examined, though on the whole, little survived from this period. The migratory practices of the early Native Americans on the East Coast naturally precluded any large accumulation of personal items. Additionally, eastern tribes were the first to be displaced during the colonization of North America. Incursion by settlers on their land, wars with other tribes, and disease rapidly removed Native Americans westward. Most of what is known about their material possessions, mainly

utilitarian objects, comes from first-hand accounts of early explorers, traders, and settlers from England and Europe.

COLONIAL FURNISHINGS

The English and European settlers to the North American colonies brought little in the way of material goods with them. Space was a premium, and most had to make what they needed when they arrived. What they did produce, in the way of furniture and other items, was based on the style they knew best, that from home. Colonial style, therefore, follows closely behind English and European style, taking into account the time it took for news of the latest style to travel overseas. As more settlers came, they brought further news of trends from the important centers of culture, and most colonists eagerly embraced the new fashions. Aside from first-hand knowledge of style made by a trip abroad, oral accounts from new arrivals, as well as letters, immigrating craftsmen also brought their own knowledge of design, along with pattern books, to waiting consumers in the colonies. Inevitably, regional variations emerged, and remained so until much later when mass production and communication made for more uniform designs.

Between the earliest colonists and the later poor to middling homeowner, there was little change in overall style of furnishings. Many continued to own only a few pieces of furniture, pottery, and pewter in the plainest style, either made by them or passed on from older generations. Keeping up with the latest fashion from abroad, while maybe desirous, was not practical. It was not until later, after the Revolution, when the emerging middle class as consumer made it possible to make and purchase cheaper versions of more fashionable objects.

The wealthy and elite colonists, however, were willing and able to spend money to procure the latest from abroad. The display of one's status was shown through not only the exterior of one's home, but also the furnishings on the inside. A chair with the most elaborate carving or a wall hanging of the richest fabric was seen to all as a sure sign of prosperity, of one who not only knew of the latest fashion, but could afford to either import it from abroad or specially commission it at home.

FURNITURE

Pre-eighteenth-century American furniture is not found in abundance in today's museums. Although age would necessarily preclude much of it from surviving until now, in fact there was not much of it produced at the time. Houses for early American colonists were small to begin with and the average homeowner did not need much in the way of interior furnishings: a storage chest, stools, a chair or two, a table, and a trundle bed might complete his furniture inventory (Krill 2001, 54). Joint stools were probably the most common furniture form; they were easy to make and many poor to middling homes might have only stools as seating furniture. Chairs were the second most common furniture form, but as they were more costly than stools, many homeowners might have only one or two examples. As such, they would sometimes be reserved for use by important guests as a sign of the owner's generous hospitality.

The Renaissance and Baroque designs from Europe heavily influenced the style of seventeenth-century American furniture. In assembly, craftsmen and

joiners were still using medieval methods of furniture making—mortise and tenon joints—just as carpenters did with home construction. Hard oak was used for more expensive pieces, while softer pine was chosen for less costly, more lightweight objects. More elaborate chairs, like those that might be offered to special guests, would be heavy in form, with solid backs joined in a square frame, square seats, and sturdy legs. Surface decoration was usually of low relief and consisted chiefly of carved or gouged designs, or turned elements (spool turning, which was a series of narrow separated rings, being the most common). Another chair type was the ladder-back, which was lighter in form as well as weight. The number of horizontal back splats varied, as did the turnings on the arms and legs. The rush-woven seat found on such chairs made it a comfortable alternative to the heavier panel chair.

For most early colonists, both affluent and poor, meals were taken in rooms used for other purposes. Small gate-leg tables were most useful; they could be brought in and set up for dining, then folded and put aside for more room. Trestle tables, though medieval in origin, were also seen in early colonial America; heavy plank tops were set on supporting legs and could be removed for storage when not in use. Another space-saving furniture form was the settle, which often had a hinged seat for use as storage space, while other examples featured a back that could flip down to form a flat, horizontal surface for working or dining. Later tables sometimes had a single drawer fit into the apron. Like the chairs, decoration was minimal on these other furniture forms, usually expressed in the turnings of the support members. A chest during this period could be the most costly item in a colonial household. Though many chests were simply fashioned as four panels and a hinged lid, carvers would often decorate the flat surfaces with elaborate or gouged designs. Some examples were also painted, the most popular colors being black, red, white, and green. Colors could be used on seventeenth-century furniture to mimic more costly pieces: black could be used to imitate expensive ebony, while more intricately painted patterns could resemble marquetry or other inlaid work (Krill 2001, 50). Such pieces were treasured objects, given on special occasions, such as marriage; they were cared for and often bequeathed in wills to the owner's descendants.

During the later seventeenth and early eighteenth century, increasing wealth, as well as increased trade abroad, allowed for new furniture styles to be introduced into the colonial home. Though little might have changed in living conditions

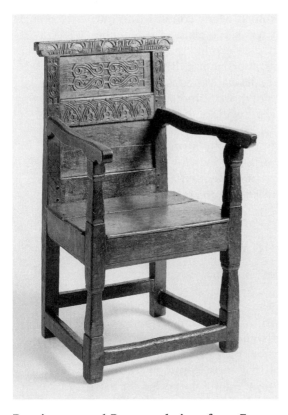

Renaissance and Baroque designs from Europe heavily influenced the style of this great chair from the seventeenth century, showing a square frame, square seat, and sturdy legs. Made in Essex County, Massachusetts. Winterthur Museum.

for the poor and middling colonist, the affluent had better access to the more sophisticated furniture forms being produced in England, and native craftsmen became more specialized in their production of furniture in the colonies. Houses of the wealthy grew in size, necessitating more furniture to fill the rooms, and as Krill states, homeowners began to have more than one kind of each object (2001, 66). Furniture sets became popular in affluent homes, as a more unified approach to interior decoration began. Sets of chairs for a table with matching decorative embellishments could be proudly displayed by a colonial homeowner, showing him to be a man of wealth and taste. Furniture during this period was light and more graceful than early seventeenth-century examples, with previous heavy forms replaced with highly elaborate surface decoration. Burl walnut veneering was a popular method of decoration, as was inlays with other woods such as maple, cherry, and apple. Turned elements also became more prominent, with large ball or bun-shaped feet, baluster supports, and ball-and-steeple finials. Chests became more popular and were raised on turned legs with carved supporting stretchers. Such high chests were lavishly decorated with wood veneering or japanning, which tried to imitate lacquer examples imported from China. A new form of lower chests with hinged slant tops became an important centerpiece in a wealthy colonist's home; it showed his wealth in being able to afford such a piece, as well as his success as a businessman, for needing such a piece of furniture in his home.

Chairs (which were now being upholstered to match the new decorative schemes) could be some of the more costly pieces in a colonial homeowner's inventory. Upholstered wing chairs were prized possessions, not only for the decorative embroidery covering it, but also

Joiners, Turners, and Cabinetmakers

Furniture making in the Colonial era was still accomplished with techniques that had been in place since medieval times. In the middle ages, guilds in England and Europe controlled most of their country's trades, and the carpenters' guild was one of the oldest, with simple furniture making being among their woodworking skills. However, in the later fifteenth century with the advent of the panel-and-frame method of furniture construction (panels fitted into a grooved frame and secured with a mortise-and-tenon joint), more complicated forms could be constructed. Most furniture was made of oak, which, while sturdy, had a tendency to split or warp if not seasoned properly. Paneled pieces allowed the wood room to expand and contract without damage. Creating a chair or chest with panels called for greater skill than before, with precise measures needed for joint construction. Some craftsman began to specialize in joint work and these *joiners* broke away from the carpenters to create their own guild. There was much debate as to which guild had the right to produce furniture, and in the early seventeenth century, laws were passed that gave the joiners exclusive responsibility for "all sorts of Cabinets or Boxes dovetailed, pinned or glued," while the carpenters' guild would continue to produce construction woodwork (Osborne 1985, 116). Another subgroup of the carpenters was *turners*, who, like carvers, added decorative elements to furniture pieces by working the wood on a foot-operated pole lathe, which turned the wood while the craftsman cut it into the desired shape with a chisel. The seventeenth century brought further decorative innovations to furniture making in the form of veneering, marquetry, and japanning. Veneering was the process of gluing thin sheets of wood to another surface to create decorative images. Marquetry, a decorative veneer, used exotic woods such as ebony, or ivory and tortoiseshell, to form a mosaic-like design on a surface. Japanning, which was an imitation of the rare and expensive oriental lacquers imported from the East, was used to decorate both furniture and smaller objects. Those who specialized in such highly decorative pieces began to refer to themselves as cabinetmakers and, like the joiners, soon broke away from the carpenter's guild. By the mid-eighteenth century, the cabinetmakers had formed a large society in London and were responsible not only for decorative veneers but also upholstery, gilding, papering, and carving.

for the skill that was needed in creating such a piece. The finest examples of upholstered and carved-back chairs of this time were characterized by S-curves found in the back, arms, and legs of the chair. This "Cyma" curve was also incorporated into pattern designs found in the covering textiles, but it was most distinctive when used as part of the structure itself. Though such chairs were mainly made for and purchased by the wealthiest colonists, even vernacular examples found in poorer households featured some variation of this ubiquitous curve and, for the first time, regional variations began to be seen throughout the colonies. New England, New York, and Philadelphia all developed distinctive styles of what is now referred to as the Queen Anne chair. Philadelphia, the largest of the colonial cities at the time, produced some of the most elaborate chairs, with a compass or horseshoe-shaped seat (far different from the square seats of earlier colonial examples) and delicately curving arms and legs.

The Windsor Chair

Further down in price, though still out of reach for some poor and middling colonists, was the familiar Windsor chair, which had its beginnings in England (possibly in Windsor, Berkshire) at the turn of the eighteenth century. The first mention of the chair in the colonies is quite early—1708—where a will noted that "a John Jones of Philadelphia…died possessed of a Windsor chair" (Watson n.d.). It is likely that this particular chair was an import, as colonial production of Windsors did not begin until around 1725.

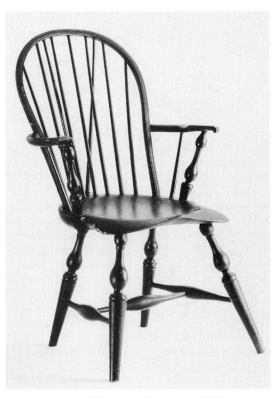

This bow-back Windsor Chair (ca. 1792) has the distinctive arched back rail with turned back-spindles, arms, and legs, and a D-shaped seat. Winterthur Museum.

Native craftsmen quickly made the chair their own, and many regional variations were produced, differing particularly in woods used, as well as the style of the back. Windsor chairs most commonly had an arched back rail with turned back spindles, arms, and legs and a D-shaped seat. The distinctive bowed back and curved arms of the chair were made by boiling and soaking the wood, then bending it around a shaping support to dry (Watson n.d.). Craftsmen varied the turned elements of the chair (often made separately by turners, then purchased by the craftsman to complete the job) to create unique designs for leg and arms supports. Specialty forms of the chair were also made, such as the writing armchair, which featured a hinged writing surface attached to one arm, or a commode chair with a concealed chamber pot beneath the seat. Painted Windsor chairs became more popular as the eighteenth century progressed, with green being the most common color; in fact, Windsor

chairs were also known as "green chairs" at the time, though an order placed by George Washington Wallingford showed the variety that could be had: "1 dozen black Windsor chairs, 1/2 dozen yellow Windsor chairs, and 3 black yellow-striped Windsor chairs" (Krill 2001, 128). For those colonists who could afford them, Windsor chairs were purchased in sets, as their lightweight construction made them easily transportable from room to porch to garden. Many Windsor chairs were used in the garden during the eighteenth century until wrought iron (and later cast iron) became more affordable. Both George Washington and Richard Bland Lee owned several dozen Windsor chairs at their Virginia plantations of Mount Vernon and Sully, respectively, and they displayed them either in the front hall or front porch for use by their many guests. During the mid-eighteenth century, a Windsor cost between 10 and 18 shillings, making it accessible to many middle-class colonists, as well as the elite (Evans 1997, 68). The simplest chairs or jointed stools still made up the bulk of the poorer colonial households, as did rough trestle tables or settees, which could double as a work surface when needed. A plain rush-seat chair cost four to six shillings in the mid-eighteenth century, and as a journeyman's daily salary was about the same, most middling households only contained the bare necessities (Krill 2001, 134).

Both furniture examples and craftsmen came from England and Europe during this period, and both were highly sought by those colonists who could afford them. Some colonial cabinetmakers made trips abroad to search out the latest styles, or had agents in place to send them examples or pattern books to use for their clients. One Boston furniture maker advertised his wares in 1726 as including: "All Sorts of Looking-Glasses of the Newest Fashion & Japan Work, viz. Chests of Drawers, Corner Cupboards, Large and Small Tea Tables &c. done after the best manner by one late of London" (Freund and Keno 1998).

By the mid-eighteenth century, a more florid and highly embellished style of furniture that had been popular in England and Europe began to reach the colonies by way of pattern books and immigrant craftsmen. Mainly French in origin, rococo furniture displayed elaborate curves, asymmetrical scrollwork, and naturalistic motifs rendered in rich woods, particularly mahogany, which was made popular from the growing trade with the West Indies. Carving was the main decorative element for rococo furniture, and many craftsmen used such pieces as vehicles for their best work. The profusion of ornament was found on all elements of this style of furniture—legs, arms, and backs of chairs; legs and tops of tables; and posts of beds. Architectural elements in rooms also were used to showcase the rococo carver's art, and wooden brackets for displaying ceramics or overmantel mirrors were elaborately carved with shells, leaves, and scrolls and then gilded for extra richness. Though some designs could have come from the craftsman himself, most relied on the growing number of pattern books for decorative ideas.

Furniture Pattern Books

During the eighteenth century, nearly 40 furniture pattern books were published in England, and these were the chief source of dissemination of style to the North American colonies (Heckscher and Kenny 2000). The books

themselves were quite costly and any importation of them on a large scale would have been prohibitive. Still, a few members of the colonial elite, including Thomas Jefferson, as well some cabinetmakers, managed to either own or view copies of such titles as *The Gentleman and Cabinet-Maker's Director* (1755), *Universal System of Household Furniture* (1762), and *Cabinet and Chair-Maker's Real Friend and Companion* (1765). Most publications were intended for the benefit of craftsmen and tradesmen to produce the latest style of furniture, and in eighteenth century colonial America, this meant costly commissioned pieces imported from abroad. Only the wealthiest of colonial homeowners could afford such furniture. *The Gentleman and Cabinet-Maker's Director,* Thomas Chippendale's publication, was the most influential pattern book for most of the eighteenth century; even after the rococo style, which he promoted, had faded in England, it was still being seen in the American colonies well after the Revolution. Many furniture forms from the mid-Atlantic and the South showed direct influence from Chippendale's *Director.* William Ince and John Mayhew's *Universal System of Household Furniture* (1762) was in direct competition for Chippendale's audience and most furniture illustrated in this publication was also in the French rococo fashion, though not many examples taken from their *Universal System* were found in the colonies. John Crunden's *Joyner and Cabinet-Maker's Darling* (1765) and Robert Manwaring's *Cabinet and Chair-Maker's Real Friend and Companion* (1765) also were highly influenced by Chippendale's rococo style, and Manwaring's designs seemed especially popular in the Boston region (Heckscher and Kenny 2000).

The following excerpt from the preface to Thomas Chippendale's *The Gentleman & Cabinet-Maker's Director* (1762) demonstrates not only Chippendale's concern for proper workmanship and promoting the gentlemanly aspect of good cabinet making, but also attempts to head off potential critics.

Of all the Arts which are either improved or ornamented by Architecture, that of CABINET-MAKING is not only the most useful and ornamental, but capable of receiving as great Assistance from it as any whatever. I have therefore prefixed to the following Designs a short Explanation of the Five Order. Without an Acquaintance with this Science, and some Knowledge of the Rules of Perspective, the Cabinet-Maker cannot make the Designs of his Work intelligible, nor show, in a little Compass, the whole Conduct and Effect of the Piece. These, therefore, ought to be carefully studied by every one who would excel in this Branch, since they are the very Soul and Basis of his Art.

The Title-Page has already called the following Work, *The Gentleman and Cabinet-Maker's Director,* as being calculated to assist the one in the Choice, and the other in the Execution of the Designs; which are so contrived, that if no one Drawing should singly answer the Gentleman's Taste, there will yet be found a Variety of Hints, sufficient to construct a new one.

I have been encouraged to begin and carry on this Work not only by Persons of Distinction, but of eminent Taste for Performances of this Sort; who have, upon many Occasions, signified some Surprise and Regret, that an Art capable of so much Perfection and Refinement, should be executed with so little Propriety and Elegance. How far the following Sheets may remove a Complaint, which I am afraid is not altogether groundless, the judicious Reader will determine: I hope,

however, the Novelty, as well as the Usefulness of the Performance, will make some Atonement for its Faults and Imperfections. I am sensible, there are too many to be found in it; for I frankly confess, that in executing many of the Drawings, my Pencil has but faintly copied out those Images that my Fancy suggested; and had they not been published till I could have pronounced them perfect, perhaps they had never seen the Light. Nevertheless, I was not upon that Account afraid to let them go abroad, for I have been told, that the greatest Masters of every other Art have laboured under the same Difficulty.

I am not afraid of the Fate an Author usually meets with on his first Appearance from a Set of Critics who are never wanting to show their Wit and Malice on the Performances of others: I shall repay their Censures with Contempt. Let them unmolested deal out their pointless Abuse, and convince the World they have neither Good-nature to commend, Judgment to correct, nor Skill to execute what they find Fault with.

The Correction of the Judicious and Impartial I shall always receive with Diffidence in my own Abilities, and Respect to theirs. But though the following Designs were more perfect than my Fondness for my own Offspring could ever suppose them, I should yet be far from expecting the united Approbation of ALL those whose Sentiments have an undoubted Claim to be regarded; for a thousand accidental Circumstances may concur in dividing the Opinions of the most improved Judges, and the most unprejudiced will find it difficult to disengage himself from a partial Affection to some particular Beauties, of which the general Course of his Studies, or the peculiar Case of the Temper may have rendered him most sensible. The Mind, when pronouncing Judgment upon any Work of Taste and Genius, is apt to decide of its Merit according to those Circumstances which she most admires either prevail, or are deficient.

Upon the whole, I have here given no Design but what may be executed with Advantage by the Hands of a skilful Workman, though some of the Profession have been diligent enough to represent them (especially those after the Gothick and Chinese Manner) as so many specious Drawings, impossible to be worked off by any Mechanic whatsoever. I will not scruple to attribute this to Malice, Ignorance, and Inability; and I am confident I can convince all Noblemen, Gentlemen, or others, who will honour me with their Commands, that every Design in the Book can be improved, both as to Beauty and Enrichment, in the Execution of it.

Many furniture forms that had been used earlier in the eighteenth century were still present by mid-century—card tables and tea tables, wing chairs, and settees were still being made but now with profuse carvings on the arms, legs, and backs. New

Overmantel mirrors were often elaborately carved and gilded in the houses of prominent Colonial families. Winterthur Museum.

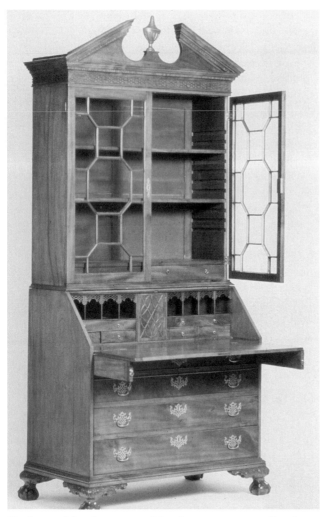

Desks and bookcase combinations were new furniture forms that often became the centerpiece in wealthy colonial homes. This fine example was made in New York City, 1770–1775. Winterthur Museum.

forms being produced were pier tables, which were commonly placed in halls or dining rooms (if the homeowner were wealthy enough to have a separate eating room); these tables were higher than normal, with marble tops and elaborate carvings on the legs and front apron (the projecting area below the top). Desk-and-bookcases were a combined form that was easily a showpiece in the parlor of some colonial elite. A low chest with three or four graduated drawers supported a bookcase unit with doors, usually glazed. In between was a fall-front writing surface, behind which were small drawers or pigeon holes for storage. Matching *highboy* and *lowboy* chests were also popular with wealthy homeowners, who were the only ones who could afford such luxury as a matched set of furniture. A highboy was a chest-on-chest raised up on curved legs, much like those seen on the Chippendale chairs of the period, while a lowboy was a smaller chest. High beds with elaborately carved posts and coordinating bed linens also appeared more frequently in wealthy homes during the mid-eighteenth century.

Regional Variations in Furniture Design

Regional variations in furniture design continued to be seen, even though more pattern books were being made available to craftsmen. A colonial furniture maker would rarely copy a complete furniture form from a pattern book, but instead use individual elements taken from different examples. Many mid-eighteenth-century chairs, for example, have carved back splats that conform to designs found in books by Chippendale and others. Or a workshop might construct a basic template, a form that they would build again and again, and then add their own unique embellishment or that requested by a client. Extra embellishment, of course, meant extra cost.

Chairs in particular varied from region to region in the mid-eighteenth century. New England craftsmen used older chair elements such as square seats and stretchers combined with the latest fashion in pierced back splats, ball-and-claw feet, and flaring crest rails (the top rail of a chair back). Philadelphia mid-century

chairs often lacked stretchers, though they also displayed elaborately carved feet and back splats, sometimes adding carving along the front skirt (the area just below the front seat edge). New York chairs from this period were characterized by their shallow carving as well as wider overall proportions, making for a heavier silhouette (Krill 2001, 87).

SILVER AND PEWTER

As in England and elsewhere, the ownership of silver was a status symbol in colonial America, and it was not until the end of the eighteenth century that any but the wealthiest homeowner could afford to use and display silver objects. Though one reason for European exploration was to find sources of gold and silver, the American colonies yielded little in the way of those precious metals. Any pieces found in the earliest colonial home were most likely brought from Europe or England by the owner. However, once silver coinage, particularly substandard Spanish silver, made its way to North America, immigrant silversmiths were able to produce items commissioned by wealthy colonists (Krill 2001, 190). At first, most silver objects were limited to a few pieces, such as a plate, cup, or porringer (a small handled bowl), and when not in use they were displayed on a chest or table in the homeowner's best room. Ornament on early silver pieces often mimicked that of furniture, and many seventeenth-century pieces had simple engraved decoration of flowers, animals, or the owner's initials. In the eighteenth century, new wealth meant new customers for silversmiths, who had increased in numbers not only through immigration, but also by taking on apprentices in trade. (Silversmiths usually began as an apprentice to a master craftsman, living and working for about seven years before moving on to begin their own shop.) The highly elaborate rococo style of furniture in the mid-eighteenth century lent itself well to being rendered in silver, and many silversmiths created spectacular showpieces for their wealthy clients. The popularity of tea drinking fueled the desire for complete tea sets in silver: tea pot, creamer, sugar bowl and tongs, hot water jug, and slop or waste bowl, and tea canister were made with matching designs for elite colonists to use and display to their guests. Silver tea spoons, of course, were a prerequisite for any tea table and were the most common silver object owned by an eighteenth-century colonist. Toward the end of the century, even middling homeowners might have a silver spoon or two and a cup proudly displayed in their home, but for metal objects that saw the most usage during the colonial period, we must turn to pewter.

Pewter is an alloy composed mainly of tin, with added copper or lead, and with a low melting point, it can be easily cast in a variety of forms (Osborne 1985, 612). Though often seen as "poor man's silver," pewter was used throughout all classes of society in colonial America. Only the poorest homeowner could not afford pewter and would have to make do with wooden utensils. Brought to the colonies by English immigrants, there was a Massachusetts pewter shop supplying wares to customers by the early seventeenth century (Osborne 1985, 613). By 1700, there were nine pewterers in that colony, as well as two in Virginia and Pennsylvania and one in Maryland (Krill 2001, 201). As most pewter came from England at this time, many of the pieces purchased in the colonies were fashioned from older pewter objects, which could

be melted down (in a pot called a crucible) and recast. This allowed pewter to be formed into the most elaborate of pieces as well as the most utilitarian, and, like silver, designs rendered in pewter often followed current trends in furniture. The most common type of ornament found on pewter consisted of molded edges (which were formed during the casting process) and inscribed lines (which were engraved on the piece with the help of a turning lathe). Though spoons were the most ubiquitous pewter objects in the colonial home, many houses had full sets of pewter plates, cups, bowls, and flagons for use and kept them highly polished and on display like their wealthier counterparts.

CERAMICS AND GLASS

In colonial America before the eighteenth century, few households used ceramic objects such as plates or bowls, and even fewer owned them. For food preparation, the majority of colonists used wooden or pewter containers and utensils and drank from pewter, leather, or horn vessels. As Krill points out, however, an exception was made with ceramic dairy vessels, shards of which were found most frequently during excavations of colonial sites (2001, 166). Earthenware dairy vessels, commonly referred to as redware, were made using the red clay found in abundance on the East Coast. The clay could be dug close to the surface, and because it was easily worked and fired at a low temperature, it was the most obvious choice for the crocks, pitchers, and jugs used in the dairying process. As they could not be fired at high temperatures, earthenwares were porous and required lead glazes to make them waterproof. Many glazes were transparent, which allowed the red clay body to be visible, although brown, yellow, orange, and green glazes were also commonly used. Though most utilitarian redwares were not decorated, many German settlers produced highly decorated wares known as *sgraffito*. Produced mainly in the southern Pennsylvania regions of Bucks, Chester, and Montgomery counties, *sgraffito* decoration was scratched into a layer of white slip (a mixture of clay and water) covering an earthenware body, allowing the red color to show (Lange 1994a, 60). Motifs such as birds, flowers, or Germanic sayings often appeared on such wares, sometimes with the addition of other colored glazes to highlight the decorations. Such objects were rarely used, however, being relegated to presentation or commemorative pieces and passed down through families as treasured heirlooms. Many potters worked only part-time; Shenandoah Valley farmers often worked during the winter months making earthenwares to supplement their income and to provide ceramics for their own use.

During the sixteenth and seventeenth centuries, stoneware items came to the colonies mainly from Germany and England. Stoneware clays could be fired at higher temperatures and, as a result, were impermeable to liquids without the addition of glazes. Glazes were frequently used as decoration, however, as the stoneware body was usually a dull grey or off-white color; like redwares, many stonewares were decorated in a scratch or *sgraffito* design. In addition to the common lead glaze, stonewares were often salt-glazed: salt was thrown into the kiln during the firing process, when the temperatures were at their highest, and the sodium combined with the clay to create a distinctive glassy, yet pitted surface. Salt-glazed stoneware was harder-wearing than earthenware

and was not prone to chipping or cracking like other ceramics. Its sturdiness lent itself well to utilitarian uses such as drinking vessels and storage jars. Production was more costly than earthenwares, however, as higher temperatures required more fuel. Stonewares became more common in colonial America during the eighteenth century, and as potteries became more sophisticated, stonewares were often seen as an acceptable substitute for the expensive Chinese porcelains.

While earthenware and stoneware objects were owned and used by both wealthy and middling colonists, porcelains were much rarer. Trade with the Far East, at first through Europe and England, and later, more directly, brought the translucent and delicate ceramics to the attention of the colonists. Ceramic wares were often shipped as part of a larger cargo of dry goods, which were sold by the importer to both retail and wholesale customers (Krill 2001, 164). In the sixteenth and seventeenth centuries, porcelain items such as vases, bowls, or cups were highly prized items owned by only the elite. By the early eighteenth century, however, they were more commonly found in upper-class colonial households. The popularity of tea drinking helped fuel a desire for proper tea equipage, and along with silver pieces, porcelain wares were also made to be used in the social ritual. Many Chinese potteries began to create wares specifically for Western import and adapted their designs for Western tastes. One prominent example is the teacup: originally made without handles, the familiar handled teacup and saucer was a concession for the European and colonial markets.

In the eighteenth century, wealthy colonists also began to commission specialty pieces from China, particularly large sets of dinnerware and tea services; initials and family crests were commonly requested. For those colonists who could not afford the costly porcelain, white stonewares were always an alternative, though European and English potteries were constantly attempting to discover the secrets of porcelain making. Staffordshire potteries in England particularly excelled in making high-quality earthenwares and stonewares that could mimic porcelain objects. Josiah Wedgwood's creamware and pearlware ceramics were quite successful in capturing the growing middle-class market in the eighteenth century. Creamware displayed a white body similar to porcelain, while the faint blue glaze of pearlware was reminiscent of the expensive Chinese blue-and-white porcelains. Though native potteries still supplied cheaper utilitarian wares for many colonists, England and China were the main suppliers of ceramics for the American colonies.

Types of Ceramics in Colonial Times

Earthenware:

Coarse clay, easily malleable
Dark brown or reddish in color
Fired at low temperature (800–1,000°C)
Porous body requires glazing to become impermeable to liquids
Prone to chipping and cracking

Stoneware:

Mixture of clay and feldspar
White, buff, or grayish in color
Fired at 1,200–1,400°C
Glaze not needed—impermeable to liquids
Salt often added during firing process for decorative, coarse glaze
More durable than earthenware

Porcelain:

Mixture of white clay and china stone (hard paste porcelain)
White, translucent body
Fired at highest temperature (over 1,250°C)
Glaze not needed—impermeable to liquids

Glass

Glass, though not as common as other utilitarian materials, was not unheard of in early colonial America. Outside of window glass, which was an expense borne only by the wealthy, any glass owned by a colonial homeowner was usually a drinking glass; larger glass serving pieces were not common until after the Revolution. The earliest industry in the North American colony, however, was glassmaking, established at Jamestown in 1608. But, as Lange states, skilled workers were hard to find. To keep their own fledgling glassworks going, England prevented many glassblowers from immigrating to the colonies, and most glassworkers in the colonies were German (1994b, 33). Glassworks were again established in Jamestown in 1621, in Massachusetts in 1639, and New York in 1645, with more to come in the eighteenth century, but few, if any, were profitable (Krill 2001, 179). Enormous amounts of fuel were required for the furnaces, and very few immigrants had access to that sort of capital. A mid-eighteenth-century glassworks was described as using "Twenty-four Hundred Cords of Wood per Annum, tho' it works but Seven Months in the Year....It is split small and dried well in a Kiln before 'tis thrown into the Furnace. The Cutting, Hauling, Splitting and Drying of this Wood employs a great many Hands, and is the principal Charge" (177). Bottles and window glass were the majority of glass objects produced in the colonies before the Revolution. For more delicate items, English, French, and Italian wares were imported at great cost. It was not until the nineteenth century that American glass became profitable enough to produce and cheap enough to be owned by many.

TEXTILES

While colonists during the sixteenth through the eighteenth centuries owned textiles in the way of clothing, furnishing textiles, or fabrics used for decorative purposes, were much more of a status symbol. For the poor or middling homeowner, any cloth they owned was most likely produced on a loom at home and repaired carefully to keep it useful. This was also true for colonists in rural areas. The raw materials (wool, flax, silk, or cotton) were produced by the homeowner and then processed into fibers for weaving. Wool from sheep or goats, linen from flax plants, silk from silk worms, and cotton from cotton plants was all raised and cultivated by colonists, much of which was exported to England, made into cloth, and then imported back to North America. The majority of colonists who produced their own cloth carded the wool by hand, even after the development of carding machines in the latter part of the eighteenth century. Flax stalks were broken to release the fibers, which were then combed to remove the strands for weaving. The raising of silkworms was a cottage industry during the Colonial period (starting as early as 1642), and civic leaders such as Benjamin Franklin tried to encourage its production by establishing premiums for every pound of cocoons produced (Schaefer 2006, 53). It was believed that the best silkworms came from Valencia in Spain, and cocoons were duly shipped to the colonies, where the silk was cultivated and then transferred to England for processing and weaving. The process for raising silkworms was lengthy, however, and often produced little product in return. Cotton, which later became such an enormous industry for the southern colonies, came from

the fibrous seed coverings of the cotton plant, which had to be separated from the seeds and then combed and spun into thread for weaving.

Textiles woven at home were usually of a plain weave, in which alternating threads (warp and weft) were passed over and under each other (the weft threads were passed back and forth through the warp threads). This was the simplest and quickest way for a colonial housewife to produce a length of cloth, which might be then made into clothing or bed linens. Such items in a poor and middle-income household were carefully darned when torn and refashioned into new items when they became worn. Bed linens or table linens (which were rare) were often treated as heirlooms and passed down through generations to be used and reused. For color, the colonial housewife used vegetable dyes to produce blues, reds, yellows, and blacks. The most common dyes were madder, which resulted in red, purple and brown colors, indigo (popular because it kept its color with repeated washings); and quercitron, bark from oak trees, which produced a yellow hue (Krill 2001, 251). The poor or middling housewife might also weave patterns into the cloth, which was time consuming, or embroider designs on the finished cloth with silk or wool threads. In general, however, poorer households in the Colonial period owned utilitarian textiles, with perhaps a single treasured embroidered bed coverlet in their inventory.

Though still expensive, imported textiles were more available to the wealthier colonist. In addition to silk, linen, wool, and cotton cloth used for clothing, textiles were purchased for bed hangings, upholstery, table linens, and window treatments. And though such wares were produced in the colonies, the latest fashions in textile designs came from abroad. In the sixteenth and seventeenth centuries, the "best" bed was often displayed in the parlor of a colonial home, it being one of the more expensive pieces of furniture in the household. Elaborate bed hangings would also accompany the bed—curtains, coverlets, quilts, and valances made from wool and linen or, later in the eighteenth century, silk—and were used to show the wealth and taste of the homeowner. *En suite* arrangements of textiles (popular in France during the seventeenth century) became the fashion for the wealthiest of colonists, and matching sets of fabric were purchased to adorn one's bedchamber. One early eighteenth-century homeowner ordered "Curtains & Vallens for a Bed, with Counterpane, Head-Cloth and Tester, of good yellow watered worsted Camlet, w/ Trimming, well made; and Bases if it be the fashion…Send also of the same Camlet & Trimmings, as may be enough to make Cushions for the chamber Chairs" (Krill 2001, 258).

Upholstery on furniture, which was being seen in the colonies by the late seventeenth century, could be as elaborate or as plain as one wished. Turkey work, which mimicked expensive Persian and oriental hand-knotted carpets, was often used as coverings during this time for chairs, stools, or squabs (a stuffed cushion or pillow for use on stools or chairs). In the eighteenth century, embroidered canvas coverings were used to cover wing chair or seat cushions; often of a colorful floral pattern, these rich textiles were highly sought by wealthy homeowners to display on expensively carved chairs.

Imported carpets were also a luxury item that few could afford during the Colonial period. Most middle-class homeowners used rag rugs or painted floor cloths, while the poorest colonists often did without. Brussels, Wilton, and Axminster, carpets imported from England at great cost, were usually displayed

in only the most public rooms in a wealthy colonial household, often with a drugget, or coarse wool cloth, on top to protect it from stains.

NATIVE AMERICAN DECORATIVE OBJECTS

As many of the Native American tribes in the East moved with the seasons, most villages they established were not of a permanent variety. Summers were usually spent near a water source to take advantage of abundant fish, while more inland areas were occupied during the winter months for hunting. Any objects carried from camp to camp were necessarily essential, and those that were not were left behind. Most decorative items, therefore, were usually utilitarian. For example, large stone vessels were used for cooking, but as these were too heavy to carry, they were often left behind for use during another season. Closer to the time of the first settlers from Europe, some tribes began to stay longer in one area, remaining through several seasons in semipermanent villages.

Clay pots, which would often have not survived the tribe's repeated moves, could now be used more frequently. Natural clays were found in ponds, riverbanks, or along ocean cliffs and were easily dug up to make the vessels. The clay was first tempered, which would increase the strength of the pot during firing and keep it from cracking; temper could be added in the form of crushed shells or sand, other pieces of broken pottery, or even cattail or milkweed seeds. The clay was worked into a ball, then into a small dish, and placed in a depression in the ground. Additional coils of clay were then added to the vessel walls and built up to the desired size, with each coil being pressed and smoothed into each other. Natural tools such as shells, sticks, and bone were then used to decorate the pots with incised lines, circles, or other patterns. The bowls or pots were dried slowly over several days and then fired in an open pit (pots were place on warmed rocks in the pit and then covered, tent-style, with hardwood). The rounded bottoms of the finished pots were ideally suited for use on the uneven forest floor in New England (Prindle 2007).

Other utilitarian items that were decorated by the eastern Native Americans were baskets made from a wide variety of materials, including birchbark, horseshoe crab shells, and tree roots. One English settler observed in 1674: "From the tree where the bark grows, they make several sorts of baskets, great and small. Some will hold four bushels, or more; and so downward to a pint. In their baskets they put their provisions. Some of their baskets are made of rushes; some, of bents; others, of maize husks; others, a kind of silk grass; others, of a kind of wild hemp; and some, of barks of trees; many of them, very neat and artificial, with the portraitures of birds, beasts, fishes and flowers, upon them in colors" (Prindle 2007). The grasses were usually dyed separately and then woven together to form a design, although patterns were also embroidered onto the basket after construction.

In addition to decorative items, such as beads, bracelets, and rings, utilitarian metal objects were also made and decorated by Native Americans—in the form of arrow points, pipes, pots, and spoons—from copper found around Lake Superior, as well as Virginia, North Carolina, and Tennessee. Western explorers arrived to find a "great store of copper, some very red, and some of a pale color; [the natives] have chains, earrings, or collars of this metal; they head some of

their arrows herewith, much like our broad arrowheads, very workmanly done" (Prindle 2007). Copper sheet metal was used to create the collars or gorgets worn by the natives and was a valuable commodity to be traded for European iron and steel. An early seventeenth-century trader wrote that Native Americans living in the Massachusetts region "offered their fairest collars or chains, for a knife or such like trifle" (Prindle 2007). By the seventeenth century, Native Americans in New England began to prefer iron and steel pots and kettles from the European traders to their own clay vessels, and production in ceramics declined. Metal pots were sturdier for use and held up well during travel. Additionally, the metal could be refashioned into other items, such as knives, axe heads, and cooking utensils. Eating spoons, made from this recovered sheet metal, were produced as early at the 1620s in New England and featured wide, flat handles cut into decorative animal shapes or featuring geometric designs incised into the metal. The natives would also take European metal utensils and replace the handles with decorations of their own.

An important object of both decoration and use for Native Americans before and during the Colonial period was the wampum. Originally made from shells (whelk shells for white beads or clams shells for purple), these beads were fashioned to make strings or belts and used for a variety of purposes—announcements of treaties or wars between tribes, signs of mourning, election of leaders, as well as gifts between tribes or individuals, and personal adornment. The color of the wampum bead was significant: White stood for peace, health, and purity, while the purple beads often meant disease or hostility. Natives would string the beads onto plant fibers and weave them onto a leather strap into intricate yet meaningful patterns. A wampum of purple with a white central design and white border was the sign of a former hostile relationship, now at peace, while a belt that had been painted red with ochre or vermilion was a call to war. Though Native Americans might not have regarded wampum as currency, early settlers did. Metal coinage was scarce at the beginning of colonization, and wampum was seen as legal tender in the colonies during the seventeenth century. "Strung money was known as wampumpeage, or merely peage. Customarily arranged in lengths of one fathom [6 feet], which contained anywhere from 240 to 360 individual beads, depending not only on the size of the beads but on their current worth....Individual strands were then worked into bands from one to five inches wide, to be worn on the wrist, waist, or over the shoulder" (Vaughan 1979, 120). Six feet of white wampum was valued at 10 shillings, while the same length in purple was 20. Once trade with English and European settlers began, particularly the fur trade, some tribes increased their production of wampum for trading purposes, particular those in the coast areas of southern New England. Other beadwork, made from ceramic, metal, bone, and stone, was produced by the eastern Native Americans and used for personal decoration, gifts, trade, and ceremonial practices.

Reference List

Chippendale, Thomas. 1762. *The Gentleman & Cabinet-Maker's Director,* 3rd ed. Reprinted, New York: Dover Publications, Inc., 1966.

Evans, Nancy Goyne. 1997. *American Windsor Furniture*. New York: Hudson Hills Press, in Association with the Henry Francis du Pont Winterthur Museum.

Freund, Joan Barzilay, and Leigh Keno. 1998. "The Making and Marketing of Boston Seating Furniture in the Late Baroque Style." In *The Chipstone Journals: American Furniture*. Available at: http://www.chipstone.org/publications/1998AF/Keno/1998kenotext.html.

Heckscher, Morrison H., and Peter M. Kenny. 2000. "English Pattern Books in Eighteenth Century America." In *The Timeline of Art History. Metropolitan Museum of Art*. 2003. Available at: http://www.metmuseum.org/toah/hd/enpb/hd_enpb.htm.

Krill, Rosemary. 2001. *Early American Decorative Arts*. Walnut Creek, Calif.: Alta Mira Press, with Winterthur Museum, Garden & Library.

Lange, Amanda E. 1994a. "Ceramics." In *Eye for Excellence: Masterworks from Winterthur*, ed. Donald L. Fennimore, Amanda E. Lange, Robert F. Trent, Deborah E. Kraak, E. McSherry Fowble, and Neville Thompson, 45–63. Winterthur, Del.: The Henry Francis Du Pont Winterthur Museum, Inc.

Lange, Amanda E. 1994b. "Glass." In *Eye for Excellence: Masterworks from Winterthur*, ed. Donald L. Fennimore, Amanda E. Lange, Robert F. Trent, Deborah E. Kraak, E. McSherry Fowble, and Neville Thompson, 31–43. Winterthur, Del.: The Henry Francis Du Pont Winterthur Museum, Inc.

Osborne, Harold, ed. 1985. *The Oxford Companion to the Decorative Arts*. Oxford: Oxford University Press.

Prindle, Tara. 2007. "Native Tech: Native American Technology and Art." Available at: www.nativetech.org.

Schaefer, Elizabeth Meg. 2006. *Wright's Ferry Mansion: The House*. Columbia, Penn.: The von Hess Foundation.

Vaughn, Alden T. 1979. *New England Frontier: Puritans and Indians, 1620–1675*. Rev. ed. New York: W.W. Norton and Company.

Watson, Judy King. n.d. "A Few Notes on the English Windsor Chair." The Antiques Council, Inc. Available at: http://focus.antiquescouncil.com/articlepage74.php.

Landscaping and Outbuildings

Any gardening practiced in the early British colonies was overwhelmingly of the subsistence variety; it was rare to find a plot of land set aside for purely ornamental use. According to Ann Leighton (1987) seventeenth-century gardens were built first and foremost for utility: "That they were pretty and gay was an accident of fortune" (228). Before the arrival of European immigrants, Native Americans used the land for sustenance, and the early settlers necessarily followed suit for many years. As Gordon De Wolf writes in "The Beginnings" in *Keeping Eden,* more stable times and more sophisticated social structures were necessary before the advent of any ornamental pleasure gardens (1992, 1). This chapter will examine the layout of urban gardens, designed for both subsistence and pleasure, along with the growing importance of enclosure as a way of protecting one's property. As more immigrants came to the colonies, villages spread out and some colonial homeowners searched for wider spaces than could be found in the crowded towns. The layout of farms and large plantations with their combination of working and pleasure gardens will be discussed. And finally, colonial outbuildings will be studied for their ornamental and practical uses.

EARLY GARDENS FOR FOOD

Any landscaping practiced by Native Americans when the first European settlers arrived was purely incidental. Dwellings were placed on land that offered the most convenient access to food, water, and building materials. John

Smith's visit to America in the early 1600s gave him the opportunity to observe the particular placement of shelters within the landscape:

> [The natives'] buildings and habitations are for the most part by the rivers and not far distant from some fresh spring. Their houses are built like our Arbors of small young springs [sprigs] bowed and tied, and so close covered with mats or the barks of trees very handsomely, that notwithstanding either wind, rain or weather, they are as warm as stoves, but very smoky, yet at the top of the house there is a hole made for the smoke to go into right over the fire....Their houses are in the midst of their fields or gardens; which are small plots of ground, some 20 [acres], some 40, some 100, some 200, some more, some less. Some times from 2 to 100 of these houses together, or but a little separated by groves of trees. Near their habitations is little small wood, or old trees on the ground, by reason of their burning of them for fire. So that a man may gallop a horse amongst these woods any way, but where the creeks or Rivers shall hinder. (Smith 1612, 100–103)

Most Native American villages encountered by early settlers were of a semi-permanent nature. Like the agricultural practices of the later colonists, fields were continually worked until the soil was completely depleted of any nutrients. Once this happened, the tribe would abandon their fields and dwellings and move to a new location. Thomas Morton, an early Massachusetts settler from 1637, described the process of readying the ground for planting:

> The Savages are accustomed to set fire of the Country in all places where they come, and to burne it twice a year, viz.: at the Spring, and the fall of the leaf. The reason that moves them to doe so, is because it would other wise be so overgrown with underweeds that it would be all a coppice wood, and the people would not be able in any wise to pass through the Country out of a beaten path....The burning of the grass destroys the underwoods, and so scorcheth the elder trees that it shrinks them, and hinders their growth very much: so that he that will looke to finde large trees and good timbcr, must [look]...to finde them on the upland ground. And this custom of firing the Country is the meanes to make it passable; and by that meanes the trees growe here and there as in our parks: and makes the Country very beautifull and commodious. (Morton 1637)

De Wolf describes this process of cultivation as "slash-and-burn": trees were girdled, which was a process where a band of bark was damaged or cut completely around the circumference of the tree, and then allowed to die in place. This, along with burning, cleared the land of unwanted undergrowth. Domesticated animals were not used at the time, so all the clearing, plowing, and planting was done by hand using wood, stone, or bone tools. Seeds were then planted in hills, sometimes along with a fish, which would provide much needed nutrients to the soil as it decayed—a practice that was required as the fields became "run out" (De Wolf 1992, 6). The natives also planted several different crops—such as corn, pumpkins, and beans—on a single piece of land. Corn kernels, most likely from the previous years harvest, were planted in the center of the hill, while squash and been seeds were spread around the corn. As the corn stalks grew, the bean vines would use them as supporting stakes and wind upwards, while the squash would spread their vines around the hills

below. Most tribes held crop fields as community property rather than owning private lots of their own.

While some early colonists in North America might have managed to have a small patch of ornamental flowers, most land was given over to production of useful crops. The first settlers in the Virginia and New England colonies were required to work quickly when establishing crops to provide enough food to survive; oftentimes, suitable shelter took second place to the growing of food: "The wealthy and principal men in New England, in the beginning of the Colonies, commenced their first dwelling houses…firstly, in order not to waste time building and not to want food the next season; secondly, in order not to discourage poorer laboring people whom they brought over in numbers from Fatherland. In the course of 3 or 4 years, when the country became adapted to agriculture, they built themselves handsome houses, spending on them several thousands" (quoted by Cornelis van Tienhoven, 1650, in De Wolf 1992, 5–6).

URBAN GARDENS

Most gardens in the early colonies, therefore, were for sustenance. And the earliest of settlers, particularly in New England, first followed the Native American practice of community land worked by everyone. Small settlements would cluster their dwellings together, usually around a common, or *green,* and a meetinghouse. Each home might perhaps have a small dooryard garden in the front or rear. Outlying fields surrounded the community and were worked jointly by the inhabitants. The gardens around early colonial urban homes were necessarily small and simple. When William Penn laid out Philadelphia in 1682, he provided greens or parks "for the comfort and recreation" of the townspeople and suggested that all dwellings be built with gardens in mind: "Let every house be placed, if the person pleases, in the middle of its plat as to the breadth way of it, that so there be ground on each side for gardens, or orchards, or fields, that it may be a green country town which will never be burnt and will always be wholesome" (Leighton 1986a, 43). It did please most early colonists to have a small dooryard garden, usually in front of the dwelling and planted with medicinal herbs and flowers. The recreated garden of Whipple House in Ipswich, Massachusetts, is an excellent example of a typical New England dooryard garden: a wooden fence surrounds the garden in the front of the dwelling, and the garden itself is split into two main sections by a wide pathway composed of crushed clam shells leading up to the door. Plants were arranged in raised beds, usually rectangular or square shaped, and held in place with boards. Raised beds were essential in urban gardens, because the closeness of the plantings made drainage somewhat difficult (Leighton 1986a, 166). Flowers grown in an urban colonial dooryard garden were not numerous. Lilies, hollyhocks, peonies, irises, and carnations were found most often, along with larger flowering shrubs, such as lilacs, planted on the sides of the gardens to give a semblance of privacy in an urban setting (Hedrick 1988, 47). A Philadelphia city ordinance from 1700 mandated the placement of sheltering bushes and trees: "every owner of a house should plant one or more trees before the door that the town may be well shaded from the violence of the sun in the heat of the summer and thereby be rendered more healthy" (Hobhouse 1992, 260).

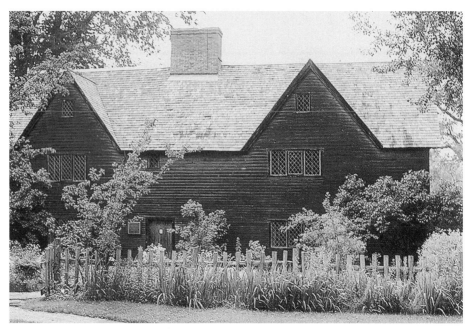

The John Whipple House of Ipswich, Massachusetts, built before 1650, whose gardens have since been reconstructed by the Ipswich Historical Society. Courtesy of the Library of Congress.

Many colonists continued the medieval practice of arranging their garden within strict, geometric lines, with smaller paths cut through beds at cross angles; the emphasis was on maximum production within minimal space. If possible, the sides and rear gardens of the dwelling were given over to the growing of fruits and vegetables. Like the formal arrangement of herbs and flowers in the front garden, vegetable beds were also laid out in geometric lines, and fruits trees were planted in single rows. Orchards were a common feature in urban gardens. While they could be ornamental, their usefulness as a food source made them ubiquitous, as one foreign visitor observed: "Every country-man, even a common peasant, has commonly an orchard near his house, in which all sorts of fruit, such as peaches, apples, pears, cherries, and others, are in plenty...They are rare in Europe, particularly in Sweden; for in that country hardly any people besides the rich taste them. But here every countryman has an orchard full of peach trees." (Kalm 1748, 56–57). The Whipple House's landscape contains a pear orchard in the back of the dwelling, laid out in a quincunx pattern, a planting design that was popular in English formal gardens: four trees were placed in a square with a fifth at the center.

While urban gardens of the early colonists were first and foremost working gardens, many, even of the middling classes, sought respite in their small garden. The colonial housewife's dooryard garden could offer some pleasure, but even more so if there was room for a flower garden on the side of the dwelling. Peter Kalm, a Swedish visitor to the mid-eighteenth-century town of Trenton, New Jersey, noticed that each house made room for a private spot: "The houses

stand at a moderate distance from one another. They are commonly built so, that the street passes along one side of the houses, while gardens of different dimensions bound the other side" (1748, 172). A central walkway was a major component of an urban garden. The walkway usually connected the house through the garden and on to an end feature, such as a seat under an arbor, a sundial, or even a small fountain. Even if the geometrically arranged beds on either side of the path contained vegetables and herbs, it was used for more than just the tending of crops. In the mid-Atlantic, these paths were usually lined with shells, which were in abundance in the area. In other parts of the colonies, crushed stone or gravel and brick was used. More unusual paving material was clay tobacco-pipe fragments, lead shot, and pottery and glass shards, all of which were used at Williamsburg; such material would provide good drainage (Hume 1974, 22). Garden books of the time recommended that the paths be rolled frequently, particularly after a rain, to keep them level and packed.

Front or dooryard gardens were most commonly seen in New England cities. These gardens were necessarily small, only running the width of the house, and extending two-thirds of that width to the front (Favretti and Favretti 1977, 25). The familiar central path split the front garden, and both sides were planted with raised geometric beds of flowers and herbs. In the South, many homes fronted directly onto the street or sidewalk, such as those in Alexandria, Virginia, or Charleston, South Carolina. In this case, most gardens were placed to the side or rear of the house and usually enclosed with walls for privacy.

Enclosure and Fencing

Fences were a necessity in keeping order in an urban colonial garden. The earliest fence design was very simple. Palings or palisades surrounded early settlements, and with each stake usually six feet high or more, the palisade construction form could be a formidable barrier. Within the stockades, smaller plots of land were fenced as well to protect precious crops and flowers from domestic animals. These smaller fences for interior protection were usually of the post-and-rail type design. The rails needed to be close enough together to keep out dogs, cattle, or chickens, yet still allow for the circulation of air into the garden. An early visitor to the colonies noticed that the agricultural pursuits were less expensive in the New World than in Europe: "First, because the fencing and enclosing of the land does not cost much; for instead of the Netherlands dykes and ditches, they set up post and rail, or palisado fences, and when new clearings are made, they commonly have fencing timber enough on the land to remove, which costs nothing but the labour, which is reasonably cheap to those who have their own hands, and without domestic labour very little can be effected" (Van der Donck 1649, 157).

Most gardens in town were enclosed; not only were their owners anxious to keep out straying animals or humans, but many towns began to pass laws requiring land to be enclosed. This established private property and private property recordkeeping. It signaled that the land was taken and reinforced the idea of possessing land by planting on it (Seed 1995, 23). In an effort to make colonists more self-supporting, the enclosing of gardens at Jamestown was enacted by the General Assembly in 1624. (This same act also required that a mulberry tree and 20 vines be planted for every male over 20.) By 1705, the General

Assembly was meeting at Williamsburg and passed a similar law concerning fences: "Every Person having any Lotts or half Acres of Land contiguous to the great Street shall inclose the said Lotts of half Acres with a Wall Pales or Post and Rails within six months after the Building which the Law required to be erected thereupon shall be finished upon Penalty of forfeiting & paying five Shillings a Month for every Lot or half Acre so long as the same shall remaine without a Wall pales or Rails" (Hume 1974, 8–10). There was even a "Viewer of Fences" in seventeenth-century New England who had the power to fine homeowners for inadequate fencing (Israel 1999, 101).

The earliest enclosed spaces in urban settings were fenced dooryards in front or back of colonial homes. These early fences were wooden, usually upright stakes with two horizontal crossbars for support—the style that would become known as the ever-popular picket fence. Wood was plentiful and the fence easy to construct. It needed to be painted and repaired frequently, but the basic materials were near at hand. The Swedish writer Peter Kalm, who visited North America in the early 1700s, took notice of the fence building practices of the colonists in Philadelphia:

> Almost all the enclosures around the cornfields and meadows hereabouts, were made of planks fastened in a horizontal direction. I only perceived a hedge of privet in one single place. The enclosures were not made like ours; for the people here take posts from four to six feet in height, and make two or three holes into them, so that there was a distance of two feet and above between them. Such a post does the same service as two or three fathoms distance from each other, and the holes in them kept up the planks, which were nine inches, and sometimes a foot broad, and lay above each other from one post to the next. Such an enclosure therefore looked at a distance like the hurdles in which we enclose the sheep at night in Sweden. They were really no closer than hurdles, being only destined to keep out the greater animals, such as cows and horses. The hogs are kept near the farm-houses everywhere about Philadelphia, and therefore this enclosure does not need to be made closer on their account. (1748, 71–72)

Fencing could be a simple rail and post or something of a more elaborate design. Benjamin Bucktrout, a cabinetmaker in Williamsburg, advertised "all sorts of *Chinese* and *Gothick* paling for gardens and summer houses" in the *Virginia Gazette* in January of 1767 (Hume 1974, 13). For the majority of early colonists, however, fencing did not take on a decorative aspect until there was money and time to be spent on it. Most fences were constructed from wood rather than stone. Native stone was scarce in some areas, and any that was imported from abroad was reserved for architectural work. While bricks were used in construction, early brick walls for enclosures were rare. Stone or brick walls, of course, gave more privacy, but they were also more expensive to build and maintain. A brick wall surrounding one's property was a clear sign to passersby of the owner's wealth.

An interesting feature, though rarely seen in the colonies, was the inclusion of broken glass in the tops of masonry enclosures. An account book from 1778 records an order for "putting glass Bottle" on a surround wall at the Virginia Governor's Palace. The practice was common in the West Indies, however, and

Dutch, English, and French immigrants brought the practice to the American colonies (Hume 1974, 17).

Sometimes a combination of brick and wood fencing was used, with a line of pickets punctuated by piers of brick. Even more expensive than brick, though, was wrought iron fencing. Wrought iron was slow to be introduced in fence construction. The Hammersmith iron foundry was active from the 1640s to the 1670s in Lynn, Massachusetts (Southworth and Southworth 1992, 27). Though it produced mainly household items, the knowledge gained from this venture allowed the firm to begin to produce large-scale ironwork for gates and fences in the following century. The high cost, however, made such fences available only to the very wealthy. By and large, these wrought iron fences and gates were imported from England at a great expense. The Governor's Mansion at Williamsburg displayed imported wrought iron gates and finials, while the Boston garden of Peter Fanueil was enclosed by wrought iron railings decorated with gilt balls (Bushman 1992, 135). William Byrd II's estate of Westover in Charles City County, Virginia, boasted an elaborate wrought iron entrance gate and fences imported from England in the 1730s. The fence was punctuated with masonry piers with carved stone finials, while the entrance piers on either side of the gate supported two large lead eagles. Those fences and gates that were produced in the colonies followed along the same lines—usually monumental stone piers flanking intricately designed gates, often topped with gilded lead ornaments such as eagles, urns, or balls. Grander homes of the urban elite called for grander enclosures, and some colonists did have the fortunes and time to ensure their homes reflected their status in society. Israel Pemberton's Philadelphia home was enclosed by a fence that "never failed to arrest the attention of those that passed that way" (Israel 1999, 105). Larger estates that used fencing were more apt to apply

Fencing Laws in Virginia in the Seventeenth and Eighteenth Centuries

1631: "Every man shall enclose his ground with a sufficient fence."

1643: "Every man shall make a sufficient fence about his cleared ground."

1646: "[A] fence shall be adjudged sufficient which is four feet and a half in height substantial close down to the bottom."

1658: "Every planter shall make a sufficient fence about his cleared ground at least four foot and a half high."

1667: "Whereas the dispatch of business in this country is much obstructed for want of bridleways to the several houses and plantations. It is enacted by this grand assembly and the authority therefore, that every person having a plantation shall, at the most plain and convenient path that leads to his house, make a gate in his fence for the convenience of passage of man and horse to his house about their occasions at the discretion of the owners."

1705: "An Act for prevention of trespasses by unruly horse, cattle, hogs, sheep, and goats; and by taking away boats and canoes. Be it enacted, by the Governor Council, and Burgesses of this present General Assembly, and it is hereby enacted, by the authority of the same, that if any horses, mares, cattle, hogs, sheep, or goats, shall break into any grounds, being enclosed with a strong and sound fence, four foot and half high, and so close that the beasts or kine breaking into the same, could not creep through; or with a hedge or fence being so close that non of the creatures aforesaid can creep through, (which shall be accounted a lawful fence,) the owner of the said horses, mares, cattle, hogs, sheep, or goats, and of any one of them, shall, for the first trespass by any of them committed, make reparation to the party injured, for the true value of the damage he shall sustain, with costs of suit; and for every trespass afterwards, double damages, and costs of suit: To be recovered in any court of record in this her majesty's colony and dominion, in such manner as the law, in the like cases, directs."

1705: "Every person having any lots of half acres of land, continuous to the great street shall in close the said lots, or half acres with a wall,

(continued)

pails, or post and rails, within six months after the building, which the law requires to be erected thereupon."

1710: "[A] convenient kitchen garden be laid out on [the Governor's Palace in Williamsburg] and be enclosed with pales, and that an orchard and pasture ground be made on the said land and be enclosed with a good ditch and fence."

1748: "Lawful fence—a strong sound fence five feet high—or a hedge two feet high upon a ditch two feet deep and three feet broad—or a rail fence two and one-half feet high upon a ditch three feet deep and three feet broad—all so close together that horses, mares, cattle, hogs, sheep, and goats cannot creep through."

Source: The Colonial Williamsburg Foundation (2007).

wooden zig-zag or split-rail forms. Both configurations used less wood than the picket form. Some colonial homeowners even used a common rail fence to line the approach to their estate: instead of trees, Dr. Henry Stevenson lined the approach to his Baltimore house with a simple rail and post fence, saving more elaborate fencing and ornaments for areas closer to the main dwelling.

COUNTRY GARDENS AND FARMS

As more colonists arrived and communities grew, the desire to have land of one's own also grew, and soon large farms and plantations ringed more closely arranged city dwellings. Most rural farms during the Colonial period were small, with the inhabitant usually holding title to the land he worked. No matter how small, however, most rural farms managed to have, in addition to a dwelling, a barn and other outbuildings, an orchard, kitchen garden, and, possibly, a flower garden. In the northern colonies, a small farm and its outbuildings were necessarily clustered together to give protection against the harsh winter weather. Many rural farm configurations in New England either strung outbuildings alongside each other in a single row to make access to each structure easier, or placed the majority of buildings to the northwest of the main dwelling house to provide shelter from winter winds (Favretti and Favretti 1977, 13). In the mid-Atlantic and southern colonies, farm configurations were more open. However, in most small and medium-sized farms, both north and south, a dooryard was a consistent feature. The dooryard (unlike a "dooryard garden" in more urban settings) was the main entrance for a working farm and was usually the space created between the house and other outbuildings. It was most often filled with dirt and mud rather than grass or flowers and served as the entrance for wagons and carts, as well as a maintenance area for such vehicles. The barn and adjoining barnyard opened up onto the dooryard, making it the obvious area for the shoeing of horses and oxen, as well as butchering and wood chopping. Activities such as candle and soap making and clothes washing and dyeing were performed closer to the main house, but still located in the dooryard. While many small colonial farms might have aspired to create a separate area for a pleasure garden, most rural homeowners continued to live and work in the same space.

On the other side of the main dwelling, possibly on a southern slope to take advantage of the light, was the garden. Small vegetables, such as peas, onions, lettuce and carrots, would be grown there, along with medicinal and culinary herbs, while larger crops were relegated to outlying fields. If space permitted, the garden might be bordered with a row of fruit trees. The layout of the rural farm garden was much like that of the urban garden; that is, set in straight lines

The dooryard of Gunston Hall, built ca. 1755–1759 in Fairfax County, Virginia.
Courtesy of the Library of Congress.

with small paths cut through well-ordered beds. Fencing, of course, like other areas of the farm, enclosed these gardens. Closely placed palings or pickets were used to enclose gardens, both vegetable and flower, which kept wandering animals from intruding. Split-rail fences with larger gaps were used to encircle larger tracts of land. The colonial housewife living on a rural farm might manage to have a small bit of grass by the front door for decorative flowers, usually referred to as a parlor garden (Favretti and Favretti 1977, 13). Like her urban counterparts, the farmwife might grow only a few varieties of flowers, such as irises, lilies, and carnations, as well as medicinal herbs.

Regardless of the size, rural farms attracted the attention of European visitors, who found them overwhelmingly neat and charming:

As we went on in the wood, we continually saw, at moderate distances, little fields which had been cleared of the wood. Each of these was a farm. These farms were commonly very pretty, and a walk of trees frequently led from them to the high-road. The houses were all built of brick, or of the stone which is here commonly met with. Every countryman, even though he were the poorest peasant, had an orchard with apples, peaches, chestnuts, walnuts, cherries, quinces, and such fruits, and sometimes we saw the vines climbing along them. The valleys were frequently provided with little brooks which contained a crystal stream. The corn, on the sides of the road, was almost all mown, and no other grain besides maize and buckwheat were standing. The former was to be met with near each farm, in greater or lesser quantities; it grew very well and to a great length, the

stalks being from six to ten feet high, and covered with fine green leaves. (Kalm 1748, 69)

Large estates and plantations also had a certain order to the arrangement of the main dwelling house and its outbuildings. Much like the smaller farms, northern estates grouped their structures in a tighter pattern for shelter than those in other areas of the country. More room, however, allowed for more utilitarian buildings: carriage houses, cowsheds, woodsheds, hay barns, summer and winter kitchens (the latter closer to the main house than the former, sometimes in the cellar), smokehouses, chicken houses, well houses, seed houses, and laundry and washhouses. Decorative as well as useful buildings, such as greenhouses, icehouses, summerhouses, gazebos, and bathhouses, might also be included in the garden of a grand colonial estate.

Plantations in the mid-Atlantic and southern colonies were by necessity larger than their northern counterparts, because they were based far more on agriculture than those in the north. In addition to the outbuildings requisite to a large working estate, the indigo, cotton, rice, and tobacco plantations mainly relied on slave labor. By 1700, the slave population in the colonies numbered some 26,000 persons, mostly located in Virginia and Maryland (Joyner 2003, 2). While slaves did work on farms in New England, their numbers were smaller; the particular crops produced there were not as labor intensive as those in the South (McGuire 1992, 17). Added dwellings, therefore, were needed for the housing of the slaves, as well as specialized structures used for storing and processing certain crops. Many plantations had a central slave quarter where all the slaves lived, such as those of Mulberry Row at Monticello, or Madison's Montpelier. Other farms built slave houses in different locations for different jobs. Slaves that worked the fields would be housed nearer to them, while house slaves would be quartered closer to the main dwelling, if not inside the house itself. Most slave dwellings were built in compact rows along a service road, sometimes forming a square, which would serve as a dooryard for their own work activities. They were one-room structures, common to many poor colonists, and often raised up on brick or stone piers, particularly in the coastal South, which was prone to flooding. There would be a central fireplace and chimney, often made of clay and sticks, opposite a door, with possibly a garret or half floor above, reached by a ladder. Some field slaves were housed in two-story dwellings, dormitory-style, while other slaves, especially house or skilled-labor slaves, might live in two-room structures, much like the hall-and-parlor configuration seen in the earliest of colonial homes (Joyner 2003, 5). Most dwellings were built of wood, although those plantations located in the South along the Atlantic Ocean were made of tabby, a mixture of burned oyster shells, dirt, sand, lime, and water.

In addition to the large-scale working fields, southern plantations created pleasure gardens that were more clearly based on English antecedents, and much time and money was spent reshaping the land around affluent southern colonial homes to mimic those in England. Three things that were necessary to the English landscape style were space, trees, and water; in the mid-Atlantic and southern colonies of North America, these features were in abundance (Leighton 1986b, 361).

Most slave dwellings were built in rows along a service road, sometimes forming a square, which would serve as a dooryard for their own work activities. Hermitage (1820), in Chatham County, Georgia. Courtesy of the Library of Congress.

Owing for some variation in location and size, most affluent country house landscapes followed a typical layout. The house itself was usually free of foundation plantings, with a broad sweep of lawn running directly up to the dwelling. This would be bisected by a broad pathway, which would lead from the road or gate in front directly to the entrance of the house. On either side of the path would be raised ornamental beds bordered and cut through with smaller paths; trees would be planted at the edges of the garden. Behind the house might be *falls,* which were terraced lawns falling away from the house toward a focal point below. Level parts of the falls might be planted with flowers or vegetables. Orchards or larger vegetable gardens might be found at the bottom of the terraces and laid out with geometric precision. Small garden seats and benches could be placed under arbors for rest and contemplation. The working areas of the estate were usually set off to one side, with their own entrance, while other outbuildings of a more ornamental nature would be placed within view of the house, with their own bordered paths leading to them.

Many colonial country estates were situated near rivers. Not only did this provide an additional means of travel and trade for the homeowner, but it could also be used to its best ornamental advantage. Middleton Place in Charleston, South Carolina, and Gunston Hall in Mason Neck, Virginia, both refashioned the landscape around the main dwelling house to take advantage of water near their locations. At Gunston Hall, a terraced hill sloped down toward the Potomac River, culminating in an overlook to a deer park below and the river beyond. The path down the terraces was laid on a straight central axis between the main

door and the overlook platform, with cross paths dividing the terraces into equal sections, a common theme in formal gardens in England and Europe. Other estates created their own bodies of water. While the practice helped with the process of draining low-lying fields, such ponds and lakes could provide an attractive focal point for the homeowner and his visitors. Crowfield, a rice plantation built in the 1730s by William Middleton in South Carolina's Low-country, boasted a Roman temple set on an island in the middle of a pond (Hill 1998, 17). Although these plantations were working farms, growing crops such as rice, indigo, or various fruits, the ornamental aspects of the landscape were important to their owners.

Pathways were a requirement for any formal garden for affluent colonists. They resembled the well-ordered beds and intersecting pathways of smaller rural gardens, only on a much grander scale. Walkways were made for two people to walk side-by-side, because the chief use of a formal garden was to be shown off to visitors. Some affluent homeowners would routinely conduct business in their gardens, even constructing special buildings just for that purpose (Sarudy 1998, 104). Many others, of course, used their gardens for pleasure and were able to transfer many indoor activities to the outside, such as dancing, playing cards, and dining.

The beautiful south garden of Gunston Hall, Fairfax County, Virginia, which mimicked formal gardens of England and Europe. Courtesy of the Library of Congress.

GARDEN STRUCTURES AND GARDEN ORNAMENTS

The most ubiquitous of all outbuildings for both affluent and poor colonists alike was the privy or "necessary," which was an outhouse. In both large and small gardens, the privy's placement was an important consideration. Too close to the main dwelling would be an affront to the senses, while too far away would make for uncomfortable journeys during a winter's evening. Most colonists had a simple wooden structure in a far corner of their garden, usually situated behind taller flowering bushes for privacy's sake. But some more affluent homeowners sought to make their privies far more ornamental. The Governor's Palace in Williamsburg, which was enclosed with imported wrought iron fences and gates and featured masonry pillars topped with stone balls, had an elaborate arrangement of privies. The formal flower garden, laid out in 1717, featured diamond-shaped parterres with brick privies built into the surrounding walls. Though some foreign visitors thought it inconvenient to have privies removed at a distance from the house, others were more appreciative. According to Hill (1998), most homes had "a little court or garden, where usually are the necessaries, and so this often evil-smelling convenience of our European houses is missed here, but space and better arrangement are gained" (23). Another outbuilding commonly seen in both affluent and middling gardens was the dovecote. They could take on the form of a brick tower with conical roof; one such example was known by 1686 at Shirley on the James River in Virginia, while another at Tryon Palace in New Bern, North Carolina, was constructed of brick and stucco (Sarudy 1998, 13). Other colonial homeowners of lesser means made do with a simple wooden box. Beehives or apiaries were also another feature in colonial gardens of all classes and were valued for their food source as well as their ornamental qualities. Beehives could be constructed of straw (also known as *beeskeps*), though wood examples were sturdier; for some more middling homeowners, a simple hollow log sufficed for their beehive.

Summerhouses and gazebos were usually found in the more prosperous gardens of the American colonists. Such structures took up valuable space

> *Letter from Eliza Pinckney (ca. 1743) of a Visit to Crowfield Plantation, Berkeley County, SC*
>
> The first we arrived at was Crow-field, Mr. Wm. Middleton's seat where we spent a most agreeable week. The house stands a mile from but in sight of the road and makes a very handsome appearance; as you draw near it new beauties discover themselves; first the fruitful vine manteling the wall loaded with delicious clusters. Next a spacious Basin in the midst of a large Green presents itself as you enter the gate that leads to the House which is neatly finished, the rooms well contrived and elegantly furnished.
>
> From the back door is a spacious walk a thousand feet long, each side of which nearest the house is a grass plat ornamented in a Serpentine manner with Flowers; next to that on the right hand is what immediately struck my rural taste, a thicket of young, tall live oaks where a variety of airy choristers pour forth their melody. . . . Opposite on the left hand is a large square bowling green, sunk a little below the level of the rest of the garden, with a walk quite around composed of a double row of fine, large flowering Laurel and Catalpas which afford both shade and beauty.
>
> My letter will be of unreasonable length if I don't pass over the Mounts, Wilderness, etc., and come to the bottom of this charming spot where is a large fish pond with a mount rising out of the middle the top of which is level with the dwelling house and upon it a Roman temple; on each side of this are other large fish ponds properly disposed which form a fine prospect of water from the house. Beyond this are the smiling fields dressed in vivid green; here Ceres and Pomona join in hand to crown the hospitable board … (Pinckney 1997, 61)

Features in Colonial Gardens

Allée: a tree-line walkway; the trees were often clipped or pleached to grow together to form a screen.

Apiary: an enclosure for keeping bees.

Arbour: a garden shelter, usually arched in form.

Armillary sphere: a type of spherical sundial.

Axis: a straight line (either actual or implied) used to center a point of view in a garden; garden elements would then be arranged along the axis.

Basin: an artificial pool usually fed by fountains or cascades.

Beds: plots of earth for growing plants.

Bower: a garden seat shaded by foliage.

Bowling green: a flat area of grass used for lawn bowling.

Box: an evergreen shrub grown for hedges, borders, and topiary features.

Chinoiserie: a decorative scheme incorporating Westernized versions of Chinese motifs; incorporated into such architectural features as fence and balcony railings, and ornamental garden houses.

Cistern: a container used for collecting and storing rainwater in a garden.

Crinkle-crankle wall: a serpentine wall, one that curved in and out, usually constructed of brick; it originated in England.

Deer park: an area on large estates for the raising of deer; unlike English deer parks, they were usually only ornamental in America.

Dovecote: a wooden, brick, or stone structure used to house doves.

Espalier: a technique for training the branches of fruit trees to grow flat along a wall or trellis.

Exedra: a semi-circular area, usually with seating, backed by a wall or hedge.

Fishpond or *stewpond:* a pond for stocking fish for food.

Grotto: an artificial cave, usually with a water feature, used as a relaxation spot in a formal garden.

Ha-ha: a sunken fence used to denote the boundary between garden and field; used as a decorative device to allow wildlife to wander freely for one's viewing pleasure without damaging planted gardens.

Hotbed or *pit:* a trough or sunken bed filled with manure and covered to cultivate exotic plant species.

Icehouse: a long shaft, usually dug into a hillside, which would be packed with crushed ice and straw and used for cooling food and beverages.

for some homeowners and lost out in favor of extra growing areas for crops. Homeowners who did place garden houses in their landscape had a variety of styles and materials from which to choose. And some colonists, depending on their location, looked on such structures as a definite convenience. As one such Virginia landowner wrote, oppressive summer heat was made easier "by cool Shades, by open Airy rooms, Summer-Houses, Arbors, and Grottos" (Hill 1998, 16). Most garden houses were built of wood, often twined with flowering vines, which would add additional shade, privacy, and fragrance. Some more substantial structures were built out of stone or brick and could often have a second story for presenting an even wider view of the surrounding landscape. Summerhouses built with oriental embellishments were quite popular during the early to mid-eighteenth century. These would often take the form of a Chinese temple or pagoda, complete with peaked roofs and fanciful finials. If summerhouses and gazebos were not situated on a tall hill, taking advantage of the view and the breeze, they could often be found at the end point of a main path.

Smaller gardens of the middle and lower classes might not have space for a summerhouse, but many of these colonial gardens did have seats in them for the comfort of the homeowner. Even the smallest garden might have a wooden stool or even a stump placed under a convenient tree or tall shrub, where the gardener might rest in the evening. Windsor chairs, which were introduced in the early 1700s, became the ubiquitous garden chair for homeowners of all classes. Lightweight and portable, they could easily be moved from inside to out, from porch to garden. Furniture makers advertised them specifically for that purpose, describing them as "fit for Piazza or Gardens" (Hill 1998, 16). Small

wooden structures, such as arbors or trellises, could also be placed in a smaller garden and, with the right foliage, added decoration as well as sustenance to the garden. In 1735, John Custis received the gift of European grapes for his Williamsburg garden from a London acquaintance, who instructed him to "run them up to cover a high arbor of trellis or, failing that, let them grown into other trees, but arbors I like best" (Hume 1974, 29).

Springhouses, icehouses, and dairy houses were also present in early colonial gardens, though they most often appeared on the larger estates of affluent homeowners: "Mr. Cock has a fine spring near his house; it came from a sandy hill, and afforded water enough constantly to fill a little brook. Just above this spring Mr. Cock had erected a building … into which were put many jugs, and other earthen vessels full of milk: for it kept very well in cold water during the great heat with which the summer is attended here. I afterwards met with many houses which were situated like this, on springs, and therefore were destined to keep the meat and milk fresh" (Kalm 1748, 71). These structures usually took the form of decorative temples and, as in the case of many icehouses, could double as a summerhouse, such as the open circular temple atop James Madison's icehouse at Montpelier, or a similar example at Ashland, Henry Clay's home in Lexington, Kentucky (Hill 1998, 36).

Reference List

Bushman, Richard L. 1992. *The Refinement of America: Persons, Houses, Cities.* New York: Alfred A. Knopf.

The Colonial Williamsburg Foundation. 2007. "Teacher Resources: Legislation Relating to Fences in Colonial Virginia." Available at: http://www.history.org/history/teaching/fenceleg.cfm.

(continued)

Kitchen garden: a garden used for growing fruit, vegetables, and herbs for household use; usually walled and situated near the kitchen entrance.

Knoll: a small hill or mount.

Knot garden: an elaborate planting design, usually with box, in the shape of knots, with colorful flowers planted in the centers.

Loggia: a covered walkway, open to one side; often attached to a dwelling.

Mount: a large mound, usually planted with grass, with a seat or platform at the top; used to view across a landscape.

Orangery: a greenhouse for growing oranges or other delicate exotic plants.

Pagoda: a garden house of chinoiserie design.

Pale: a pointed wooden stake used to make a paling fence.

Palisade: a fence made of pales.

Parterre: a level space, usually rectangular and on a terrace near a house, laid out in decorative patterns with plants or gravel.

Parterre de broderie: a parterre design resembling embroidery.

Pergola: a structure made of uprights and connecting arches to support climbing plants and trees; often trained to create a covered walkway.

Pleaching: the practice of intertwining tree branches on a line of trees to create a wall or screen effect.

Portico: a colonnade used as a connecting feature between two buildings or a building and a garden area.

Raised beds: a bed lifted above the surrounding ground to allow drainage; usually kept in place with wood planks or woven twigs.

Rill: a small stream or brook used as a decorative garden feature.

Quincunx: a planting design of five trees arranged to form a square, with trees and each corner and a fifth in the center.

Topiary: a pruned and shaped tree or bush used as a design element in a garden.

Treillage: an elaborate construction of trelliswork.

Trellis: a fence-like structure used to train vines.

Wellhead: a structure, usually of marble, built around the opening of a well.

Wilderness: an artificially designed grove of trees with walkways.

De Wolf, Gordon. 1992. "The Beginnings." In *Keeping Eden: A History of Gardening in America*, ed. Walter T. Punch, 1–11. Boston: Little, Brown and Company.

Favretti, Rudy, and Joy Favretti. 1977. *For Every House a Garden: A Guide for Reproducing Period Gardens*. Chester, Conn.: The Pequot Press.

Hedrick, U. P. 1988. *A History of Horticulture in America to 1860*. Portland, Ore.: Timber Press.

Hill, May Brawley. 1998. *Furnishing the Old-Fashioned Garden: Three Centuries of American Summerhouses, Dovecotes, Pergolas, Privies, Fences, & Birdhouses*. New York: Harry N. Abrams, Inc.

Hobhouse, Penelope. 1992. *Gardening through the Ages: An Illustrated History of Plants and their Influence on Garden Styles from Ancient Egypt to the Present Day*. New York: Simon & Schuster.

Hume, Audrey Noël. 1974. *Archaeology and the Colonial Gardener*. Williamsburg, Va.: The Colonial Williamsburg Foundation.

Israel, Barbara. 1999. *Antique Garden Ornament: Two Centuries of American Taste*. New York: Harry N. Abrams, Inc.

Joyner, Stephanie. 2003. "Slave Housing Patterns within the Plantation Landscape of Coastal Georgia." Master's thesis, University of Florida. Available at: http://etd.fcla.edu/UF/UFE0000714/joyner_s.pdf.

Kalm, Peter. 1748. "Travels into North America; Containing its Natural History, and a Circumstantial Account of its Plantations and Agriculture in General." American Journeys Collection, Wisconsin Historical Society Digital Library and Archives. Available at: http://content.wisconsinhistory.org/cdm4/document.php?CISOROOT=/aj&CISOPTR=14606&CISOSHOW=14365.

Leighton, Ann. 1986a. *Early American Gardens: "For Meate or Medicine."* Amherst: University of Massachusetts Press.

Leighton, Ann. 1986b. *American Gardens in the Eighteenth Century: "For Use or For Delight."* Amherst: The University of Massachusetts Press.

Leighton, Ann. 1987. *American Gardens in the 19th Century: "For Comfort and Affluence."* Amherst: University of Massachusetts Press.

McGuire, Diane Kostial. 1992. "Early Gardens Along the Atlantic Coast." In *Keeping Eden: A History of Gardening in America*, ed. Walter T. Punch, 13–29. Boston: Little, Brown.

Morton, Thomas. 1637. "Description of the Indians in New England." In *New English Canaan*. The American Colonies, Swarthmore University History Department, Bruce Dorsey, 1999. Available at: http://www.swarthmore.edu/SocSci/bdorsey1/41docs/08-mor.html.

Pinckney, Eliza. 1997. *The Letterbook of Eliza Lucas Pinckney*, ed. Elise Pinckney. Columbia: University of South Carolina Press.

Sarudy, Barbara Wells. 1989. "A Chesapeake Craftsman's Eighteenth-Century Gardens." *Journal of Garden History* 9: 141–152.

Sarudy, Barbara Wells. 1998. *Gardens and Gardening in the Chesapeake, 1700–1805*. Baltimore, Md.: The John Hopkins University Press.

Seed, Patricia. 1995. *Ceremonies of Possession in Europe's Conquest of the New World*. New York: Cambridge University Press.

Smith, John. 1612. "A Map of Virginia: With a Description of the Country, the Commodities, People, Government and Religion." American Journeys Collection, Wisconsin Historical Society Digital Library and Archives. Available at: http://content.wisconsinhistory.org/cdm4/document.php?CISOROOT=/aj&CISOPTR=4406.

Southworth, Susan, and Michael Southworth. 1992. *Ornamental Ironwork: An Illustrated Guide to its Design, History, and Use in American Architecture*. New York: McGraw Hill.

Van der Donck, Adriaen. 1649. "A Description of the New Netherlands." American Journeys Collection, Wisconsin Historical Society Digital Library and Archives. Available t:http://content.wisconsinhistory.org/cdm4/document.php?CISOROOT=/aj&CISOPTR=12072.

Glossary

See also the previous chapter, "Landscaping and Outbuildings" for a list of terms related to gardens and landscaping during colonial times.

adobe: A type of building material, sometimes made into bricks, made of a mixture of clay and sand and straw, dried in the sun rather than fired in a kiln. It was primarily used in the Southwest both by Native Americans and by Spaniard settlers. It is an ancient material and technique for building. In Spain, it was introduced by the Islamic invaders of the Middle Ages, and the word comes from an Arabic term meaning brick.

adze: A tool with a wooden handle and an arched metal blade, used for smoothing a rough beam or other piece of wood.

best bed: The best bed of the house was sometimes still found in the parlor of the homeowner, even into the eighteenth century. Later, beds began to be moved out of sight of the visitor, as the parlor became a place to entertain visitors.

cabinetmaker: A carpenter who specializes in more decorative pieces than standard carpentry. In colonial times these craftspeople began to refer to themselves as cabinetmakers, and like the joiners, soon broke away from the carpenters' guild. By the mid-eighteenth century, the cabinetmakers had formed a large society in London and were responsible not only for decorative veneers but also upholstery, gilding, papering, and carving.

Chippendale: A style of furniture, named after English furniture maker and designer Thomas Chippendale (1718–1779); it was prevalent in the colonies from approximately 1750–1790. It featured ornate and curving forms, and even after the rococo style that Chippendale promoted had faded, it was still being seen in

the American colonies, and after the revolution, furniture was still being made that followed Chippendale's embellished styles. Mahogany was the prevalent wood. Chippendale's book *The Gentleman and Cabinet-Maker's Director,* published in 1754, contained patterns of his furniture design and helped to spread his work through the American colonies.

clapboards: The most popular material for house building in colonial New England, clapboards were short planks, about five or six feet long, placed horizontally on the exterior of houses.

coquina: a type of limestone produced by the buildup of shells over many thousands of years. Coquina had to be dried for several years before it was hard enough to be used in building. It was mainly used in buildings in Spanish Florida. The Castillo de San Marcos, built between 1672 and 1695 in St. Augustine, Florida, was made from coquina.

Daub: *See* wattle and daub.

froe: A long metal wedge, extending at right angles to a short wooden handle. It was used to split off clapboards for siding houses and shingles for roofing.

gable: The triangle formed by both sides of a sloping roof. Houses might have many gables, depending on how the roof was designed. The front of the house might feature the gable, or the side might.

gambrel roof: A likely invention by the Dutch, it featured two slopes; the top slope was typically less steep than the bottom slope. It lowered the roof, yet preserved the same usable attic space. It is often found on barns outside of the eastern United States.

Georgian: A style of architecture named for the period of the English Kings George, I, II, and III, who reigned from 1714 to 1811. It was influenced by Andrea Palladio (1508–1580) and his reinterpretation of classical Roman architecture, which became known as the *palladian* style. It became popular in colonial times, especially in the English colonies, but was primarily used to design homes for wealthy citizens or for public buildings.

hall: The main room or living room of an early colonial house; it may have been the only room in some cases and was generally interpreted as the room having a fireplace in which the cooking was done.

hearth: In colonial times, the hearth was not just the area in front of the fireplace, but also the fireplace itself, which was the hallmark of the home. Fireplace exteriors might measure up to 7 feet wide and 10 feet tall, and might feature a massive oak lintel which rose to the roof and 6 feet above the ridgeline. The hearth and the fireplace represented the most dominating element within the dwelling's interior. The food was cooked in and warmed by the hearth, and the room, if not the whole house, was warmed by it.

highboy: A chest-on-chest raised up on curved legs, much like those seen on the Chippendale chairs of the period, while a *lowboy* was a smaller chest. They were built primarily between the late seventeenth and late eighteenth centuries in both Britain and in America.

Japanning: An imitation of the rare and expensive oriental lacquers imported from the East, used to decorate both furniture and smaller objects.

lime: In colonial building, a substance for making mortar (the substance that holds bricks together) or plaster. In colonial times, the most common source of lime was from burning limestone, marble, or seashells, particularly oyster shells.

longhouse: These Native American structures were essentially elongated wigwams, with arched roofs and sides covered in bark, thatch, or hides. Measuring up to 100 feet in length, with multiple smoke holes in the roof, the longhouse could hold up to 14 families at once, along with additional storage space.

mortise and tenon: A type of joint in house construction and in furniture making where a hole or groove on one piece of wood (the *mortise*) receives a *tenon*, which is another piece of wood that fits into it and forms a joint.

Palladian: A style of architecture, created by Andrea Palladio (1508–1580), an Italian architect, and based on ancient Roman style. This style became popular throughout Europe and into the English colonies. Thomas Jefferson's design of the University of Virginia and his home, Monticello, were based on Palladio's works.

parlor: The room used to receive guests. A somewhat old-fashioned term now, it is equivalent to a formal living room.

pewter: An alloy composed mainly of tin, with added copper or lead. Because of its low melting point, it could be melted in a crucible and easily cast in a variety of forms. Though often seen as "poor man's silver," pewter was used throughout all classes of society in colonial America. Only the poorest homeowner could not afford pewter.

privy: The outhouse, or toilet, for a household. It was outside, usually placed in a far corner of the garden, neither too close, to convey odors, nor too far, to be difficult to get to in winter or bad weather. Most colonists had a simple wooden structure, often placed behind tall flowering bushes for privacy. Wealthy families, especially in the later years of the colonies, placed theirs in ornamental gardens with decorative details such as wrought iron fences or pillars, and the privy was usually built of brick.

saltbox: A type of house style, found primarily in New England, that is characterized by an asymmetrical roof. It was created when settlers began to add lean-to additions for a bedroom, kitchen, or dairy. It has two or one and one-half stories in the front, and one story in the back. The name comes from the similarity to a box held for salt, which had a slanting lid. In the south, the same kind of design might be called a "cat slide."

sgraffito: An artistic technique that applies two layers, with the top one scratched or cut to reveal the bottom layer. (*Sgraffito* means *scratched* in Italian.) In America, in colonial times, it was found in earthenware produced mainly by German settlers in the southern Pennsylvania regions of Bucks, Chester, and Montgomery counties. *Sgraffito* decoration was scratched into a layer of white clay and water, which covered an earthenware body, allowing the red color to show. Motifs such as birds, flowers, or Germanic sayings often appeared on such wares, sometimes with the addition of other colored glazes to highlight the decorations.

spermaceti: A substance used for making candles. Found in the heads of sperm whales, it produced a hard candle that did not melt in the hands and

burned cleanly and brightly The best and most expensive candles were made from it.

stone-ender: A wooden house that featured a massive stone chimney on one end, perhaps comprising the entire wall, and was influenced by similar houses seen or lived in by settlers from Western England. They were prevalent in Rhode Island, which had access to good stone for building and limestone for mortaring.

tabby: A mixture of sand, lime, and crushed oyster shells to form a concrete. It was poured into wooden molds to harden into blocks over two or three days; or poured directly into a pit dug in the ground to form a foundation; or, poured on load-bearing timbers, it could make a roof. Tabby was plastered or stuccoed for protection, particularly where it might be exposed to the weather. Its origins may have been in Spain or Portugal or in West Africa. It was used primarily in Georgia, South Carolina, and Florida.

tallow: Used for soap and candle making, it was most commonly made from the fat of domestic cattle, but all kinds of animal fat could be used. In some cases, bayberries and other berries could be cooked to create vegetable fat for tallow candles. Tallow from animal fat was usually smoky and odiferous.

townhouse: In colonial American times, a narrow house in the city, usually one room wide, with or without another room behind, and two or more stories tall.

treenails: Many houses in early New England were held together with dried wooden pegs known as treenails (pronounced *trunnels*), usually made from locust wood.

turner: A craftsperson who added decorative elements to furniture pieces by working the wood on a foot-operated pole lathe, which turned the wood while the worker cut it into the desired shape with a chisel.

wattle and daub: A combination and technique for building, used primarily in colonial New England, the technique used vertical stakes of wood, woven together with smaller pieces of branches, and bound with a mixture of clay, sand, and possibly straw. It could be plastered over for a smoother finish. It is a method that has been used since prehistoric times and was prevalent in England up until the eighteenth century.

wigwam: An arched or domed dwelling made by Native Americans, primarily those people from the northeastern tribes, from young saplings bent over and lashed together and covered with bark, hides, or woven mats. There was an opening in front. Many early English settlers built types of wigwams to live in.

Windsor chairs: A chair that most commonly had an arched back rail with turned back spindles, arms, and legs, and a D-shaped seat. Colonial production started in 1725; they were probably originally imported from England.

Resource Guide

PRINT RESOURCES

Baker, John Milnes. 1994. *American House Styles: A Concise Guide.* New York: W. W. Norton.

Blackburn, Roderic. 2002. *Dutch Colonial Homes in America.* New York: Rizzoli.

Brinkley, M. Kent, and Gordon W. Chappell. 1996. *The Gardens of Colonial Williamsburg.* Williamsburg, Va.: The Colonial Williamsburg Foundation.

Burns, William E. 2005. *Science and Technology in Colonial America.* Westport, Conn.: Greenwood Press.

Bushman, Richard L. 1992. *The Refinement of America: Persons, Houses, Cities.* New York: Knopf.

Calloway, Stephen, ed. 1996. *The Elements of Style: A Practical Encyclopedia of Interior Architectural Details from 1485 to the Present.* New York: Simon & Schuster.

Carley, Rachel. 1994. *The Visual Dictionary of American Domestic Architecture.* New York: Henry Holt and Company.

Carroll, Charles F. 1973. *The Timber Economy of Puritan New England.* Providence, R.I.: Brown University Press.

Carson, Cary, Ronald Hoffman, and Peter J. Albert, eds. 1994. *Of Consuming Interests: The Style of Life in the Eighteenth Century.* Charlottesville: University Press of Virginia for the United States Capitol Historical Society.

Note: This is the Resource Guide for Part I of the volume. For Resource Guide to Part II (1781–1820), see page 261.

Chippendale, Thomas. 1762. *The Gentleman & Cabinet-Maker's Director*, 3rd ed. Reprinted, New York: Dover Publications, Inc., 1966.

Condit, Carl. 1982. *American Building: Materials and Techniques from the First Colonial Settlement to the Present.* Chicago: University of Chicago Press.

Deetz, James. 1977. *In Small Things Forgotten: The Archaeology of Early American Life.* New York: Doubleday.

Donnelly, Marian C. 2003. *Architecture in Colonial America.* Eugene: University of Oregon Press.

Dreicer, Gregory K., ed. 1996. *Between Fences.* Washington, D.C.: The National Building Museum and Princeton Architectural Press.

Emmett, Alan. 1996. *So Fine a Prospect: Historic New England Gardens.* Hanover, N.H.: University Press of New England.

Evans, Nancy Goyne. 1997. *American Windsor Furniture.* New York: Hudson Hills Press, in Association with the Henry Francis du Pont Winterthur Museum.

Fairbanks, Jonathan, and Elizabeth Bidwell Bates. 1981. *American Furniture: 1620 to the Present.* New York: Richard Marek.

Fales, Martha Gandy. 1973. *Early American Silver.* New York: Dutton.

Favretti, Rudy, and Joy Favretti. 1977. *For Every House a Garden: A Guide for Reproducing Period Gardens.* Chester, Conn.: The Pequot Press.

Fennimore, Donald L., et al. 1994. *Eye for Excellence: Masterworks from Winterthur.* Winterthur, Del.: The Henry Francis Du Pont Winterthur Museum, Inc.

Fleming, John, and Hugh Honour. 1977. *The Penguin Dictionary of Decorative Arts.* New York: Penguin Books.

Fleming, John, Hugh Honour, and Nikolaus Pevsner. 1999. *The Penguin Dictionary of Architecture and Landscape Architecture.* London: Penguin.

Forty, Adrian. 1986. *Objects of Desire: Design and Society Since 1750.* London: Thames & Hudson.

Garrett, Elisabeth Donaghy. 1990. *At Home: The American Family, 1750–1870.* New York: Harry N. Abrams, Inc.

Garrett, Wendell, ed. 1998. *George Washington's Mount Vernon.* New York: Monacelli Press.

Gelernter, Mark. 1999. *A History of American Architecture: Buildings in their Cultural and Technological Context.* Hanover, N.H.: University Press of New England.

Gordon, Elsbeth. 2002. *Florida's Colonial Architectural Heritage.* Gainesville: University Press of Florida.

Gowans, Alan. 1992. *Styles and Types of North American Architecture.* New York: IconEditions.

Guinness, Desmond, and Julius Trousdale Sadler, Jr. 1982. *Newport Preserv'd: Architecture of the 18th Century.* New York: Viking Press.

Hardyment, Christina. 1992. *Home Comfort: A History of Domestic Arrangements.* New York: Viking Press.

Harris, Cyril. 1998. *American Architecture: An Illustrated Encyclopedia.* New York: W. W. Norton.

Harris, John, and Jill Lever. 1966. *Illustrated Glossary of Architecture, 850–1830.* London: Faber & Faber.

Harrison, Peter Joel. 1993. *Fences.* Richmond: Dietz Press.

Hawke, David Freeman. 1988. *Everyday Life in Early America.* New York: Harper and Row.

Hawley, Henry. 1964. *Neo-Classicism: Style and Motif.* Cleveland, Ohio: Cleveland Museum of Art.

Headley, Gwyn. 1996. *Architectural Follies in America.* New York: John Wiley and Sons.

Hill, May Brawley. 1998. *Furnishing the Old-Fashioned Garden: Three Centuries of American Summerhouses, Dovecotes, Pergolas, Privies, Fences, & Birdhouses.* New York: Harry N. Abrams, Inc.

Hobhouse, Penelope. 1992. *Gardening through the Ages: An Illustrated History of Plants and their Influence on Garden Styles From Ancient Egypt to the Present Day.* New York: Simon & Schuster.

Hume, Audrey Noël. 1974. *Archaeology and the Colonial Gardener.* Williamsburg, Va.: The Colonial Williamsburg Foundation.

Hume, Ivor Noel. n.d. *A Guide to the Artifacts of Colonial America,* 2nd ed. Philadelphia: University of Pennsylvania Press.

Hume, Ivor Noel. 1983. *Martin's Hundred: The Discovery of a Lost Colonial Virginia Settlement.* New York: Dell Publishing.

Ierley, Merritt. 1999. *Open House: A Guided Tour of the American Home, 1637—Present.* New York: Henry Holt & Co.

Johnson, Claudia Durst. 2002. *Daily Life in Colonial New England.* Westport, Conn.: Greenwood Press.

Kebabian, Paul B., and William C. Lipke, eds. 1979. *Tools and Technologies: America's Wooden Age.* Burlington: University of Vermont for the Robert Hull Fleming Museum.

Kennedy, Roger G. 1985. *Architecture: Men, Women and Money in America, 1600–1860.* New York: Random House.

Kimball, Fiske. 1966. *Domestic Architecture of the American Colonies and of the Early Republic.* New York: Dover Publications.

Krill, Rosemary. 2001. *Early American Decorative Arts.* Walnut Creek, Calif.: Alta Mira Press, with Winterthur Museum, Garden & Library.

Lane, Mills. 1986. *Architecture of the Old South; Georgia.* New York: Beehive Press.

Lane, Mills. 1991. *Architecture of the Old South; Maryland.* New York: Beehive Press.

Larkin, David, June Sprigg, and James Johnson. 1988. *Colonial Design in the New World.* New York: Stewart, Tabori & Chang.

Leighton, Ann. 1986a. *American Gardens in the Eighteenth Century: "For Use or For Delight."* Amherst: The University of Massachusetts Press.

Leighton, Ann. 1986b. *Early American Gardens: "For Meate or Medicine."* Amherst: University of Massachusetts Press.

Leighton, Ann. 1987. *American Gardens in the 19th Century: "For Comfort and Affluence."* Amherst: University of Massachusetts Press.

Maccubbin, R. P., and Peter Martin, eds. 1984. *British and American Gardens in the Eighteenth Century.* Williamsburg, Va.: Colonial Williamsburg.

Mayhew, Edgar deN., and Minor Myers, Jr. 1980. *A Documentary History of American Interiors from the Colonial Era to 1915.* New York: Charles Scribner's Sons.

McAlester, Virginia, and Lee McAlester. 1991. *A Field Guild to American Houses.* New York: Alfred A. Knopf.

Morris, Alistar. 1996. *Antiques from the Garden.* Suffolk: Garden Art Press.

Osborne, Harold, ed. 1985. *The Oxford Companion to the Decorative Arts.* Oxford: Oxford University Press.

Outwater, Myra Yellin. 2000. *Garden Ornaments and Antiques.* Atglen, Penn.: Schiffer Publishing, Ltd.

Palladio, Andrea. 2002. *The Four Books on Architecture.* Trans. Robert Tavernor and Richard Schofield. Cambridge, Mass.: M.I.T. Press.

Peterson, Harold L. 1971. *American Interiors from Colonial Times to the Late Victorians.* New York: Charles Scribner's Sons.

Poppeliers, John C., et al. 1983. *What Style Is It? A Guide to American Architecture.* Washington, D.C.: Preservation Press.

Punch, Walter T., ed. 1992. *Keeping Eden: A History of Gardening in America.* Boston: Little, Brown.

Rifkind, Carole. 1980. *A Field Guide to American Architecture.* New York: Plume.

Russell, Howard S. 1976. *A Long, Deep Furrow: Three Centuries of Farming in New England.* Hanover, N.H.: University Press of New England.

Sarudy, Barbara Wells. 1998. *Gardens and Gardening in the Chesapeake, 1700–1805.* Baltimore, Md.: The John Hopkins University Press.

Sloane, Eric. 1973a. *A Museum of Early American Tools.* New York: Ballantine Books.

Sloane, Eric. 1973b. *A Reverence for Wood.* New York: Ballantine Books.

Stilgoe, John R. 1982. *Common Landscape of America, 1580–1845.* New Haven, Conn.: Yale University Press.

Sweeney, John. 1963. *The Treasure House of Early American Rooms.* New York: W. W. Norton & Co.

Symes, Michael. 1993. *A Glossary of Garden History.* Buckinghamshire, Eng.: Shire Publications, Inc.

Vlach, John Michael. 1993. *Back of the Big House: The Architecture of Plantation Slavery.* Chapel Hill: University of North Carolina Press.

Whitehead, Russell, and Frank Choteau Brown. 1977a. *Colonial Architecture in Massachusetts.* New York: Arno Press.

Whitehead, Russell, and Frank Choteau Brown. 1977b. *Colonial Homes in the Southern States.* New York: Arno Press.

Whitehead, Russell, and Frank Choteau Brown. 1977c. *Early Homes of New York and the Mid-Atlantic States.* New York: Arno Press.

Wolfe, Stephanie Grauman. 1993. *As Various as Their Land: The Everyday Lives of Eighteenth-Century Americans.* New York: Harper Collins.

MUSEUMS, ORGANIZATIONS, SPECIAL COLLECTIONS, AND USEFUL WEB SITES

Boston College. http://www.bc.edu/bc_org/avp/cas/fnart/fa267/contents.html. A Digital Archive of American Architecture. The Boston College Department of Fine Arts maintains this site, which includes information on and pictures of houses and buildings in the United States from the seventeenth through twentieth centuries, in addition to material on urban planning history, World Fairs, and more.

Colonial Williamsburg. http://www.history.org/. The official Web site for the extensive living history museum in Williamsburg, Virginia, which is the restored eighteenth-century Williamsburg, once capital of Britain's empire in the New World. Among numerous features, Williamsburg offers living interpreters and many restored houses of Williamsburg.

George Washington's Mount Vernon Estate and Gardens. http://www.mountvernon.org. The Mount Vernon Ladies' Association maintains this site, which includes archeological information on Washington's home and plantation.

Heckscher, Morrison H., and Peter M. Kenny. "English Pattern Books in Eighteenth Century America." In *Timeline of Art History.* New York: The Metropolitan Museum of Art, 2000. Available at: http://www.metmuseum.org/toah/hd/enpb/hd_enpb.htm.

Jamestown Settlement and Yorktown Settlement. http://www.historyisfun.org. The Web site for the living museums of Jamestown, Virginia, and Yorktown, Virginia. Provides

education materials and information about the features of both of these towns, settled in 1607.

Joyner, Stephanie. 2003. "Slave Housing Patterns within the Plantation Landscape of Coastal Georgia." Master's thesis, University of Florida. Available at: http://etd.fcla. edu/UF/UFE0000714/joyner_s.pdf.

Kalm, Peter. 1748. "Travels into North America; containing its Natural History, and a circumstantial Account of its Plantations and Agriculture in general." American Journeys Collection, Wisconsin Historical Society Digital Library and Archives. Available at: http://content.wisconsinhistory.org/cdm4/document.php?CISOROOT=/aj&CISOPTR=14606&CISOSHOW=14365.

Morton, Thomas. 1637. "Description of the Indians in New England." The American Colonies, Swarthmore University History Department. Available at: http://www.swarthmore.edu/SocSci/bdorsey1/41docs/08-mor.html.

Native Tech: Native American Technology and Art. http://www.nativetech.org. A site providing historical and contemporary information on indigenous technology and art, focusing on the Eastern Woodlands Indians.

Plimoth Plantation. http://www.plimoth.org. Plimoth Plantation is a living museum, presenting exhibits, programs, live interpreters, and historic settings of two cultures in the 1600s: the Wampanoag People and the colonial English community.

Plymouth Archaeological Rediscovery Project. http://plymoutharch.tripod.com/. A site devoted to the archeology of Plymouth colony and the surrounding area.

PreservationDirectory.com. http://www.preservationdirectory.com/HistoricalPreservation/Home.aspx. A comprehensive online resource for historic preservation, building restoration and cultural resources in the United States and Canada. It lists more than 3,000 history museums and house museums in North America.

Smith, John. 1612. "A Map of Virginia: with a Description of the Country, the commodities, People, Government and Religion." American Journeys Collection, Wisconsin Historical Society Digital Library and Archives. Available at: http://content.wisconsinhistory.org/cdm4/document.php?CISOROOT=/aj&CISOPTR=4406.

Society for the Preservation of New England Antiquities. http://www.historicnewengland.org. Historic New England. Offers collections, classes, publications, and preservation information.

The Thomas Jefferson Papers at the Library of Congress. http://memory.loc.gov/ammem/mtjhtml/mtjhome.html. Contains many items relevant to the development of Monticello.

Thomas Jefferson's Monticello. http://www.monticello.org/. The site of Thomas Jefferson's home, Monticello, built in 1769. It offers tours, classes, preservation of the house and extensive gardens, research, and the Thomas Jefferson Center for Historic Plants, which studies and preserves historic plant varieties.

University of South Alabama Center for Archaeological Studies. http://www.usouthal.edu/archaeology/. Includes much material on archeological digs relevant to colonial period, with a particular emphasis on the Mobile area and the French colonies in North America.

Van der Donck, Adriaen. 1649. "A description of the New Netherlands." American Journeys Collection, Wisconsin Historical Society Digital Library and Archives. Available at: http://content.wisconsinhistory.org/cdm4/document.php?CISOROOT=/aj&CISOPTR=12072.

Virginia Center for Digital History. http://www.virtualjamestown.org. Virtual Jamestown. This site, maintained by the Virginia Center for Digital History, includes many

elements relevant to the building and maintenance of Jamestown. Also includes an extensive database of more online resources.

Watson, Judy King. A Few Notes on the English Windsor Chair. The Antiques Council, Inc. Available at: http://focus.antiquescouncil.com/articlepage74.php.

VIDEOS/FILMS

Colonial House. PBS. 2004. DVD. 8 hours. Originally a series on PBS television, featuring a group of twenty-first-century Americans who volunteered to live as settlers to the New World in 1628 on the Plimoth Plantation. This video history also notably features Wampanoag tribe members of the area, who portray their seventeenth-century ancestors. The Web site for the program has a number of essays about life then and lesson plans and a tour of the houses and buildings from the period. See http://www.pbs.org/wnet/colonialhouse.

PART TWO

Homes in the Federal Era, 1781–1820

Melissa Wells Duffes

Introductory Note

The Federal period was a time of transition for the young country. No longer ruled by a patriarchal institution, yet not seen as a fully formed entity, Americans were in search of a national identity. The country was aware that the world's eyes were on them and knew that the first few decades of their existence were crucial for their long-term success. Americans were in a position to create their own history, their own symbols, their own style, and this was as carefully considered—and as hotly debated—as the intricate details of the new government. While many sought to sever long-held ties and embrace the new, others wished to keep close to former traditions. This conflict continued throughout the Federal period and impacted the way Americans thought of themselves and their place in the world. This section of the volume will look at the dominant architectural style in America following the Revolution and how the political and cultural climate of the time directly influenced the way Americans of all classes built their homes, decorated their interiors, and landscaped their surroundings.

The first chapter, "The End of the Eighteenth Century: How Politics, Philosophy, and Culture Affected Architecture," is an introductory look at the Federal period, the years between 1780–1820, when America was still trying to find her own voice in the larger world. This chapter will examine how three factors—political, philosophical, and cultural—contributed to the architectural and decorative styles that developed during this time.

The political landscape just after the Revolution was fraught with difficulty, not the least of which was developing a new national style that would help to legitimize the young country in the eyes of the world. Philosophical be-

liefs, which played such a large part in the decision to ultimately break with England, also guided choices that created the architectural framework of the post-Revolutionary period. And lastly, cultural influences from a variety of sources, one of which was seen as the aggressor just a few years before, helped shape the visual style that defined the United States during its infancy.

The second chapter, "Styles of Domestic Architecture around the Country," discusses the basic components of Federal period architecture and how regional, cultural, and socioeconomic differences impacted both design and construction. Though the majority of Americans still resided in rural areas, cities were on the rise and new forms of housing, such as attached dwellings, were being developed, while the rural area coped with the effects of becoming less rural. Geographical distinctions—from the bustling port cities of New England, the burgeoning seat of power in the mid-Atlantic area, the agrarian traditions of South, and the vast unknown of the Western Territories—played a huge part in the design and function of both affluent and ordinary homes.

The third chapter, "Building Materials and Manufacturing," looks at building materials and manufacturing in the Federal period and changes that occurred in construction, design, and services. It was a time of evolution; old ways were still being used, but new inventions were on the horizon. Innovations in construction, as well as the preparation of common materials, such as wood and brick, impacted how dwellings were built. Innovations in design, with improvements in iron and plaster manufacture, influenced embellishment of the Federal period home. And innovation in services, where perhaps the largest and most important changes took place during this period, affected basic modes of living for citizens of the new nation.

The fourth chapter, "Home Layout and Design," is an examination of the home layout of the poor, middle, and upper classes; the variations in plan according to location; and changes to the basic design. Outside influences, such as the use of builders' guides and pattern books, changed how homes were built, as did the emergence of the professionally trained architect. These influences also resulted in modifications to the traditional interior shapes of homes, which, in turn, allowed for new room forms to emerge. Daily rituals were also changing, and new rooms appeared to accommodate them. Shifting ideas about nature and the landscape around the home also determined the various changes made to dwellings to accommodate this desire to bring more of the outside in.

The fifth chapter, "Furniture and Decoration," explores the different styles seen in furniture and the decorative arts in the Federal period. As with the search for an appropriate architectural form, a decorative style suitable for the young republic was also a focus of some of the country's early leaders. Different motifs became popular, particularly those of a classical and patriotic nature, and many discussed their particular use and interpretation with great interest. Changes in the interior layout of houses, brought about by new architectural styles and the subsequent development of new rooms, allowed new furniture forms to emerge. The influx of pattern books, master craftsmen, and luxury goods from abroad also impacted the evolution of a national style.

The final chapter, "Landscaping and Outbuildings," discusses the different types of gardens found in the Federal period in America. Gardens for subsistence continued to be of vital importance to most people in the young country.

But beyond that, the role of the gentleman farmer began to influence the way many viewed the land and their role in it. The republican values that were being promoted by the early leaders of the country, particularly the agrarian lifestyle favored by Thomas Jefferson, had an impact on all facets of life. From the gardening books they read, the early nurseries and seed houses that emerged, and the growing interest in native flora and fauna, Federal period Americans began to think of themselves and their relationship to the land in different ways. Even pleasure gardens, long an exclusive domain of the wealthy, began to change in shape and meaning for affluent and common citizens alike.

"Homes in the Federal Era, 1781–1820" also includes a timeline to put prominent event dates of the period into context; a glossary for terms that may be unfamiliar; and a resource guide, which provides recommended information for readers from a wide variety of resources, including books, articles, and Web sites.

Acknowledgments

I am very grateful to those special few for their encouraging phone calls, emails, and IMs, telling me what a wonderful time they were having without me, and how much fun I was missing while working on this book. Hey, thanks guys!

Timeline

1781	The first American coal mine is opened in the Appalachian region of Virginia.
	Pennsylvania becomes the first state to abolish slavery.
1783	The first daily American newspaper, *The Pennsylvania Evening Post,* is published in Philadelphia.
	Former officers of the Continental Army form the Society of the Cincinnati, with George Washington as its first president.
	The Paris Peace Treaty is signed with Britain, giving the United States all land east of the Mississippi river, south of Canada, and north of Florida. This formally ends the Revolutionary War.
1784	New England Shakers begin to sell seeds in paper packets.
	The first America ship, *Empress of China,* arrives in Canton carrying ginseng root, which will be exchanged for tea and silk.
	Congress adopts the Land Ordinance of 1784, dividing the land north of the Ohio River, west of the Appalachian Mountains, and east of the Mississippi River into 10 separate states.
1785	Congress passes another Land Ordinance, which allows them to raise money through the sale of land laid out in the Ordinance of 1784. It also provides for political organization of the territories.
1787	The Northwest Territories are created by the passage of the Northwest Land Ordinance, which allows surveying in land west

of the Appalachian Mountains. It also bans slavery in the new territories.

The dollar is introduced as the official unit of currency in the United States.

1789 George Washington is elected President of the United States, with John Adams as Vice President. The inauguration is held in New York City.

The Departments of War, State, and Treasury, and the Supreme Court are established by Congress.

Thomas Jefferson is named Secretary of State.

Congress passes an act to make Washington, D.C., the Capital of the United States. The government will continue to meet in Philadelphia while the city is being constructed.

The first patent act is passed by Congress. It is awarded to Samuel Hopkins of Vermont for the processing of potash, which was used in soap and pearlash, which produced carbon dioxide in bread dough.

The first U.S. census is taken with a total population of 3,939,214.

1790 A design competition is held for the "President's House" to be built in Washington, D.C. Even though Thomas Jefferson submits his own designs, Irishman James Hoban's drawings are selected.

1791 Pierre Charles L'Enfant presents his plans for the city of Washington, D.C., to George Washington, which include an 82-acre park with a "Presidential Palace."

Vermont becomes the 14th state.

1792 George Washington is reelected as President for a second term.

Washington himself sites the "President's House" on a sloping ridge overlooking the Potomac River in Washington, D.C.

A deadly yellow fever epidemic hits the East Coast, particularly in Charleston, Philadelphia, New Haven, New York, and Baltimore. Ten percent of the population of Philadelphia dies from the disease.

1793 The Capitol cornerstone is laid by George Washington in a Masonic ceremony.

The first American stove patent, for a design made from cast iron, is granted to Robert Haeterick from Pennsylvania.

1794 The first natural history museum is opened in Philadelphia by Charles Wilson Peale. The museum will receive the bulk of zoological specimens brought back by the Lewis and Clark Expedition.

The Whiskey Rebellion takes place in western Pennsylvania, as farmers protest the federal tax set on distilled spirits in 1791. Washington calls out the militia to stop the uprising, which is the first use of the Militia Law.

1796 The first cookbook authored by an American, *American Cookery* by Amelia Simmons, is published in Hartford, Connecticut.

1797 The first patent of a cast-iron plow is given to Charles Newbold in Chesterfield, New Jersey. It was not successful, because many farmers believed the iron would poison the soil.

John Adams becomes the second President of the United States, with Thomas Jefferson serving as Vice President.

1798 The first American vineyard is planted in Lexington, Kentucky.

1799 George Washington dies at his home, Mount Vernon.

1800 The second U.S. census is taken, with a population of 5,308,483.

The "President's House" is completed and occupied by President and Mrs. Adams. Congress also moves to the new Capitol in Washington, D.C.

1801 Thomas Jefferson becomes the third President of the United States and the first president to be inaugurated in Washington, D.C.

1802 The first hotel in the United States opens in Saratoga Springs, New York. Many modern conveniences are seen for the first time in hotels.

1803 Ohio becomes the 17th state.

The Louisiana Purchase, between France and the United States, more than doubles the size of the country; 828,000 square miles, all the French territories west of the Mississippi River, are purchased for $15 million.

1804 Meriwether Lewis and William Clark begin their expedition, ordered by President Jefferson, from St. Louis to the Pacific Ocean. They are looking for a direct water route across the continent, as well as examining the natural resources within the new territory.

Congress passes the Land Act, which reduces the price of western lands from $2.00 to $1.64 per acre, in hopes of encouraging western expansion.

1805 The Charleston Botanic Garden and Society is established as the first botanical society in America. It is devoted to the primary study of native plants.

Thomas Jefferson begins his second term as President of the United States.

1806 Congress passes the Embargo Act against England, which is in protest of the seizure of American ships and the impressments of their crew by Britain.

The first American gardening book, *The American Gardener's Calendar: Adapted to the Climate and Seasons of the United States*, is published by Bernard M'Mahon.

1807 Congress passes the Embargo Act, which bans all foreign trade; no exports from the United States to other countries are allowed, a restriction on some British goods is also imposed.

1808 Slave importation into the United States is outlawed by Congress.

1809 James Madison becomes the fourth President of the United States. He is the first president to be inaugurated in American-made clothes.

1810 The Berkshire Agricultural Society is established as the first agricultural association in the United States.

New York surpasses Philadelphia to become the largest American city.

The third U.S. census is taken, with a population of 7,239,881.

1811 A grid pattern is adopted for all future streets in New York City.

An earthquake measuring an estimated 8.6 on the Richter scale hits Missouri, causing the Mississippi River to momentarily reverse its direction. Tremors continue for several months and can be felt all the way on the East Coast.

1812 Louisiana becomes the 18th state.

Congress declares war with England.

Peter Gaillard of Lancaster, Pennsylvania, receives a patent for the horse-drawn "Mowing Machine."

James Madison is reelected for a second term as President of the Untied States.

1814 British troops invade Washington, D.C., and set fire to the Capitol building and the White House. President and Mrs. Madison flee the city. A sudden rainstorm prevents the city from being completely destroyed.

The Treaty of Ghent is signed in Belgium, which ends war between the United States and Britain.

Francis Cabot Lowell opens the first factory combining power cotton spinning and weaving machinery in Waltham, Massachusetts.

1816 The Gas Light Company of Baltimore becomes the country's first coal gas company.

Indiana becomes the 19th state.

1817 Baltimore becomes the first American city to light a street with gas.

James Monroe is inaugurated as the fifth President of the United States.

1817 Mississippi becomes the 20th state.

The Erie Canal begins construction. It eventually measures 363 miles, from Albany to Buffalo, New York, and is completed in 1825. It is built to connect New York City with the Great Lakes.

1818 Illinois becomes the 21st state.

1819 The *Savannah* becomes the first steamboat to cross the Atlantic Ocean, though much of the voyage is made under sail power.

The Florida territories are ceded to the United States in a treaty with Spain.

Alabama becomes the 22nd state.

1820 The Missouri Compromise admits Missouri as a slave state and Maine as a free state.

Congress passes the Public Land Act, where western land prices are set at $1.25 per acre.

The fourth U.S. census is taken, with a population of 9,638,453.

The End of the Eighteenth Century: How Politics, Philosophy, and Culture Affected Architecture

This chapter will look at the three main contributing factors—political, philosophical, and cultural—to the architectural and decorative styles at the end of the eighteenth century through the early years of the nineteenth century, or what is commonly known as the Federal period. The political landscape just after the Revolution was fraught with difficulty, not the least of which was developing a new national style that would help to legitimize the young country in the eyes of the world. Philosophical beliefs, which played such a large part in the decision to ultimately break with England, also guided choices that created the architectural framework of the post-Revolutionary period. And lastly, cultural influences from a variety of sources, one of which was seen as the aggressor just a few years before, helped shape the visual style that defined the United States during its infancy.

On the eve of the Revolution, the colonies were still mostly rural, but cities were starting to grow. In the 1770s, the combined population of the four largest cities (Philadelphia, New York, Boston, and Charleston) was nearly twice that of the entire colonial population just 100 years earlier. Philadelphia was the largest city, with 33,000 inhabitants; New York had 22,000; Boston, 16,000; and Charleston had 12,000 (Ierley 1999, 37). After the Revolution, the infant country began to grow by leaps and bounds. Between 1780 and 1820, the population grew from 3 million to nearly 10 million inhabitants.

Dating the Federal period in American architecture can be difficult. Some historians see it occurring only after the Revolution (and even that can be contested), while others look to the early stirrings of revolutionary fervor. In fact, Mark Gelernter calls this period the "Age of Revolution" and gives a start

The First Census

The census was first mandated in 1787 during the Constitutional Convention. One of the problems faced by the early leaders was how to fairly distribute the Revolutionary War debt among the former colonies. One of the reasons for a new Constitution was to give Congress the power to tax the citizens, something that had not been established by the Articles of Confederation 10 years earlier. Some Convention representatives from the smaller states thought it unfair to have the debt divided equally, complaining of financial disadvantages compared to the larger states. A population count was decided to be the best way to determine the tax structure of each area. A state-by-state count would also be used to set the number of representatives each state would be allowed to send to Congress, replacing the previous method of "one state, one vote." In this way, they reasoned, states would be less inclined to inflate their populations for the purposes of representation if it meant more taxes. The first census was begun in 1790, with federal marshals visiting every household to note the head of the house and the numbers of persons residing there (free white males above and below the age of 16, free white females, all other free persons, and slaves). It took 18 months to complete (U.S. Census Bureau 2003). A big change from the pre-Revolution days was that Philadelphia was no longer the most populated city; it had been overtaken by New York with 33,000 inhabitants to its 28,000, and Boston was a distant third with 18,000.

date of 1763 (1999, 97). This book will use the most commonly cited beginning date of 1780, although some authors use 1790 when creating a more detailed timeline (Roth 1979, 361). An end date is more easily agreed upon, with 1820 being the most common. As with all historic styles, however, beginning and end dates are never concrete, with inklings of future styles occurring well before the start date and echoing long after the supposed end.

POLITICAL INFLUENCES

The themes discussed in John Locke's *Two Treatises of Government* (1689) and David Hume's essays of 1752 played a major part in the American colonies break with England. The idea that government should rule by the consent of the governed was central to the Revolutionary cause; monarchism ignored the natural rights of man and basically forfeited any obedience on the colonists' part. It was the idea of "natural rights" that men such as Jefferson, Thomas Paine, and Samuel Adams kept returning to as justification for their political struggle. In the end, of course, they prevailed, but the struggle did not end there. As Gelernter states, while Americans were quite clear what they were fighting against, they were less sure when it came to replacing the previous form of government (1999, 107). Or, as the case may be, replacing the dominant style of architecture.

There were two main political parties in post-Revolutionary America, both founded around the time of the second presidential election in 1792. Their members competed for control over the government of the young country while also trying to unite the republic against outside forces. Though the war with England had necessitated cooperation between the various colonies, the long and difficult process to create a working government afterward began to divide the former British subjects.

The Constitutional Convention

The Constitutional Convention, which took place in Philadelphia in 1787, left some attending delegates less than satisfied. The Articles of Confederation, which had been drafted some 10 years earlier, had served the country during wartime but were now seen as outdated. During the debates over the

ratification of the amended document, two factions developed—the Federalists and the Anti-Federalists. The Anti-Federalists felt the Constitution went too far in giving rights to a central government and weakening the rights of the individual states, which they felt could lead to monarchism, with the President essentially functioning as a king. They began a publishing campaign against any support of the proposed Constitution, writing articles under pseudonyms such as "Centinel," "Federal Farmer," "Cato," and "Brutus." They urged caution against acting too swiftly and spoke of the dangers inherent in substituting one bad form of government with another: "[The proposed Constitution] is devoid of all responsibility or accountability to the great body of the people, and that so far from being a regular balanced government, it would be in practice a permanent Aristocracy" ("Centinel" 1787).

The opposition, led in part by Alexander Hamilton and James Madison, were strong supporters of the Constitution and laid out their defense in a series of articles that became known as "The Federalist Papers." Hamilton, Madison, and John Jay used their own pseudonym from ancient Rome, that of "Publius." They advocated that a central government was necessary to avoid dissension between the various states, and they stressed that the separation of powers within such a government would serve as a way to avoid tyranny. Madison wrote, under the guise of "Publius": "In framing a government, which is to be administered by men over men, the great difficulty lies in this: you must first enable the government to control the governed, and in the next place, oblige it to control itself" ("Publius" 1788). The tactic worked, and the Constitution was ratified, but the division between leaders of the young government remained.

First Political Parties

The first presidential election of 1789 saw George Washington moved into position as leader of the country with little opposition; the runner-up, John Adams, became Vice President. The first Congress met in New York City, the nation's current capital, that year. However, a break was beginning to occur between two former allies, Hamilton and Madison. Madison, along with other leaders, was becoming concerned about what he saw as Washington and Hamilton's pro-British, pro–strong government agenda, citing that many of their policies, such as the development of a national bank, national debt, and a navy, were unconstitutional. By the time Washington was elected for a second term as President in 1792, two distinct political parties were being formed. Hamilton's Federal party was a natural continuation of the faction he had formed during the Constitutional debates, albeit without the presence of James Madison. The party attracted those who believed in a strong nation, both financially and militarily—particularly merchants, lawyers, and religious leaders—with most support coming from the New England states.

The Democratic-Republicans, formed by Thomas Jefferson and James Madison, were in opposition to nationalistic policies and instead promoted states' rights and strict Constitutional interpretation. They accused the Federalist party of being pro-British and pointed to the Jay Treaty, which created closer economic ties with Britain, as evidence of this. They favored a more neutral stance with European powers and found their strongest support in New York and the South. The Federalist party remained dominant through the rest of the

eighteenth century, during the Washington and Adams administrations. But with the election of Thomas Jefferson, the power of the Federalists began to wane, and Jefferson's republican virtues took center stage.

Identification with Ancient Culture

The idea of the natural rights of man, of citizens being able to govern themselves and determine their own fate, logically put Revolutionary leaders in sympathy with the ancient Roman Republic. This was not just happenstance. Western civilization had long stressed the study of Classical texts as paramount to a young man's education. Many men reached adulthood with a firm grasp of the philosophy, politics, and culture of ancient Rome and Greece, and this knowledge guided them in forming their opinions of government, religion, art, and personal values. They endlessly discussed the writings of their Classical heroes, debated minute points with others, and overall, held most of the ancient past up to the highest standards of morality and virtue. However, not all early Americans venerated the Roman Empire or the Greek city-states. As with the development of the two governmental parties, different sides argued the various merits and deficiencies of certain Greek and Roman rulers and governments, each group likening their own side to the virtuous republic while seeing their opponents as representing the ultimate cause of the destruction of that republic. Samuel Johnson wrote "Nobody but a schoolboy... should whine over the Commonwealth of Rome, which grew great only by the misery of the rest of mankind" (Gowans 1992, 93). Patrick Henry, an outspoken Anti-Federalist, cautioned against emulating the ancients when setting up the new government lest America follow the same path "found in ancient Greece and ancient Rome—instances of the people losing their liberty by their own carelessness and the ambition of a few" (Virginia Ratifying Convention 1788).

The Federal period itself was a politically divided time. The last two decades of the eighteenth century saw a great deal of change, though in terms of architectural style, perhaps not as much as some would have liked. Jefferson thought it imperative that the new nation develop her own unique architecture—to cut ties physically and symbolically with Britain and start anew: "how is a taste in this beautiful art to be formed in our countrymen, unless we avail ourselves of every occasion when public buildings are to be erected, of presenting to them models for their study and imitation?... I am an enthusiast on the subject of the arts... as its object is to improve the taste of my countrymen, to increase their reputation, to reconcile them to the rest of the world, and procure them its praise" (Jefferson to Madison in 1785, in Boyd 1953).

However, most new American citizens continued to follow English and European building designs, regardless of the political implications. As Mark Gelernter wrote, "Revolutionary zeal in politics did not convert to revolutionary zeal in architecture" (1999, 114). The new Americans were too close to their Puritan fathers to make a drastic change. Most—once they moved beyond the shelter-for-survival stage of architecture—looked for something familiar: "They wanted to recreate the environment they had known, the environment that told them who they were, what their place in the world was" (Gowans 1992, 15).

Before the Revolution, the most common style of architecture could be considered today as Colonial or Georgian, though the latter seems to be applied

to a grander style of house, while the former is used more often as a general designation of a house built in the American colonies during the eighteenth century. And, as with all styles, the Colonial or Georgian home did not disappear in 1780. The style continued to be popular and used by many new homebuilders well into the nineteenth century and beyond. However, as one author stated, the Revolution effectively halted most domestic building projects and could be seen as ending the reign of Georgian architecture as the dominant style (Poppeliers, Chambers, and Schwartz 1983, 20). Because New England was seen as a stronghold of Federalist sentiment, it would seem quite natural that the architectural style that began to appear in homes built by wealthy merchants in the northern coastal cities might later bear the same name.

Before turning to the practical characteristics of the Federal style, another factor of the period needs to be examined—the philosophical influences of the early leaders and how they played a part in the development of the Federal period style.

PHILOSOPHICAL INFLUENCES

The philosophy of the European Enlightenment was another important factor in influencing the early colonial leaders to seek separation with England, and it had a large impact on shaping the new country's national style. European thinkers believed that man and society once existed in perfect harmony. This was before "artificiality" took control of human behavior, but by studying the past, contemporary man could once again achieve perfection (Gelernter 1999, 98). For guidance, the philosophers of the Enlightenment looked to Republican Rome and saw in it the height of civilization in the world. And, likewise, the founders of America saw their new country not as a democracy, but as a democratic Republic. It was quite natural, then, for burgeoning statesmen—and architects—to look to the very style of ancient Rome and Greece for inspiration in fashioning a national image. Many enlightened thinkers, such as Edward Gibbon in 1761, saw the study of the ancients as crucial to their understanding of current events: "[the] habit of alternatively becoming a Greek or a Roman, a disciple of Zeno or of Epicurus, is admirably adapted to develop and exercise… the rare power of going back to simple idea, of seizing and combining first principles" (Wiener 1973–1974, 2: 90).

Renaissance Thought

Part of the prevailing philosophy in Europe in the eighteenth century was that the study of the past would lead to enlightenment in the present. This had been the case long before the eighteenth century, as Renaissance humanists began to view the past as distinct from their present, though it was a subject of debate on just which age was superior. As David Lowenthal states, the Renaissance was the first age to think of itself as modern, and quite separate from the remote past it idolized and the immediate past it wished to disown (1985, 86). Renaissance thinkers "discovery" of ancient texts allowed them to see themselves as creators in their own right, as this quote from Erasmus indicates: "To restore great things is sometimes not only a harder but a nobler task than to have introduced them" (Lowenthal 1985, 84). And such creativity could

give them control over their own tumultuous present. A certain amount of ambivalence, which would reoccur during and after the American Revolution, was present in humanistic thought. Greek and Roman culture was seen as the pinnacle in human achievement, certainly in comparison with the Middle Ages, but many humanists also believed in their age's own superiority and the ability to even surpass that of the ancients. The past could be kept alive through its study and in turn be used to push forward toward perfection.

In imitating the past for benefit of the future, the question of strict allegiance to forms often was raised. The recognition by some philosophers that imitation was impossible because conditions were radically different was offset by the idea from others that such changes were superficial. "Those things that are contained in human nature are never changed," wrote one humanist philosopher (Lowenthal 1985, 79). And it was by such imitation that the ancient past was brought to the Renaissance world. Many architects of the period, as well as artists and philosophers, imitated the past to learn from it and, for some, to improve it. This thought would be echoed by late eighteenth-century American thinkers, particularly Jefferson, who was able to use his eclectic knowledge of the past against contemporary problems.

Enlightenment Thought

This belief in man's ability to advance beyond the accomplishments of his past, while venerating this past at the same time, was a theme of the European Enlightenment in the eighteenth century. And this would be accomplished, the philosophers believed, through the basic applications of reason and rationality. A rational and scientific approach to culture, religion, and politics would show the universal principles needed to govern such concepts. Systematic thinking could be applied to all human activity, which would allow man to reach a state of natural order, where civilization had once been and could be again.

Architecture, or the arts in general, was not specifically addressed in most Enlightenment texts. In fact, many eighteenth-century philosophers, particularly the French *philosphes,* saw the modern arts as in an inevitable decline against the rise of intellectual progress. While scientific development was a natural outcome of accumulated knowledge, the arts seemed to suffer from comparison. While one might choose to admire the architecture of ancient Rome, it was quite another matter to try and surpass them in excellence and beauty, as the eighteenth-century politician Richard Steele noted: "Nature being still the same, it is impossible for any modern writer to paint her otherwise that the ancients have done" (Lowenthal 1985, 94). Admiration of the past almost necessitated inferiority on the part of the admirer. Voltaire believed that to try and exceed that which was created before would lead to "excessive novelty," which would corrupt their predecessors' "beautiful simplicity of nature" (Lowenthal 1985, 94).

This is not to say that the arts were wholly ignored by eighteenth-century philosophy; as we shall see, Federal period thinkers in America saw architecture as a crucial element in the moral and social development of the young country. Before then, however, there were those who attempted to reconcile the issue of architecture and reason. The Abbé Marc-Antoine Laugier (1711–1769) published *Essays on Architecture* (1753), which was a typical Enlightenment

treatise on the rationality of architecture. Laugier argued for natural purity in architectural styles and cited the example of the "rustic hut": four tree trunks growing up to form supporting columns for a roof made of sloping branches, which in turn formed a pediment. Nature herself had provided this pure and perfect structure without any embellishments, and Laugier called for all buildings to be constructed with such simplicity. "One should never put anything in a building for which one cannot give a solid reason" (Pierson 1986, 209). Laugier's architectural philosophy was a strict one; because there were no pedestals or pilasters in nature's construction, there should be none in man's. Like the tree trunks forming the rustic hut, columns were to rise straight up from the ground with no base. Any entablatures, arches, or pediments not expressing the pure idea of a roof were also forbidden. It was architecture reduced to principles of rational philosophy.

Ideas from such writers as Laugier influenced many eighteenth-century architects and thinkers in both England and America; particularly with Thomas Jefferson, who identified much with the ancient past, yet also believed in the laws of nature. Jefferson's strong and unwavering belief in a new architectural style as an imperative for the new nation led him to promote an approach that was a combination of two very influential sources—the pure Roman architecture he had read about in various architectural treatises and seen first-hand in Europe; and French Enlightenment thinking, where a rational approach to the study of man could result in the creation of a harmonious society.

Federal Period Thought

American philosophy during the Federal period can be seen as a mixture of British and European Enlightenment with native Puritan ideals. The ultimate result of American thought during the latter half of the eighteenth century was the Revolution and subsequent founding of a new country, but seminal American thinkers reached this conclusion through a variety of concepts. Above all, eighteenth-century American philosophy seemed to be about optimism, that the very power of man's mind and actions could bring about change. Moral philosophy for the Puritans meant a study of both the soul and its faculties; reasoning was a factor just as much as ethics. Added to this was the idea of a natural philosophy, which was put forth by John Locke and Isaac Newton, and the Scottish philosophy of common sense, popularized by Adam Smith and David Hume. This combination was cultivated and promoted by the writings of Jefferson, Franklin, Madison, and others, thinkers on what has been called "the intellectual frontier of the British Empire" (Kennedy 2001).

As taken from these various concepts, a sense of moral virtue permeated much of early Federal period philosophy in which man had an innate sense of right and wrong and, therefore, as Locke believed, was rational and good. This was an idea of natural law, from which came natural rights and the right of every man to life, liberty, and happiness. These natural rights were innate in themselves, not coming from any existing law, and as such, were immoveable. These rights were thought to be given equally to all (including women and slaves, hence the antislavery movement that became more vocal during this period), which meant that there was no natural governance of one person over another. As there was, obviously, an established system of authority throughout

history, they reasoned that it was established to protect natural rights, but then only by consent. When that authority oversteps its bounds, the contract binding the government and the governed is naturally dissolved. The British Empire had broken its contract with the colonies and revolution was then justified. It was, perhaps, easier to revolt against an unjust authority in the beginning, than it was to form a new type of authority that would hold to the idea of natural rights. Some, such as Jefferson, continued to promote the idea of a republican or popular form of government as the only naturally occurring one, while others believed that a balanced form of government, different forms of power given to different groups, would best serve the most people. This battle for either a strong central government or a union of powerful states continued throughout the Federal period, paving the way for even larger conflicts to come.

The final factor that came to play in the development of a national style was cultural in origin. The political and philosophical influences of Europe and the ancient past were instrumental in shaping a representation of America, but visible ideas and examples were also needed to help guide the young country in her search for a national image.

CULTURAL INFLUENCES

Artists and philosophers have always searched the past for artistic inspiration. What made the enthusiasm for Greek and Roman architecture in the eighteenth century different from before were the changing perceptions of that past. Newly discovered primary sources enabled the study of ancient cultures. While previous generations saw the present as a continuation of the past, the current inhabitants of the eighteenth century saw the preceding eras as separate and distinct. Rather than one style leading naturally to another, each successive style stood alone as a complete idea; each style "became a matter of objective choice, in which the stream of history was bypassed and specific formal ideas were removed intact from their historical context and applied to problems of the present" (Pierson 1986, 206).

Renaissance philosophers revered the past. But there was a difference between the Renaissance veneration for the classical past and that of the post-Revolutionaries in America: For the sixteenth-century humanist, Roman culture was so far in the past that he was required to recreate that past to view it; eighteenth-century thinkers saw the Renaissance interpretation of the classical past as too close for comfort. While they might appreciate the rediscovery made on the part of the humanists, they were also still too visible. They, too, needed to go back to the original (Lowenthal 1985, 124).

The Founding Fathers also saw themselves as a distinct and separate age, particularly wishing to be distinct from their immediate past as a colony of England. It becomes clear why Jefferson was so adamant that the United States develop her own culture. He believed that every generation had the right to erase past institutions and install their own: "The rights of one generation will scarcely be considered hereafter as depending on the paper transactions of another" (Jefferson to George Washington in 1794 in Jefferson [1903–1904], 9: 284). Some even went so far as to advocate a dismantling of the laws every 19 years, which at that time was an adult generation's average duration (Lowenthal 1985, 108). Many saw the young country's lack of history as an ideal situation

and deplored other countries who were weighed down by tradition. However, there were some in the generation during and immediately after the Revolution that, while eschewing the recent past of their British heritage, looked farther back to an idealized time.

Early Archaeology

The burgeoning field of archaeology helped fuel this sense of separate and distinct styles. For some time, Rome had been the only ruins known in the western world, and even then, most people were only familiar with the illustrations of Giovanni Piranesi (1720–1778). Piranesi was an artist, architect, etcher, and archaeologist. His most famous collection of works, *Della magnificenza ed architettura de' Romani,* published in 1761, was quite influential to those traveling to Europe on their Grand Tour, even though the sketches were largely imaginary and highly romantic.

Classical architecture, however, had been a part of European architecture long before the eighteenth-century. Classical antiquity was at last being seen as having artistic value, and Greco-Roman examples were built during the Renaissance using the rediscovered principles of symmetry and ordered space; the new style was referred to as *all'Antica,* or "in the Antique manner." Architectural treatises by Serlio and Palladio were being published. All that needed to happen was for the style to spread to other parts of Europe, which it did, first to France and then on to England. It was still only an approximation of ancient Greek and Roman architecture, a mixture of real and imagined elements. It would not be until the early eighteenth century that true scholarly studies could be made.

Though primitive excavations had happened throughout history, records were rarely kept, and many artifacts were removed or destroyed. In 1738, however, as workmen were building a summer home for the King of Naples, they discovered the city of Herculaneum, which had disappeared under molten lava in the first century. Ten years later, Pompeii, destroyed at the same time as Herculaneum, was also uncovered. These early discoveries showed new ideas of domestic and public architecture and decoration on a scale that had never been seen. Other archaeological investigations began to take place, and suddenly, the eighteenth century was getting a fuller and truer picture of Roman and Greek societies, beyond the political. Excavations revealed new and exciting styles, which were, in turn, studied, copied, and shared with the rest of the world. Travelers to these sites recorded their impressions on the spot and returned home to publish their findings. Images of Greek and Roman architecture only available through architects like Palladio were now widely available to everyone, not just a select few. They could be studied and copied by all who had an interest in ancient architecture.

Early Publications

Curious and adventurous men from England, France, and Germany began to travel to distant and remote locations on the continent in search of ruins from the ancient world. Some visits were taken as part of a gentleman's Grand Tour of Europe, while others mounted expeditions to specific places in hopes of recording what they found. One of the earlier travelers was Robert Wood

(1716–1771), who journeyed to Palmyra in Syria to view the remains of Roman temples. His drawings of the trip, *Ruins of Palmyra,* published in 1753, were one of the first English contributions to architectural scholarship (Summerson 1993, 380). His measured drawings of the ruins in the city of Baalbek, in Lebanon, came out in 1757. In 1762, English architects James Stuart (1713–1788) and Nicholas Revett (1720–1804) published *The Antiquities of Athens,* a collection of their drawings from Grecian ruins they visited between 1751–1755. This marked the first time an accurate image of Greek architecture and style had been presented to Europeans (Pierson 1986, 207). Two years later, in 1764, the German archaeologist Johann Joachim Winckelmann produced another book on Greek architecture, *The History of Ancient Art,* which helpfully explained the difference between Greek and Roman sculpture.

Arguments had long occurred as to which culture was superior, with many artists, architects, and amateur archaeologists participating in the debate. Piranesi's *Della magnificenza,* in fact, had been an answer to earlier works proclaiming Greece to be the zenith in classical art and architecture. An essay from the Scottish painter Allan Ramsay, *The Investigator, a Dialogue on Taste,* promoted the Greek as well as the Gothic arts over Roman examples. Another, J. D. Le Roy's *Les Ruines des plus beaux monuments de la Grèce* (1758), illustrated accurate engravings of the Acropolis. Piranesi's contribution sought to prove Roman architecture as the more advanced by "sheer weight of evidence" (Summerson 1993, 308). Rome had traditionally been viewed as a great improvement on the Greek culture that preceded it, and certainly many eighteenth-century architects and thinkers continued to believe this. This was particularly true in America in the early Federal period, with Jefferson and his followers holding to the concept of Roman art and politics as the ideal example of culture. Others, through the examination of such treatises by Stuart or Winckelmann, began to see Greece has a wholly separate and distinct culture with virtues all its own. In America, however, a more concentrated appreciation and interpretation of Greek culture did not catch on until after the Federal period.

It was also in 1764 that Scottish architect Robert Adam (1728–1792) presented the drawings he had made from the Emperor's palace at Spalato (now Split, in Croatia). *Ruins of the Palace of the Emperor Diocletian at Spalatro in Dalmatia* was a tremendous success for Adam, and created a style of architecture and design that became profoundly influential in Britain and, more important, to the early Federal period style in America. Adam's visit had taken place several years before, during his Grand Tour of the continent from 1754–1758, when he studied with architect Charles Louis Clérisseau (who would later collaborate with Jefferson on the Virginia State Capital in Richmond) and Giovanni Piranesi. Diocletian's palace, built in 305, had been studied before, but Adam's was the first systematic survey of the site that had been made and served as his entrée into the world of architecture and interior design.

Here, in an excerpt from the introduction to his book *Ruins of the Palace of the Emperor Diocletian at Spalatro in Dalmatia,* Adam describes his reasons for visiting and his experiences during the trip to Spalato to research the ancient palace architecture.

The buildings of the Ancients are in Architecture, what the works of Nature are with respect to the other Arts; they serve as models which we should imitate,

and as standards by which we ought to judge: for this reason, they who aim at eminence, either in the knowledge or in practice of Architecture, find it necessary to view with their own eyes the works of the Ancients which remain, that they may catch from them those ideas of grandeur and beauty, which nothing, perhaps, but such an observation can suggest.

Scarce any monuments now remain of Grecian or of Roman magnificence but public buildings. Temples, amphitheatres, and baths, are the only works which had grandeur and solidity enough to resist the injuries of time, and to defy the violence of barbarians: the private but splendid edifices in which the citizens of Athens and of Rome resided, have all perished; few vestiges remain of those innumerable villas with which Italy was crowded, though in erecting and adorning them the Romans lavished the wealth and spoils of the world. Some accidental allusions in the ancient poets, some occasional descriptions in their historians, convey such ideas of the magnificence, both of their houses in town and of their villas, as astonish an artist of the present age. The more accurate accounts of these buildings, which we find in Vitruvius and Pliny, confirm this idea, and convince us, that the most admired efforts of modern Architecture, are far inferior to these superb works, either in grandeur or in elegance. There is not any misfortune which an Architect is more apt to regret that the destruction of these buildings, nor could any thing more sensibly gratify his curiosity or improve his taste, than to have an opportunity of viewing the private edifices of the Ancients, and of collecting, from his own observation, such ideas concerning the disposition, the form, the ornaments, and uses of the several apartments, as no description can supply.

This thought often occurred to me during my residence in Italy; nor could I help considering my knowledge of Architecture as imperfect, unless I should be able to add the observation of a private edifice of the Ancients to my study of their public works. This led me to form the scheme of visiting the Ruins of the Emperor Dioclesian's Palace at Spalatro, in Dalmatia; that favorite building, in which, after resigning the empire, he chose to reside. I knew, from the accounts of former travelers, that the remains of this palace, though tolerably entire, had never been observed with any accuracy, or drawn with any taste; I was no stranger to the passion of the prince for Architecture, which prompted him to erect many grand and expensive structures at Rome, Nicomedia, Milan, Palmyra, and other places in his dominions; I had viewed his public baths at Rome, one of the noblest, as well as most entire, of all the ancient buildings, with no less admiration than care; I was convinced, notwithstanding the visible decline of Architecture, as well as of the other arts, before the reign of Dioclesian, that his munificence had revived a taste in Architecture superior to that of his own times, and had formed artists capable of imitating, with no inconsiderable success, the style and manner of a purer age. The names and history of those great masters are now unknown, but their works which remain, merit the highest applause; and the extent and fertility of their genius, seem to have equaled the magnificence of the monarch by whom they were employed.

Induced by all these circumstances, I undertook my voyage to Dalmatia with the most sanguine hopes, and flattered myself that it would be attended not only with instruction to myself but might produce entertainment to the public.

Having prevailed on Mr. Clerisseau, a French artist, from whose taste and knowledge of antiquities I was certain of receiving great assistance in the execution of my

scheme, to accompany me in this expedition, and having engaged two draughts-men, of whose skill and accuracy I had long experience, we set sail from Venice on the 11th of July, 1757, and on the 22nd of that month arrived at Spalatro.

This city, though of no great extent, is so happily situated, that it appears when viewed from the sea, not only more picturesque but magnificent. As we entered a grand bay, and sailed slowly towards the harbor, the Marine Wall, and long Arcades of the Palace, one of the ancient Temples, and other parts of that build-ing which was the object of our voyage, presented themselves to our view, and flattered me, from this first prospect, that my labor in visiting it would be amply rewarded.

To these soothing expectations of the pleasure of my task, the certain knowl-edge of its difficulty soon succeeded. The inhabitants of Spalatro have destroyed some parts of the palace, in order to procure materials for building; and to this their town owes its name, which is evidently a corruption of Palatium. In other places houses are built upon the old foundations, and modern works are so in-termingled with the ancient, as to be scarcely distinguishable: assiduity, however, and repeated observation, enabled me to surmount these difficulties. Attention to such parts of the palace as were entire, conducted me with certainty to the knowl-edge of those which were more ruinous; and I was proceeding in my work with all the success I could have expected, when I was interrupted by an unforeseen accident.

The Venetian governor of Spalatro, unaccustomed to such visits of curiosity from strangers, began to conceive unfavorable sentiments of my intentions, and to suspect that under pretence of taking views and plans of the Palace, I was really employed in surveying the state of the fortifications. An order from the Senate to allow me to carry on my operations, the promise of which I had procured at Ven-ice, had not yet arrived; and the governor sent an officer commanding me to de-sist. By good fortune General Graeme, commander in chief of the Venetian forces, happened at that time to be at Spalatro on the service of the State. He interposed in my behalf, with the humanity and zeal natural to a polite man, and to a lover of the Arts, and being warmly seconded by Count Antonio Marcovich, a native of that country, and an officer of rank in the Venetian service, who has applied himself with great success to the study of Antiquities, they prevailed on the gov-ernor to withdraw his prohibition, though, by a way of precaution, he appointed an officer constantly to attend me. The fear of a second interruption added to my industry, and, by unwearied application during five weeks, we completed, with an accuracy that afforded me great satisfaction, those parts of our work which it was necessary to execute on the spot.

Encouraged by the favorable reception which has been given of late to works of this kind, particularly to the Ruins of Palmyra and Balbec, I now present the fruits of my labor to the public. I am far from comparing my undertaking with that of Messieurs Dawkins, Bouverie, and Wood, one of the most splendid and liberal that was ever attempted by private persons. I was not, like these gentlemen, obliged to traverse deserts, or to expose myself to the insults of barbarians; nor can the remains of a single Palace vie with those surprising and almost unknown monuments of sequestered grandeur which they have brought to light; but at a time when the admiration of the Grecian and Roman Architecture has risen to such a height in Britain, as to banish in a great measure all fantastic and frivo-lous tastes, and to make it necessary for every Architect to study and imitate the

ancient manner, I flatter myself that this work, executed at considerable expense, the effect of a great labor and perseverance, and which contains the only full and accurate Designs that have hitherto been published of any private Edifice of the Ancients, will be received with indulgence, and may, perhaps, be esteemed an acquisition of some importance. (Adam 1764, 1–4)

Robert Adam

Robert Adam (1728–1792) is often considered one of the most influential architects working in the neoclassical style, but as Summerson states, he was not a pure neoclassicist. Adam freely took elements from neoclassicism that he believed would help present a sense of spatial drama and movement, but he also discarded those he did not want (Summerson 1993, 409). This was a departure from the rigid and measured architectural orders that had been followed since the Renaissance. Even the builders of the classical temples were not above making changes if needed, Adam believed. He wrote: "the great masters of antiquity were not so rigidly scrupulous. They varied the proportions as the general spirit of their compositions require, clearly perceiving that however necessary these rules may be to form the taste and correct the licentiousness of the scholar, they often cramp the genius and circumscribe the ideas of the master" (Whiffen 1993, 24). Adam's exteriors were not all that groundbreaking. His designs were a form of early palladianism, as were those of an older and more traditionally classical architect William Chambers. It was in Adam's interiors, however, that one finds the most revolutionary departures from Classical style, and it is these interiors that most influenced early Federal period style. For such a significant architect, Robert Adam published very little—only two books in his lifetime: *The Ruins of the Palace of the Emperor Diocletian at Spalatro in Dalmatia* (1764) and *The Works in Architecture of Robert and James Adam* (3 vols., 1773–1822).

Unlike earlier Enlightenment philosophers who believed that the perfection of past architecture made it impossible for contemporary artists to create their own, Adam saw the past as a strong instrument of inspiration that could inspire his age to match, if not surpass, their examples. In his book on the palace at Spalato, he wrote that such ruins "had revived a taste in Architecture superior to that of [Diocletian's] own times and formed architects capable of imitating, with no inconsiderable success, the stile and manner of a purer age" (Lees-Milne 1947, 68). The Adam style in England was one of sophistication and complexity. Adam's language of interior motifs was vast, borrowing from such sources as Roman, Greek, and Etruscan cultures, as well as traditional Palladian design and contemporary French neoclassicism. His motifs included classical Roman style medallions, vases, urns, tripods, and scrolls; grotesques and animal motifs; and ribbons, swags, and floral garlands. He had a unified approach to interior design, with wall decorations, floor coverings, window treatments, hardware, furniture, paint colors, and upholstery fabrics all coordinated into a single theme. His use of vibrant pastel colors, gilt and marble embellishments, and highly stylized ornaments created some of the most unique and fashionable interiors in mid to late eighteenth-century England.

A defining characteristic of Adam's interior style was his use of different room shapes, a lesson he learned from his studies abroad, particularly at

Robert Adam's Love of Decoration

Robert Adam was the middle son of William Adam, an influential architect in his own right. Robert grew up in Scotland and became an assistant apprentice to his father, as did his two brothers, John and James; the brothers became partners after the death of their father in 1748. Adam's sketches of Diocletian's palace, made while touring Europe from 1754 to 1758, not only brought him to the attention of the public in England, but also gave him years of inspiration for his buildings, interiors, and furniture design. Most of Adam's exterior work was made to existing buildings, such as Kedleston Hall in Derbyshire, where he added a domed saloon reminiscent of the Pantheon; or a double portico at Osterley Park (Middlesex). It is in Adam's interiors, however, where the most revolutionary designs were seen, and indeed, Adam designed entire suites of furniture to be installed in his creations, right down to the upholstery and floor coverings. Adam's love of decoration and color was not confined to the walls; chairs, sofas, bookcases, and screens were painted, gilded, or inlaid with colorful and exotic woods. Adam's chairs had oval, lyre, or shield-shaped backs with straight legs, a marked departure from the popular curved cabriole leg—used by such furniture makers as Chippendale—that had dominated furniture design up until this time (although Chippendale is known to have made at least one set of Adam-designed furniture for Harewood House in Leeds). He also took inspiration for his furniture designs from other ancient cultures that were being rediscovered at the time. He designed monumental sideboards in a Grecian style, with heavy pedestals underneath and attached urns mounted on top. His sketches for carpets and andirons would have gothic tracery, while his Etruscan and Egyptian styles introduced red and black colors along with griffins and harpies, sphinxes and lions. Adam's influence eventually waned after the 1770s, as public taste turned away from his highly decorated schemes. His style became seen as old-fashioned and too elaborate; "gingerbread," as one critic called it, "sippets of embroidery" (Wilton-Ely 2001, 147). Of course, at this same time, the Federal style was beginning to make an impact on American interiors; most homeowners, like the English, did not favor Adam's ornate embellishments, but they found his delicate schemes of color and unity much to their liking.

Diocletian's palace at Split; it was a feature he believed had been overlooked by classical architects from the Renaissance. What he discovered in the ruins was a variety of spatial shapes—oval, circular, and rectangular spaces—contained within a box. Such variety in design had not been suspected of Roman architecture, but Adam showed the range in colors, textures, and shapes that ancient Romans lived with—or, at least, the powerful Romans (although Herculaneum and Pompeii showed common houses to be similarly decorated). The two key elements in his study of the baths at Split—rich surface decoration and differently shaped rooms—became hallmarks of his designs in England and, later, in America (Gelernter 1999, 108).

In Adam's preface to his own book of published designs, *Works in Architecture* (first published in 1773), he clearly showed his preference for varied interiors and their impact on the observer: "the parade, the convenience, and social pleasures of life, being better understood, are more strictly attended to in the arrangement and disposition of apartments" (Pierson 1986, 216). This was a basic departure from earlier classical architecture, which was based on clear and precise forms, both inside and out. What Adam introduced was variety in interior spaces, laid out according to need, not principle. Even if the exterior remained symmetrical (as it did until much later in the eighteenth century), the interior need not follow the pattern.

One such example is Syon House in Middlesex. Originally built in the Italian Renaissance style in the sixteenth century, Adam was retained to redesign the interiors in the 1760s. Working with a rectangular shell, Adam re-imagined the interiors as differently shaped rooms surrounding a central rotunda. On one side, an oval anteroom led to a rectangular hall with an apse, which in turn led to a square corner room. Other rooms with

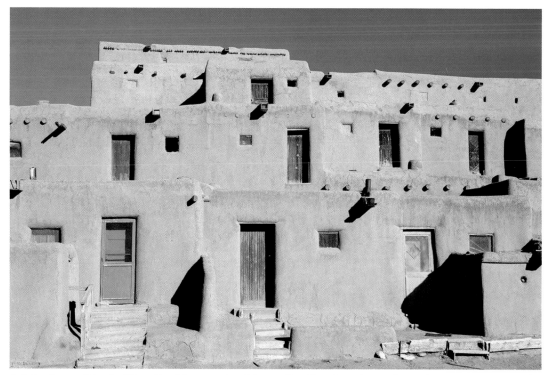

Adobe is used in the Taos Pueblo, north of Santa Fe, New Mexico, where there are many adobe homes side-by-side in the pueblo. First constructed between 1000–1450, Taos Indian families still live in the pueblo today. © Tashka/Dreamstime.com.

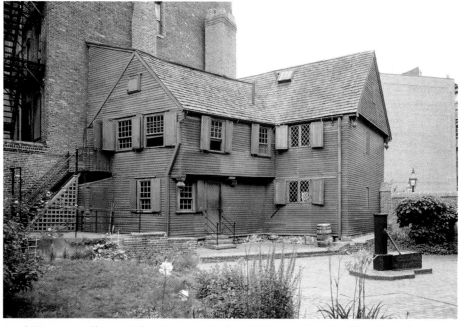

Paul Revere—silversmith, pioneer, industrialist, and a leading Revolutionary activist—owned this house in North Square from 1770 to 1800. Constructed ca. 1678–1680, the building is the sole survivor of Boston's seventeenth-century row houses. Courtesy of the Library of Congress.

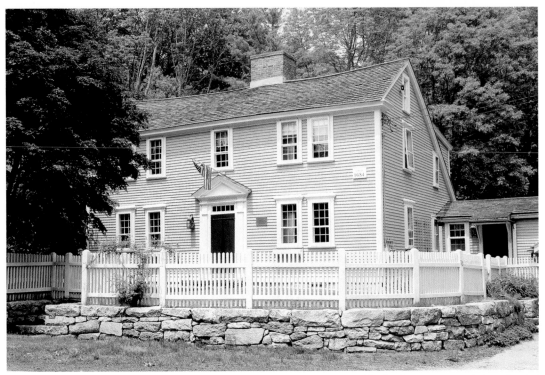

A nicely restored Colonial style home in Pennsylvania, originally built ca. 1684. © Jimplumb | Dreamstime.com.

A restored spring house in New Jersey, originally built ca. 1700. The small building was used to cover natural springs and wells. © Reddy | Dreamstime.com.

"Kiskiack" or the Henry Lee House, built ca. 1725 in Yorktown, Virginia, is characterized by its fine brickwork of Flemish bond with glazed headers above the beveled water table and English bond below. The expense of building with brick, as well as the intricate pattern laid, was unusual in this part of the colonies, attesting to the wealth and status of the owner. Courtesy of the Library of Congress.

The William Hammersley House, initially called "Bachelor's Hope," was originally built in 1700 in St. Mary's County, Maryland. Courtesy of the Library of Congress.

Westover, built in 1730 in Charles City County, Virginia, was typical of the affluent, Palladian-inspired home of the Colonial Period. Courtesy of the Library of Congress.

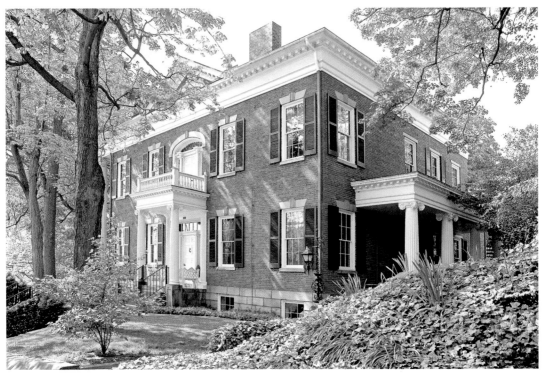

A beautifully restored Federal style home in Lancaster, Ohio, originally built ca. 1780. © Mshake | Dreamstime.com.

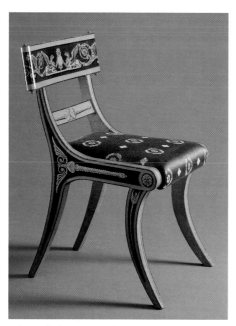

Above left: **Many decorative designs of the Federal period were taken directly from ancient sources. The frieze from the Roman temple of Antoninus and Faustina was painted on the back of this klismos chair, ca. 1815–1825.** Winterthur Museum. *Above right:* **Count Rumford's redesign of the fireplace produced greater heat by slanting the sides and the back of the fireplace walls, as well as narrowing the flue opening This also used less fuel than the typical eighteenth century stove.** Courtesy of the Library of Congress.

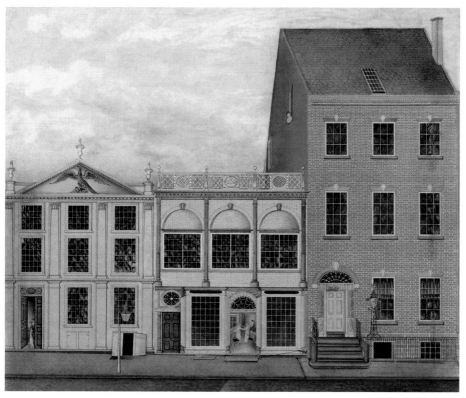

The shop and warehouse of furniture maker Duncan Phyfe was located on Fulton Street in New York City. In this view, painted by John Rubens Smith in 1816–1817, customers can be seen through the center door admiring Phyfe's wares. Metropolitan Museum of Art.

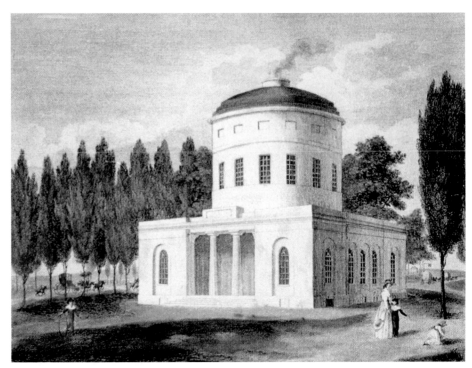

The first public waterworks in America, the Center Square Pumphouse in Phila-delphia, was designed by Benjamin Latrobe in 1801. Courtesy of the Library of Congress.

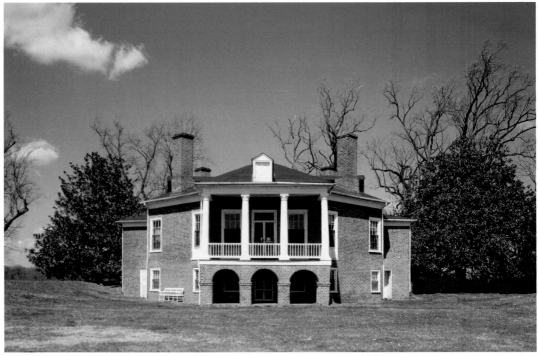

Jefferson's last house, Poplar Forest (1806–1812), combined elements of Palladio's villas with French architectural details to produce this octagonal brick dwelling. The exterior was inspired by Palladio's Temple of Vesta, while the interior featured such French touches as an indoor privy and an alcove bed. Courtesy of the Library of Congress.

Wallpapers became fashionable in the Federal period. French artist Joseph Dufour was responsible for many exotic designs that graced the walls in affluent homes. The Art Archive / Bibliothèque des Arts Décoratifs Paris / Gianni Dagli Orti.

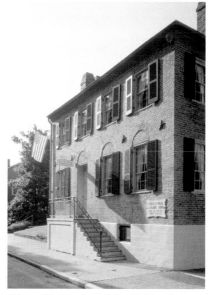

The Robinson-Schofield house, built around 1821 in Madison, Indiana, is a distinctive version of the Federal style in the city, and stands opposite two historic Federal style houses of the same period, the Sullivan house, and the Hyatt house. Courtesy of the Library of Congress.

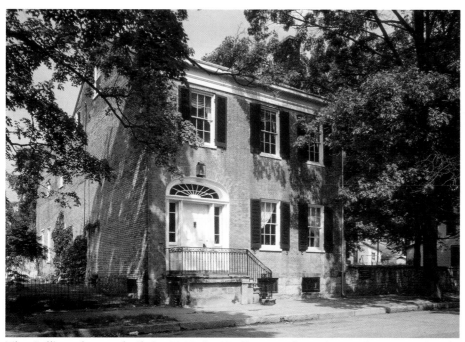

The Sullivan house, built in 1818, in Madison, Indiana, is another example of a Federal period city home. Courtesy of the Library of Congress.

This mahogany-veneered card table with gilded sphinx was made in 1817 by Charles-Honoré Lannuier, one of the premier cabinetmakers working in New York City in the early eighteenth century. French émigré Lannuier designed furniture for the Federal period elite and often incorporated elements of ancient Greece and Rome, popular decorative themes found on many objects during this time. The Metropolitan Museum of Art / Art Resource, NY.

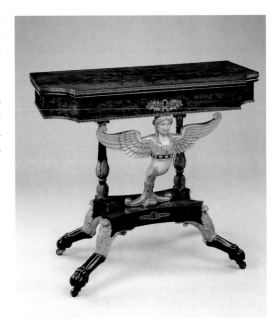

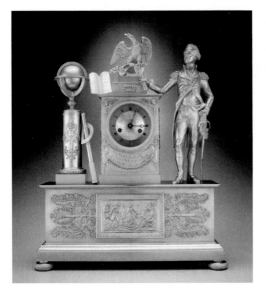

A French gold and brass shelf clock (1804–1817) portrayed a multitude of familiar patriotic images as decorative embellishments, including a figure of Washington, an eagle with a shield, stars, torches, and a globe. Winterthur Museum.

varied shaped covered the remaining sides, with little or no relation to the exterior. The decorations were just as varied. Adam incorporated marble columns in the Ionic orders, a gilt and plastered compartmentalized ceiling, and rich green and blue colors on the walls in one room. In an adjoining area, he placed Doric columns; a flat, beamed ceiling; and painted motifs of swags, medallions, and paterae on the walls (Summerson 1993, 400).

The Federal style would echo Adam's themes of differently shaped rooms inside a symmetrical shell. Still later architects, such as Benjamin Latrobe and William Thornton, would experiment with asymmetry on the exterior as well. Jefferson also experimented with varied room forms, at Monticello and later at Poplar Forest, and was very much aware of shaping the room to its particular use. Interior decoration would also follow, but in an extremely subdued manner. The young country's search for a style borrowed much from Adam, while mostly remaining true to their Puritan roots. But by the time America was beginning to search for her own style of architecture, Adam's influence in Britain was waning.

Antique Influences in the Federal Period

Though it would be easy to see the Federal period style as merely a transplantation of the Neoclassical style in Britain, several factors made for a different interpretation when it reached America: The Revolution halted much building in the colonies and affected the availability of materials and labor; the geographic remoteness of the main cities in the United States from other cultural centers meant that trends were slow in coming, if they reached them at all; and the perceived need for a national culture by the early leaders of the country allowed for an openness and experimentation on the part of some architects and designers (Pierson 1986, 210).

Images of architecture based on classical designs arrived in America mainly through English builders' guides and pattern books, such as William Pain's *The Practical House Carpenter* (1792), which illustrated many of Adam's designs. George Hepplewhite's *The Cabinet-Maker and Upholsterer's Guide* (1788) and Thomas Sheraton's *The Cabinet-Maker and Upholsterer's Drawing Book* (1793), containing designs influenced by Adam, also made their way across the Atlantic to lend inspiration. These interpretations of the ancient past resonated most strongly with the intellectual leaders of the young country—George Washington, Benjamin Franklin, and, above all, Thomas Jefferson. These men had studied the philosophical writings of the great Greek and Roman thinkers and were wholly aware that the years following the Revolution would be the most crucial in developing a cultural consciousness. Nearly all important cultural decisions during this time were made with an eye to the Classical past. The very framework of the new government was carefully managed to compare with that of ancient Rome; the terms that were used—the *Senate,* the *Society of the Cincinnati,* even the pseudonyms used during political debates, such as *Cato* or *Publius*—were all a deliberate homage to the past. A country so clearly basing itself on the principles of republican culture necessarily needed an appropriate style. And though the identification with the classical past became far more self-conscious toward the latter half of the Federal period, it was merely a continuation of what had been planned since before the Revolution.

Another important influence on the basic concept of American society came from the ancient pastoral poets, such as Virgil and Theocritus, and the image of Arcadia. The idea of the perfection of man and the benevolence of nature were central ideas in Enlightenment philosophy, and Jefferson used these ideas to promote his concept of America as an agrarian paradise. Jefferson's self-identification with the pastoral Roman farmer and his life-long promotion of rural values were pivotal in his beliefs of a free society and the subsequent realization of a national style, and it was by virtue of the farmer that this freedom would be sustained. It was just such principles that were perhaps behind his motivation to form the Democratic-Republican Party in the early 1790s, or the decision to purchase 828,000 square miles of additional land for the infant nation. The Louisiana Purchase was unconstitutional, as many of his critics pointed out, and it also put him in direct conflict with another early leader of the republic, Alexander Hamilton, whose own image of the nation was one of strong industry and competitive commerce (Gelernter 1999, 107).

When Jefferson wrote *Notes on the State of Virginia* in 1781, he was doing more than merely writing a visitor's guide. In this, he laid out very clear ideas on his desired path for the young country: "Those who labor in the earth are the chosen people of God... While we have land to labor, let us never wish to see our citizens occupied at a workbench" (Jefferson 1781–1782, 290). It was Jefferson's defense of an agrarian lifestyle: a lifestyle that would allow America to be self-sufficient, free from authority abroad, and mostly importantly, would create a moral and rational citizenry. This was not a vision of large-scale agricultural production, however. Jefferson's Arcadian ideals were for a rural, pastoral lifestyle, far from commerce, crowds, and the corruption that they produced. His philosophy of natural law allowed that this was the true order of things; that man was meant to live free, harmoniously, and moderately in nature with an enlightened and republican government of like-minded individuals.

It is with Jefferson that one also finds the most direct and important designs based on ancient architecture. While serving as Minister to France for President Washington from 1784–1789, Jefferson was able to visit many Roman ruins throughout Western Europe. One he returned to again and again was the Maison Carrée at Nîmes in southern France. To him, the building epitomized the perfect Roman temple and was an example of the architectural style he wished America to develop; he called the temple "the best morsel of ancient architecture now remaining" (Pierson 1986, 296). The structure was very simple: a rectangular building set on a high platform with steps and fronted with a portico and columns on three sides. A single door was set into the front façade. Just before leaving for Europe, Jefferson had managed to convince his home state to move its capital from Williamsburg to Richmond, which, while making it more accessible to Virginians residing further to the west, also represented yet another break with England—the removal of a reminder of British rule in the Virginia colony. Therefore, when he was asked to supply an architect to design the new Virginia State Capitol, Jefferson decided to send his own designs based on the temple at Nîmes. With the help of Charles Louis Clérisseau (who had tutored Robert Adam 30 years earlier), Jefferson set about converting the Roman temple to the needs of a modern government. Windows, of course, were introduced, as well as provisions for heating, and also a gallery. Jefferson also changed the orders of the capitals (the upper part of a column) from Corinthian

to Ionic, which effectively toned down the elaborateness of the building. Orders also held distinctive virtues, according to Masonic teachings (Jefferson was a member of the order): Doric orders stood for strength; Corinthian columns proclaimed beauty; and Ionic, which Jefferson chose, stood for wisdom. It has been called the first public building of pure temple form seen in the United States (Pierson 1986, 297). Jefferson's choice was a highly symbolic one; he had removed a symbol of oppressive authority and a direct link with the recent past and replaced it

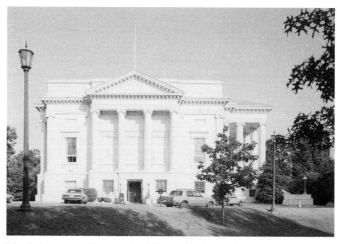

Virginia State Capitol building, designed by Thomas Jefferson from 1785 to 1792. Courtesy of the Library of Congress.

with an icon of republicanism and rational thought. This was just the type of architecture he envisioned for the new nation.

Jefferson's allegiance to Roman orders (instead of Greek orders) came from his belief that Roman architecture held more variety in design than any Greek examples. And for the most part, Jefferson held to his admiration of ancient Rome and designed his homes and other buildings in the style as an example to others, hoping that they might inspire the new nation to reach for the Roman ideals in culture, philosophy, and politics. Jefferson, as an ardent classicist, enthusiastically promoted the temple portico form as an ideal style for a dwelling. Though his designs for the Virginia State Capitol were a classic example of this, the idea did not catch on until after the Federal period (Kimball 1966, 160). Jefferson also promoted a more Palladian plan of a symmetrical building crowned with a dome. Monticello, of course, is one example of this. But again, as with the temple form, this style did not reach its true expression until later (Kimball 1966, 161). At the close of the Federal period, the classical idiom was recognized as an American way of building and set the stage for the Greek revival, which became prominent several decades into the nineteenth century—the end result of Jefferson's experiments with classical form.

Reference List

Adam, Robert. 1764. *Ruins of the Palace of the Emperor Diocletian at Spalatro in Dalmatia.* Accessed from The University of Wisconsin Digital Collections. Digital Library for the Decorative Arts and Material Culture. Available at: http://digicoll.library.wisc.edu/cgi-bin/DLDecArts/DLDecArts-idx?id=DLDecArts.AdamRuins.

Boyd, Julian P., ed. 1953. *Papers of Thomas Jefferson,* vol. 8. Princeton, N.J.: Princeton University Press.

"Centinel." 1787. no. 1, Oct. 5. Accessed from The Constitution Society. Founding Documents. Available at: http://www.constitution.org/afp/centin01.htm.

Gelernter, Mark. 1999. *A History of American Architecture: Buildings in their Cultural and Technological Context.* Hanover, N.H.: University Press of New England.

Gowans, Alan. 1992. *Styles and Types of North American Architecture: Social Function and Cultural Expression*. New York: Harper Collins.

Ierley, Merritt. 1999. *Open House: A Guided Tour of the American Home, 1637–Present*. New York: Henry Holt & Co.

Jefferson, Thomas. 1781–1782. *Notes on the State of Virginia*. Accessed from The University of Virginia Library Electronic Text Center. Available at: http://etext.virginia.edu/toc/modeng/public/JefVirg.html.

Jefferson, Thomas. 1903–1904. *The Writings of Thomas Jefferson*, ed. Andrew A. Lipscomb and Albert Ellery Bergh. Washington, D.C.: Thomas Jefferson Memorial Association.

Kennedy, Rick. 2001. "Philosophy from Puritanism to Enlightenment." Accessed from The Pragmatism Cybary. Timeline of American Thought. Available at: http://www.pragmatism.org/american/philosophyfrompuritanism.htm.

Kimball, Fiske. 1966. *Domestic Architecture of the American Colonies and of the Early Republic*. New York: Dover Publications. First published in 1922 by Charles Scribner's Sons.

Lees-Milne, James. 1947. *The Age of Adam*. London: B.T. Batsford, Ltd.

Lowenthal, David. 1985. *The Past is a Foreign Country*. Cambridge, Mass.: Cambridge University Press.

Pierson, William H., Jr. 1986. *American Buildings and Their Architects*, vol. 1. New York: Oxford University Press.

Poppeliers, John C., S. Allen Chambers, Jr., and Nancy B. Schwartz. 1983. *What Style Is It? A Guide to American Architecture*. Washington, D.C.: Preservation Press.

"Publius." 1788. no. 51, Feb. 8. Accessed from The Library of Congress. The Federalist Papers. Available at: http://thomas.loc.gov/home/histdox/fed_51.html.

Roth, Leland M. 1979. *A Concise History of American Architecture*. New York: Harper & Row.

Summerson, John. 1993. *Architecture in Britain, 1530–1830*. New Haven, Conn.: Yale University Press.

U.S. Census Bureau. 2003. "History." Accessed from the U.S. Census Bureau. Available at: http://www.census.gov/acsd/www/history.html.

Virginia Ratifying Convention [to the U.S. Constitution]. 1788. June 4. Accessed from The Constitution Society. Founding Documents. Available at: http://www.constitution.org/rc/rat_va_04.htm#henry-01.

Whiffen, Marcus. 1993. *American Architecture Since 1780: A Guide to the Styles*. Cambridge, Mass.: MIT Press.

Wiener, Philip P., ed. 1973–1974. *The Dictionary of the History of Ideas: Studies of Selected Pivotal Ideas*. New York: Charles Scribner's Sons.

Wilton-Ely, John. 2001. "'Gingerbread and Sippets of Embroidery': Horace Walpole and Robert Adam." *Eighteenth-Century Life* 25(2): 147–169.

Styles of Domestic Architecture around the Country

During the Colonial period, the predominant style in England was Georgian or Palladian. This was interpreted in America to some degree, mainly in affluent houses such as Westover (1730) in Virginia or Cliveden (1763) in Philadelphia. Though many ordinary homes had touches of the Georgian, it was mainly a style for conservative, wealthy colonists and, after the Revolution, for many conservative Americans. Most construction stopped during the war with England, and when citizens returned again to building, many returned to the familiar Georgian style. In fact, some architects complained of certain builder's continued devotion to the Georgian style into the early nineteenth century (Calloway 1996, 204). Change was slow in coming; slower in some places than others. And in certain locations, particularly rural, houses continued to be built as they had been in the previous century. There was dramatic change for some, however, and though the period in question is relatively short, its effects were widespread and long lasting.

This chapter discusses the basic elements of Federal period architecture, concentrating on the exterior elements, and examines the major substyles present at the time. The differences between urban dwellings and rural homes are also discussed, with a specific look at the beginnings of the row house in America. Regional differences—between New England, the mid-Atlantic, and the South—in the Federal period are looked at, first with affluent homes and then vernacular examples. Finally, westward expansion, though just beginning at this time, did have an impact on the spread of the Federal style, and is examined as well.

There has always been a difference of opinion when it comes to the exact name for the architectural period that took place during the late eighteenth

and early nineteenth centuries. One problem stems from the fact the term *Federal* is used for both the political period in history as well as the building style that took place during this time. Some architectural historians divide different phases of the period along political lines—quite naturally, of course, as many of the early political leaders were also the first tastemakers in the country. In addition to the most popular Federal style, other terms are: High Georgian (Gowans 1992), Adamesque (Poppeliers, Chambers, and Schwartz 1983, 31), and English Adam Style (McAlester and McAlester 1991, 158). Other historians separate the period into two phases, such as Federal and Neoclassical (Baker 1994), or Early Classical Revival and Late Classical Revival (Krill 2001, 104). Some go even further than that; Pierson's descriptive term for the period is "American Neoclassicism," which is broken up into the Traditional, Idealistic, Rational, and National (1970, 210). In most cases, however, Federal is the most common term used to describe the style that occurred during this time, and it shall be used in this case, almost as an umbrella term.

While dates and terms may vary, most architectural historians do acknowledge a predominant style occurring during 1780–1820, with a similar, though smaller, style running concurrently. In addition to the main Federal style, this substyle has been known variously as Roman Revival, Classical Revival, Neoclassical, or Jeffersonian. The use of Jefferson's name is deemed appropriate by many, as this style was mainly championed by him and functioned almost more as a philosophical exercise than an architectural style. Along with the desire to emulate the Republican virtues of ancient Rome in the construction of a new government, Jefferson also saw artistic inspiration. The most obvious difference between the Federal style and this substyle was the initial influence: In England, the style originated from Robert Adam's study and inspiration of the villas of Roman nobility, while Jefferson, an ardent classicist, looked to the public buildings of Rome for visual cues.

While the Federal style could be seen throughout the United States during this time, the Roman Revival style, as a private architectural style, tended to appear chiefly in the South. Until the Greek Revival style began in the 1820s, Jefferson's influence was seen mainly on public buildings, such as banks, libraries, or government offices.

In discussing the basic elements of Federal period style, it should be remembered that the most notable characteristics were to be found on upper- and middle-class dwellings; new styles in architecture, interior design, and decorative arts were made available to those who could afford them, at least during the early years of America. Architectural styles in general varied little for poor and middling houses. While some changes did occur in those areas, they were most often interpreted as a regional difference. The following discussion, then, focuses mainly on upper- and middle-class homes, with more vernacular examples to be examined later.

BASIC ELEMENTS OF FEDERAL ARCHITECTURE

Architectural influences from abroad reached the seaports in America first, which meant New England. During the first official census taken in 1790, the Northeast region had a little over one million inhabitants. The mid-Atlantic cities of New York and Philadelphia were the largest, with 33,000 and 28,000

residents, respectively, but New England made up for it in sheer concentration of port cities. Boston was by far the largest city in the region at 18,000, but Salem, Marblehead, and Gloucester, Massachusetts, all had populations of more than 5,000; as did Providence and Newport, Rhode Island; with New Haven, Connecticut; Newburyport, Massachusetts; and Portsmouth, New Hampshire, all just fewer than 5,000 people each (U.S. Census Bureau 1998). The style began with the wealthy merchants in the port cities then spread south and west, but along the way, naturally, changes occurred. Regional differences in architecture, like in most things, varied greatly due to accessibility of materials, cost, and cultural influences. However, as one author stated, whether it was a "Salem shipbuilder, Philadelphia banker, or Charlestown planter-trader," Federal style homes were more alike than not through the different regions (Rifkind 1980, 29).

Main Exterior Features

The Federal style has been noted by architectural historians as particularly excelling in simplicity, restraint, and subtleness. The average Federal house was a simple box, usually two rooms deep, sometimes with projecting wings (mainly in rural locations), or none, as was the case in more urban settings. Its lightness and delicacy were a change when compared to the heavier Georgian style that preceded it. The five-part façade on some of the larger colonial homes continued into the Federal period, while smaller dwellings would be three bays, or parts, wide, such as a central door flanked by two windows. It was not always an odd number, however, as with examples from New England after 1800 that would have two or four windows across the front, with the entrance on the side of the dwelling (Kimball 1966, 208).

Though the most decorative aspect of the Federal period house was usually to be found on the interior, certain exterior elements were developed that managed to move the heavier, more traditional aspects of Colonial Georgian architecture aside, replacing them with attenuated and delicate forms, a sophistication many thought was needed in the young republic.

Doors and Entranceways

The most common identifying feature of a Federal style home seemed to be concentrated on the entrance façade, particularly with the door surrounds, which became more prominent and more decorative than their Colonial counterparts. These entranceways provided the main emphasis to the exterior decoration of the house—in some cases, particularly in urban row houses, or on smaller rural examples, the only exterior decoration—and could range from elaborate door surrounds with a crown or entry porch, to more simplified designs with sidelights on either side of the door. Sidelights were a new feature in the Federal period, one author stated that they first appeared in 1788 in Philadelphia (Kimball 1966, 216). Along with the transom, sidelights could allow light into the halls, which, with the new interior design scheme of the period, became rooms of some importance. Semicircular or elliptical fanlights above the door were common in both elaborate and simple entranceways, though

rectangular fanlights or a complete omission of lights were also seen. Toward the end of the Federal period, straight transoms were being used. In fanlights, lead substituted the colonial use of wooden muntins, or glazing bars, between the glass panes.

The doors themselves were generally six-paneled with ovolo- or convex-shaped moldings and pine construction, though more elaborate doors would often feature eight panels. When present, the door surrounds took various forms, with the top taking on a rectangular, oval, or pedimented shape. The surrounds could be as elaborate or simple as the owner wished, though commonly surrounds began rather restrained and grew more decorative throughout the Federal period. Rounded cornices would often be of a thinner frame, with beading or other decorative motifs applied on the edges, while the inset fanlight would be elaborately traced with wooden or lead muntins. Flat-topped door surrounds could be quite heavy, with a stepped cornice and molding such as an egg-and-dart motif or dentils. Other times, the frieze would be decorated with applied swags or ribbons. Elaborate pediments, often of the broken variety, became heavier and less decorative in the later Federal period, and rectangular cornices were used more frequently.

With most homes having at least a few steps up to the main entrance, particularly in urban areas, some kind of door surround, if not a full-blown entrance porch, was usually present. Projecting porches used rectangular, arched, and pedimented crowns with pilasters and columns for support. Some of the most heaviest and elaborate of surrounds could be rectangular in shape, with a heavy molded crown and decorative central panel with applied ornamentation, and framed by pilasters or freestanding columns, often four, but sometimes six were seen on very elaborate examples. Sometimes a curved iron railing would be placed on either side of the front steps. Semicircular or even full porticoes, such as the one at Tudor Place (1815) in Georgetown, were seen in the more high-style Federal homes. These usually contained different geometrical room shapes, with the arched porticoes echoing the rooms within. Some porches on high-style dwellings would feature a flat-topped balcony with balustrade above, while others might extend upwards of two stories. The latter, though, were usually found on more Roman Revival dwellings in the South.

Windows

Windows were another important feature in the Federal style house. Identifying characteristics of the period were different shapes (rectangular, bowed or bay, round, or lunette), sizes (tall, wide, or thin, with large panes of glass), and decorative embellishments (such as delicate lead muntins, straight or curved). Where once windows would be a nine-over-nine pane configuration, the Federal period saw more six-over-six panes with very deep and thin muntins, usually less than one inch (Calloway 1996, 211). In addition to the introduction of sidelights, another feature seen during this period was the double-hung sash window. Originally, windows were small, with small panes of glass, and fixed into the wall or perhaps pivoted inwards on a hinge attached to the side. The development of the sash window, with one sliding sash that could be raised and held in place by pins, was a welcome change. Double-hung windows, with both

sashes moving up or down, became popular during the eighteenth century in America. Counter-weights hidden in the window frame would eventually hold the windows open, but pins were usually the most common method during this period (McAlester and McAlester 1991, 154). Double-hung sash windows on Federal style homes were placed singly but in symmetrical rows. They usually ranged five bays across and were centered with the front door. Triple sash windows were also seen and could be carried almost down to floor level in grander homes, often doubling as doors. Tudor Place (1815) in Georgetown, designed by William Thornton, had three-part windows set in curved frames, installed in a circular portico, with sashes that could be raised up into the ceiling to allow the window openings to be used as doors to the garden beyond. French doors, which had been seen earlier in the eighteenth century, were still employed as an alternative to triple sash windows and became even more popular with the increased interest in nature and the outdoors in the later eighteenth century.

Glass manufacturing in America during this period was not very successful. A glass blowing company started by Caspar Wistar began in Salem, New Jersey, in 1739, but the war ended his business by 1780 (Munsey 2005, 2–3). A polished-plate process was being used by the French in the late seventeenth century and by the English in the 1770s, but it was not until later in the nineteenth century that quicker and more affordable methods were used. Nevertheless, larger panes of glass became possible, albeit imported and still expensive, and this availability helped promote sash window use. Pre-Revolution pane sizes were usually 6-by-8 inches, but during the Federal period they increased to 8-by-12 inches (McAlester and McAlester 1991, 156). Larger panes of glass also signified visible wealth and were certainly a way to announce one's status to passersby. As was common in many Georgian homes updated with Federal style features, older windows on the front façade might be replaced with newer versions and larger panes, while the expense of such replacement could be offset by keeping the original windows on the sides and back of the house, away from public view.

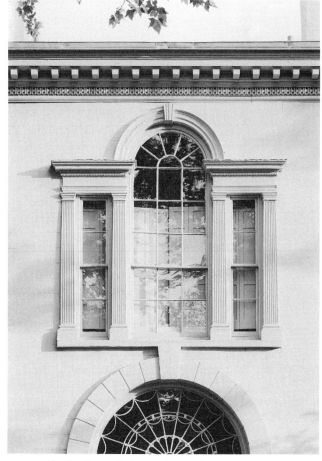

Central Palladian windows above the entrance to Lemon Hill (ca. 1799), Philadelphia, Pennsylvania. Courtesy of the Library of Congress.

In brick examples of Federal period homes, a variety of window heads or lintels were used, including a flat lintel, a keystone lintel, or a keystone without a lintel. In high-style Federal homes, the lintel and keystone might be of a light marble set in to contrast with the brick. Wooden frames surrounding windows on brick houses were rarely seen after 1800 (McAlester and McAlester 1991, 156). Before then, however, an elaborate frieze above the window was also used, as was a cornice mold above the window. Other examples could have a pediment feature with or without accompanying pilasters or columns. Later into the Federal period, however, elaborate window framing became more rare, like the wooden frames.

Three-part Palladian windows, a holdover from classical or Georgian architecture, were commonly used, but in a lighter and more decorative fashion, set with fanlights and sidelights above doors. Elaborate tracery designs formed by lead muntins would often be seen on the sidelights and fanlight of Palladian windows. Other times, Palladian windows were seen on the side or front gables, or in dormers, or slightly recessed with façade arches. The inset arches could be either plain or, as was seen later on in the Federal period, filled with fanlights or applied decoration, such as swags or garlands. Elliptical windows were also seen on gable ends of Federal homes.

Windows in the Colonial period were usually square-headed, though Palladian three-part windows were seen, usually placed above the main entrance. Windows in the Federal period, however, were topped with a variety of forms, such as semicircular or elliptical, as well arched groupings. Into the nineteenth century, however, the arched Palladian scheme became more square-headed. If arched windows were used on a Federal façade, they were usually on the bottom stories, with straight windows reserved for the top floors. In addition to changes in ornamentation from bottom to top windows, a typical three-story house of the period might have windows that would decrease in height to the roofline.

Roofs

Other typical exterior elements of the Federal home included a hipped roof, balustrade, prominent end chimneys, molded cornices, corner boards, and plain walls. Hipped roofs, which had four sloped sides meeting at a sharp ridgeline, were often of a low pitch, almost flat in some cases, and could be concealed by a decorative balustrade just above the eaves. Concealed or flat roofs had been used earlier in the eighteenth century, and builders in the Federal period continued what Kimball called "an aversion to visible roofs" (1966, 192). Flat roofs that could be used as parapets were built during this period, much like entry porches that had balconies on their roofs, but invariably they leaked and had to be replaced with a low-hipped roof. The Octagon (1801) in Washington, D.C., is one such example. Benjamin Latrobe's design for a flat roof leaked from the very start, even though it was constructed by layering tar-soaked canvas on top of wood planks and set at a slope to drain the water away from the center. It was replaced in 1815 with a low roof, still invisible to the street, as was the architect's wish (Ierley 1999, 64). Gambrel roofs, which had two slopes on each side, were still seen on many older and less high-style homes that had been built in the early eighteenth century; as with other adapted homes of the

period, however, many were modified to lower the pitch, in keeping with the new Federal style for low roofs. The side gable roof was perhaps the most commonly used roof style during this period; the pitch could be raised or lowered to suit changing tastes, and it was easier to construct such a roof when compared to other types.

Chimneys, either interior or exterior were usually smaller and narrower than earlier Georgian examples. Owing to the somewhat unusual interior layout of some Federal period homes, many chimneys were relegated to end walls. This was a pattern in plainer houses, as a center hall and staircase, which necessitated the removal of the chimney to other locations, was replacing the older colonial form of a central chimney within a multi-use room.

Cornices were present on many Federal period façades, yet continued the theme of exterior simplicity on most examples. Cornices would usually be decorated with shallow moldings, although dentil moldings or egg-and-dart motifs were also quite common. More elaborate cornices would have applied elements below the roofline, with swags, medallions, or paterae being set in the frieze. Cartouches with applied elements such as urns, ribbons, or rosettes could also be seen on the upper façade of masonry constructed high-style dwellings.

Roofline balustrades were used to hide the visible roof and seemed to occur more on northern high-style houses than elsewhere. While they had appeared in Georgian architecture, they began to be used with more frequency during the Federal period and were often used to encircle a balcony or walkway made possible by the low-pitched roof.

Columns in the Federal Period

The Federal period saw an increase in the use of classical orders, particularly with the Roman Revival substyle. Its main champion was Thomas Jefferson, who usually preferred a strict interpretation of Roman orders rather than an amalgamation, as was seen later with the Greek Revival style. Architects used columns sporadically in the early Federal period, and builder's guides recommended lengthening and lightening them, which would be in keeping with the delicacy of the Federal style. There were five orders: *Doric*, the oldest and simplest of the Greek orders, has a heavy and plain column, though it sometimes could have broad fluting with an equally unadorned capital and base. The cornice above a Doric column was simple and blocky. It was commonly used in the Federal period. *Ionic* is the second of the ancient Greek orders. The capital is often ornamented with an egg-and-dart band below two scrolls or volutes. The shaft is usually fluted and normally stands on a base. *Corinthian* is the most ornate of the Greek orders. In the eighteenth century, this column was used to mark the best floor or room of a house. The capital is decorated with curling acanthus leaves ending in volutes at the top of the capital, while the column, also fluted, is more slender than either the Doric or Ionic orders. *Tuscan* is one of two orders based on Roman architecture and is the plainest of the five orders. The column is shorter than the Doric and unfluted, with a base and capital also devoid of any ornament. This was the most commonly used order during the Federal period. *Composite* is the other order based on Roman architecture. The capital combines elements of both the Ionic, with the scrolls on top, and the Corinthian, with acanthus leaves below. It is the most elaborate of all the orders. Benjamin Latrobe, who used the Greek orders throughout his architectural designs, developed two new architectural orders for use on American buildings. In the north wing of the Capitol building, Latrobe placed a column with the sprouting flowers and leaves of the tobacco plant, while another fluted column, installed in the vestibule to the Supreme Court, displayed bundled ears of corn.

Balustrades would typically be constructed of slender posts interspersed with thicker pedestals, but after 1800, more fanciful designs were used, including Chinese lattice patterns (which Jefferson used at Monticello), fan motifs, or carved, flat panels alternating with pillars.

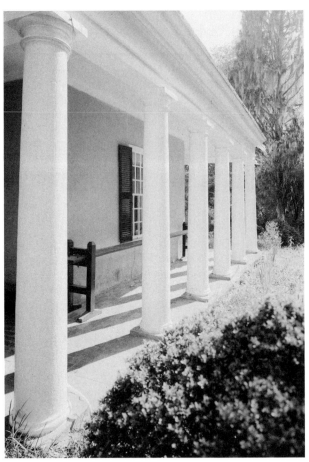

A fine example of a Tuscan colonnade. Courtesy of the Library of Congress.

Other Exterior Decoration

Earlier colonial exterior features, such as rustication or engaged columns, fell into disuse during the Federal period. Surface features were usually left smooth, with any decoration concentrated around the windows and entryways. Exterior walls were usually plain, though sometimes with string or belt courses, molded, or often with applied decorations of swags or sheaves of wheat or plaques. These were most often found on three-story, high-style homes, sometimes applied with contrasting plaster, or with complimentary brick or marble molding. Engaged columns or corner pilasters were present, but after 1800, they became the exception rather than the rule (McAlester and McAlester 1991, 154). Other features from the Georgian period that remained were quoins, found on the corners of houses, and dentil moldings, usually occurring on cornices at the roof or over the doorway.

Height of Houses

Federal period homes varied in the number of stories they contained, mostly depending on economics and location. Poor and middling homes would logically have only one story or perhaps one-and-a-half. The addition of a second story for these dwellings was a sign of prosperity, as well as a desire for privacy, a concept that was becoming more important during this period. Country homes of the affluent would also have two floors at most. For town houses, three stories were common and four stories were not unheard of. As the width of urban dwellings was significantly smaller than country houses, it was natural that space be made up in the height of the structure.

ROMAN REVIVAL SUBSTYLE

Like the Federal style, the Roman Revival style is also know by many other names: Early Classical Revival (McAlester and McAlester 1991, 169), Neoclassical (Gelernter 1999, 120), Jeffersonian Classicism (Roth 1979), Jeffersonian (Poppeliers, Chambers, and Schwartz 1983), even "Revolutionary Democratic"

(Gowans 1992, 103). Thomas Jefferson is so closely identified with this style that his name is often used as the descriptive term for this type of architecture. Unlike proponents of the Federal style, however, Jefferson viewed the Roman Revival style as much as a philosophy in addition to an architectural fashion. His strict adherence to the Roman orders made his every design a study in the pure principles of geometry. He saw architecture as a teaching tool, as well as an aesthetic choice; one only need look at the pavilions he designed for the University of Virginia, each structure displaying a different architectural order for study.

Jefferson was quite conscious that his tastes and styles would have an influence on the nation at large, and he used architecture for the education of his fellow countrymen, as well as for his own enjoyment. In a letter to James Madison, Jefferson made clear how important art and design were in directing the style of the young country: "How is a taste in this beautiful art to be formed in our countrymen unless we avail ourselves of every occasion when public buildings are to be erected, of presenting to them models for their study and imitation?" (Jefferson to Madison in 1785 in Jefferson "This Beautiful Art").

However, because the style Jefferson espoused was based on public Roman buildings, rather than private Roman villas, most pure Roman Revival structures were public ones. Jefferson's Virginia State Capitol in Richmond, which he based on a Roman temple he visited in France, is one of the earliest examples of temple building in the United States. State houses and other assorted government buildings also began to be built in this monumental style during the Federal period. When Jefferson spoke of the new country developing its own national style, this is what he was searching for: a visual expression of the republican principles he believed were being formed after the break with England. Benjamin Latrobe, although he built many dwellings in the more delicate Federal style, also designed grand public structures with distinct Roman features. His Bank of Pennsylvania (1798), as well as the Baltimore Cathedral (1804–1821), helped establish this classical revival style as one of grandeur and solemnity; important architecture for important functions. His contributions to the Capitol building, particularly the dome, also illustrate the power of symbolic icons. As Gowans points out, the icon was strong enough for 47 of the 50 state capitols to emulate the design, not to mention the numerous local government buildings found in many counties across the country (1992, 85).

However, temples did not make for the most comfortable of living arrangements. There were some notable private examples of dwellings in the Roman Revival style, though mainly from Jefferson himself, and even then with some acknowledgement to ease of living and rational planning. Jefferson's Monticello went through several versions before it was complete. The original conception owed much to Palladio, whose architectural books were among the first to be acquired by Jefferson (Pierson 1970, 297). French influence on Jefferson's Roman Revival style was also strong, however, because it was during Jefferson's time as Minister to France that he encountered structures that had the most lasting impression on him. In addition to the Temple of Augustus at Nîmes, Jefferson was also intrigued, "violently smitten," he writes, with the Hôtel de Salm (1782–1786) in Paris (Pierson 1970, 298). In the end, Monticello had both Roman Revival and Federal characteristics. The low, one-story building with a pediment and columns centered below an octagonal dome was certainly Roman influenced (and strongly reminiscent of the Hôtel), but the roof and

balustrade, along with elliptical bays and octagonal rooms, could be seen in high-style Federal homes during the same period. Jefferson's last house, Poplar Forest (1806–1812), combined elements from Palladio's villas to produce an octagonal brick dwelling, which Gowans says is "Jefferson's most systematic exercise in geometric design" (1992, 108). As is probably appropriate considering its most vocal champion, the Roman Revival was chiefly a southern style and was rarely seen above Pennsylvania (McAlester and McAlester 1991, 170). Domestic examples tend to occur with frequency in Virginia or areas settled by Virginians.

The Roman Revival style is sometimes confused with Greek Revival, which did not start to make an impact until after the 1820s. Though there are many similarities, on the whole Roman Revival structures adhered to stricter classical rules than did the subsequent Greek style, which eventually utilized a looser interpretation of Classical orders. Also, the familiar fanlight over the front door, found in both Federal and Roman Revival styles, was rarely seen in the Greek style. Roman Revival homes also tended to have Federal interiors. Though the exterior of these dwellings rarely showed any hint of the interior layout, elliptical, circular, and polygonal spaces were common in the revival homes. In the end, however, the Greek Revival style traveled farther and influenced more domestic architecture than Roman Revival, and it was even called "the National Style" (McAlester and McAlester 1991, 182).

The Roman Revival style, as noted previously, ran approximately concurrent with the main Federal style. There were many similarities between the two: both favored rectilinear forms, often with projecting wings. Also, a five-part composition was seen in both styles, along with low-pitched, hipped roofs, though the Palladian three-part plan, with a central block and two flanking wings, was also seen in the substyle. The overall feeling of the Roman Revival style, however, tended to be heavier, more masculine, than the Federal style. Most often constructed of brick, wood, stucco, and stone variations were also built.

Main Exterior Features

Doors and Entranceways

One of the first and most prominent differences seen with the Roman Revival when compared with the Federal style is the use of a centered gable or pediment over the entranceway, often taking the height of two stories, or least the full height of the structure, in more affluent examples. It is the typical Federal entranceway on a grand scale. The portico was usually centered over the doorway, but it could also encompass the entire front as a temple form, though this usually occurred later in the period. Columns, usually of the Doric or, more commonly, the Tuscan order, would appear below, most often in twos or fours. And, because the typical Roman Revival house was often raised up from the foundation, steps leading to the entrance were most always present, with the columns usually spaced evenly around them.

Like the older, Georgian style homes that adopted Federal style characteristics, many earlier built dwellings merely added touches of the Roman Revival style to the exterior. Often massed plan houses, which were two- or three-rooms deep with three or five bays across, would attach a pedimented portico to the

front for an updated, fashionable look. Sabine Hall (1730) in Warsaw, Virginia, is an example of a typical colonial home that added a Roman Revival style portico nearly 100 years later. Side or back porticoes were also present on some of the largest Roman Revival style homes, and they probably functioned just as much for comfort in the hot summer months as an aesthetic expression.

When compared to Federal entranceways, Roman Revival door surrounds themselves were heavier, yet plainer in style. The elaborate swags and floral motifs, often found on Federal door surrounds, were replaced with simple medallions or Greek key motifs. Paterae were some of the more commonly used decorations, often placed on side panels below the sidelights or across the entablature. On less grand Roman Revival style dwellings, sidelights were narrower and often unadorned with any leading. Fanlights, however, were just as prominent as in Federal style examples, and would often have multiple radiating designs, such as traceried fan patterns as well as roundel motifs in an encircled, glazed band. An attached pediment above the fanlight might take the form of a broken pediment with either a blank face or perhaps a single medallion motif. Other times, the temple portico shape was replaced with a rectangular entablature with little or no ornamentation.

Windows

Like with the Federal style, Roman Revival windows were usually of the double-hung sash variety, tall in height, with large panes of glass. And, like the Federal style, they were aligned in rows, usually five across. Unlike the other style, however, Roman Revival windows tended to be straight-topped rather than arched. The exception would be found in the lunette or semicircular window in the pediment, or in the upper stories or side gables. Jefferson's octagonal dome at Monticello had lunette and semicircular windows all around its façade. Arched windows on the façade were found occasionally, but with minimal decorative surroundings or lintels; Homewood (1803) had two hyphens connecting the outer wings, along with simple arched windows, which contrasted with the rectangular examples on the rest of the structure. The three-part Palladian window, found on many Federal period examples, evolved into rectangular forms, with straight-topped, plain cornices.

Roofs

Roofs found on Roman Revival dwellings were much like those on Federal style houses; that is, side-gabled roofs, hipped roofs, or low-pitched roofs sometimes, but not often, surrounded by a balustrade. Occasionally, front-gabled roofs were seen, but usually in conjunction with a three-part Palladian plan: a two-story center block with a full-height temple portico, flanked by one-story wings on either side. These, however, were not often seen. Comparatively though, roofs were much more visible in the Roman Revival style than in the Federal style.

Unique to Roman Revival structures was the use of the dome, or rotunda, found occasionally on high-style houses, Monticello being a prime example. The dome was a common theme in Palladio's designs, particularly his *villa rotonda* (which was a symmetrical building set in a vertical axis); it was natural

that the Roman Revival should embrace the form. However, as Kimball states, it was not until after the dome was used on public buildings, such as churches, that it began to be seen on private dwellings (1966, 175). And even then, it only caught on in any number after the Federal period. Jefferson was quite fond of the rotunda form and used it in his proposed designs for the President's House in 1792 (Kimball 1966, 171). Smaller cupolas were built on some Roman Revival homes, but the majority of larger domes were reserved for public buildings, such as the U.S. Capitol.

URBAN LIVING VS. COUNTRY LIVING

Foreign visitors to American cities in the late eighteenth to the early nineteenth centuries remarked on the neatness and cleanliness of the homes there. Many brick houses in towns were painted either bright red or yellow, with the seams highlighted in white paint, giving them a fresh look (Garrett 1990, 17–19). Some, however, saw this as a lack of variety; Charles Dickens thought American homes were too fancy, too neat and ornamented, writing that New England wood-framed homes were the "whitest of white" and had "no more perspective than a Chinese bridge on a teacup"(Garrett 1990, 20). With the overall neatness and symmetry of the Federal style, the carefully placed window openings and delicately carved door surrounds and pediments, most visitors agreed with one writer who saw city and town homes as having "the air of nice furniture than of buildings" (Garrett 1990, 20).

Layout of Towns

Many towns laid out during the Federal period followed along the lines of the more fashionable neighborhoods in London: a collection of square plots

for homes, with public squares or greens in the center of town. Government buildings and churches often dominated the middle of towns, and the most fashionable homes usually grew up along side them, or, at the very least, had their faces turned toward them. Older towns would have such pockets of affluence mixed with plainer homes of craftsmen, artisans, and workmen, while the newer laid-out towns would relegate the finer homes to major streets leading to the civic center, while outlying streets held the lower-class service population.

In the Federal period, New England towns tended to be a mixture of both the urban and rural: urban homes surrounding a common or civic area with outer rural farmsteads. Conversely, mid-Atlantic towns were widely dispersed along roads that led from one grid-shaped village to another (Rifkind 1980, 246). Small and large farms dominated the South, with only a few principal cities present during the Federal period. Wealthy landowners with thousands of acres would have large homes situated on their holdings, while smaller farms might be rented out to tenant farmers.

Jefferson was adamantly opposed to the idea of cities, and anti-urban sentiments were a large part of his personal philosophy. His plans for America imaged it more as an Arcadia rather than a Utopia—men working in harmony with nature, not subduing her. In Jefferson's *Notes on the State of Virginia*, he laid out his pastoral theory that only through free, uncultivated land could a proper society form: "the mobs of great cities add just so much to the support of pure government, as sores do to the strength of the human body" (Jefferson 1781–1782, 291). The passage of the Land Ordinance Act of 1787 laid the Northwest Territories open for settlement, which would seem to be right in line with Jefferson's hopes for "unbounded land." He wrote to Madison that same year: "When [people] get piled upon one another in large cities, as in Europe, they will become corrupt as in Europe" (Roth 1979, 81). However, the land was divided into strict grids, regardless of natural obstacles and, as Gelernter notes, many town layouts, as well as roads and state boundaries, still reflect this original survey to this day (1999, 125). An Arcadian landscape was easier to envision in the relatively docile east, while the frontier west required that nature be subdued to survive.

Urban Houses

To compare urban-built Federal homes with their rural counterparts is to also compare regional styles. For all practical purposes, the Federal style had its beginnings in the coastal cities and towns, particularly in New England seaports such as Boston, Salem, and Providence. Close mercantile ties with England, combined with the new wealth of merchants, enabled building on a large scale. Though many built homes reflected older, more conservative Georgian tastes, new elements seeped in through influences from abroad. This was coupled, of course, with the young nation's desire to be seen as a cultural beacon in its own right. Town homes and row houses in New York, Boston, and Philadelphia reflected their owners' need to display their culture, taste, and wealth.

For city living, Federal period homes could adapt easily. Unlike most rural Federal style dwellings, urban homes were usually three bays (a vertical division of doors and windows) across, rather than five. Attached houses most often had flat roofs and rarely roofline balustrades, though both high-pitched roofs and

balustrades could be found in New York and Boston (Rifkind 1980, 32). Gables were most often on the sides of the buildings, if detached. Dormers could also be present, usually in two-story row houses. Because most homes opened close onto the street, entry porches were also rare, though again, examples were found. Row houses would have common front stair rails in iron, as well as iron balconies or curved window bays, especially in Boston (McAlester and McAlester 1991, 154). Basements were usually a half story or full story from the street, with prominent first-floor rooms above; noises and smells from the street were controlled in this way. In the less grand homes of middle-class merchants, most often their businesses would be located on the bottom floor, necessitating that the living quarters be situated above it.

Basic building materials also differed in town and country. Most urban dwellings were built of brick, usually laid in Flemish bond, with alternating headers (the ends of bricks) and stretchers (the long side of bricks). Many fire regulations in town required the use of brick, particularly in any common walls; oftentimes, the natural red was covered over with enamels of other reds, yellows, or grays, which would act as a sealant against harsh, wet weather. As further decoration, seams between the bricks would be often highlighted with a white color. This sameness in design often resulted in criticism from visitors from abroad; said one Russian traveler in 1811: "Almost all the private residences in America are built on the same plan. They have the same façade and are laid out in the same way. Having seen one house, you may confidently say that you know them all. This is so complete true that of the millions of houses to be found in the United States they are hardly a thousand that differ from the rest" (Garrett 1990, 17–18). This repetition, with symmetrically proportioned and placed elements, was certainly in keeping with the Enlightenment principles of rational order.

Wood used in doors and framing on urban dwellings would also vary, though usually predicated by region rather than urban or country location. Wooden shutters were a common feature in urban homes, necessitated by the noise and dust coming from street level. In cities, privacy was always an issue, and with many homes built right onto sidewalks, shutters as well as Dutch-style double doors could be used to allow air to circulate into homes, while keeping prying eyes (or roaming livestock) out.

Row Houses and Town Houses

Urban blocks of houses have been referred to as both town and row houses. In a stricter definition, a town house could be attached or detached, but built closely and scaled similarly with other dwellings on the street. A row house is part of an attached block of houses, built in a consistent or even identical style with adjoining houses (McCown 2005). Row houses were a relatively new concept in the Federal period, although there were records of small attached tenement housing in Philadelphia by the 1720s (Gowans 1992, 80n25). Architects who had traveled to England saw some of the most elegant examples firsthand; Lansdown Crescent, Somerset Place, or The Circus all inspired them to return to the United States to design their own. After a visit to London in the mid-1780s, Charles Bulfinch (1763–1844) produced several designs for row houses in his native Boston. His earliest and best-known design for a block of houses was the

Tontine Crescent in 1793. The original plans called for 16 houses, 480 feet in length, with 3 stories and a basement each and arranged, as the name indicated, in a crescent shape, curving around an elliptical park named in honor of Benjamin Franklin (Handlin 2004, 43). As was the case with many of these blocks of houses, the ends were to have slightly different features, such as projecting pavilions and an arched passageway in the center. They were to be constructed of brick and painted grey to simulate the stone construction found on English examples. In the end, however, only one-half of the crescent, Franklin Place, was built. Bulfinch also designed other Boston row houses: a group of four houses on Park Street in 1805 and Colonnade Row, which consisted of 19 attached homes, in 1810. Other cities and other architects soon followed with their own versions of the London row house. Examples appeared in Philadelphia in 1800 and 1801, one designed by Benjamin Latrobe. Robert Mills designed another block of homes in Philadelphia in 1809, while John McComb produced a block of six houses in New York City (Kimball 1966, 198).

While many individual architects designed (and in the case of Bulfinch, financed) row houses, early developers also saw the form as a way to create more living space within an urban area. In fact, during the initial stages of building in Washington, D.C., row houses were the predominant form of housing. Building regulations had already been set in 1791, which stipulated brick and stone for party walls (to decrease the dangerous spread of fire), as well as limiting the height to 40 feet and requiring all structures to face the street. As early as 1793, the same year Bulfinch was envisioning the Tontine Crescent, a scheme of row houses built around residential squares was designed for the nation's new capital city. The North American Land Company, in collaboration with architect William Lovering, built a development block of 30 houses in the 1790s (Scott 2005). Row houses were not seen in any great number, however, until after the Federal period, when they began appearing frequently in New York, Baltimore, and Philadelphia.

Franklin Place, designed by Charles Bulfinch in 1793, was part of a planned block of sixteen houses to be built on Franklin Street in Boston. Courtesy of the Library of Congress.

Rural Houses

In rural locations, the essential silhouette of the Federal style home

changed. Because space was less of an issue in the country, the affluent three-story, three-bay square house was replaced with a two-story rectangular block, five bays across, sometimes with projecting side wings, an obvious holdover from the Georgian period. Like many urban homes, gables on rural examples would be located on the sides of the building, though hipped roofs and centered gables were also present. Like their urban counterparts, rural dwellings could be either high style or plain, depending on the wealth and position of its owner.

Rural affluent homes, particularly in the South, tended to be of a five-part plan: a central block, with hyphens on either side connecting to end wings. Homewood (1803) in Baltimore, Maryland, and Bremo (1819) at Bremo Bluff, Virginia, were both examples of rural Federal period homes with a five-part plan, though the Lyman House, in Waltham, Massachusetts, as originally designed by Samuel McIntire in 1793, also displayed wings connected by hyphens (Kimball 1966, 189). However, many rural homes of the period were merely enlarged, the owners finding it more economical to rebuild rather than start from scratch. Monticello itself was famously redesigned several times between 1770–1809.

REGIONAL DIFFERENCES

Affluent and Middle-Class Houses

Many high-style homes in the New England area had side gabled roofs, the most common form for Federal style houses throughout the country. However, they were not as highly pitched as examples in other parts of the country, because the need for heat often took precedence over style. The hipped roof of a very low pitch, often with a surrounding balustrade, could be found on the most elaborate homes in New England, on both two- and three-story examples. Town homes and row houses in the North were often three stories, while their more rural counterparts were usually only two. Federal style roofs on mid-Atlantic affluent homes were also usually of the common side-gabled variety and topped mainly two-story dwellings. However, in Georgetown and Alexandria, with their prosperous merchants and high maritime traffic,

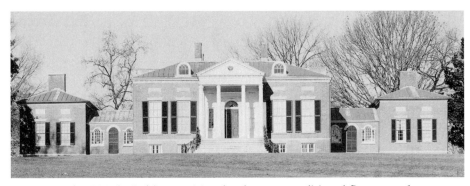

Homewood (1803) in Baltimore, Maryland, was a traditional five-part plan: a central block, with hyphens connecting end wings on either side. Courtesy of the Library of Congress.

three-story town and row houses were particularly present. In the South, affluent and middle-class dwellings displayed higher pitched roofs, which meant more circulation of air, making them ideal for the hot summer months; consequently, these were used more often than the lower-pitched examples fashionable in the North.

In New England, chimneys on affluent and middle-class homes were usually centrally placed for better circulation of heat, though sometimes the complicated room arrangements common in many Federal period homes would often determine the placement of a chimney. As many Federal homes now had central hall-with-stair combinations, center chimneys were not an option and were often relegated to the gable end, either singly or in pairs. In southern Federal style homes, chimneys were mostly seen on the ends of houses and, in the deep South, placed on the outside to keep the heat from remaining inside.

Brick-constructed affluent and middle-class houses were seen in all parts of the United States, more so in urban areas than in rural locations. Generally, however, building with brick was more popular in southern locales than elsewhere, as it kept houses cooler in the summer and warmer in the winter. Jefferson himself was concerned about the use of wood for homes and tried to influence the use of more brick, saying: "In a house, the walls of which are of well-burnt brick and good mortar, I have seen the rain penetrate through but twice in a dozen or fifteen years. . . . These houses have the advantage, too, of being warmer in winter and cooler in summer than those of wood; of being cheaper in their first construction, where lime is convenient, and infinitely more durable. . . . A country whose buildings are of wood, can never increase in its improvements to any considerable degree" (Jefferson 1781–1782, 280).

Wood and iron detailing on affluent and middle-class houses was also seen in all locations of the country, though iron was used more often in urban areas. Wrought iron balconies in New Orleans and gates in Charleston were largely derived from European precedents, particularly French and Spanish influences in New Orleans. However, Boston, New York, Philadelphia, and Georgetown all had multiple examples of ironwork, each with their own specialties. Philadelphia town homes boasted delicate wrought iron railings, while Boston Federal style homes usually displayed decorative iron fences. European craftsmen brought their own styles to America and mixed them with both Georgian and Federal style themes. Repeating motifs on fences and railings displayed such Greek and Roman influences as anthemions, lyres, acanthus leaves, or spears and shields, while newer motifs, such as Chinese fretwork, were also used. Wood detailing would usually incorporate many of the same themes that were seen in ironwork, but simple pickets and posts were also used for fencing, either at ground level or as a balustrade on the roofline or surrounding a piazza or veranda. Typically, wooden fencing was more common than iron in both the North and the South during the Federal period (Calloway 1996, 231).

Vernacular Houses

Many homes of the middling and lower classes only had smaller touches of Federal style, if any. Most houses of this type continued to be built as they had been in the early eighteenth century.

New England

Ordinary homes in the New England region, predominantly constructed of wood, evolved along with high-style dwellings, albeit in a less adorned or dramatic fashion. From the Colonial period, the wood frame, one-room dwelling and the saltbox example gradually grew in size and comfort to what is referred to as a *massed plan:* two rooms deep with a centrally located chimney (McAlester and McAlester 1991, 78). In the case where a single-room house evolved to a two-room width, the façade was usually symmetrical: centered door with ranked windows, either three or five across. Further symmetry was displayed when the center-hall plan with paired end chimneys evolved from the earlier center chimney examples. If the dwelling were a traditional one-room structure, with only one window and door on the front and an end chimney, an addition to the chimney end would result in an asymmetrical façade with perhaps four ranks across.

Aside from the Federal style seen in a symmetrical façade, vernacular houses in New England had little other detailing that was found in affluent rural homes or in urban areas. Any exterior detailing was usually situated around the doorway, as was prominent in more high-style Federal structures. More often, however, the door surrounds were more of a Georgian than Federal style, with a straight cornice and perhaps a small transom above. A more elaborate vernacular example might display an entryway with simple pilasters, or a portico with plain wooden columns for support. Sash windows would also be an up-to-date detail added to the vernacular house, if they could be afforded.

As McAlester and McAlester point out, the move from the single room to saltbox to massed plan took place mainly in the coastal areas of New England, the first inhabited locations (1991, 78). As settlers traveled further west, through New York into the upper Midwest, massed plan houses were built new, rather than evolving from smaller examples.

Mid-Atlantic

The log building technique of northern Europe traveled with the Dutch, German, and Scandinavian settlers who first congregated in the middle colonies. Though there were other materials used, hewn-timber logs were the easiest and cheapest materials for home building. Most log dwellings began and evolved along the same lines as the frame houses of New England; that is, a single-room structure with an end chimney or two-roomed central chimney house. And like their New England counterparts, additions were made as time and finances permitted. Unlike New England, however, the mid-Atlantic log house rarely evolved into a two-story massed plan. Because most were originally built with extra space under the eaves, it was more common to have a half-story addition. As for additional rooms, differences in construction did not allow for an easy expansion. As log dwellings depended on all four corner joints to brace each other, the removal of one wall to open up other space was difficult. As such, many additions were made by building another log dwelling against the original, complete with a second exterior door. Some were constructed around an end chimney, while others created symmetrically spaced doors and paired chimneys by building an addition at the opposite end. Another solution was to build a wood frame

addition to the main log structure. Decorative touches for middling log dwellings were few, little beyond windows, perhaps, or the addition of a columned porch. Some structures, however, were covered in shingles or weatherboard and whitewashed, which would give it a more finished and up-to-date appearance. Like New England settlers, westward expansion from the Mid-Atlantic took the middling log dwelling across to the Appalachian Mountains and beyond. Field and quarried stone construction appeared in Federal period vernacular houses mainly in the Pennsylvania, Delaware, and Hudson River Valley areas (Rifkind 1980, 245), while wood frame houses could be found throughout the Mid-Atlantic. Like the New England evolution of vernacular dwellings, these too went from one room to a massed plan throughout the Federal period.

The South

While brick was used in construction of homes throughout the United States, southern brick dwellings tended to outnumber those examples in other areas. Red clay was found in many southern locations, allowing for brick to be made on site rather than imported, a considerable expense. However, the labor that was needed to make enough brick for a house was also considerable; therefore, most southern vernacular homes were of wood frame construction, leaving the brick for the affluent homeowners. The basic Federal style dwelling evolved from the typical one-room structure, much like New England examples, but with one important difference—the absence of a central chimney. Because of the climate, end chimneys were overwhelmingly used, as the heat would be relegated to the outside of the building. Therefore, when the one-room, end chimney house was inevitably enlarged, it was usually expanded to the two-room, central hall, and paired chimney style. One-story homes tended to be more common than two stories. Instead of building up, the southern vernacular house would enlarge to the side or rear, ultimately forming what became familiarly known as the Shotgun style. Another typical characteristic of Federal style vernacular homes in the South was the introduction of the full-width front porch (McAlester and McAlester 1991, 82). West African and Caribbean influences were brought to play in the appearance of long, low-hanging roofs and wide porches. In both vernacular and high-style examples, the South took advantage of what breezes they could find; if it was financially possible, a second porch was added to the rear of the dwelling. As for Federal style exterior decorations, little was seen beyond any columnar embellishments, though the center hall and paired chimney plan allowed for Federal style symmetry to occur.

Ohio River Territories and Beyond

As the young country rapidly expanded, there was a constant need for westward movement. By 1800, 1 million people lived between the Appalachian Mountains and the Mississippi River (Gelernter 1999, 124). Western expansion was prevalent in the early years of the nineteenth century. But even before then, in 1787, lands to the west were laid out on a grid system between the Ohio and Mississippi Rivers. Money was needed after the Revolution, and the Congressional Land Ordinance was seen as a way to ease the economic

strain. Jefferson advised Congress to survey and subdivide the land north and west of the Ohio River. Six-mile grids were marked out, which were in turn divided into 36 one-mile squares. This grid system kept large tracts of land together and "furthered the American propensity for a dispersed pattern of settlement" (Handlin 2004, 50). This grid system would, of course, become the standard layout for cites. Then, in 1803, the lands Napoleon had taken from the Spanish just three years before were up for sale. The subsequent deal with the United States added 828,000 square miles of new territory to the young country—from the Mississippi to the Rocky Mountains.

Western settlers did not really develop a unique style of architecture during this period, as might be expected. Coming from the East, they followed traditional styles dominant there. The log cabin, which was cheap and quick to construct, requiring little skill other than chopping wood, became the standard house of the western frontier. Settlers from German, Swedish, or Dutch descent built log cabins, which would serve as temporary shelter. Sometimes, however, they became more permanent and were added on to over time, while many settlers would continue to move further west and had little time to build something more permanent. On the farther plains where timber was scarce, settlers made do with sod houses, saving any timber for constructing roofs for a watertight barrier.

For settlers located closer to waterways, materials were easier to come by, and even the poorest dwellings could have a wood frame or log dwelling. Typical of this was the town of Franklin, Missouri, located on the Missouri River on the western edge of civilization, and a staging area for wagon trains traveling on the Santa Fe Trail. Laid out in 1816, there were 124 houses by 1819; of that, 120 were built of logs, two of wood frame, and two of brick (Bushman 1992, 388).

As for any architectural style during the Federal period, western settlers had to rely on their own memories of the homes they left behind, as well as any pattern books that were carried west. Asher Benjamin's pattern books were reprinted well into the nineteenth century and continued to promote the Federal style long after it had begun to fade in the East. Wood frame vernacular houses, particularly of the I-form, would add little touches of Federal style in a columned portico or symmetrical façade. However, any evolution of the sort seen back East had no time to take place; the post-Federal period brought rapid changes in technology, and mechanization ended much of any regional vernacular style.

THOMAS JEFFERSON'S VIEWS OF ARCHITECTURE IN VIRGINIA

The following excerpt, taken from an [essay] written by Thomas Jefferson, discusses his views of architecture in Virginia, both public buildings and private houses. He makes a solid case for buildings and houses constructed of brick, instead of wood, referring to a prejudice against brick at the time, which was considered unwholesome.

> The private buildings are very rarely constructed of stone or brick; much the greatest proportion being of scantling and boards, plastered with lime. It is impossible

to devise things more ugly, uncomfortable, and happily more perishable....The only public buildings worthy mention are the Capitol, the Palace, the College, and the Hospital for Lunatics, all of them in Williamsburg, heretofore the seat of our government. The Capitol is a light and airy structure, with a portico in front of two orders, the lower of which, being Doric, is tolerably just in its proportions and ornaments, save only that the intercolonnations are too large. The upper is Ionic, much too small for that on which it is mounted, its ornaments not proper to the order, nor proportioned within themselves. It is crowned with a pediment, which is too high for its span. Yet, on the whole, it is the most pleasing piece of architecture we have. The Palace is not handsome without: but it is spacious and commodious within, is prettily situated, and, with the grounds annexed to it, is capable of being made an elegant seat. The College and Hospital are rude, misshapen piles, which, but that they have roofs, would be taken for brick-kilns. There are no other public buildings but churches and courthouses, in which no attempts are made at elegance. Indeed it would not be easy to execute such an attempt, as a workman could scarcely be found here capable of drawing an order. The genius of architecture seems to have shed its maledictions over this land. Buildings are often erected, by individuals, of considerable expense. To give these symmetry and taste would not increase their cost. It would only change the arrangement of the materials, the form and combination of the members. This would often cost less than the burthen of barbarous ornaments with which these buildings are sometimes charged. But the first principles of the art are unknown, and there exists scarcely a model among us sufficiently chaste to give an idea of them. Architecture being one of the fine arts, and as such within the department of a professor of the college, according to the new arrangement, perhaps a spark may fall on some young subjects of natural taste, kindle up their genius, and produce a reformation in this elegant and useful art. But all we shall do in this way will produce no permanent improvement to our country, while the unhappy prejudice prevails that houses of brick or stone are less wholesome than those of wood. A dew is often observed on the walls of the former in rainy weather, and the most obvious solution is, that the rain has penetrated through these walls. The following facts however are sufficient to prove the error of this solution. 1. This dew on the walls appears when there is no rain, if the state of the atmosphere be moist. 2. It appears on the partition as well as the exterior walls. 3. So also on pavements of brick or stone. 4. It is more copious in proportion as the walls are thicker; the reverse of which ought to be the case, if this hypothesis were just. If cold water be poured into a vessel of stone, or glass, a dew forms instantly on the outside: but if it be poured into a vessel of wood, there is no such appearance. It is not supposed, in the first case, that the water has exuded through the glass, but that it is precipitated from the circumambient air; as the humid particles of vapor, passing from the boiler of an alembic through its refrigerant, are precipitated from the air, in which they were suspended, on the internal surface of the refrigerant. Walls of brick or stone act as the refrigerant in this instance. They are sufficiently cold to condense and precipitate the moisture suspended in the air of the room, when it is heavily charged therewith. But walls of wood are not so. The question then is, whether air in which this moisture is left floating, or that which is deprived of it, be most wholesome? In both cases the remedy is easy. A little fire kindled in the room, whenever the air is damp, prevents the precipitation on the walls: and this practice, found healthy in the warmest as well as coldest seasons, is as necessary in a wooden as

in a stone or a brick house. I do not mean to say, that the rain never penetrates through walls of brick. On the contrary I have seen instances of it. But with us it is only through the northern and eastern walls of the house, after a northeasterly storm, these being the only ones which continue long enough to force through the walls. This however happens too rarely to give a just character of unwhole-someness to such houses. In a house, the walls of which are of well-burnt brick and good mortar, I have seen the rain penetrate through but twice in a dozen or fifteen years. The inhabitants of Europe, who dwell chiefly in houses of stone or brick, are surely as healthy as those of Virginia. These houses have the advantage too of being warmer in winter and cooler in summer than those of wood, of being cheaper in their first construction, where lime is convenient, and infinitely more durable. The latter consideration renders it of great importance to eradicate this prejudice from the minds of our countrymen. A country whose buildings are of wood, can never increase in its improvements to any considerable degree. Their duration is highly estimated at 50 years. Every half century then our country be-comes a tabula rasa, whereon we have to set out anew, as in the first moment of seating it. Whereas when buildings are of durable materials, every new edifice is an actual and permanent acquisition to the state, adding to its value as well as to its ornament.

Notes on the State of Virginia (1781–1782),
"Query 15, Colleges, Buildings, and Roads"

Reference List

Baker, John Milnes. 1994. *American House Styles: A Concise Guide.* New York: W. W. Norton.

Bushman, Richard L. 1992. *The Refinement of America: Persons, Houses, Cities.* New York: Alfred A. Knopf.

Calloway, Stephen, ed. 1996. *The Elements of Style: A Practical Encyclopedia of Interior Architectural Details from 1485 to the Present.* New York: Simon & Schuster.

Garrett, Elisabeth Donaghy. 1990. *At Home: The American Family, 1750–1870.* New York: Harry N. Abrams, Inc.

Gelernter, Mark. 1999. *A History of American Architecture: Buildings in Their Cultural and Technological Context.* Hanover, N.H.: University Press of New England.

Gowans, Alan. 1992. *Styles and Types of North American Architecture: Social Function and Cultural Expression.* New York: Harper Collins.

Handlin, David P. 2004. *American Architecture.* London: Thames & Hudson.

Ierley, Merritt. 1999. *Open House: A Guided Tour of the American Home, 1637–Present.* New York: Henry Holt & Co.

Jefferson, Thomas. 1781–1782. *Notes on the State of Virginia.* Accessed from The University of Virginia Library Electronic Text Center. Available at: http://etext.virginia.edu/etcbin/toccer-new2?id=JefVirg.sgm&images=images/modeng&data=/texts/english/modeng/parsed&tag=public&part=15&division=div1.

Jefferson, Thomas. "This Beautiful Art." Letters. Accessed from The University of Virginia Library Electronic Text Center. Available at: http://etext.virginia.edu/etcbin/toccer-new2?id=JefLett.sgm&images=images/modeng&data=/texts/english/modeng/parsed&tag=public&part=36&division=div1.

Kimball, Fiske. 1966. *Domestic Architecture of the American Colonies and of the Early Republic.* New York: Dover Publications. First published 1922 by Charles Scribner's Sons.

Krill, Rosemary. 2001. *Early American Decorative Arts.* Walnut Creek, Calif.: Alta Mira Press, with Winterthur Museum, Garden & Library.

McAlester, Virginia, and Lee McAlester. 1991. *Field Guide to American Houses.* New York: Knopf.

McCown, James. 2005. "Row House, Town House, Brownstone." *Boston Globe,* October 9, 2005. Available at: http://www.boston.com/realestate/articles/2005/10/09/row_house_town_house_brownstone/.

Munsey, Cecil. 2005. "The Wistars." *Bottles and Extras* (Fall): 2–7. Available at: http://www.fohbc.com/PDF_Files/TheWistars.pdf.

Pierson, William H., Jr. 1970. *American Buildings and their Architects: The Colonial and Neoclassical Styles.* New York: Oxford University Press.

Poppeliers, John C., S. Allen Chambers, Jr., and Nancy B. Schwartz. 1983. *What Style Is It? A Guide to American Architecture.* Washington, D.C.: The Preservation Press.

Rifkind, Carole. 1980. *A Field Guide to American Architecture.* New York: Plume.

Roth, Leland M. 1979. *A Concise History of American Architecture.* New York: Harper & Row.

Scott, Pamela. 2005. "Residential Architecture of Washington, D.C., and its Suburbs." Center for Architecture, Design, and Engineering. Library of Congress. Available at: http://www.loc.gov/rr/print/adecenter/essays/Scott.html.

Tavernor, Robert. 2000. "Palladio's Four Books on Architecture." *Architecture Week.* Available at: http://www.architectureweek.com/200/0719/culture_1–1.html.

U.S. Census Bureau. 1998. "Population of the 100 Largest Cities and Other Urban Places in the United States: 1790 to 1990." Available at: http://www.census.gov/population/www/documentation/twps0027.html.

Whiffen, Marcus. 1993. *American Architecture since 1780: A Guide to the Styles.* Cambridge, Mass.: MIT Press.

Building Materials and Manufacturing

During the Revolutionary War, new building practically ceased; it was not until the 1780s, after the Peace of Paris, that construction began again on a scale similar to before (Roth 1979, 53). However, building techniques and materials did not radically change as the Colonial period gave way to post-Revolutionary America. Many people continued to build their dwellings in much the same way as their fathers and grandfathers had done. There were a few innovations during the Federal period that made work easier, though not radically so. Many new innovations were absorbed into old techniques with little fanfare. The Federal period was an in-between time in many respects—still using old methods from the previous century, but beginning to see a glimmer of innovation on the horizon. The manufacturing techniques of cast iron and glass are two such examples, as is the balloon frame. Both cast iron and plate glass production did not reach a useful stage until after the Federal period, in the 1840s and 1850s, and the balloon frame was not put into use until well into the 1830s. Nevertheless, more iron embellishment and larger panes of window glass were becoming common during the late eighteenth and early nineteenth centuries, and structures were being designed and built at the same time that were far more sophisticated in comparison to what had come before.

This chapter examines building materials and manufacturing during the years 1780–1820. Innovations in construction are discussed, as well as the basic components used in building with the most common materials, wood and brick, and how these innovations impacted building. Innovations in design, such as improvements in iron and plaster manufacture, and how this affected embellishment of the home are also discussed. And finally, innovation in services, which contained perhaps the largest and most important changes

during this period, are examined, with special attention to the inventions that changed some basic modes of living for late eighteenth-century Americans.

INNOVATION IN CONSTRUCTION

Construction materials for homes built during the Federal period vary from location to location. And even though personal finances, as well as cultural background, would also play a part in whether a dwelling was built of wood, brick, sod, or stone, for all but the most affluent, the availability of local materials and location were usually the determining factors.

To guard against the harsh New England winters, most Federal period homes in that area used wood for both the framing and exterior covering; it was cheap, plentiful, and effective. Brick or stone might have been added for any foundation work or for the chimneys. In the Pennsylvania and Hudson River Valley areas, stone was more readily available and the settlers, many from German descent, used traditional techniques to construct stone dwellings with timber-framed roofs. In the Chesapeake and southern regions, where clay was present, both brick homes with wood roofs, as well as all wood structures were built during this time.

The choice of construction materials also limited the size of Federal period dwellings. For wood-frame buildings, the length of available timbers would necessarily impact the size of the rooms and width of the house. Also, because natural light was still the main source of illumination, most homes could not be built more than two rooms deep, though three rooms were seen in more affluent examples. Heating was also a consideration, because larger rooms were more difficult to keep warm. For brick- or stone-constructed dwellings, weight restrictions had to be taken into account. Thicker walls were needed to carry heavier loads, but thicker walls also cut into valuable room space and made openings for windows more difficult. Also, the height of dwellings was usually restricted to the number of floors the owner could comfortably walk, though this was really only an issue in urban areas (Gelernter 1999, 153).

Wood-Frame Houses

Most wood-frame dwellings during the Federal period were constructed in the post-and-beam fashion, much as they had been for centuries before. Heavy timber posts were the vertical supports and were either squared off or left round (as in more vernacular examples), and they supported the outside frame along with smaller intervening posts spaced widely apart. The posts were connected to horizontal beams by mortise-and-tenon joints. One of the oldest wood joins, a square or rectangular tongue (the tenon) is cut to match a square or rectangular hole (the mortise). Wooden pegs could be used to secure the join. Crossbeams were used to support any upper floors. The process was slow and complex; it required skilled joiners, heavy hewn-timber frames, and complicated joints. The balloon frame simplified the process considerably, but it was not used until the 1830s at the earliest. Machine-cut nails and machine-sawn lumber also began to make an impact on building techniques, but during the Federal Period, the majority of wooden houses, particularly rural, were built using older methods.

Roman numerals were scratched into beams to act as guides for construction. Twelfth Street Meeting House (1812), Philadelphia. Courtesy of the Library of Congress.

Two types of construction used in post-and-beam dwellings were scribe carpentry and square rule carpentry. Scribe carpentry, common into the early nineteenth-century, meant that every post and beam were cut to fit only certain other members, and each had to be numbered (or scribed) so as to be assembled properly. (In the attics of period homes today, one can find beams with Roman numerals scratched into the surface, which would act as a key to matching it with its complementary post.) In square rule carpentry, which came about in New England in the eighteenth century, beams and posts were interchangeable, making assemblage easier. A modification of post-and-beam construction was a braced frame system, which emerged as materials such as nails became easier to obtain. Instead of allowing the intervening posts between the corner timbers to carry the weight, diagonal corner braces and vertical studs closely spaced helped distribute the load (McAlester and McAlester 1991, 36).

Depending on the location of the structure, brick or stone were used in certain places of a wood-frame dwelling, such as in the foundation layer, or, after 1800, as *nogging,* which was brick, stone, or other masonry rubble used as in-fill for wood frames. Because most wood-frame houses had clapboard nailed directly onto the frame, the interior would be hollow. Nogging would provide some sort of wind barrier to the interior and soundproofing (The Corporation for Jefferson's Poplar Forest 2007). The practice continued, especially in more rural areas, throughout the nineteenth century.

Two innovations during this period—circular saws and nail production—made construction of wood frame houses somewhat simpler, though it should be remembered that, for most people, these did little to change the way they constructed their dwellings.

Circular Saws

Improvements in sawing techniques helped to speed up some home building to a certain degree. Traditionally, the felling axe and the broad axe were the most important tools in preparing timber for construction. The felling axe,

which weighed around six to seven pounds and was about four feet in length, was used in the initial cutting of a large tree. The tree trunk was notched and then undercut on both sides, which could allow for greater accuracy in its fall. If the timber was to be finished, a broad axe was used. This axe could weigh up to 12 pounds, with a 12-inch curved and beveled blade. The broad axe was used to square off the round timbers on all four sides and smooth out any surfaces for construction (Pennie 2007). Any smaller members would need to be cut from the larger timbers using a pitsaw, which was worked by two men using a long, heavy double-handled saw, one standing at ground level, the other down below in a pit or trench. It was a long and laborious process, but it was the only really effective way at the time to cut large amounts of timber for construction. A day's work could produce about 100–200 board feet.

Waterpower greatly helped the sawing process, and mills were established early on in colonial America. Situated near a running stream or falls, a mill could use the water to power a wheel attached to a single saw. Logs were hewn on one side and loaded into a frame, which was then pushed toward the vertical water-powered saw. The saw cut almost to the end of the log, which was then pulled back and pushed forward again for the next cut. When the entire log was cut, the solid end was split from the cut planks. Small portable mills could be taken to the site at first, but larger and more permanent sawmills were established, with the timber being transported from the forests to the mills most effectively by floating the logs downstream. The introduction of the steam engine into the sawmilling process did not occur until after the Federal period, in the 1830s, and even then, waterpower was most often used until the late nineteenth century (Brodbeck 2003).

The invention of the circular saw was a great improvement in the sawing technique; the round metal disk with teeth on the edge cut the timber by spinning and could speed up the entire process. The exact inventor of this type of saw, though, is still debatable. There is mention of a type of circular saw being used in England in 1777, while other sources credit the Dutch with the invention in the sixteenth or seventeenth century. In any case, circular saws were being used in English mills by the early nineteenth century. The first arrival in America is also questionable. Sister Tabitha Babbitt (1784–1854), a member of the Harvard Shaker Community, is often credited with creating the first circular saw used in a sawmill in 1813. The legend is that while watching men working with pitsaws, she devised a simpler way to cut down on the lost motion of hand sawing. She fashioned a blade from tin, attached it to a wooden disk, and affixed the whole on her spinning wheel spindle. (She is also credited with inventing an improved version of cut nails, a new method of making false teeth, and an improved spinning wheel head; Bellis 2007).

Nails

The use of iron nails also greatly helped in the construction of wood-framed dwellings. Some form of iron spike has been used throughout history for fastening or joining objects, usually wood. The earliest nails used in construction were hand-wrought, made one-by-one, usually by a blacksmith, or *nailor.* A square iron rod, about five feet in length, was heated in a forge and hammered on all four sides to create a pointed end. The rod was then notched at the desired length and snapped off. This other end was either hand-hammered flat, or placed in a

nail header, which would hold the nail in place while the smith hammered the end to create the nail head. The most common nail head shape was a rosehead; but there were also butterfly heads, which were broad and flat in shape; and L-heads, which were more narrow and used primarily for flooring and finishing work (Visser 1996). Today these nails are often referred to as square nails because the nail shaft retained the shape of the original square rod. In house building, certainly up until 1800, nails were mainly used to hold sheathing and roof boards to the wooden frame, while wooden pegs or cut joints were used for larger joins. Before the nineteenth century, however, nails were quite scarce, and dilapidated buildings would often be burned down to collect the nails that had been used; any bent ones were easily straightened by a blacksmith.

Because they were made by hand, nails varied in size until the split wood shingle came into general use in vernacular architecture. Then the one-inch nail became more common. The term *penny* was used to refer to the size of a nail, a term that was already being used in early seventeenth-century England. This designation, based on the English monetary system of shillings and pence, referred to the cost of 100 nails in pence. Therefore, a 6-penny nail would be a very small finishing nail, while a 20-penny nail would be much larger and reserved for heavier jobs such as house framing (Allen 2002–2007).

Though England was the world's largest producer of nails, importing them was quite expensive, and many colonists made their own. From around 1790 until 1830, another type of nail, a cut nail, was manufactured (referred to as "type A" nails by architectural historians). Nail cutting machines appeared by the mid-eighteenth century and were able to greatly speed up nail production, but these machines were not seen in any great number. The cutting machine was used like a guillotine; the blade was brought down by hand on a long iron bar, shearing off the rod to the desired length. The bar had to be turned by hand several times to create the point, however, and nail heads were still hammered by hand (Visser 1996).

Thomas Jefferson established a nailery on his farm at Monticello in 1794, hoping to supplement his income. Iron nailrods were shipped down to Virginia from Philadelphia and used by male slaves, usually ages 10–16, to produce the nails. Initially, Jefferson's nailery made only hand-wrought nails, numbering around 8,000–10,000 per day and ranging in size from 6-penny nails to 20-penny nails. In 1796, however, Jefferson obtained a nail-cutting machine, which sped up the process. With this machine, his nailery could produce 4-penny nails, amounting to 63 pounds per day. Jefferson used his nails for his own construction projects, and he sold them in nearby counties in Virginia (James Madison bought them for use at his home, Montpelier), but ultimately, he was unable to compete with cheaper nails being imported by larger nailerys elsewhere (Thomas Jefferson Foundation 2003c).

During the 1820s, after the Federal period, a new nail cutting machine was developed that automatically flipped the iron bar each time a cut was made. These "type B" nails were used throughout most of the nineteenth century.

Exterior Materials Used in Wood-Frame Dwellings

The wood-frame vernacular house was clearly derived from the English cottage prototype—timber frame with wooden weatherboard covering it. The English traditionally used plaster as the outer covering, because wood was

rather scarce; this resulted in the familiar half-timbered house constructed with the wattle-and-daub method. In America, however, plentiful wood meant that weatherboards were used more often. They also replaced the traditional use of thatch for a roof covering, using wood shingles instead.

Most wood-frame homes during the Federal period were covered in clapboard, much as they had been during the Colonial period. Horizontal sheathing was either pegged or nailed to studs or beams, which were attached to the larger post members by mortise-and-tenon joints. Earlier clapboards were from five to eight inches in width, and four to six feet in length, and they were usually tapered, being split from a round log. Owing to regional variations, white pine was the most commonly used wood for external sheathing, but hemlock, spruce, and cypress were also used. Early on in the eighteenth century, the boards were usually thicker and beveled at the ends to form a joint and overlapped on the exterior of the building. Later in the eighteenth century, featheredged clapboards with a thinner edge were used; it also became fashionable to expose more of the clapboard during the overlapping process, though thicker boards persisted in use until about 1800 (Williams and Williams 1957, 34).

Brick Houses

Wood might have been the most abundant natural resource to use for building material, but it was also prone to rot, insect damage, and, of course, fire. Building with brick, then, had its advantages. Brick making was first recorded in the colonies in the early seventeenth century, in Virginia and Massachusetts in particular; the remains of brick kilns were found at Jamestown dating from the 1630s. It was a slow and laborious process, however, and much of the brick that was used for building here was brought from England, used as ballast on ships. "Paying ballast" was any weight taken on in port that the ship-owner could conceivably sell at his destination. Rocks and stones from England were also used, but bricks were far more profitable. The *Abigail,* the first ship that sailed into Salem, Massachusetts, in the early seventeenth century, brought 10,000 bricks with it as ballast (Spafford 2005). Bricks were signs of wealth because they were building materials that had to be purchased, rather than obtained for free like wood. The prosperous shipping merchants in New England might build their homes out of brick they had imported from England. Traditionally, brick homes built during the Federal period were found more in the southern states, but in any part of the young country, a brick house was usually seen as a prestigious house.

There were not many innovations in the building of brick homes, because brick had been manufactured for centuries. And, as with wood, the Federal period stood on the cusp of invention: still using old brick-making techniques, too early for the steam-powered machines of the mid-nineteenth century that would make things easier. What was new, perhaps, was that they were being built in larger numbers than before.

Brick Manufacture

Brick, of course, is one of the oldest building materials, dating back more than 5,000 years. Adobe brick is the oldest type of brick; mixed with straw

for strength, hand-shaped blocks of clay were left out in the sun to dry and then stacked to form a shelter. The main ingredient, clay, was not found everywhere, as with other building materials, and therefore, it was usually limited by local availability and usually manufactured at the construction site. Bricks were made by hand through most of the eighteenth century, and certainly through the Federal period. Although a brick-making machine was patented in 1800, the process was not really perfected until the 1830s (Masonry Institute of Washington 2007). Clay was dug by hand, usually in the fall of the year, and then left exposed to the elements during the winter. The freezing and thawing process softened the clay for later working and removed unwanted oxides; by spring, the clay was ready to be formed. It would first be screened to remove any rocks or stones and then placed in a soaking pit with water to achieve the right consistency for molding. Kneading was usually done by hand, a laborious process; steam-powered kneading machines were not in use until after the Federal period.

Brick makers were skilled laborers and moved from site to site, working with whatever help the client provided. Most brick making was done in an assembly-line fashion, with certain workers responsible for certain processes along the way. An assistant brick molder would gather the clay and hand it off to the head brick maker. The clay was rolled in sand and then pressed into a sanded mold. The sand was to keep the clay from sticking to the mold; the use of beech wood for the brick molds themselves was also supposed to prevent sticking. Excess clay was removed and given back to the assistant molder to be used again. About 3,500–5,000 bricks a day could be made this way.

Single or double molds, or even six-brick molds were used to hold the clay. Another assistant then took the filled molds to a drying area where the clay brick was removed from the mold and placed on a bed of sand. Stacked in a herringbone pattern, the clay bricks were left to dry in the sun for two weeks. During that time, the clay was straightened and given a smooth surface by wooden edgers. The bricks were then fired in a kiln at varying degrees for one week and slowly cooled in the kiln for another. The skill and experience of the brick maker was instrumental in determining when the bricks were done (Bonomo 2005). However, heat was not uniform in most kilns, and the bricks were unevenly fired. Depending on their location in the kiln, some bricks were better used for exterior construction, ones perhaps that were more evenly fired and of good color, while softer bricks might be used elsewhere. Underfired bricks were known to be more porous and were usually reserved for insulation on the inner walls. Colors also varied in fired bricks, depending on the temperature and the original clay used. *Clinkers* were bricks that were burned or warped, and these were often used for rubble or for garden paths or walls (Hudson River Brickmaking 2007). Most bricks were rectangular, but there were other molds used to form specialty bricks: semicircular molds for shaping coping bricks, which helped drain water away from walls; compass bricks, which were wedge-shaped and used to form circular patterns; and square paving bricks, for covering larger areas (Crews 2006).

Jefferson was quite outspoken about the use of brick in home construction, noting the ugliness of houses constructed of "scantling [small pieces of wood] and boards" and the superiority of brick construction in terms of longevity and ability to withstand climate changes. At Monticello, three slaves working

with a master brick molder could make about 2,000 bricks a day (The Colonial Williamsburg Foundation 2007).

Brick Construction

Bricklayers were also skilled labor and were responsible for making the mortar on site, usually a mixture of lime and sand, although other ingredients, such as animal hair, crushed shells, or brick dust, were added. Up until the mid-nineteenth century, this was the main type of mortar used in masonry construction. It was important for moisture to be allowed to evaporate through the walls, and lime mortar was permeable. Different types of pointing, or the joining of bricks by mortar, were used. Usually, a flush mortar joint was the most common, where the mortar was scraped flat against the bricks, while a raked joint would be slightly inset. A bricklayer could produce fancier joints by running his trowel along the mortar joint at an angle, either up or down (McAlester and McAlester 1991, 39). Another added embellishment was to paint the mortar joint white, as a contrast to the red of the brick. Some Federal period homes that covered brick walls with stucco would stencil over the surface to simulate brick or marble blocks.

Bricklayers almost acted as architects in many respects; it was their job to keep walls straight and corners true (except where curves were required), and they used their artistic sense when it came to brick patterns and pointing. The two bricklaying patterns most commonly used in the Federal period were English bond and Flemish bond. English bond had alternating rows of bricks that were laid end-to end and then side-to-side, while Flemish bond alternated short and long brick sides in the same row. English bonds were the strongest bond and could be used one-brick thick, although most brick walls were two-bricks thick for better support, as well as insulation. At the University of Virginia, however, Jefferson designed the brick walls surrounding the pavilion gardens in a serpentine pattern only one-brick thick, calculating that the curve allowed the wall to support itself and, therefore, would use up to 25 percent less bricks in construction (Library of Congress 2000). Most brick homes built at this time (as well as stone dwellings) had walls that were around two feet thick, with heavy horizontal beams supported inside built-in niches. Sometimes the beams were joined to the masonry walls with heavy beam irons, or bolts, and supported floors and roof joists. Some wooden braced frame dwellings would have two brick walls on the gable sides and wooden walls on the front and back (Williams and Williams 1957, 44).

Roofs

Roof construction for the average home in the Federal period continued much as it had during the Colonial period; that is, a side gabled roof with principal heavy supporting rafters, widely spaced, combined with common lighter-weight rafters, more closely spaced, which would be covered in wooden shingles. (Later balloon framing made such heavy supports quite unnecessary, of course.) This was used on both wooden and masonry constructed houses. A pitched gabled roof also created an additional space, what became known as the attic or garret, that could be used as storage or living space. This type of roof framing was the simplest because it used the least amount of supporting

members. On the hipped roof, which became very popular in this period and was to be found on more high-style Federal homes, the framing was more complex, especially on the lower-graded hipped roofs, which had a larger surface area and, therefore, more area to support. In this type of roof, principal and common rafters were joined with hip rafters and jack rafters, which were the smaller rafters that formed the additional sloping sides in a hipped roof (McAlester and McAlester 1991, 44).

Wooden shingles of oak or cedar were the usual roofing material used in the eighteenth century. Either sawn or split, most shingles measured 16–20 inches long and were usually laid in a course, or staggered, pattern to ensure full coverage of the roof (McAlester and McAlester 1991, 47). Like the clapboard sheathing on the exterior walls, shingles were overlapped to create a weather-resistant surface. For the low-hipped roofs fashionable in the Federal period, another covering might have been used. The Octagon in Washington, D.C., was originally built with a flat roof that was built up using layers of tar-soaked canvas on top of wood planks. Though the tar was quite water resistant and the roof itself slightly sloped to drain off any water, the Octagon was plagued with leaks, and a hipped roof was eventually put in its place (Ierley 1999, 64).

Windows

In Federal period construction, the use of the sash window allowed for a greater number of windows to be present in the design, more than ever before. In the seventeenth century, the casement, or side-hung window was the most common opening in most homes. Small panes of glass (usually measuring 6 × 4 inches) were joined together with lead joints and surrounded by a wood frame. The panes were usually diamond shaped, as three diamond-shaped panes could be cut from one pane of crown glass. Glass was quite expensive and had to be imported, so it was a sign of wealth to have multiple windows.

The double-hung sash with a wooden frame and muntins was being used in the early eighteenth century, and the smaller windows were quickly replaced. A certain type of polished glass was being produced in France by the mid-1700s, and this allowed for larger panes to be used (Ierley 1999, 191). (Plate glass, however, was not invented until the mid-nineteenth century, and it substantially lowered the cost of window glass.) The lighter and airier feel of the Federal period style seemed to call for just such windows, with thin muntins and larger openings. Additionally, with the new style of end chimneys, sometimes placed in pairs, heat was better controlled inside, which would allow for more windows with larger panes to be installed. Many older colonial homes from the early eighteenth century were updated in the Federal period by simply replacing the casement windows with sash windows. Double-hung windows were slid up and down in tracks, at first fixed in place by metal pins, but they were later balanced and controlled by counterweights concealed in the window casing.

In some very affluent and modern homes of the Federal period, triple-hung windows were used. Usually extending from floor to ceiling, these windows could be opened to a great height and used as doors. Often positioned in a row of two or three across, they would open out onto a veranda, porch, or even immediately onto the lawn outside the house. Practically, they were useful in gathering the breezes into the house, while stylistically, they helped create

the illusion of nature coming right into the house. James Madison's home, Montpelier, had a pair of triple-hung windows in the drawing room that were used as a means of reaching the back lawn.

INNOVATION IN DESIGN

The English influences in the Federal style's delicate motifs and the Roman Revival's classically derived forms were rendered in many different materials during this time. New or improved techniques were available for artists, builders, and craftsmen to use in the Federal period, and the highly decorative themes of the period's style were the result.

Improvements in Ironwork

During the seventeenth century in the colonies, a few ironworks were started, but none proved long lasting; costly materials and lack of skilled labor made many of the ventures unprofitable. Local blacksmiths produced most of the ironwork at the time, mainly utilitarian objects such as tools, cooking utensils, or hardware. Any decorative work that was done was more costly, and therefore, only the wealthiest colonist could afford iron railings or fences.

The main type of iron produced in the Federal period was wrought iron, which used low-carbon iron that was highly malleable and could be hammered hot on an anvil or cold on a bench. Wrought iron could be twisted, pulled, and stretched without breaking; it was also less susceptible to rust, making it ideal for exterior decorative embellishments. Blacksmithery was the most common technique used when working wrought iron. The artisan worked with hot metal on an anvil, free-shaping it with hammers and chisels, or with specialty tools, such as a swage, which was a die used for shaping; a fuller, which would make indentations in the metal; or a punch, for forming holes. The iron could then be joined together by a hammered weld method, where the iron was heated and hammered to seal it to other pieces (Southworth and Southworth 1992, 19).

Wrought ironwork embellishments became prominent in the Federal period, especially in the southern cities of Charleston, Savannah, and New Orleans, but it was also seen in Boston, Philadelphia, and New York City. European craftsmen who settled in America brought their ironworking techniques with them and trained local artisans. In the South, planters would hire them to teach their slaves ironworking skills. Slaves were most likely responsible for much of the southern Federal period ironwork.

As with architectural pattern books and builder's guides, ironwork pattern books were also published during the Federal period, initially in France, then England, and later, America. J. Jores' *A New Book of Iron Work* (1756), William and John Welldon's *The Smith's Right Hand* (1765), J. Bottomley's *A Book of Designs* (1793), and I. and J. Taylor's *Ornamental Iron Work* (1795), all were influential in inspiring Federal period ironworkers with their creations (Southworth and Southworth 1992, 30). European neoclassical influences were easy to render in wrought iron, and ironworkers were able to create delicate forms that mimicked the plaster, paint, or wood that was found in Federal style homes. One pattern book published just after the Federal period, *The Smith and Founders Director,* by Lewis Nockalls Cottingham, was very influential in early ornamental ironwork, and many examples from the book were used in Boston.

Most decorative ironwork made in the Federal period was wrought iron, because the process of making cast iron was really not perfected until the 1840s. Cast iron was worked in a liquid state; high carbon iron was melted and poured into molds for shaping, because it was too brittle for manipulation like wrought iron. There was a cast iron industry in England during the last half of the eighteenth century, and most cast iron pieces were imported at great cost from there. In America, cast iron only supplanted wrought iron in use in the 1850s. Cast iron was seen, however, as very small, applied decorations on wrought iron forms, such as bosses, rosettes, spears, or medallions on iron fences or railings.

Improvements in Plasterwork

Plaster was long used as a decorative embellishment. Lime and sand were mixed by the Romans to form a base for marble dust and pigments, and plaster was also modeled and polished to a marble-like shine. During the Renaissance, artists favored plaster, because it could produce elaborately detailed decoration without the heaviness of stone. Plaster of Paris was used for repeated decorative schemes during the eighteenth century. Plaster decorations for Federal period interiors were made from lime-enriched plaster of Paris, lime putty stucco, or even papier mâché. They could be molded on site with a template or stamped with a die and applied directly to the desired surface (Calloway 1996, 216).

Plaster was quite useful in embellishing the Federal period interior. The combination of gypsum and lime yielded a substance that was highly malleable and could be cast, incised, stamped, colored, and stenciled, in addition to the common method of molding. The ceiling cornice, which could be one of the more elaborate elements to a Federal period interior, was first formed by attaching a plain sheet metal template of the cornice profile molding to the wall with wooden dowels and lime putty. Molded elements, such as leaves, flowers, or geometric figures, were then fixed to the cornice using plaster. Painting and gilding followed. Other decorative features in a high-style Federal interior, such as center medallions, compartments, or panels, were also formed in this fashion (Flaharty 1990).

Plasterwork for decorative embellishments on the interior and exterior of Federal period houses was initially imported from England; builders in America could buy ready-made decorations or the molds to make them in a myriad of patterns and styles. While pattern books gave general ideas of decorative motifs for mantels, cornices, or wall treatments, details were lacking, therefore much of the applied decoration was imported from abroad. Molds were purchased and used by the craftsmen to ornament their client's homes, and many similar or even identical motifs could be found on mantels throughout the young Republic during this time. Grecian Muses, cornucopia, swags, and urns were repeatedly used. Many American craftsmen working in the latter half of the eighteenth century did not yet have the skills to match carvers from abroad. European craftsmen settled in America and trained many native plasterers. Their trade was very skilled, and a good plasterer was highly sought. There was a plasterer's guild in Philadelphia by the 1790s. Though native craftsmen were not as advanced in carving as those working in England, the Embargo Act of 1807 was a catalyst in their becoming skilled (Kimball 1966, 258). Because

plaster compositions were not available for importation during that time, American carvers had to create their own. Simple forms such as rosettes and medallions were attempted at first, but they became more elaborate as artisans grew in skill. The embargo against British goods could also be seen as speeding up other American manufacturing processes, such as textile production, which allowed it to grow on its own and lessen the country's reliance on the English.

INNOVATION IN SERVICES

Most homeowners in the Federal period were using the same technology in their daily life as the previous generation of colonists. However, there were those who were curious enough, as well as affluent enough, to experiment with the innovative techniques and objects that were being quickly discovered, patented, and produced at the end of the eighteenth century. Those who were able to take advantage of new technology were the self-taught architects, gentlemen farmers, and amateur botanists of the affluent classes, men that had the leisure time to explore new ideas and methods; who were familiar with the innovations and advances being made abroad; and who were of the same mind as their fellow philosophers, mostly the early political leaders, that the potential of the young country was limitless. Many of these men were founders or at least members of learned societies in the states and corresponded with other members from abroad. They obtained the latest treatises written on experiments with light and heat, metallurgy and electricity, and philosophical texts on nature and religion.

New Advances in Heating and Cooking

Fireplaces

For many in the Federal period, fireplaces were the main source of heat and illumination—for some, the only source. This was despite the fact that fireplaces were very inefficient for heating a room, because most heat would disappear up the chimney. Directly in front of the fire, one could be warm, almost too much sometimes. But just a few feet further back, the temperature dropped dramatically. As quoted in Garrett, "with the largest fire we can make in my room, water will freeze within six feet of it" (1990, 188). Cast-iron liners were a feature of some fireplaces, and these would radiate a bit more heat, as would plastering and whitewashing the interior of the fireplace, but on the whole, it did not make much difference. One of the main reasons why fireplaces were so inefficient was their very construction. Large, square, and box-shaped, many fireplaces had double duty as cooking stoves, and a large opening was necessary. However, as a stylistic change during the Federal period, the large colonial fireplace became smaller, narrow in width and depth. There were other factors, however, that made this move more than just a matter of taste.

Count Rumford was actually one Benjamin Thompson (1753–1814), a native of Woburn, Massachusetts. A loyalist during the Revolution, Thompson fled to England in 1776, where he became Undersecretary of State to George III and, later, an imperial count of the Holy Roman Empire (Ierley 1999, 50). His subsequent experiments in the fields of heat, light, and cooking revolutionized

a very important aspect of the eighteenth century, that of bodily comfort. Rumford had always been a critic of fireplace design and "those local hindrances which forcibly prevent the smoke from following its natural tendency to go up the chimney" (Buckley 2006). By slanting the sides and the back of the fireplace walls, as well as making the throat, or flue opening, smaller, a greater amount of heat was produced, with less waste of fuel. Rumford wrote essays detailing his fireplace designs in the late 1790s, and by the early 1800s, many modern homes boasted Rumford-style fireplaces.

Wood was the main fuel for fires during the Federal period. Enormous amounts were needed to maintain constant heat, and it was estimated that a single family needed 15 to 50 cords of wood per year (Garrett 1990, 187). Though coal was first mined in the colonies in the early eighteenth century in Virginia, it was still relatively rare in the late Colonial period in America. It was quite expensive to obtain because it was shipped from England as ballast and used mainly for shell production during the Revolutionary War. It was only after the discovery of coal in western Pennsylvania in 1808 that it became a more common heating source. Most homes, however, continued to be heated with conventional fireplaces, and coal-burning grates were not seen in any number until the nineteenth century, though some of the more modern affluent homes in the Federal period had coal-burning grates installed in their wood-burning fireplaces. Coal fireplaces were smaller in width and depth and could easily fit into an older fireplace opening. Brick hobs were built out on either side of the opening, with an elevated iron grate, or basket, set in-between them. Coal fireboxes were being manufactured as a single unit in England and imported to America in the early nineteenth century, but during the War of 1812, the lack of British goods helped spur on the manufacture of American-made grates (Seale 1979, 60). By the 1830s, many urban homes were heated by large, coal-fueled furnaces.

Stoves

The well-known Franklin stove (which Franklin called the "Pennsylvania Fireplace") was invented before the Federal period, around 1742. Franklin complained about the inefficiency of open fireplaces for heating, saying that "the cold Air so nips the Backs and Heels of those that sit before the Fire, that they have no comfort, 'til either Screens or Settles are provided" (Garrett 1990, 190). Essentially a freestanding fireplace that projected into the room, it functioned much like an iron stove. Burning wood would cause hot air to be released through side vents. It was known for keeping the temperature at around 50 degrees, which was certainly an improvement over open fireplaces (Ierley 1999, 162). Unfortunately, it also lacked a chimney, which caused smoke to be released from the bottom of the stove, keeping it from ever working as efficiently as it could. Franklin declined to patent the stove and instead, published the plans so others might improve on the design. In the 1780s, David Rittenhouse enhanced the Franklin stove by adding an L-shaped chimney to vent the smoke upward (Massachusetts Institute of Technology 1999).

Another method of heating that was seen more often in the Federal period was the European-inspired iron stove. Stoves made from sheet iron had been used in northern Europe since the sixteenth century, and German and Dutch

settlers to America brought them along. More efficient heaters than fireplaces, stoves had more surface area to radiate the heat and could be small enough to dismantle during the summer months for extra space. Six-plate heating stoves (so-named because they were made of six sections of cast-iron) became popular in the late eighteenth century and were often used in combination with other heating sources, such as wood or coal fires in distant rooms and a stove in a central location (Calloway 1996, 227). The design of the six-plate stove allowed for many variations in style, and some late Federal period examples had cast-iron urns as decorative embellishments on the top.

Small portable foot stoves were also used with frequency in the Federal Period. Usually constructed of tin and wood, they contained an iron dish of hot coals that could provide extra warmth for cold extremities. As with the six-plate stoves, foot stoves were brought to America by German and Dutch settlers and were first widely seen in churches as a little amenity for the female worshippers. So ubiquitous was this use that the stoves became known as "female warming stoves," and most men thought of them as "effeminate luxuries" (Garrett 1990, 190).

Central Heating

Central heating did not become fully functional and practical until the late nineteenth century, however, it was present in a very few homes during the Federal period and was certainly a welcome innovation for those lucky enough to have it. Jefferson sketched out a plan of an early version of a central heating system in 1790, which was a central boiler with pipes leading to small heating elements (urn- and boxed-shaped) in different rooms. An early and rudimentary version of just such a central heating system was installed in the White House during James Madison's presidency in the 1810s. A brick furnace built in the basement generated heat that was fed through registers to the room immediately above it (Ierley 1999, 65). In 1820, a central heating system was installed at Wyck in Philadelphia. It also worked on the principal of gravity, where hot air from the coal-fired furnace in the cellar (which was actually more of an enclosed fireplace) rose up through masonry channels to rooms above (Ierley 1999, 166). The draw of hot air from below was stronger if a fire was burning in the fireplace.

Cooking in the Federal Period

Cooking in the Federal period continued much as it had during the previous century. Recipes were handed down from mother to daughter, and it was not until the late eighteenth century, with the publication of Amelia Simmon's *American Cookery* in 1796, that a cookbook was printed in the young nation. It was the first to feature the word "American" in the title and also the first to feature recipes using native ingredients. Wild turkey, pumpkin pie, and watermelon-rind chutney found their way into the first edition, while more European ingredients were eschewed: "Garlicks, tho' used by the French, are better adapted to the uses of medicine than cookery" (University of Delaware Library 1994). Much like pattern books, once the first cookbook was published, many others followed quickly in its wake—160 titles alone during the first half of the nineteenth century. Most cookbooks combined elements of cookery,

Count Rumford and His "Range"

Massachusetts native Benjamin Thompson (1753–1814) helped revolutionize the way one cooked meals with his invention of an ingenious stove, a clear forerunner of the modern kitchen range. While living in Europe, Count Rumford (as Thompson became known) began to experiment with different forms of heating. Rumford was mainly concerned about the loss of heat in contemporary heating devices, such as the fireplace, and, in the case of cooking heat, the noxious fumes produced from using charcoal. Rumford's idea was to have separate containers for cooking vessels set into a larger brick container, which he called an enclosed fireplace. Each opening on the top of the brick surface would hold a pot or kettle for cooking, with its own heat sourced located underneath. All the separate heat sources were fed to a centralized location in the rear of the fireplace. What was perhaps most revolutionary, at least in terms of cooking, was that each heat source had its own damper, so that the heat could be individually controlled for each burner. When Rumford's writings on his enclosed fireplace designs were published in American in 1804, many had a chance to envision a modern way of cooking, though very few had the means to make it a reality.

Some Federal period homeowners did install their own versions of the Rumford range in their dwellings. George Read II's new home, built in 1803 in New Castle, Delaware, had a modified version of the range, one that used hot air drawn from the fireplace to facilitate cooking; the Rundlet-May house (1807–1811) in Portsmouth, New Hampshire, boasted a more traditional Rumford stove, with three boilers set into a brick fireplace (Ierley 1999, 59). At Monticello, Jefferson's kitchen had an eight-opening stew stove, as well as an integrated kettle set that ensured a ready supply of hot water (Thomas Jefferson Foundation 2003a).

medicine, and helpful hints for the Federal period housewife. Another early American cookery and advice book was *The Frugal Housewife, or, Complete woman cook,* published by Susannah Carter in 1803; though it contained many recipes with British antecedents, it featured an appendix, "Containing Several New Receipts Adapted to the American Mode of Cooking," which included recipes for Indian pudding, buckwheat cakes, cranberry tarts, and maple beer, to name a few (Carter 1803).

For centuries, most cooking had been done in an open hearth. Colonial settlers brought the technique with them, and the process continued in various forms well into the nineteenth century, and in some more remote areas, even longer. A large open hearth was the centerpiece of the kitchen, and various kettles and pots would be suspended on metal hooks or swinging arms, which could be placed over the fire. This method chiefly served for heating liquids, such as water or soups. For other needs, such as baking, a mound of hot coals placed on the stone hearth would act as a burner. With an iron Dutch oven placed over the coals, and an additional layer of coals on top, baking could be done inside the oven quite easily. "Spiders," or three-legged trivets, placed on hot coals could also be used for frying foods. A tin reflector oven, which would be placed in front of the fire for baking or roasting, was also popular throughout the Colonial period. Brick ovens built into the fireplace walls were also a common feature in kitchens, though it took careful planning to determine the order in which items were baked so as to take advantage of the cooling temperatures inside the oven. The open-hearth cooking method continued throughout the Federal period in most poor and middling homes and certainly in the most rural of locations. However, there were advances during the Federal period that some homeowners, usually those with financial means, took advantage of.

As fuel supplies became scarcer (and more expensive), the massive kitchen fireplace as a main source of heating, cooking, and illumination began to be replaced by smaller fireplaces and iron cookstoves, such stoves being sometimes

placed directly into the large kitchen fireplace. The Rumford stove, or variations thereof, was installed by those that could afford it. Separate boilers with enclosed, individual heat sources made controlled cooking easier, cleaner, and cheaper, though some Federal period homeowners were reluctant to part with the older methods; one wrote that while she was "pleased with my Uncles plan of Rumfordising the mode of Cookery for the summer," she concurred "with the Cook that the sight of the Fire is far to be preferred in Winter" (Garrett 1990, 101).

New Advances in Plumbing

Bringing Water into the Federal home

Piping water into the Federal period home was for only the wealthiest and most forward-thinking homeowner. The majority of people during this time made do with carrying buckets from the well or pump to the desired location. Some made extensive use of cisterns, usually fed through gutters from the roof. This system, however, depended on rainfall and was not foolproof. A well was still the most commonly used method for getting water and was dug as close as possible to the main dwelling, or outside kitchen, for ease of transportation. Some homeowners would even build small "well houses" to enclose the well or even build an extension from the house to include the well inside. Some roof-fed cisterns used pipes to carry water into the kitchen itself. In the Octagon, in Washington, D.C., pipes were fed from the cisterns down into the basement, where the kitchen was located.

Water well and pump outlet from west wing in Cliveden House (1763–67), Philadelphia. Courtesy of the Library of Congress.

Indoor Outhouses

In spite of advances in plumbing, and some ingenious solutions, the young country still remained far behind Europe when it came to the indoor privy. For propriety's sake, outdoor privies were placed as far away as possible from the main dwelling, although one Frenchman felt compelled to complain in 1816: "[Indoor lavatories] are an unknown luxury in the United States, where there are only 'little houses' five hundred paces from the house whenever possible. That is very disagreeable in winter with the snow, and in summer" (Thomas Jefferson Foundation 2003b). When climate, time of day (or night), or physical conditions made it impossible, chamber pots and close stools were used, most often in the bedroom. Even with the increase in privacy during the Federal period, however, one's own bedroom was still not as private as one would hope, and some more affluent homeowners installed indoor privies. These indoor privies, or water closets, had been used in Europe, and a rudimentary form had been available in England since the early eighteenth century. Some more affluent homeowners in the Federal period built an attached wing or an ell to the main structure, positioning the privy there. This was something our Frenchman approved of: "In Washington, Madam Barlow placed hers at the end of the piazza; that is a great improvement. But that lady has French manners" (Thomas Jefferson Foundation 2003b).

Some water closets were constructed that would connect with bedrooms or other more private spaces in the house. Thomas Jefferson constructed three indoor privies at Monticello in 1796. Each had a shaft connected to a brick tunnel, which was 160 feet long. From inside, the tunnels ran out to the grounds. Jefferson also included shafts that would run upwards through the roof; these "air tunnels," as he called them, would draw air up and out of the privies. A very primitive form of water closet was installed in Annapolis, Maryland, around 1765, and it used water from a roof-fed cistern (Ierley 1999, 253). A water closet was present in the White House in 1804, while Gore Place in Waltham, Massachusetts, had one by 1807. A Philadelphia house designed by Benjamin Latrobe one year later also called for a water closet, as well as a bathtub with a heated cistern. The instances of documented water closets, however, were few and far between, and it wasn't until the late nineteenth century that patented toilets began to be used with any regularity. Englishman Joseph Bramah had invented a "valve closet" at the end of the eighteenth century, and most water closets that were in the United States were imported from his firm. For most Americans, however, and certainly for those in the Federal period, the outhouse was the only water closet they knew.

Public Waterworks

At the beginning of the nineteenth century, Philadelphia was the most commercial city in the young Republic. It was also quite technologically advanced for the time, because it was the site of the first public waterworks in America, the Center Square Pumphouse, designed by Benjamin Latrobe in 1801. An earlier attempt at a large water supply for a town was in Boston in 1652. Wooden pipes were constructed to carry water from a spring to a central reservoir. But, as Ierley states, because the reservoir was only 12 feet square, its uses were limited (1999, 86). In Philadelphia, an early application

of steam power allowed water to be pumped from a nearby dammed basin on the Schuylkill River to the main station and then on from there to an elevated wooden reservoir; wooden pipes then carried the water to different hydrants in the city. It had been only 50 years before when steam power was first used to pump water from a flooded copper mine in New Jersey. England had been experimenting with steam power since the early eighteenth century, and the machine ordered by the owner of the New Jersey mine came from a family of steam engine builders in Cornwall. However, steam power in the late Colonial and early Federal period remained chiefly experimental, until Latrobe's design. Though it had its share of malfunctions, and was not widely used until later in the nineteenth century, the use of steam power helped revolutionize the way the home functioned for its inhabitants.

Though the connection between disease and public water supplies had long been understood, little progress had been made by the eighteenth century to combat the spread of contamination through water. Laws had been periodically passed to fight outbreaks, such as the location of one's outhouse next to public water supplies, but epidemics still occurred. Sewers were constructed that attempted to move waste away from inhabited areas of the city, but often they just removed them to a nearby stream or river. In 1809, there were only a few sewers in Philadelphia, a city with a population of 50,000, and some of these sewers were privately owned, which meant the owners could charge for the use of them (Ierley 1999, 83). It was not until closer to the middle of the nineteenth century when cities began to have substantial underground sewer systems.

Bathing in the Federal Period

Bathing during the Federal period (and well into the nineteenth century) could take place in different rooms. For many poor and middling homes, the kitchen was most often used for bathing. A ready supply of hot water could be easily obtained in the kitchen, and the tub, usually small and portable, could be set in an available corner for use and then removed just as easily. Water was poured into the tub by buckets and usually emptied in the same manner. The tub was made in a variety of materials and sizes: a tin-lined wooden tub, "with Castors under ye bottom and a brass lock to let out the water," was purchased in 1803 by a Philadelphia family, while a copper-lined tub could be purchased for $25 in 1807 (Ierley 1999, 90). Most people during the Federal period, however, made do with a washbasin and cloth in the privacy of their bedrooms, with a full or semi-immersion bath taking place once a week, if that. As Ierley points out, soap was not part of the bathing ritual in any real way until the mid-nineteenth century, soap being reserved mainly for laundry rather than personal use (1999, 97). George Read II had a substantial, fixed tub in his home in New Castle, Delaware, which was something of a rarity. It was 7-1/2 feet in length and was connected by pipes that enabled it to be filled with hot water. Though the water had to be bailed out at the end of bathing, such a luxury was only possible for the wealthiest of Federal period homeowners. A "shower-bath" was also not unknown during this period, but it was probably more of a rarity than a fixed bathtub, and certainly not as effective. Water was usually held in a tin container and drained through colander-like holes in the bottom, but not with any sufficient force. It was not until much later in the nineteenth century that a bathroom would contain all the

elements that are found in today's bathrooms. This only came when plumbing technology and space were more widely available.

New Advances in Lighting

Candles

Candles and oil lamps had sufficed for the seventeenth- and eighteenth-century homeowner, but both had their disadvantages. Candles could be quite expensive to buy, depending on the type of fat used, and making them was arduous and time consuming. The typical candle of the period was a tallow candle, made from beef or mutton fat. Candle making usually took place in the fall during butchering. The fat would be melted and strained repeatedly, then left to sit until the pure tallow rose to the surface. Candles were then either dipped or poured into molds. Like soap, candles were made all at once, usually once or twice a year, because it was a messy and hot process. Tallow candles guttered and had to be watched carefully, taking care to keep the wick trimmed so as to not extinguish the flame. Candle wax made from bayberries was used as an alternative to tallow candles; however, they tended to melt in hot weather. Those made from beeswax or spermaceti were the most highly prized, as well as the most costly. Spermaceti was oil that came from the sperm whale; it burned brighter and was harder than tallow or beeswax and could hold its shape in hot weather.

Candles were usually stored in an enclosed box in the kitchen, close to where the household's candlesticks were usually cleaned and stored. Because the majority of candles were made from animal fat, special care had to be taken to keep them safe from hungry rodents.

Machine-made wicks became available in the early nineteenth century, and this was a great timesaver. Other experiments with wick shapes and fiber combinations led to brighter and clearer flames, with less guttering. However, some people in the Federal period were unable to even afford candles and had to make do with firelight and perhaps candlewood, which was a knot of pitch pine, or rushlights, which were rushes dipped in tallow, to light their evenings.

The glass chimney and circular hollow wick of the Argand lamp increased air flow and intensified the amount of illumination. Courtesy of the Library of Congress.

Lamps

Betty lamps, which burned animal fat or fish oil, were found in many seventeenth-

and eighteenth-century homes; however, these lamps tended to smoke, and the odor was not pleasant. After 1800, brass and glass lamps that burned whale oil were more readily available and could be found in a variety of styles. Some were freestanding, while others fixed to the walls as sconces, and many had tin reflectors that could attach to radiate a stronger light. In the most affluent homes, crystal chandeliers with gilt or bronze elements were placed in the most important rooms. The glass and gilt would reflect the light in dozens of different directions. Expensive candles lighted most chandeliers, though the more affluent homeowner, of course, could afford to burn more candles; it was a sure sign of wealth as well as hospitality to have a dining room lit with multiple spermaceti candles during an evening's entertainment.

One improvement in lighting technology (though an expensive one) was the invention of the Argand lamp in 1782, developed by Swiss inventor Aimé Argand. The lamp, which burned whale or lard oil, gave off a cleaner and brighter light. The secret to the brightness of its flame was a tubular, hollow wick (rather than a flat solid one) that allowed a current of air to pass both inner and outer surfaces of flame. A glass chimney placed above the lamp increased the draft and intensified the light, while a central fuel reservoir fed the wick by gravity (Garrett 1990, 145). Argand lamps were already being imported from Europe in the 1790s; Washington himself had imported three brass examples. They were also produced in expensive silver or in cheaper Sheffield plate, tin, or iron, and in the later Federal period, they began to appear in more households. They were beyond the reach of most ordinary people, however, and most during the Federal period relied on cheaper light.

Firsts in American Technology During the Federal Period

1755: 1st application of steam power in America was made by Josiah Hornblower at the Schuyler copper mine, Bergen County, New Jersey, to pump water out of flooded mine shafts.

1787: 1st successful steamboat run was made by John Fitch (1743–1798) on the Delaware River and patented by him in 1791. It was based on steam engine designs by Scotsman James Watt in 1769.

1790: 1st successful textile mill was Samuel Slater's mill in Pawtucket, Rhode Island, which used water-powered machinery. It was based on designs from Englishman Richard Arkwright's spinning frame from 1769. (This was also the 1st American factory to successfully produce cotton yarn using water-powered machines.)

1793: 1st patent for a cast-iron stove was made by Robert Haeterick of Pennsylvania.

1794: 1st patent for a cotton gin was made by Eli Whitney. Numerous imitations followed, and Whitney's patent was not upheld in court until 1807.

1797: 1st patent for a washing machine was made by Nathaniel Briggs of New Hampshire; it was essentially a scrub board with the patent title "Clothes Washing."

1801: 1st large-scale water-supply system was Fairmont Water Works, Philadelphia, Pennsylvania, designed by Benjamin Latrobe. Steam power pumped water from the Schuylkill River to a central reservoir and then on through wooden pipes.

1806: 1st use of coal gas for lighting was made by David Melville, Newport, Rhode Island. In 1810, "Lamp Gas" was also patented by Melville.

1809: 1st patent received by a woman was made by Mary Kies, South Killingly, Connecticut, for a method of weaving straw with silk and thread.

1809: 1st patent for a grass mower was made by Peter Gaillard of Lancaster, Pennsylvania, for a horse-drawn "Mowing Machine."

1813: 1st use of a circular saw in a saw mill was made by Tabitha Babbitt (1784–1854), who was working in the spinning house of the Harvard Shaker Community; this improved the function of two-man sawpits.

1813: 1st power loom was introduced by Francis Cabot Lowell (1775–1817), Waltham, Massachusetts, and was based on designs by Englishman Edmund Cartwright in 1785.

(continued)

1820: 1st use of an acentric or "copying" lathe was made by Thomas Blanchard (1788–1864), Middlebury, Connecticut, which allowed the standardization of irregularly shaped objects.

Reference List

Allen, David. 2002–2007. "All About Nails." Accessed from Appalachian Blacksmiths Association. Available at: http://www.appaltree.net/aba/nails.htm.

Bellis, Mary. 2007. "Inventors, The History of Hardware Tools." Accessed from About.com. Available at: http://inventors.about.com/library/inventors/bltools.htm.

Bonomo, Rick. 2005. "Brickmaking." Accessed from Ricks Bricks. Available at: http://www.shol.com/agita/thespiel.htm.

Brodbeck, Beau. 2003. "Historical Review of Sawmills in Alabama." Accessed from Alabama Agricultural Experiment Station Foundation Grant Program. Early History of Sawmills and the Lumber Industry. Available at: http://www.ag.auburn.edu/~cbailey/sawmills.htm.

Buckley, Jim. 2006. "Count Rumford." Accessed from Buckley Rumford Fireplaces. Available at: http://www.rumford.com/Rumford.html.

Calloway, Stephen, ed. 1996. *The Elements of Style: A Practical Encyclopedia of Interior Architectural Details from 1485 to the Present.* New York: Simon & Schuster.

Carter, Susannah. 1803. *The Frugal Housewife, or, Complete Woman Cook.* New York: G. & R. Waite. Accessed from The Michigan State University Libraries. Digital Collection. The Historic American Cookbook Project, 2004. Available at: http://digital.lib.msu.edu/projects/cookbooks/html/books/book_02.cfm.

The Colonial Williamsburg Foundation. 2007. "Brickmakers at Colonial Williamsburg." Accessed from Colonial Williamsburg. Experience the Life. Available at: http://www.history.org/Almanack/life/trades/tradebri.cfm.

The Corporation for Jefferson's Poplar Forest. 2007. "Second Restoration Phase (1998–2007)." Accessed from Thomas Jefferson's Poplar Forest. Available at: http://www.poplarforest.org/restorationlphasetwo.html.

Crews, Ed. 2006. "Making, Baking, and Laying Bricks." *Colonial Williamsburg Journal* (Winter). Accessed from The Colonial Williamsburg Foundation. Available at: http://www.history.org/foundation/journal/Winter05-06/bricks.cfm.

Flaharty, David. 1990. "Preserving Historic Ornamental Plaster." Accessed from The National Park Service, Preservation Briefs, no. 23. Available at: http://www.cr.nps.gov/hps/tps/briefs/brief23.htm.

Garrett, Elisabeth Donaghy. 1990. *At Home: The American Family, 1750–1870.* New York: Harry N. Abrams, Inc.

Gelernter, Mark. 1999. *A History of American Architecture: Buildings in Their Cultural and Technological Context.* Hanover, N.H.: University Press of New England.

Hudson River Brickmaking. 2007. "Brickmaking History." Accessed from Brick Collecting. Available at: http://brickcollecting.com/history.htm.

Ierley, Merritt. 1999. *Open House: A Guided Tour of the American Home, 1637–Present.* New York: Henry Holt & Co.

Kimball, Fiske. 1966. *Domestic Architecture of the American Colonies and of the Early American Republic.* New York: Dover Publications.

Library of Congress. 2000. "Thomas Jefferson: Exhibition Overview." Accessed from The Library of Congress. Available at: http://www.loc.gov/exhibits/jefferson/over view.html.

Masonry Institute of Washington. 2007. "Development of Brick." Accessed from The Northwest Masonry Guide. Available at: http://www.masonryinstitute.com/nwmg/part2/prod_a1-p1-2.html.

Massachusetts Institute of Technology. 1999. "Inventor of the Week Archive: Benjamin Franklin." Accessed from The Lemelson-MIT Program. Available at: http://web.mit.edu/invent/iow/franklin.html.

McAlester, Virginia, and Lee McAlester. 1991. *Field Guide to American Houses.* New York: Alfred A. Knopf.

Pennie, Archie M. 2007. "When the Axe was King." Accessed from The Outaouais Heritage Web Magazine. Available at: http://outaouais.quebecheritageweb.com/article_details.aspx?articleId=150.

Roth, Leland M. 1979. *A Concise History of American Architecture.* New York: Harper & Row.

Seale, William. 1979. *Recreating the Historic House Interior.* Nashville, Tenn.: American Association for State and Local History.

Southworth, Susan, and Michael Southworth. 1992. *Ornamental Ironwork: An Illustrated Guide to Its Design, History, and Use in American Architecture.* New York: McGraw-Hill, Inc.

Spafford, Bob. 2005. "The Voyage of the Hector." Accessed from Rootsweb.com, Spafford Family. Available at: http://members.aol.com/gamel2/hector.html.

Thomas Jefferson Foundation. 2003a. "Monticello's 'new' Kitchen." Accessed from Monticello, Home of Thomas Jefferson. Available at: http://www.monticello.org/pressroom/showArticle.php?id=107.

Thomas Jefferson Foundation. 2003b. "Monticello's Privies." Accessed from Monticello, Home of Thomas Jefferson. Available at: http://www.monticello.org/reports/interests/privies.html.

Thomas Jefferson Foundation. 2003c. "Nailmaking at Monticello." Accessed from Monticello, Home of Thomas Jefferson. Available at: http://www.monticello.org/plantation/work/nailmaking.html.

University of Delaware Library. 1994. "An American Feast: Food, Dining, and Entertainment in the United States." Accessed from the University of Delaware. Special Collections Department. Available at: http://www.lib.udel.edu/ud/spec/exhibits/american.html.

Visser, Thomas D. 1996. "Nails: Clues to a Building's History." Accessed from The University of Vermont. Historic Preservation Research. Available at: http://www.uvm.edu/~histpres/203/nails.html.

Williams, Henry Lionel, and Ottalie K. Williams. 1957. *Old American Houses: How to Restore, Remodel, and Reproduce Them.* New York: Bonanza Books.

Home Layout and Design

The Federal period in America brought changes to both the exterior and interior of private dwellings. While the exterior was mainly effected by changes in aesthetics both local and abroad, interior layouts began to reflect different ideas in comfort and convenience for the late eighteenth-century American. Some changes were seemingly small, such as a simple relocation of a chimney or door, but such changes created whole new patterns of living for the homeowner. In this chapter, typical home layouts of the poor, middle, and upper classes are discussed, their variations in plan according to location, and changes to the basic design. Outside influences, particularly for affluent houses, are examined, such as the use of pattern books by builders and homeowners alike, as well as the very concept of a builder, rather than an architect, which was also changing during this period. These influences also resulted in modifications to the traditional interior shapes of homes, which, in turn, allowed for new room forms (or new uses for older rooms) to emerge. And finally, shifting ideas about nature and the desire to combine more of indoor living with the outside is looked at, including the various changes made to dwellings to accommodate this desire.

ORDINARY HOMES OF THE FEDERAL PERIOD

In the early eighteenth century, aside from a few notable buildings, most people lived in a one-room wood frame or log structure that was remarkably similar throughout the colonies. Usually 18 by 20 feet, it consisted of a single room on the main floor, often with a loft area above, reached by ladder or stairs. Sometimes the single room would be divided by a partition; other times, there might be a

lean-to attached to the rear of the building to provide a little extra space. The dwelling usually went unpainted outside, with interior walls often plastered and whitewashed. Windows were small, possibly with little panes of diamond-shaped glass or, in very poor homes, just a hinged wood panel to cover the opening. Even through the Federal period and beyond, this type of vernacular structure was repeatedly constructed and lived in by the poor and middling classes. The uniformity of these dwellings, particularly in the New England region, is apparent, and it is only after 1800 that striking differences in these houses are seen. A variety of factors, from the opening of the western frontier, to the spread of pattern books, and the steadily increasing influence of industry, all contributed to end the homogeneity of these structures (Pillsbury and Kardos 1970, 23).

During the early to mid-eighteenth century, New England homes of the middle and poorer classes, particularly in rural areas, still were all some sort of variation on the one-room cottage, a holdover from the earlier Colonial period, which itself can be traced back to rural England (Pillsbury and Kardos 1970, 23). The most common type, the hall-and-parlor, had a single room with a central fireplace and chimney; one side was relegated to an all-purpose hall, where most of the cooking, eating, working, and essentially, living was done, while the other side, the parlor, was reserved as the best room, slightly more private than the hall, with possibly the homeowner's best bed and best furniture displayed. A loft or half story could be above and was usually reached by a ladder or tight staircase located in a corner or boxed into the chimney. A lean-to attached to the rear of the house, making it one-and-a-half rooms deep, would have updated the dwelling for the family, perhaps one that needed more room or had increased financial means. The familiar New England saltbox configuration, with the added lean-to, or the form that became known as the Cape Cod, with a central chimney dividing two to four rooms, all grew out of the earlier one-room cottage. When the Federal period began, these types of central-chimney dwellings still existed and continued to be built, but many were also being converted to a central-hall plan, which moved the chimney to the end wall, with a hall or stair hall in its place, giving a more decisive divide to the house. Some of the larger middle-class houses might also have paired chimneys, a reflection of the high-style configurations currently being seen on more affluent homes. Another arrangement would raise the roof of the rear lean-to up to a second story, resulting in a dwelling that was two-rooms deep. While the loft or half-story floor plan would allow that space to be most often used as storage as well as sleeping for children or lesser family members, a full-story addition usually meant that the best bed could be moved upstairs to one of the rooms, leaving the parlor room to evolve into a true parlor more familiarly seen in the nineteenth century. This type of change in the traditional configuration of the middle-class home, of moving more private rooms upstairs or away from the main areas of the house, was seen in all parts of the country during the Federal period. In the common homes of this time, the cooking, eating, and working might still be done in the same room, but when extra space could be afforded, the new rooms most often became ones for privacy.

Poor and middle-class homes of the Mid-Atlantic exhibited more variety during this period than their northern counterparts, owing to a varied ethnic population. The typical wood-framed, one-room floor plan, like the New

England examples, was also built here, usually by English settlers; one important difference, however, was that the chimney was often placed on an end wall rather than in the center of the house. Immigrants from numerous cultures, especially German, Dutch, and Swedish, in addition to religious groups such as the Quakers, all settled particularly in the Delaware and Pennsylvania regions and brought their own architectural traditions to bear on the familiar one-room dwelling. One form unique to this area was the log house, built mainly by German and Swedish settlers. Though based on the template of the wood-framed, one-room dwelling, the shell was constructed with logs rather than split boards. (Traditionally, German log houses were constructed with mud and stones in-between the logs, while Swedish builders stacked logs tight against each other, with no intervening spaces.) A layout referred to as a continental cabin was used for many log dwellings, and it was built with a more centrally located chimney and three rooms of varying sizes on the ground floor and a half-story reached by side stairs (Pillsbury and Kardos 1970, 49). McAlester and McAlester state that the terms *log cabin* and *log house,* often used interchangeably, are really two different forms: the house form was a more permanent structure, with squared timber and careful corner notching, making for an easier surface to waterproof with clay, plaster, or even weatherboarding; while the cabin form was really more of a temporary shelter, and it used round, undressed logs and overlapping saddle notches on the corners, resulting in large gaps that were difficult to fill (1991, 84).

Growing families who wished to update their log homes during the Federal period usually had to build separate structures side-by-side. Each interior space, or *pen,* was a completely enclosed unit and could not be added on to as in the case of wood frame homes (McAlester and McAlester 1991, 82). Log houses were joined at the corners for strength and relied on those joints for stability; removing them would weaken the whole building. Separate pens would be built next to each other, directly adjacent, though sometimes they would be built beside and behind the original structure. Additional doors would be added to the new additions, often resulting in the family needing to exit one room to the outside in order to enter the next room. Easier solutions would include building a wood-frame lean-to or ell, which would allow greater flexibility, though in some locations, the availability of cut boards made this an impossibility. Just as with the New England examples, however, both wood frame and log house dwellings in this region could be reconfigured with end chimneys, and perhaps a second story, resulting in a "one over one" floor plan, which has been referred to as an "I" house (Pillsbury and Kardos 1970, 53). Lean-tos running the width of the house were also used to update these dwellings in the Federal period, as well as extending the roof to form a porch.

Poor and middle-class homes in the Southeast also drew upon the one-room floor plan, but with differences unique to their geographical location. A main variation was that end chimneys were used, rather than central ones, and they were invariably located on the outside of the walls rather than on the interior. Keeping cool was a factor in this region, of course, and exterior chimneys helped to control the heat inside the house. The lack of severe winters also resulted in the southern vernacular home spreading out rather than up when it was time for an addition. An update for a southern Federal period home might

A "Tidewater" dwelling was usually a two-room house with a long porch formed by an extended roofline running along the length. **Kenmuir, Ragland House, Louisa County, Virginia.** Courtesy of the Library of Congress.

involve adding another room onto the non-chimney end and possibly adding another end chimney there as well. For houses that did rise up to two stories, a central staircase, like in the Northeast and Mid-Atlantic, was most common, though here, a central stair-and-hall combination might have occurred earlier in order to accommodate another southern tradition of a matching door placed opposite the front entrance. Two doors across from one another on the long side of the house helped keep the inhabitants cool during the summer months. These homes would then have a symmetrical floor plan, much like the more affluent Federal homes of the period. A version of these two-room houses, referred to by some historians as a Tidewater dwelling, featured a porch running the length of the house, usually formed by extending the roofline supported on posts (Pillsbury and Kardos 1970, 78). Again, the porch was used to ease the comfort of the homeowner on hot days, and it was also used for storage. Another feature particular to homes along the coastal plains or other areas susceptible to flooding was a raised foundation, usually several feet above the ground on brick or stone pillars. In addition to keeping out water, it also allowed for the circulation of air, reducing the occurrence of rot.

Regardless of location, one- and two-room frame dwellings and log cabins belonging to the poor and middling classes continued to be built well into the nineteenth century, though changes that were taking place with the style of affluent homes trickled down to the middling homeowners. If one could not afford to build new, certain changes could be made to one's dwelling to keep up with the changing styles being set in the port cities of the young republic. In

addition to enlarging the home, adding a wing to the side or back, or perhaps even a second chimney, small exterior cosmetic changes could also help turn a later seventeenth- or early eighteenth-century house into a Federal period home. The use of brick or painted clapboard was one way, as was an orna-mented doorway and window. And with windows, the use of the double sash, along with increased size and symmetrical placement, helped update a home. But the most common change was taking place inside, with reconfigurations of rooms, resulting in more privacy and more leisure time for the common Federal period family.

As the familiar hall-and-parlor layout evolved into the central-hall form, the parlor side, which was viewed as a middle-class homeowner's most important room, began to be used as a place of leisure and relaxation. In these homes, practical uses for parlors (such as bedrooms) were phased out. The best bed might be moved to a more private room that had been added to the first floor or even up to the second floor, while the homeowner's best furniture would be displayed in the parlor. A study of inventories of such homes show the lack of bed linens in parlors and increased storage of ceramics, chairs, and small tables instead. This was happening throughout the country in the Fed-eral period in all but the very poorest dwellings. During the late eighteenth and early nineteenth centuries, there was a marked rise in the ownership of consumer goods by all classes, not just the wealthiest. Even the middle and poor classes usually strove to own whatever trappings of gentility they could afford. With objects, this usually amounted to smaller goods, such as a teacup or silver spoon, which would be displayed in the increasingly important parlor room. The all-purpose hall side of a middle-class dwelling began to be used more as a workspace, rather than an all-encompassing living area. Usually con-taining the kitchen, the dirtiest, hottest, and less-genteel indoor jobs, such as cooking or washing (both clothes and people), were relegated to this room; in the smallest of houses, it was also a storeroom. While upper class homes of the Federal period might have an indoor winter kitchen and an outdoor summer kitchen, the middle-class and poor homes made do with one. While some of the poorest families might continue to take their meals in this room, it was a sign of prosperity for them to remove to the parlor for their breakfast or sup-per. Small tables, which might have been used by a more wealthy household as a side or tea table, were proudly placed in the parlor room for dining. It was also in the parlor where the family might gather in the evening after the day, to rest, read, or sew. As opposed to a wealthy homeowner's series of different parlors—the best parlor, the back parlor, the sitting room, and the day room—the middle-class homeowner's single parlor sufficed.

In some cases, a middle-class homeowner might have the means to build a lean-to onto the rear of his dwelling, a rear ell. The advantage of such a structure was that it could be built without changing the roofline or remov-ing whole walls, which would weaken the entire structure. Extra ground-floor space meant more room for the family and often the main kitchen area would be moved to the ell, leaving the larger room free for different activities. If a dwelling was of a single story, the former kitchen could be used as a parlor or sitting room for the family, while the parlor would continue to be used for sleeping. Other times, ells would be used for storage space, extra sleeping space for family members, or quite often, both.

As it was the affluent classes that were mainly responsible for initially transmitting the new style to the country, the design of their homes must now be considered.

Asher Benjamin's Advice to Homebuilders

Asher Benjamin's *The American Builder's Companion* (1806) offered advice that might have seemed self-evident to some. But Benjamin was writing for an American audience and, specifically, an audience that was increasingly moving away from self-sufficiency and needed to be taught skills that their predecessors had taken for granted. He also kept in mind the location of these future homebuilders, mentioning the latest styles seen in the more urban areas of the United States, very aware that his readers would want to be appraised of the newest trends. The climate of America during the hot summer months was also taken into account, because Benjamin was careful to include provisions for air circulation.

> *Observations on the building of Houses.* The first thing to be done in planning a house, is to know the wants of the person who is to occupy it; the next, to know the situation of the ground it is to cover; then to take into consideration the number, size, and height of the rooms wanted; also, proper and convenient stairs, entries, passages, etc. Let the kitchen be situated, so as to have as easy a communication with the dining and breakfast rooms as possible; let the pantry or china closet communicate with the dining room by a door, and with the passage from the kitchen by a door or window. Place the doors in such a manner as to make the distance from one part of the house to the other, as short as possible; still keep uniformity in view, as it is one of the greatest beauties in architecture; yet convenience ought not to make too great a sacrifice to it. The eye ought to see, at the same time, every part of the building, and be sure that no one part of it interferes with another; also, to see that the rooms are properly lighted, and at the same time, that there are a sufficient number of windows, and of a size suitable for the external part of the building.
>
> Strength, convenience, and beauty, are the principal things to be attended to. To have strength, there must be a good solid foundation; and never place piers over openings of windows or doors. Openings of windows or doors in different stories, ought to be exactly perpendicular, one over the other. Care ought to be taken, not to place heavy girders or beams over doors or windows, or to lay timber of any kind under fireplaces. As to the proportion of windows to rooms, we do not believe any certain determined rule can be given for their height and breadth, although there are several European writers, who have given rules for their proportion. We think Sir William Chambers has given the best proportion of any one we have seen, yet we do not find it to answer in all cases; he adds the depth and the height of the rooms on the principal floor together, and takes one eighth part thereof for the width of the window. The width and height of doors, depends on the size and height of rooms in some degree, although there is not any room so small as not to require a door sufficiently large for a person to pass through its opening. In the course of our own practice, we have made doors for rooms of sixteen by eighteen or twenty feet, and ten feet high, three feet wide, and seven feet or seven feet two inches high. When rooms have been twenty by twenty three or twenty four feet,

and twelve or fourteen feet high, we have made the doors three feet six or seven inches wide, and seven feet eight inches, or eight feet high; all the doors in the same room ought to be of the same size, except where two doors are placed together between the two principal rooms, which are called folding doors. They ought to be made from eight to twelve inches higher than the other doors of the room, or they will, on account of their width, appear to be lower than the others; these folding doors are commonly used in Boston, and are very convenient, particularly so when placed between small rooms, both for the circulation of air, when windows and doors are opened, and for the reception of large companies.

The size of outside doors, must be governed by the building in which they are placed. If in a townhouse with a narrow front and small windows on each side… three feet four or six inches will do very well for its width, but if wanted for a large house, and without side lights, it ought to be made much wider; say from three feet ten inches to four feet; and in some cases, four feet four or six inches wide, and never less than two diameters high.

The chimney ought not to project into the room more than from fifteen to twenty inches if it can be avoided, and care should be taken to place them on the most convenient side of the room… Never make the funnel less than twelve inches square, and if there is sufficient room, sixteen inches is a good size where a fireplace is about four feet between the jambs. (Benjamin 1806)

AFFLUENT HOMES OF THE FEDERAL PERIOD

Affluent homes of the Federal period, like the middle- and lower-class examples, also went through a variety of changes to the interior as well as the exterior. Homes that were built new at this time would often attempt to display the latest styles available from abroad. Increasingly, this came to be homes built by newly prosperous merchants and traders, mainly in the ports of the New England area, such as Boston, Salem, and Marblehead, Massachusetts; Newport and Providence, Rhode Island; and Portland, Maine. These homeowners, with their close mercantile ties to England, had naturally looked to that country for architectural styles and continued to do so long after the Revolution. Other port cities on the Atlantic coast had direct and ongoing commercial contact with England and Europe, and their affluent citizens also wanted to build homes in the newest fashion. Philadelphia, New York, Baltimore, Alexandria, Charleston, and Savannah all displayed newly built, high-style homes during this time. Americans in the Federal period were able to keep up with architectural trends and interior design styles from England and Europe in a variety of ways. Depending on their means, trips abroad were one way of learning about fashionable forms, or, if that were not feasible, contact with someone who had made the Grand Tour and, even more helpfully, brought back a volume of architectural drawings by Abraham Swan or Robert Morris, or sketches of ancient ruins in Greece and Rome by James Stuart, Nicholas Revett, or Robert Adam. Lending libraries were also becoming common during the Federal period, and a curious homeowner could borrow a copy that might provide inspiration. Pattern books or builder's guides from abroad also were often consulted for designs; some written specifically for the American market could also reveal stylistic changes, albeit in a third- or fourth-hand manner.

And lastly, if not most simply, a visit to any port town by a prospective home builder would reveal the newly fashionable homes being constructed at a rapid pace by prosperous merchants and affluent gentlemen.

Concept of *Builder* vs. *Architect*

One type of architect during the Federal period was the gentleman amateur: learned, affluent men who, under the influence of Classical literature and the European Enlightenment, dabbled in a variety of disciplines, some more successful than others. They studied art, religion, philosophy, botany, zoology, and languages, many becoming self-taught experts in the process. Thomas Jefferson, of course, is one of the most well known of the gentleman amateurs in multiple fields, but especially in architecture, designing buildings for himself and his friends, as well as for the nation. Other successful gentlemen architects were Charles Bulfinch, who designed homes for other members of the Federal upper class, mostly in and around Boston, even though he was not a "trained" architect; and William Thornton, a medical doctor whose designs for the United States Capitol were chosen in 1794. Both of these men, like Jefferson, had experienced European architecture first-hand and brought this experience to bear in their designs.

Charles Bulfinch in particular was an example of a gentleman amateur who excelled in self-instruction. From a prominent Boston family, he attended Harvard University and, after graduating, began designing homes for his family and friends as a hobby. In 1785, Bulfinch made his Grand Tour of Europe, visiting Italy, France, and England. Jefferson, who was in Paris at this time as American Minister to France, arranged for him to see some of the more architecturally important buildings (Handlin 2004, 44). After he returned, Bulfinch set about designing buildings full time. He was known mostly for his work in and around his hometown of Boston, designing public buildings such as the Massachusetts State House, University Hall at Harvard, and numerous churches. He also took over as architect from William Thornton for the U.S. Capitol in 1817. His work on private dwellings was also extensive, and in 1793, Bulfinch designed Tontine Crescent in Boston, one of the earliest row house schemes in America, which was inspired by examples he had seen in London during his tour. Because of his wealth, Bulfinch was able to successfully finance this project, as well as others, something, perhaps, that a trained architect could not have done so easily.

It was not until the end of the eighteenth century that the first fully trained architects began to make their mark on the United States; and even then, it would be some time before an American-born architect appeared. Benjamin Henry Latrobe is commonly referred to as the first professional architect to practice in the new nation. Latrobe emigrated from England in 1795, where he had been a student of both architecture and engineering (setting a standard for architects to come). Other trained architects from abroad, such as James Hoban from Ireland (who won the design competition for the President' House), Stephen Hallet from France (who supervised part of the building of the U.S. Capitol), and George Hadfield from England (who designed the Custis-Lee Mansion, now Arlington National Cemetery), brought their skills to the United States and, most importantly, taught a new generation of native-born architects.

Two important architects of the Federal period were not native—William Thornton and Benjamin Henry Latrobe—but their work influenced many of their American contemporaries. Although raised in England and trained as a doctor in Edinburgh and Paris, William Thornton (1759–1828) left his mark on history as an amateur architect. While practicing medicine in Philadelphia in 1789, he submitted a design for Library Hall for the Library Company of Philadelphia. His winning contribution, a Palladian façade with pilasters, inspired him to compete for the design of the new Capitol building in the young Federal city. His drawings captured the attention of George Washington and his Secretary of State, Thomas Jefferson, and Thornton's designs were chosen in 1794. While many of his original ideas were changed during construction, the flanking wings and façade of the Capitol's central portion remained as Thornton intended.

While the Capitol building was underway, Thornton also designed two homes for prominent families, the Tayloes and the Peters. Colonel John Tayloe, who was rumored to be the richest plantation owner in Virginia, had Thornton design a home for his oddly angled corner plot in Washington. Though basically Federal in its restrained style, the Octagon was built using a circle segment with rectangles and a triangle, making it unique for its time. Tudor Place, designed for Thomas Peter and his wife, Martha Custis Peter, the granddaughter of Martha Washington, was conceived as more of a villa, situated on a hill in Georgetown. Like the Octagon, Thornton proposed several differently shaped rooms for the interior, though only one was retained—the central saloon, which opened out to a temple portico with supporting columns. The exterior brick walls were also stuccoed and scored to resemble marble blocks, giving the house a very smooth and uniform surface.

Another British-born architect who had a lasting influence on American architecture was Benjamin Latrobe (1762–1820). The first fully trained architect to work in America, Latrobe apprenticed to an engineer while still in England before emigrating to America in 1795. He made his reputation early on by designing public buildings such as the Bank of Pennsylvania (1798), the Baltimore Cathedral (1804–1818), and, most notably, the U.S. Capitol (1803–1817), changing much of Thornton's original designs. Jefferson had appointed Latrobe surveyor for the building of the Capitol, and it was his job to oversee the construction according to Thornton's plans. Arguments ensued between Latrobe and Thornton, however, resulting in many changes to the design, particularly the interiors, where Latrobe introduced two original American architectural orders based on the tobacco leaf and the corn plant.

Latrobe designed many private homes as well, such as the Van Ness house (1813–1819) in Washington, D.C., and the Markoe house (1808) and the Burd house (1801), both in Philadelphia. Though Latrobe designed or worked on nearly 60 homes, because most of them were built in urban areas, there are only three that still remain today: the Decatur house (1817), built for Commodore Stephen Decatur in Washington, D.C.; the Pope Villa (1811), built for Senator John Pope in Lexington, Kentucky; and Adena (1806), built for Governor Thomas Worthington in Chillicothe, Ohio.

Before examining the role of pattern books and builder's guides in the spread of the Federal style in the United States, the role of a builder, rather than an architect, must be made clear. The modern conception of an architect was not

present until after the beginning of the nineteenth century. Most houses were designed and constructed by trained builders, carpenters, joiners, and masons. They relied on their past skills, as well as guidebooks and pattern books written by other members of their profession. Though mostly anonymous, there were some builders who stood out and, by using and publishing builder's guides, helped disseminate the new style throughout the United States. Samuel Mc-Intire (1757–1811), who practiced in and around Salem, Massachusetts, and John McComb (1763–1853) in New York City, were just two craftsmen who made an impact during the Federal period. McIntire, in particular, was known to have owned a copy of William Pain's *Practical House Builder,* an English build-er's guide that was published in America in 1796 (Kimball 1966, 150). Asher Benjamin (1773–1845), who also worked in Massachusetts, relied heavily on Adam's architectural books when he wrote *The Country Builder's Assistant* (1796) and *American Builder's Companion* (1806; Kimball 1966, 151). Most homes were built with a combination of a carpenter's knowledge, a builder's guidebook, and an owner's instructions. John Dickinson's Wilmington, Delaware, home was remodeled in 1794, with Dickinson, like many other homebuilders, taking a primary role in the design. While Abraham Swan's guide, *Book of Architec-ture* (c. 1774), was consulted, Dickinson also wrote instructions for the builder to look at specific homes in nearby Philadelphia for examples of chimneys and mantels, doors, stairs, and windows. One such house, known as "Mansion House," was built in the late 1780s by William Bingham, one of the wealthiest landowners in the country. Bingham has spent considerable time in England before returning to Philadelphia to build his home. His direct contact with the architectural styles in England were translated into Mansion House and, in turn, to John Dickinson's own home in Wilmington (Bushman 1992, 238). Even after professional architects began to appear, however, they were usually known for their designs of government buildings, churches, and large private homes, while the bulk of smaller houses were still designed and constructed by anonymous builders.

Use of Pattern Books and Builders' Guides

Architectural treatises had long since been a part of a wealthy English gen-tleman's library. Obtained while abroad in Europe on the Grand Tour, or im-ported at great expense back home, these books showed his good taste in the ancient arts. Vitruvius's *Ten Books of Architecture* (30 B.C.), the only complete ar-chitectural treatise to survive from the ancient world, and Palladio's *Four Books of Architecture* (1570) were perhaps the most well known, certainly the most influential. Reprints of these volumes, along with Colin Campbell's *Vitruvius Britannicus* (1715) or Robert Castell's *Villas of the Ancients* (1728), would cer-tainly have graced the shelves of a country house library, a house most likely designed along Palladian lines, which the books enthusiastically promoted. Though these publications made their way slowly to the American colonies during the eighteenth century, few colonists had the wherewithal to design a Palladian villa, and several decades passed before books specifically targeted toward Americans began to appear. Even Adam's *Ruins of the Palace of Diocletian at Spalatro* and Stuart and Revett's *Antiquities of Athens,* which excited a new gen-eration of gentleman architects, had a cursory impact on American architecture

in the later eighteenth century. What they did spur on, however, was a spate of pattern books published by other designers who, borrowing from the pages of the Adam brothers, presented a more practical approach to home building.

Between the years of 1724 and 1790, 275 new pattern books were published in England and Europe, in addition to the reprinting of at least 170 older titles (Bushman 1992, 102). These books slowly made their way westward with the new classical Renaissance ideals that were replacing a largely medieval style in England. Pattern books were usually written by craftsmen, carpenters, or builders and illustrated with engravings of designs—some taken from older treatises, some by the authors themselves. William Halfpenny, who produced 20 different books of architectural designs between 1722 and 1755, directed his books at both builders and owners of country homes (Summerson 1993, 340). Batty Langley's publications were to be an aid for builders as well, with titles such as *A Sure Guide to Builders* (1729) and *The Builder's Compleat Assistant* (1738) (Fleming, Honour, and Pevsner 1999, 169). His *City and Country Builder's and Workman's Treasury of Designs* from 1740 contained more practical advice than the architectural treatises earlier in the century, and it is these types of books, along with immigrating craftsmen, that brought new ideas to the young country.

Asher Benjamin's *The American Builder's Companion: or a New System of Architecture Particularly Adapted to the Present Style of Building in the United States,* published in Boston in 1806, was based on earlier English pattern books, but tailored specifically for the new American homeowner:

> Books on Architecture are already so numerous that adding to their number may be thought to require some apology; but it is well known to any one in the least conversant with the principles of Architecture, that not more than one third of the contents of the European publications on this subject are of any use to the American artist in directing him in the practical part of his business. The style of building in this country differs very considerably from that of Great Britain, and other countries in Europe, which is partly in consequence of the more liberal appropriations made for building in those countries, and of the difference of materials used, particularly in the external decorations. The American Mechanic is, therefore, in purchasing European publications, under the necessity of paying two thirds of the value of his purchase for what is of no real use to him; and as the principal part of our designs have been executed by our own hands, we feel confident that this publication will be found to contain more useful information for the American workman than all the European works which have appeared in this country, and which, for the most part, are mere copies one from the other. (Benjamin 1806)

The needs of American homebuilders were markedly different, and even though the young country's tastes still owed much to England, the desire to strike out on its own was too great. Materials were different, some scarcer than others, and money also played a large part in the changes, as did the talents of available craftsmen. Early builder's guidebooks published in the United States focused chiefly on the details of a dwelling, rather than the overall result. The books would show examples of door and fireplace surrounds, window openings, and staircases. The basic construction techniques were not mentioned,

because most authors assumed that their readers knew how to build a house. The embellishments were what the guides concentrated on, hence the term *pattern* books. Between 1797 and 1860, 188 architectural books were published in America (Bushman 1992, 243).

New Room Shapes

The new layout and design of many affluent homes in the Federal period can best be seen as a combination of the idea of Classical form paired with the practicality of modern convenience. As Kimball noted, inspiration for the style was twofold: "inspiration from the classic, whether directly or through the English version of Pompeian decoration" and "influence from France toward freer composition of plan and space" (1966, 152). From the outset, an important consideration when siting a new Federal period home was the topography of the land. For affluent town dwellers, there was often not much choice, but rural homeowners had more to work with. What was necessary for many, however, was a raised hill on which to orient the dwelling. Whether it was natural, as could be found in the country, or artificially contrived, as often happened in town, a raised promontory from which to look down was very important for the affluent Federal homeowner. Latrobe was mindful of this for his wealthy clients when he wrote in 1798: "When you stand upon the summit of a hill, and see an extensive country of woods and fields without interruption spread before you, you look at it with pleasure . . . this pleasure is perhaps very much derived from a sort of consciousness of superiority of position to all the monotony below you" (Sarudy 1998, 32). For homes built with their main entrance facing north, principal rooms might sometimes be placed facing south for garden exposure. Tudor Place, in Washington, D.C., is a good

Some Influential Pattern Books for Federal Period Architecture

Asher Benjamin (1773–1845), American Architect

The Country Builder's Assistant (1796); first American builder's guide; borrowed heavily from William Pain's publications.
The American Builder's Companion (1806); influenced by American architect Charles Bulfinch; revised over the next 20 years.
The Architect; or The Practical House Carpenter (1830); most popular American architectural book of the nineteenth century.

Owen Biddle (1774–1806), American Carpenter

The Young Carpenter's Assistant; or A System of Architecture, Adapted to the Style of Building in the United States (1805); early American builder's guide.

William Halfpenny (d. 1755), English Architect

Practical Architecture (1724); one of the first Palladian Revival books; influential in later eighteenth-century American architecture.
The Modern Builder's Assistant (1742); pattern book for country houses.

John Haviland (1792–1852), American Architect

The Builder's Assistant (1818); early use of Greek form in American architecture.

Batty Langley (1696–1751), English Architect; books influenced American architect Samuel McIntyre

The Builder's Compleat Assistant (1738); described principles of architecture according to Palladio.
City and Country Builder's and Workman's Treasury of Designs (1740); also contained patterns for furniture construction.
Gothic Architecture, Improved by Rules and Proportions (1747); influential in the Gothic Revival in America.

Robert Morris (1701–1754), English Architect

Select Architecture (1757); influenced Thomas Jefferson's designs for Monticello.

(*continued*)
Peter Nicholson (1765–1844), Scottish Architect

The Carpenter's New Guide (1792); influenced American architects Asher Benjamin and Charles Bulfinch.

William Pain (1730–1790), English Builder

Practical House Carpenter (1766); influenced by Robert Adam's designs.
Practical Builder (1774); first published in America in 1796.

Abraham Swan (act. 1745–1768), English Carpenter and Joiner

The British Architect: Or the Builder's Treasury of Staircases (1745); first architectural pattern book published in America (1775).

example of this. The front entrance was placed on the north side, but the main rooms (drawing room, parlor, saloon) all faced south with the view across the sweeping lawn down toward the Potomac and Virginia beyond. Service passageways, private rooms, and staircases were placed on the north side, with double doors off the main hall for added privacy. Some Federal period homes placed important rooms, such as drawing rooms and dining rooms, on the floor above the main entrance. This style was French in origin and seemed to be well suited to sideways-oriented homes in Charleston, South Carolina, or town houses in the Northeast, particularly those designed by Bulfinch in Boston (Kimball 1966, 158). In some cases, where the best view happened to be in the front, the principal rooms, such as a drawing room or saloon, would be put in place of the entrance hall, either supplanting it altogether or removing it to another part of the house. The Swan house, in Dorchester, Massachusetts, is such an example; the drawing room is placed in the best viewing location (front and center), causing the two entrances (for symmetry's sake) to be built on either side and the hall to run length-wise through the center of the main floor (Kimball 1966, 162).

The standard interior cube shape of colonial times remained prominent during the Federal period. In fact, the box-like qualities of the Federal house are one of its hallmarks. The center stair hall layout, which had four equal rooms on each side, was the basis for the Federal home, and that, along with rectilinear lines and a hipped roof, was standard for middle- and upper-class homes during this period. However, a complex form of Federal home existed alongside this plainer version, one that was more classically based and was strongly influenced by the Adam style in England. In these houses, shape, orientation, circulation, and room use all changed to make a unique structure, if not on the outside, then on the inside. These dwellings were more geometrical in outline, with curved rooms, projecting bays, and shallow hipped roofs often hidden behind a balustrade.

Curvilinear rooms were an important addition to the Federal period interior and one of its distinguishing features. Robert Adam's studies of ancient Roman architecture had shown him the variety of room shapes used by the Romans—circular, oval, and rectangular—and he used this knowledge to experiment with spaces inside traditional forms. Adam noticed that the Romans were able to place square rooms adjoining circular rooms, all contained within a rectangular space, by thickening the walls between the rooms, sculpting each side to fit each shape (Gelernter 1999, 108). In America, instead of the symmetrical cube, early Federal period architects and builders began playing with interior spaces, breaking up the square to create unique layouts. Page after page

in builders' guides showed floor plans with interior rooms of oval, rectangular, and elliptical shapes. Sometimes it was necessary that the changes were contained within the cube, particularly when remodeling early eighteenth-century houses or with town or row houses, where walls could not be moved. In fact, most of Adam's work was done on homes built in the previous century, and he became known for his skilful re-imagining of spaces set within fixed walls. In a plan for a large town house by Asher Benjamin, the addition of a simple curved wall within a square room not only changed the space of that room, but created new spaces in the adjoining rooms as well (Calloway 1996, 205). Or for a group of Boston town homes designed by Charles Bulfinch in 1804, the removal of the staircase to a circular space in the rear of the house refashioned the interior cube into a unique floor plan with several different straight-sided spaces.

As affluent houses continued to experiment with different room shapes, a certain trend was found in what Fiske Kimball called "the more ambitious and characteristic houses," that of the projecting elliptical room, usually a principal room such as a saloon or drawing room (1966, 164). This feature was found in France during the reign of Louis XV and made its way to England where it was seen in both designs and structures. Thomas Jefferson was a strong proponent of the form and had planned such a feature in early designs of Monticello. In the Federal period, Charles Bulfinch, James Hoban, John McComb, and William Thornton all designed houses with circular or semicircular interior rooms that pushed past the exterior walls. The Swan house in Dorchester, Massachusetts, and the Gore house in Waltham, Massachusetts, are both excellent examples of the form. The bowed room was also seen outside of New

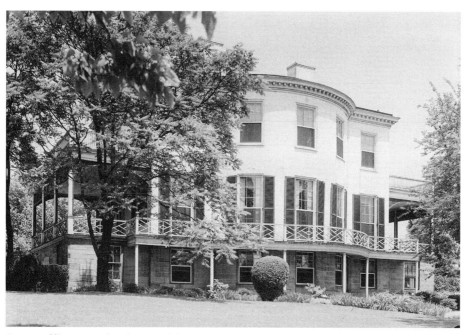

Some affluent Federal period homes featured interior elliptical rooms that projected out past the exterior walls. Lemon Hill (ca. 1799), Philadelphia. Courtesy of the Library of Congress.

England: the Russell house, in Charleston, South Carolina, was built with projecting elliptical rooms. Most were centered on the axis and faced the "garden front," which was usually at the rear of the house. Even in the case of the Russell house, which was turned sideways as was typical of Charleston houses, the room, which served as a dining room, was centered in the structure. Other rooms, while not fully rounded on all ends, nevertheless pushed past the boundaries of the exterior to form bays, usually paired on either side of the entrance way, particularly in town homes, or at either ends on larger, detached houses. These shapes could be semicircular or segmented.

Woodlands, in Philadelphia (1788), also employed a variety of room shapes inside the cube, as well as two oval spaces projecting to the sides in the rear of the house. Tudor Place in Washington, D.C., which was designed by William Thornton, originally had plans to contain two oval rooms along the front of the house, as well as an unusual circular portico, which projected partway into the center room beyond the entrance hall. Thornton also designed a house for Colonel John Tayloe, the Octagon, in 1798, which was situated on a corner lot near the President's house in Washington, D.C. Making the most of an unusually shaped lot, along with the Adamesque idea of unique room shapes, Thornton placed a circular entrance hall on the corner of the lot, with a staircase in a hall behind it on a diagonal axis and two projecting wings containing rectangular rooms to either side. Irregularly shaped houses, like the Octagon or Jefferson's Popular Forest (which was a true octagon), were not that common and functioned more as an exercise in geometric design, usually at the owner's request, than as a practical building style. Consequently, many of these architectural experiments were constructed as public buildings, such as churches, banks and exchange houses, tollhouses, or railroad stations (Gowans 1992, 111).

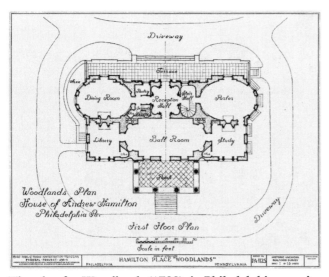

The plan for Woodlands (1788), in Philadelphia, was influenced by Robert Adam's use of varied room shapes contained within a cube. Courtesy of the Library of Congress.

New Room Use

The older hall-and-parlor configuration left little choice in the use of rooms; privacy, as well, was not an option. Even in the more affluent homes during the seventeenth century and early eighteenth century, rooms played multiple roles, with the rearrangement of furniture quickly turning a workroom into an eating room and then back again. In contrast with the preceding Colonial period, rooms began to be adapted to specific uses. This is most clearly seen in middle- and upper-class dwellings, where new homes would include individual, purpose-built rooms such as a dining room, games room, tea room, dressing room, or library. Homes

with specific, named rooms were being seen in England after the 1750s, and, of course, had been present in France for many years before that. Advertisements for homes to rent in London during the 1780s show the idea of specialty rooms already in place. Dressing rooms and closets are mentioned, as are breakfast parlors, powdering-rooms, eating rooms, and water-closets (Ierley 1999, 44).

The Parlor

In America, as houses grew larger and more decorative, room use shifted; the parlor was one of the more obvious examples. During the change from the common hall-and-parlor layout to the central-hall form, the parlor, which at one time would have contained the family's best bed, as well as most of their furniture, began to be used as a place of leisure and relaxation. Rather than a working room, the parlor became strictly an entertainment room used for different events—taking tea, playing cards, conversation, or dancing; as Bushman remarks, all practical function was removed from it (1992, 120). Guests would be entertained in the parlor, and the family could gather there in the evening for rest. "The single most telling indicator of a household's commitment to genteel values was the presence of a parlor with no apparent function but to sustain visiting, conversation, and genteel rituals" (Bushman 1992, 121). Most households began moving in this direction during the Federal period, as more consumer goods became available, wages were on the increase, and, consequently, more examples of multiroomed dwellings were being built. Separating rooms into single-use spaces was not new to the wealthy, but more people were now able to show at least some sort of pretensions to refinement and strove to have public and private spaces divided. For the middle and upper classes who might have already had a parlor, additional rooms could result in varying degrees of sophistication, separating a parlor from a drawing room, a sitting room, or a saloon, all used for entertainment, but in very different situations.

The Front Hall

The new center-hall layout in many homes changed the function of the main entrance. By turning the area into a separate room with walls on either side and doors leading to other rooms, the hall could be used as both a welcoming entrance to visitors, as well as a room for living. Grand entrance halls were still built for affluent homeowners, complete with stairways designed to impress. However, many new homes built in the Federal period, both affluent and common, began to view the hall as a transition room, a smaller anteroom that would lead into larger spaces. In some homes, it functioned as a passageway to other areas both public and private. As privacy became more important during the Federal period, central halls, as well as hallways and other passages, were considered more carefully than they had been before. At Tudor Place, the front hall is a small, elegant space, but really no more than a pass-through to the grand saloon beyond it. In the plans for the Barrell house in Charlestown, Massachusetts, designed by Charles Bulfinch, the front door opened into a foreshortened vestibule that acted as more of a hallway for rooms to either side; across the hall on the other side were glimpses of a grand oval drawing

room (Kimball 1966, 160). In the late eighteenth century, Montpelier, James Madison's home, originally had a long front hallway with doors at either end for air circulation, but in the early nineteenth century, it was shortened to become a passage running length-wise to formal rooms on both sides and to act as an entrance to the drawing room beyond.

In many southern Federal period homes, the hall had several functions; one of the most important and most common was as a breezeway between the front and rear doors placed opposite each other. These halls were long, running the depth of the house, though the width varied. The furnishings found in southern front halls and hallways during the spring and summer months testify to its use as another room for leisure or work. Chairs and tables were placed to make use of natural light coming in from front and rear open doors and to take advantage of the cross breezes that this layout provided. If large enough, the front hall could also double as a storage area, with side tables folded up along the walls, ready for use. The lightweight chairs (most often Windsor), settees, and small tables could also be easily transferred to the outside to serve as seating in the gardens. At Sully Plantation in Chantilly, Virginia, built by Richard Bland Lee in 1794, the 12-foot wide front hall contains doorways to rooms on either side as well as the main staircase to the second floor, but it is of sufficient width to also function as another room. The family would gather in the evenings under an elegant glass and brass lantern hung from the ceiling, and during special celebrations, the room would be cleared of furniture for dancing. In winter, the front hall usually lost its role as a sitting room, as the cold coming in would render it fit only for a passageway, although as technology permitted, some homeowners would place a small iron stove in the hall and continue to use it through the winter months.

Staircases and Stair Halls

In the interior, privacy was important in new room arrangements, and while a Federal home might delight its guests with an unusual layout, it also made it clear that there were spaces accessible only to certain persons, namely the family. A major difference in these houses was the removal of the main staircase, usually situated in the entrance hall and, in older grand homes, an integral part of the interior layout. Stairs in these new affluent homes were often put off to one side of the entrance hall, if not removed to another room entirely, which would lessen the chance of being used by a stranger. At Tudor Place, William Thornton designed the main staircase to reside off the marble entranceway, behind a set of double doors that could be closed for even further privacy. Staircases were also contained in curved or polygonal spaces, placed inside a square space, or curled in projecting bays. In the plans for the Van Ness house, also in Washington, D.C., and the Woodlands in Philadelphia, both curving staircases are shown in separate rooms off of the main hall, though clearly still a large part of the decorative scheme of the house.

Staircases that were not contained within their own area, such as a side room, could be made to twist delicately into space. The staircase at the Russell house in Charleston, South Carolina, was placed in an elliptical well and seemed to float in mid-air (Kimball 1966, 167).

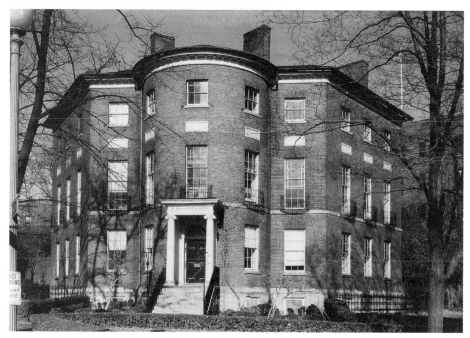

William Thornton used a triangular corner lot to design a unique, geometric dwelling composed of circular and rectangular rooms. The Octagon (1798), Washington, DC. Courtesy of the Library of Congress.

The Federal period staircase was a great departure from the straight steps of the Colonial period. The variety of room shapes called for a variety of staircase designs, and some craftsmen excelled in this, particularly Samuel McIntire and Charles Bulfinch. Even stairs with straight runs might curve at the ends, with the handrail following the sweep of the steps. This was seen in more common dwellings, where the traditional hall-and-parlor layout gradually changed into a center hall plan with the staircases often relegated to the sides, which might have straight runs with curved landings between. Certain staircases, however, remained as a grand statement for the homeowner, especially in the freestanding examples from Montmorenci, from Warren County, North Carolina (now installed at the Winterthur Museum), or the Patrick Duncan House in Charleston, South Carolina.

As dwellings tended to increase in length during this period, moving from one part of the house to the other could present the opportunity for complicated circulation. Secondary staircases and passageways helped the family move through the house with increased privacy. In most newly built affluent homes, the circulation of servants and other staff was relegated to special staircases of their own, usually located toward the rear of the dwelling or off to the sides. Sometimes, entire lengths of the house would be relegated to service and family passageways. Both Tudor Place and Montpelier had service halls running along one side of the house, with front and back stairs for separate family and servant usage.

Dining Rooms

Dining rooms were also a relatively new addition. In the early eighteenth century, most families, both poor and upper class, tended to take their meals in the same room where they might work or relax, according to space constraints as well as the seasons. Rooms with fireplaces would naturally be used for many activities, including eating, during the winter months, while warmer days might see a table set up in the hall or passageway or even a porch, if available. Small side tables, which normally resided along the walls, would be brought out to serve as an eating surface and then put back in place at the end of the meal. In more affluent homes, where there might be larger gatherings than just the immediate family, whole rooms could be cleared and set up for dining. Though long a practice in France and in England for the wealthy, dining rooms set aside for just such a purpose did not come quickly to the United States. When they did, however, it was clearly a mark of status to have such a purpose-built room. During the Federal period, rooms appeared that were used as dining rooms all the time. Tables and chairs would remain in place, ready for the next meal. Even if the family still took supper together in a smaller room much of the time, the dining room became a popular addition to the new house layout of the time. A room with a dining table that was always in place meant that the homeowner had room to spare. Long extension tables became popular for these rooms, and square or half-round ends could be added to make room for additional guests and then folded and stored along the walls to be used as side or serving tables. After 1800, alcoves were added in dinning rooms strictly for the placement of a sideboard, a rather new piece of furniture in the Federal period. Both Bulfinch and Latrobe had recesses built into homes they designed for their clients, and Jefferson had one installed at Monticello. Such alcoves served to highlight what was commonly one of the most expensive pieces of furniture in the home, and they also provided more space for the circulation of guests and servants around an increasingly large dining table.

In affluent homes, the concept of privacy and accommodation also meant a desire for easier access to the dining room from the kitchens. Basement kitchens, as usually seen in urban town homes or in northern areas, would often have service stairs leading from the kitchen directly up to the dining room, or, as was the case at Monticello, a butler's pantry adjoining the dining room. At Sully Plantation in Virginia, a covered walkway led from the outside kitchen up a side stair to an outside door, which opened directly into the dining room. Montpelier had both an outside kitchen (summer) and a basement kitchen (winter), with appropriate walkways and back stairs from the dining room leading to each.

Bedchambers, Bathrooms, and Closets

While the concept of a separate room for sleep was not new for wealthy homeowners, the ability to divide spaces into public and private was new to the middling and poorer classes in the eighteenth century, and during the Federal period, moving the best bed out of the parlor and into its own room was seen as a mark of status. With the bed and its textiles being one of the more highly prized objects in some households, it was natural to want to display it. Even

into the nineteenth century, a bed winch, or bed key, was kept close at hand; in the event of a fire, the bedstead and hangings could be quickly dismantled with the winch and saved (Garrett 1990, 36). However, as homes grew larger for all classes, a room in the back of the first floor or on the second was set aside as a sleeping chamber, first for the parents or elderly members of the house, or even honored guests, then later for the children. Garrett rooms remained in the Federal period, however, for extra sleeping spaces for children or servants. Kitchens, too, might also serve as sleeping quarters for servants, which would be considered cozy in the winter months. Bedrooms with a sleeping alcove for the bed, as well as a separate dressing room, were French in origin. The *chamber à l'alcove,* which was seen during the reign of Louis XIV, made its way to England, though not in great numbers, and it was slowly introduced to America by architects and builders. Jefferson, influenced by the interiors he saw during his time as minister to France, built one into his homes at Monticello and Poplar Forest, while Latrobe included it in a house he designed in Washington, D.C., in the mid-1810s (Kimball 1966, 155).

Even though bedrooms were placed to be out of public view in the Federal period home, most houses did not have the luxury of having a bedroom solely for sleeping. As in the early eighteenth century, many bedrooms still doubled as sitting rooms, albeit a more private one than before. Comfortable chairs, with a fireplace and windows, could easily serve the household as an extra room for working, sewing, taking tea, or generally being out of the public eye. Separate rooms for bathing during this time were not very common, so most bedrooms also doubled as bathing chambers, as well as a place to keep a chamber pot, or "closestool." Jefferson had sketched a plan of a cabinet room adjacent to his bedroom, where he planned to have piped water brought in for use in the water closet and greenhouse (Ierley 1999, 57). Only the most modern of homes would have a separate water closet for private use, though some more affluent homes added a dressing room for extra privacy that the bedroom might not afford. In the middle-class and poorer dwellings, the bedroom would have to suffice for most private activities, which, while certainly not ideal, was a distinct improvement over the public parlor room of the seventeenth and early eighteenth centuries.

First-floor closets or storage rooms that functioned much like pantries were quite common during the Federal period. Gunston Hall, in Mason Neck, Virginia, had several such rooms on the first and second floor that were stores for items such as tea, sugar, spices, and medicines. Such closets would serve as distribution points for the management of expensive items for household use. Closets for storage of clothing were also seen, but they were mainly shelved alcoves for storing clothing and linens flat. Linen presses and high chests were the more common method of storing textiles; hanging clothes was not a common method until well into the nineteenth century. For most Federal period homeowners, extra rooms for clothing were simply not needed. Trunks or small chests in bedrooms or upper hallways sufficed for most.

New Rooms for Outside Views

Porticoes, piazzas, verandas, and terraces were all seen as part of Federal period architecture. Though all were slightly different architectural con-

structions, these elements were basically exterior features that could be used for indoor activities. In classical architecture, a *portico* was a porch with a low-pitched roof, with an entablature and pediment in front, and supported by columns underneath. This functioned as the main entry and central visual element on the façade on many Federal period homes. (Affluent homes of a certain size might also have an additional entryway, a *porte-cochère*, which was a portico wide enough for carriage access, usually placed off to the side.) The portico could be as elaborate or plain as was desired; besides a common rectangular shape, semicircular forms were also seen, especially in southern Federal homes in Savannah and Charleston. The portico, while essentially a framing device for the entranceway, could be substantial enough to form an open room of sorts. In combination with the glazed sidelights and transom, such a feature formed a passageway of its own, from outside to in, allowing more of an exchange between the two areas. This could especially be felt if there were opposite doors in the entranceway, which could be opened for cross ventilation and better light. Montpelier, in Orange, Virginia, had both a front and back portico. The front featured a classical temple pediment that, in its final form, featured columns extending all the way to the ground; the rear portico had a Tuscan colonnade supporting a flat roof, which was bounded by a Chinese-style balustrade to form an upper terrace (Hunt-Jones 1977, 69). Both were used for relaxation and entertaining by the family and their guests. Numerous lightweight benches and chairs would be placed on them for comfort and often for storage. Two-story porticoes of a monumental form were also seen, such as the structure on the south side of the President's House, Montpelier, or at Jefferson's Poplar Forest. Most were of a temple form, with a pediment and four columns, though very shallow or flat roofs with a balustrade also were seen.

Southern Federal period architecture, chiefly the Roman Revival or Jeffersonian style, was particularly known for such monumental porticoes, which could be seen on the front, back, or sides of the dwelling, with a variety of upper porches or balconies featured underneath the pediment. West African and Caribbean influences were brought to play in the appearance of long, low-hanging roofs and wide porches in this region. Verandas and galleries were quite popular additions to the southern home in the Federal period. Open-sided, roofed walkways, or verandas, were used on all sides of the dwelling, sometimes encircling the entire structure. The veranda could be used to bring more of the exterior into the house and, when furnished with lightweight chairs and small side tables, could function as a room in its own right.

Homeowners from all classes tried to introduce more of the outside into their homes during this time, even if it were a simple extension of a roof on a middle-class home. Clockmaker William Faris owned a small house and garden in Annapolis, Maryland, and in 1799, he added a small wooden porch with steps on the back of his dwelling, overlooking the garden (Sarudy 1998, 11). It was small, yet just enough for him to sit in the evening to enjoy any breezes that might be available. More affluent homeowner Charles Carroll had earlier added a porch with stone columns to his own Annapolis home, which was no doubt seen and admired by many in the town. City gardens in the Federal period were still largely laid out in a geometric pattern and were best viewed from above, from just such a veranda or balcony. These outdoor spaces could function as a viewing platform as well as a cool spot to relax.

The Charleston town house was particularly adept as its use of combined exterior and interior spaces. Originally, Charleston town homes had been built just like any other groups of attached homes throughout the colonies; however, after a great fire in 1740, the narrow detached sideways house so synonymous with Charleston style began to replace the older homes (Ierley 1999, 37). And because of their location, the architecture of these homes revolved extensively around outdoor spaces. The typical affluent Charleston home was a single house, one-room deep, with the short side turned to the street and a veranda running the length of the house. Influences from the West Indies made such spaces quite common (Pierson 1986, 232). Many homes rose to three stories, with a veranda on each floor. Principal rooms would be located just inside, separated only by French doors or triple-hung windows, which could be easily thrown open to catch the breeze. Most gardens would be located on this side of the house as well, and so, with such a narrow structure and so many open areas, almost every room in the house would be open to the outside and the garden.

Like Charleston, cities along the Gulf Coast in Alabama, Mississippi, and Louisiana boasted waterside houses with long open galleries covering the buildings from top to bottom. Many families spent most of the hot summer months on these piazzas working, eating, and sleeping. Beds, benches, tables, and chairs were routinely moved from interior rooms to outside spaces for the comfort of the inhabitants. Some Federal period homeowners, particularly in New Orleans, gave such exterior rooms even more of an interior feel by hanging netted hammocks and large curtains on the outer side of the balconies to shield from the rays of the sun. Venetian blinds and lattices also served to keep out the heat.

Reference List

Benjamin, Asher. 1806. *The American Builder's Companion; or, A New System of Architecture: Particularly Adapted to the Present Style of Building in the United States of America.* Boston: Etheridge and Bliss. Accessed from The University of Wisconsin Digital Collections. Digital Library for the Decorative Arts and Material Culture. Available at: http://digital.library.wisc.edu/1711.dl/DLDecArts.AsherBenj.

Bushman, Richard L. 1992. *The Refinement of America: Persons, Houses, Cities.* New York: Alfred A. Knopf.

Calloway, Stephen, ed. 1996. *The Elements of Style: A Practical Encyclopedia of Interior Architectural Details from 1485 to the Present.* New York: Simon & Schuster.

Fleming, John, Hugh Honour, and Nikolaus Pevsner. 1999. *The Penguin Dictionary of Architecture and Landscape Architecture.* London: Penguin.

Garrett, Elisabeth Donaghy. 1990. *At Home: The American Family, 1750–1870.* New York: Harry N. Abrams, Inc.

Gelernter, Mark. 1999. *A History of American Architecture: Buildings in Their Cultural and Technological Context.* Hanover, N.H.: University Press of New England.

Gowans, Alan. 1992. *Styles and Types of North American Architecture: Social Function and Cultural Expression.* New York: Harper Collins.

Handlin, David. 2004. *American Architecture.* London: Thames & Hudson.

Hunt-Jones, Conover. 1977. *Dolley and the "Great Little Madison."* Washington, D.C.: American Institute of Architects Foundation.

Ierley, Merritt. 1999. *Open House: A Guided Tour of the American Home, 1637–Present.* New York: Henry Holt & Co.

Kimball, Fiske. 1966. *Domestic Architecture of the American Colonies and of the Early Republic.* New York: Dover Publications.

McAlester, Virginia, and Lee McAlester. 1991. *Field Guide to American Houses.* New York: Alfred A. Knopf.

Pierson, William H., Jr. 1986. *American Buildings and Their Architects,* vol. I. New York: Oxford University Press.

Pillsbury, Richard, and Andrew Kardos. 1970. *A Field Guide to the Folk Architecture of the Northeastern United States.* Hanover, N.H.: Dartmouth College, Department of Geography.

Sarudy, Barbara Wells. 1998. *Gardens and Gardening in the Chesapeake, 1700–1805.* Baltimore: The John Hopkins University Press.

Summerson, John. 1993. *Architecture in Britain, 1530–1830.* New Haven, Conn.: Yale University Press.

Furniture and Decoration

Washington started early in his quest for the latest taste from abroad. In 1757, he wrote to his agent in London: "whatever Goods you may send me ... you will let them be fashionable—neat—and good in their several kinds" (W. Garrett 1998, 189). In 1789, while he was serving as president, Washington instructed his secretary Tobias Lear to procure certain decorative objects for the Presidential dining table: "The President is desirous of getting a set of those waiters, salvers, or whatever they are called, which are set in the middle of a dining table to ornament it ... Mr. Morris & Mr. Bingham have them, and the French & Spanish Ministers here, but I know of no one else who has" (Fales 1973, 20). Washington himself wrote to Gouverneur Morris, placing his trust in his friend's good taste: "Will you then, my good sir, permit me to ask the favor of you to provide and send to me, by the first ship bound to this place or Philadelphia, mirrors for a table, with neat and fashionable, but not expensive, ornaments for them, such as will do credit to your taste?" ("Washington to Morris" 1890). "Neat" and "fashionable" were terms that did not need explaining to a person of Washington or Morris's class in the eighteenth century. To be in accord with the latest styles from abroad was the goal, and such universal terms would be immediately understood.

Morris's reply, along with the shipment of the requested items, speaks to the close and careful thought these men were giving to the style of their new nation and how the country would be perceived by the rest of the world: "You will perhaps exclaim that I have not complied with your direction as to economy, but you will be of a different opinion when you see the article. I could have sent you a number of pretty trifles for very little prime cost, but you must have

had an annual supply, and your table should have been in the style of a petit maitresse of this city . . . I think it of very great importance to fix the taste of our country properly, and I think your example will go far in that respect. It is therefore my wish that everything about you should be substantially *good and majestically plain,* made to endure" (Morris 1970, 270).

This chapter explores the different styles that were seen in furniture and decorative arts in the Federal period. Just as some of the early leaders wished for America to develop an architectural style appropriate to a young republic, they also believed that decorative embellishments should be in keeping with a new nation on the rise and serve as a reminder to their goal. The different motifs that became popular in the Federal period, namely classical and patriotic, are discussed, including their initial influences and the subsequent interpretations and relationships with certain objects. The ways in which these motifs were used in the Federal period home are then examined; surface decoration on walls, ceilings, and floors all used elements from these new motifs. Some furniture forms continued as they had in the past, but new rooms called for innovative designs; these new forms and the way they were used are also explored. And finally, the method of spreading these new styles is looked at, the movement of influence from abroad in the form of pattern books and craftsmen, as well as the importation of luxury goods.

DECORATIVE MOTIFS

The early leaders of the new country were most often the early tastemakers. The rest of the world was watching them, and they were aware that the first few years of the infant country were very important for its long-term success. The intricacies of government were carefully laid out, debated, changed, and set into motion, creating a form of government they hoped would be an example to other nations. Just as influential, however, were the daily trappings that Americans surrounded themselves with. Whether they were symbols from the ancient or even near past, or icons newly formed, Federal period motifs were both inspired by, and influencing, outside forces.

Classical Motifs

By the mid-eighteenth century, decorative motifs in the colonies were changing, reflecting more of the fanciful air of the French rococo style, which had been popular in Europe earlier in the century. Shells, rocks, leaves, masks, and animal forms were being combined in a playful, asymmetrical manner, and any classical motifs, such as scrolls or acanthus leaves, were highly stylized; flower and leaf images were elongated or shortened to fit in a particular area and became mere abstractions of their original form. Any historical associations that might have been made with these motifs were incidental. Affluent colonists ordered furniture and other decorative objects from England and Europe or had local craftsmen make pieces that were ornamented with foliage, volutes, C-scrolls, Gothic arches, Chinese pagodas, or imaginary birds. As it was in England, while the exterior of affluent colonial homes in the mid-1700s might be quite austere, interiors could be highly ornamented (Krill 2001, 12).

A more historical use of motifs began to be seen in England by mid-century, with the renewed academic interest in the classical arts of ancient Rome and Greece. The architectural books being published in the mid-1700s by Robert Wood, James Stuart, Nicholas Revett, and Robert Adam showed a multitude of decorative motifs from the ancient past, some well known, others more novel. New, more archaeological forms were combined with winged griffins, female figures, festoons, and trophies of war, music, and art to create what was seen as a purer form of ancient decoration, rather than the stylized, fanciful rococo forms. Adam's illustrations from Spalato and his later *Works in Architecture* helped spread his style throughout England. His interpretations of images found on Roman stucco work became set standards for classical motifs in the late eighteenth century; anthemion, acanthus, swags, paterae, medallions, animal heads, urns, lamps, and tripods were seen in multiple combinations on wall and ceiling surfaces, carved or inlaid on furniture, engraved on silver, painted on ceramics, and woven or printed onto textiles.

These motifs that were being filtered down to the young republic toward the end of the eighteenth century were a combination of older classical forms and the new lighter style of Robert Adam. While depicted sparingly on the exterior of some Federal period homes, it was in the interior where they were used to their best advantage. For early Americans, classical motifs from ancient Rome and Greece were thought of as the most tasteful forms and, when used, would allow them to be seen as sophisticated connoisseurs of style, as well as learned citizens of a new nation. Just as identification with ancient Roman architecture would be seen as an appropriate style for post-Revolutionary America, so, too, would any associative motifs from that age. And even though the style was essentially an English-influenced style, most Americans had little conflict with it. Some saw government and the arts as separate entities and could embrace English design while simultaneously rebuking her authority. Even after the Revolution, wealthy merchants, particularly in New England coastal cities, kept close ties with England because of their trade. As such, their styles reflected the Adam style in England, albeit with much more understated lines. It was such conservative tastes of early Americans that kept a version of the Adamesque style popular in the new country long after it had faded in England.

Some former colonists, however, were anxious to avoid a British-influenced classical style and tried to find an alternative line to ancient Rome and Greece, either directly or through European influences. Jefferson in particular was concerned about America's burgeoning culture being too swayed by British thought: "I fear nothing for our liberty from the assaults of force; but I have seen and felt much, and fear more from English books, English prejudices, English manners, and the apes, the dupes, and designs among our professional crafts" (Jefferson to Horatio Spafford in 1814 in Foley 1900, letter 358). The bucrania, or ox-skull motif, used as decoration by Jefferson and others, was directly copied from forms carved on marble altars from ancient Rome. The frieze from the Roman temple of Antoninus and Faustina was painted on the back of chairs. Figures of Muses with their attributes were taken directly from ancient relief carvings and placed on mantelpieces, ceilings, and door surrounds of affluent Federal period homes. And in painted images of the early leaders, many of the sitters chose to be depicted in the garb of Roman senators: "As to the style or costume [for a statue of George Washington], I am sure the artists, and every

The Octagon, fireplace frieze, Washington, DC. Dover Pictoral Archives.

person of taste in Europe, would be for the Roman. Our boots and regimentals have a very puny effect" (Jefferson to Nathaniel Macon in 1816 in Foley 1900, letter 7740). Even though many of the same images were being used in British decorative arts, some were quite careful to point to the more direct influence of an early culture.

Patriotic Motifs

In keeping with the strong feeling of kinship with the republican government of Rome, combined with the continuing fervor of American independence, new motifs of a more immediate form were introduced. While trophies of war such as arrows, spears, shields, and torches had long been a part of the classical style, they, as well as other military or patriotic motifs began to be seen alongside more sedate images of rosettes, urns, and floral garlands in Federal period decoration.

After 1812, naval battles of the war were popular scenes for decorating firebacks or mantels, or as a painted panel above a looking glass. A carved mantelpiece from a house in Carlisle, Pennsylvania, depicted a scene from the Battle of Lake Erie centered in a plaque. Another carved image of the battle on a mantelpiece from Philadelphia can attest the popularity of the motif, as well as the beginning of mass marketing for decorative items (Sweeney 1963, 88). Images of the founding fathers and war heroes, particularly George Washington and the Marquis de Lafayette, were seen on countless objects in a variety of forms. Earthenware was a popular medium, and naïve paintings depicted the two great men on platters and jugs. Early transfer prints from England also showed images of Washington, as well as scenes from the Revolution and the War of 1812, clearly an instance of target marketing on the part of British ceramics factories. A French gold and brass shelf clock portrayed a multitude of patriotic images as decorative embellishments, including a figure of Washington,

an eagle with a shield, stars, torches, and a globe. Ceramic relief portraits of leaders, such as Washington and Benjamin Franklin, were also available as small and affordable trinkets for the patriotic Federal period citizen (Sweeney 1963, 96). These figures were produced in Jasperware, a fine-grained, unfired stoneware invented by Wedgwood; the body was usually of a colored matte surface with applied molded decoration in white. Motifs of all sorts were used during the Federal period, and through pattern books, craftsmen were able to offer a multitude of styles to their customers. Hugh and John Finlay, working in Baltimore in the early nineteenth century, offered painted furniture with a variety of decorative embellishments: "Varnished, gilt and ornamented in a style not equaled on the continent—with real views, fancy landscapes, flowers, trophies of music, war, husbandry, love, etc., etc" (Krill 2001, 104).

SURFACE DECORATION

On the whole, surface decoration in Federal period homes tended to rely more on shapes, such as applied moldings, than on color and pattern. Certainly when seen in light of what was to come later in the nineteenth century, Federal period surface decoration seems quite subdued. This was one major difference between the Adam style in Great Britain and the young country's interpretation of it in the late eighteenth century. The Adam style, though light and delicate, was seen as too rich for the tastes of for-

The Eagle Motif

When Congress adopted the eagle as the national bird in 1782, it was not without some dissension. During the planning stages for the design of the Great Seal of America, a two-headed eagle, a rooster, dove, and phoenix in flames were all submitted as potential symbols for the country. The two-headed eagle was thought too reminiscent of heraldry, however, and the bald eagle was ultimately chosen. Benjamin Franklin later remarked that the final designs looked more like a turkey than an eagle. Furthermore, the eagle was a bird of "bad moral Character," while the turkey a more respectable bird, "a bird of Courage, and would not hesitate to attack a Grenadier of the British Guards who should presume to invade his Farm Yard with a red Coat on" (Franklin to Mrs. Sarah Bache in 1784 in MacArthur 2008). It was the eagle, however, that was added to the pantheon of motifs, rather than the turkey, and it was seen in a variety of forms. It was often gilded—on wood and metal—as well as appearing in relief on applied stucco carvings over doorways or on looking glasses. Expensive mahogany case pieces, such as chests, secretaries, and tall clocks, would feature carved wooden eagles as finials or as decorative inlays in central medallions on the surface. The eagle appeared everywhere—carved as a ship's figurehead, engraved into silver, pewter, or brass (particularly on brass plates for drawer pulls), embroidered on quilts or samplers, woven into carpets and wall hangings, and painted onto fine porcelains and common earthenware containers. Shields, a holdover from classical motifs, were also combined with the eagle for an image cast on iron firebacks, block-printed on textiles, or centered within a broken pediment over a mantelpiece. The eagle and shield, with accompanying arrows, stars, and olive branch, was also inlaid into fine furniture with lighter woods, in the center of tables, or in chair backs.

mer Puritans. Adam used gilt and multicolored marbles in his interiors, as well as vibrant pastels and, as was seen in his Etruscan-style interiors, contrasting colors of black, white, and terracotta. This proved too much for the more traditional tastes in America. The general spirit of Adam was retained—intricate, classical details and graceful lines—while reigning in the excess of color and pattern. The Federal style was a restrained Adam style.

Of course, these new changes in the Federal period took place mainly in affluent and middle-class homes, though for a middle-class homeowner, a simple interior update might be all that could be afforded. A new mantel carved in the

latest style, tinted walls, or a side chair made by a local craftsman using an English pattern book might be the most manageable change a middle-class citizen could make. In the poor and middling homes, however, surface decoration was rare beyond the plastered walls.

Walls

For walls in high-style Federal homes, the biggest change was the removal of full paneling throughout a room, a very heavy decorative motif that had been common in the Georgian period. Certainly one not in keeping with the latest desire for lightness and delicacy, the walls were gradually replaced with white or light colored plaster. Large expanses of wall were generally left blank in order to concentrate more decoration on individual forms, such as doorways, cornices, or mantelpieces. Earlier, more Adam-influenced walls would display cartouches, or ornamental panels, bordered with applied plaster strips, but as the Federal period progressed, less became more and a flat surface became more desirable. Decorative dados (the area below the chair rail) persisted in some cases throughout the Federal period, but were usually of a less ornate nature; oftentimes, the feature was paired down to the minimal chair rail that encircled the room, with flat plaster above and below. While the chair rail kept furniture from marking the walls, particularly during the early part of the Federal period when furniture was so moveable, it also functioned as a unifying theme for the room, drawing all the elements together in a single line. If paneling was kept below the chair rail to the floor, it was usually lightened visibly by painting it white. An alternative to white plaster decoration on wall surfaces was the process of graining, or painting the wood to resemble mahogany. This was seen on paneling, molded work, and particularly doors.

Wallpaper

Until after the War of 1812, the best wallpapers were imported from France and were quite costly. Produced in sheets of varying sizes (depending on the size of the paper mold), the papers were painted with a ground color for background before adding any decorative scenes or patterns with woodblocks (Seale 1979, 32). For affluent homes, these imported papers were the most fashionable and the most desired, and they were being advertised in American newspapers early on. "The most modern and tasty patterns" were promised by a Philadelphia ad in the 1780s (Sweeney 1963, 121). Before the turn of the century, designs were usually quite plain with decorative borders. After 1800, however, the patterns became more pronounced, with stripes or floral designs. The most elaborate papers featured picturesque scenes from abroad. An advertisement in the *New England Palladium* in 1817 featured "Setts of monuments of Paris, a very elegant Hanging"; French artist Joseph Dufour was responsible for many exotic designs that graced affluent homes (Sweeney 1963, 81). Other elaborate designs were *trompe l'oeil* imitating rustic stone arches or marble columns, such as was used in the front hall at Gunston Hall in Virginia. The choices for patterns could be dizzying: Thomas and Caldcleugh, Baltimore merchants, advertised over 200 patterns of wallpapers to choose from. Some homeowners ordered varnished papers, which would reflect candlelight in a darkened room, creating luminous and shifting designs, while others bought papers sprinkled

with isinglass or mica (or perhaps they would apply it themselves to save costs) to give a sparkling look to the room. Even if one could not afford wallpapers from France, itinerant artists were available to paint scenes directly onto the wall, often depicting local sights. The Carroll house in East Springfield, New York, had images of nearby Lake Otsego painted on the stair hall walls by one William Price. Stenciling was also popular for wall decoration, particularly in the New England area.

Wallpapers, however, were not desired in every room of the house; because of the expense of obtaining them, only the most public rooms would be papered, such as the hall, parlor, or dining room. Some Federal period home-owners eschewed wallpaper altogether; there were complaints that the papers could not be washed without being harmed and that they were more likely to harbor insects, something also thought of with carpets. It was also suggested that wallpapers and fabric wall hangings be kept to a minimum in dining rooms, as odors were believed to be more easily trapped in textiles (silk wall coverings were rarely seen after the Revolution). And as the period progressed, wall coverings in general were seen less and less and did not come back into prominence until well into the nineteenth century. In fact, many Federal period houses had no wallpapers, particularly for the middle and lower class; for many homeowners, plain walls were better used as a backdrop for the display of more costly furniture, looking glasses, and textiles.

If walls were not papered, out of choice or lack of funds, paint could be used to decorate surfaces. Most walls, if painted, were usually of a soft pastel; most homeowners relied on smaller touches of color to highlight certain areas of the room—colors with such names as "Verditure blue, Prussian blue, pea-green, straw, stone, slate, cream, or cloth" (E. D. Garrett 1989, 46). There were some bolder uses of color during the period, but like the Adam style of surface ornamentation, wall colors were usually toned down to suit American tastes. As was seen to a greater degree in the Victorian period, rooms in the Federal era were starting to become associated with male and female activities, with certain colors being appropriate for certain spaces. In dining rooms, for example, the most common colors were shades of reds and greens which, when paired with the darker woods like the mahogany that was used for much of the dining room furniture, gave the room a more masculine appearance. This was desired as it was in direct contrast to the lighter colors and woods commonly found in the drawing or sitting rooms of the period, which were understood to be more "female" domains.

Carved Decorations

Carved ornamentation on walls was used at the dado and baseboard level, around the fireplace, and along the cornice. Gougework, carved designs made with a hollow chisel, would encircle the room on the chair rail in a variety of popular patterns—egg-and-dart, guilloche, or simple fluting or fretwork. The same designs could also be found along the cornice or skirting board and the paneling that was left below the chair rail could be inset with carved panels or cartouches. Though the skill levels of native carvers were thought not to be up to English standards, many used imported pattern books to produce suitable copies. William Pain's *Practical House Carpenter* (1766) was published in

Boston in 1792, and gave craftsmen multiple motifs to reproduce—or at least be influenced by—for their clients (Kimball 1966, 259).

Fireplaces

The most elaborate decorations on interior wall surfaces were usually reserved for the carved elements comprising the fireplace surround. Decorative mantels continued from the Colonial into the Federal period, though where the former relied on heavy overmantels as well as surrounds, the latter paired down the elements and placed more emphasis on the frieze and supports. Very high-style Federal homes might have an imported marble fireplace for one or two principal rooms; some marble mantels were imported from England during this time, but because they were incredibly expensive, they were not often seen. Cast cement mantels were also used; William Thornton imported two mantels made of Coade stone for use in the Octagon in 1800 (Kimball 1966, 248). Most Federal period homes, however, had wooden mantels.

Pattern books abounded with decorative schemes for mantelpieces and craftsmen made use of books by William Pain *(Practical House Carpenter)* and Asher Benjamin *(The Country Builder's Assistant)*. Carved motifs on the surround could echo the cornice, with fretwork or egg-and-dart along a stepped mantel, or perhaps fluted pilasters along the sides. Carvings could also appear on the capitals of the side supports or on the entablature. Supports for mantelpieces varied, from pilasters, half-pilasters, columns, or panels. Columns would often be fluted or reeded, while panels would be enriched with applied festoons, ribbons, or bellflowers. Coupled colonnettes, however, did not appear until toward the end of the Federal period. The frieze above the fireplace opening likewise varied in embellishment. This space lent itself to decoration well and could be highly elaborate, with carved or applied composition elements such as classical scenes, medallions, swags, husks, or ribbons. Some would have simple geometric patterns, like Greek key or guilloche, while plainer examples would make do with inset panels. Wedgwood plaques centered in the frieze appeared early on, such as the example in the dining room at Monticello, but more native themes also appeared, such as the Horn of Plenty motif, or the eagle and shield. Earlier Federal period fireplace surrounds might have an additional overmantel of a pediment with urn-shaped finials and carved scrollwork. Toward the end of the period, motifs became heavier, more robust, with marble slips set around the opening and Ionic or Tuscan supporting columns on either side.

Ceilings

Ceiling decoration also varied depending on the finances of the owner. Affluent homes would have plastered ceilings with applied composition or plaster ornament; middle-class homes would have plain plastered ceilings, while poor and middling dwellings made do with boarded and whitewashed ceilings. Whitewash could be made cheaply at home and discouraged mildew; because it was prone to flaking, however, most whitewashes had to be refreshed every year (Seale 1979, 37). Though the Federal period downplayed much of the excesses of the English Adam style, the ceiling was one area that could be highly decorated. Composition ornaments or plaster-of-Paris molded elements were added in a variety of patterns and styles: modillions, rosettes, dentils, or egg-and-dart

motifs all appeared on ceilings in affluent homes. Some of the more elaborate examples would have a wide cornice covered in multiple repeating motifs, corner coves or quarter rosettes, and ceiling borders. Sunbursts would be placed in the center of the ceiling, often acting as a surround for a chandelier or hanging lantern, or even centered above a circular staircase.

Compartmentalized ceilings were directly influenced by English Palladian style. These were usually very deep moldings with heavy and elaborate designs. For Federal period ceilings, the sections dividers were quite flat and usually combined with more delicate motifs; rectangular, square, or oval segments would be set out on ceilings separated with thin applied moldings. Inside the compartments, decorations would most often consist of swags, husks, or bell-flowers formed into diamond or roundel shapes. The ceiling of the large dining room at Mount Vernon, completed in 1788, had a compartmentalized and coved ceiling and detailed plaster ornaments of agricultural elements, such as tools and crops. Plaster and stucco compositions were made in England and exported to America for use in such elaborate designs. The molds were also sold to craftsmen, who could produce decorative elements on the site. In addition to being pressed into a mold for shaping, wet plaster was also stamped with a die to form the design. Ceiling decoration, such as central sunbursts or medallions, and corner motifs were usually reserved for the most important rooms in the house, but they also gave way to simpler and plainer forms as the period progressed. As with other decorative elements in the Federal period home, pattern books were consulted for ideas. William Pain's two publications, *Practical House Carpenter* (1766) and *The Practical Builder* (1774), which reached the young country after the Revolution, provided architectural details for ceiling decoration as well as staircases, mantelpieces, and door surrounds.

Floors

As with ceilings, floors also varied from owner to owner. Before the turn of the century, softwoods, such as white pine, were the wood of choice for most floors in the New England region, while the middle and southern states used yellow pine. Most homes did not have hardwood floors until the mid-nineteenth century. Affluent homes laid down boards joined with tongue-and-groove joints, while common houses had irregular boards with differing widths, nailed or pegged to joists. The poorest dwellings, particularly in rural areas, might have made do with earthen floors, packed hard until a tough surface developed. Some wooden floors would be stenciled in repeating patterns along the edge, or in an all-over pattern imitating marble or even carpet, while others might be painted a solid color. Thomas Jefferson installed a parquet floor at Monticello in 1804, which was quite rare, using a combination of cherry and beech wood to form a diamond pattern (Calloway 1991, 218).

In the most high-style Federal period homes, entry halls might be laid in marble (on top of a wooden or brick framework), which, though cool in the hot summer months, could only be afforded by the most affluent homeowner. These floors were usually of solid white marble, although a checkerboard pattern might be picked out with alternating black or blue stones. (Staircases in these dwellings, especially those that led off of an entry hall, might also be laid in marble.) Other nonwooden surfaces could be found in many kitchens

and servants quarters during the Federal period; brick, flagstone, and, later, terracotta tiles were often laid in these rooms, usually directly on a bed of sand without any mortar. More sand would be spread on top to be worked into the cracks by daily use; in other instances, particularly in the Deep South, red stucco was used (E. D. Garrett 1989, 97). Kitchen floors, of course, would need constant cleaning and masonry surfaces could be easily washed. Such hard surfaces of wood, marble, and brick, even covered with rugs, needed repeated sweepings. Until the turn of the century, brooms were made from bound twigs, which would only remove larger clumps of debris from the floor. In 1797, however, a Massachusetts farmer, Levi Dickinson, discovered that stalks from broomcorn produced a much cleaner sweep, and his invention, as Bushman states, established "a new standard of cleanliness" (1992, 265).

Floor coverings varied according to the seasons as well as the finances of the homeowner. Most households went through seasonal changes, and in the hot summer months, bare floors were most commonly seen. For those homeowners who wanted an extra barrier against the dirt that inevitably was tracked in, there were many different options. One form of floor covering in the eighteenth century, particularly in rural New England regions, was a fine sprinkling of beach sand. Found in kitchens, parlors, even bedrooms, fresh sand would be laid down each morning, and, as one nineteenth-century writer stated: "drawn into a variety of fanciful figures and twirls with the sweeping brush, and much skill and pride was displayed therein in the devices and arrangement" (Schaefer 2006, 81).

A more common floor covering found in middle- and upper-class homes alike was a canvas floor cloth. This was seen most often in the summer months, when carpets were taken up, in lieu of a bare floor. Many were imported from England and Scotland and were painted in intricate patterns with bright colors, stenciled with fanciful designs, or even marbleized. For those that could not afford to import floor cloths, there were many artisans in America that offered their services, advertising their work as being in "the best, neatest, cheapest" manner (Krill 2001, 285). Canvas floor cloths could be easily cleaned and repainted when needed; it was even recommend that they be coated in milk and then buffed dry for extra shine (E. D. Garrett 1989, 34). Most importantly, canvas floor cloths kept wooden floors or expensive carpets from being damaged. In Federal period dining rooms, a crumb cloth or table rug was spread out under the table during meals. The cloth could be made of baize or brown linen, or drugget, which was a coarse wool fabric.

Straw mats were another cheap alternative for floor coverings and even in affluent homes might substitute for a finer carpet in the hot summer months. Like wall hangings, though, there were some that disapproved of straw matting, believing that it harbored insects and any smoke from fireplaces. Most straw mats were imported from England until the 1780s, when trade with China opened up a new source of matting, and by 1820, straw mats were referred to as Canton or India mats (Seale 1979).

While floor coverings of any type did not often appear in colonial homes, textile carpets were certainly a rarity and seldom seen before 1750. England was not able to have a successful carpet-weaving industry until the seventeenth century, and any carpets imported to the colonies from abroad were extremely dear. By the end of the eighteenth century, however, there were small weaving

workshops in Philadelphia that were advertising carpets, though it was after the Federal period, of course, before any extensive carpet industry in America began. Peter Sprague's Carpet Manufactory was operating in Philadelphia by the 1790s, and many other small carpet stores opened by the end of the eighteenth century.

Oriental carpets were quite valuable and were rarely used on the floor until the eighteenth century. Instead, affluent homes in the Federal period would have Brussels or Wilton carpets laid down. In England in the 1740s, certain carpets were produced on a machine with a wire-formed pile, rather than the Oriental method of hand knotting. If the loops of the pile were cut (which would give the carpet a velvety feel), it was known as a Wilton carpet; Brussels carpets had uncut loops. Axminster carpets, which were hand-knotted on a vertical loom but produced in both England and America, were still more expensive than the machine-made examples. Brussels and Wilton carpets were woven in strips of 27 to 36 inches wide and could be matched up to cover a large expanse of floor (Seale 1979, 79). Though carpets were made in England that imitated the Oriental examples, designs on Wilton and Brussels carpets in the Federal period displayed more floral and classical motifs, more in keeping with the patterns seen on wallpapers and other textiles, than on costlier carpets from the Far East.

Flat-woven carpets, produced on a loom without a pile, could be obtained for less by middle-class homeowners. And for some, these carpets could be woven at home. They were not as desirable for homes of any pretension, however, because they wore out quickly. For the lower-class house, many would have hand-made yarn or rag rugs; they were small, easily cleaned, and could be moved about as needed. Even in affluent homes in the Federal period, rag rugs were usually found in the service areas, kitchens, laundries, or servants' rooms.

NEW FURNITURE FORMS FOR NEW ROOMS

In the Federal period, many new innovative and specialized furniture forms were made, reflecting the distinct change that occurred in the lifestyles of Americans after the Revolution. The new furniture forms spoke of new configurations in American households—and new activities that needed new equipment. Where once a small side table had been multipurpose, individual ones were made for specific uses: card playing, tea drinking, or eating. Chests-of-drawers, which had contained a multitude of items, now began to specialize in their contents— linen chests, silver chests, bottle chests, or book chests. Many rooms also began to be used for specific functions, or reserved for a single purpose, such as dining, entertaining, and sleeping.

Leisure Time

Leisure time became important in the period immediately following the Revolution. As commerce began again, the wealth of Americans increased, and leisure suddenly became an important component to a person's life. More leisure time meant more time for relaxation and entertainment. The affluent always had some rooms devoted to entertainment, such as parlors, saloons, and

drawing rooms, but new furniture forms appeared that showed the growing importance of such spaces for both middle and upper class alike. Sewing tables, tea tables, writing desks, gaming tables, reading stands, and canterburys (stands for holding sheet music) began to appear in Federal period homes.

Gaming or card tables were probably the most ubiquitous of the newer furniture forms, and the most versatile. Usually small, lightweight, and extremely portable, these tables could stand along the walls of a room, out of the way, and then be easily moved into place when needed. Many of these tables featured attached leaves that could be folded, raised, or lowered depending on the size needed, and they often featured candle slides for holding lights. Though they could function as a surface for numerous activities, the fact that they were known as card tables shows their main use—as a table for sitting and enjoying an increasingly popular pastime.

Tea tables, usually with small, round tops on a pedestal support, were useful for displaying the treasured tea set of china or silver, as well as being used to serve the tea during that much beloved social event. Round-top tables usually featured a tilting top and could be stored against the wall out of the way. Larger rectangular or square tea tables were more stationary and tended to stand next to or near seating areas in the parlor or drawing room. When colonists first began to acquire tea items, such as cups, bowls, and pots, these treasured pieces (usually mismatched) would often be displayed on a mantel or in a glazed cupboard. But as early Americans were able to acquire more pieces, matched sets would be permanently displayed on a tea table, ready for use.

Sewing tables were small side tables designed to hold sewing paraphernalia. The top, which usually lifted up on hinges, would have compartments for thread, needles, and scissors, while a lower drawer or, more commonly, a silk bag attached underneath, would hold unfinished work. There would often be a candle slide that could be pulled out for supporting a candlestick for evening work. These tables themselves were often vehicles for a high degree of ornamentation—in addition to the decorative textile work that was associated with such pieces, often the top of the table itself would be embellished by the lady of the home or her daughters, with painting or inlaid designs, as proof of their artistic skills.

Writing desks also made an appearance during this time. The slant-top desk, which was a chest or bureau with drawers below and a slanted and hinged flat writing surface above, was a mainstay throughout the Colonial period and continued to be used by many early Americans. The Federal period writing desks, however, displayed a variety of new features. There were tambour desks, which had small reeded doors that could slide open to reveal smaller drawers and pigeon holes; cylinder desks, with either a reeded or solid curved top that slid up and down; and desks with a vertical, fall-front writing surface (as opposed to the earlier slanted top). Some fall fronts would lower to rest on slides, while others could be pushed into the desk itself. Secretary bookcases, featuring a desk below and bookcase above, were also becoming popular during the Federal period. Given a prominent place in the home, the piece showed that the homeowner was someone of status who needed books and a place to correspond and conduct business. And, of course, a lady's writing desk, usually kept in affluent dressing rooms or drawing rooms, was a delicate, highly ornamented piece.

In rooms specifically used for relaxation and conversation, sofas, settees, and numerous chairs were placed in groups throughout to facilitate easy conversation. As the period progressed, these configurations began to remain where they were, even when the room was not in use, quite different from earlier in the eighteenth century when chairs and tables were always ranged along the wall, placed carefully out of the way until needed. And, as expected, as new furniture pieces made their way into a home, older pieces were relegated to the second-best rooms, private spaces away from view. Only the most up-to-date furniture and furnishings would be seen in the public spaces of a Federal period household.

Dining Furniture

The addition of a dining room to many houses in the Federal period was a new concept. Previously, most homeowners except for the very affluent would eat in various rooms in the house, usually on small tables brought in and set up for just that purpose. After the meal, the table would be removed and the room restored to its usual configuration. To have a room that was specially set-aside for dining had been a sign of luxury. But in the Federal period, more homeowners were able to have separate dining rooms, even small ones, and these rooms resulted in new furniture forms for dining. One noticeable piece was the dining table. As the table was able to remain in the center of the room permanently, it could be longer than usual. Though some homeowners still used smaller side tables laid end-to-end as their dining table, extension tables became popular in the Federal period. Accordion-type mechanisms allowed the table to extend or retract to suit the number of guests and removable leaves were provided to fit in the center. Separate half-round tables for the ends were usually set against the wall and used as side tables when not needed at the main table. Perhaps the most important piece in the dining room, and often the most expensive, was the sideboard. Side tables, as mentioned before, had been in use for some time, but this was a new, purpose-built form, richly decorated, and made to be displayed. In England, the sideboard was sometimes put behind a columned screen to highlight its importance, while in America, many dining rooms in the Federal period were being built with a recess or niche along one wall just for the placement of the sideboard (E. D. Garrett 1989, 87). A sideboard would often have a serpentine front, which, along with the wall niche, would allow guests and servants to safely navigate a room crowded with people and furniture. A typical sideboard would have deep drawers on either side of a central drawer or cupboard. Many drawers were fashioned with compartments to function as wine and spirit holders, while others were lead-lined to be used as beverage coolers. The best silver serving pieces were displayed on the top, along with knife boxes, candlesticks, and crystal. George Hepplewhite, who designed many sideboards, thought the form indispensable: "the great utility of this piece of furniture has procured it a very general reception; and the convenience it affords render a dining room incomplete with a sideboard" (E. D. Garrett 1989, 87). A gilded mirror with wall sconces on either side usually completed the scene.

Bottle tables, also known as mixing tables, were another new form, created with a single function in mind, in this case, the display of glass bottles or

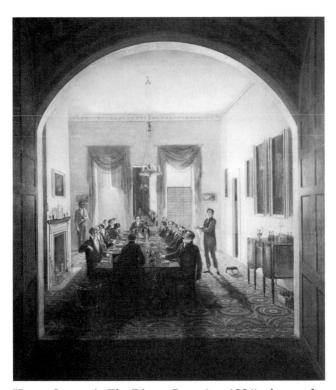

Henry Sargent's *The Dinner Party* (ca. 1821) gives a detailed view of an affluent interior in a Federal urban home. New furniture forms found in this dining room include a serpentine sideboard and a cellaret for cooling wine, in addition to a Wilton carpet covered with a "crumb cloth," looking glasses, and a mantle clock. Picturedesk.

decanters for alcohol. Usually set off to the side in the dining room, bottle tables could also double as a mixing table (for drinks) or as a serving table during a meal. A breakfront chest or secretary would also stand in the dining room, proudly displaying the china and silver of the owners. Other furniture that was deemed appropriate for a dining room in wealthy homes would be side and armchairs, the new cellaret (a separate box for holding wine and spirits), side and serving tables, china closets, wool carpet, looking glasses, family portraits, marble mantels, and a clock.

As for middle-class dwellings, often a back sitting room or parlor would double as an eating room. Even if a household were able to set aside a separate room for eating, it was often not used except on special occasions. Small, light tables usually kept off to the side could be set up in the middle of the room, with chairs brought in as needed. A typical dining parlor or sitting room of the middle class might contain a small side table, card or tea tables, a chest for tablewares, lightweight side chairs, and possibly a looking glass. In some northern urban areas in the Federal period, dining rooms might be found in the basement alongside the kitchen. This was not very desirable—a dearth of views, low ceilings, and a general lack of appropriate atmosphere kept many from laying out their house as such. In the smallest of homes, of course, the kitchen would double as an eating room (as well as the location for many other activities). Pine tables and chairs and other older pieces of furniture would naturally be found in a kitchen and could be used to fashion a makeshift dining area. In middling households during the winter, a family might choose to eat in the kitchen, taking advantage of the warmth from the hearth.

Built-in Furniture

The different room shapes that were being used in Federal period homes made for odd corners, sometimes creating difficulty in positioning a desired piece of furniture. Built-in furniture was not new; cupboards, sometimes with glazed doors, had been placed on either side of a fireplace in affluent colonial homes. These spaces, with solid doors, were also used for storing items such as linens and were referred to as closets. Many affluent homes in the

Federal period had closets located in such spaces: Wright's Ferry Mansion, in Columbia, Pennsylvania, had 10 closets; Dolley Todd (later Dolley Madison) had closets built into every wall with a fireplace in her Philadelphia home (Ierley 1999, 181). But with the new interior layout in the Federal period, more creative forms could be seen. Floor-to-ceiling bookcases with glazed doors decorated with intricate tracery were found in some of the most high-style homes. Built-in cases such as these would often be painted or grained to match the surrounding woodwork. Washington had bookcases installed at Mt. Vernon in the 1780s, with pigeonholes on top, shelves in the middle, and closed cupboards below (Calloway 1991, 225). Seating areas were installed in recesses on either side of the chimneybreast and, with the addition of some comfortable cushions, could function as a private conversation area. Thomas Jefferson developed a revolving, shelved cupboard, a *Beaufait,* as he called it, which could rotate between the dining room and the pantry for ease of service during meals. Built-in mirrors were also becoming popular in the Federal period, as were console tables, usually placed below, with a carved and gilt leg or bracket for support (Calloway 1991, 226).

DISSEMINATION OF STYLES

Much like architectural styles, designs for furniture and ornamentation came to America by way of pattern books from England. Most influential were George Hepplewhite's *The Cabinet-maker and Upholsterer's Guide* from 1788 and Thomas Sheraton's *The Cabinet-Maker and Upholsterer's Drawing Book* (1793). Both Hepplewhite and Sheraton drew heavily on Robert and James Adam's *Works in Architecture,* which provided designers an "encyclopedia of motifs" from which to borrow. Hepplewhite simplified Adam's furniture designs, making them available to a wider audience, while Sheraton's *Drawing Book* was made for a more specific craftsman, urging them to pay attention to, and use only, classical proportions in their furniture making (Krill 2001, 102). Both Sheraton and Hepplewhite replaced the intricate carvings of Adam with flat, though richly embellished, inlaid designs.

American furniture makers used such pattern books for their own creations. Krill believes that it was the spread of such pattern books (as well as the increased ease in transportation) that led to an American style of furniture, rather than regional differences that were present before the Revolution (2001, 105). As it was, the differences became much more subtle. Intricate inlay decorations or a particular turned leg could sometimes mark the hand of a certain craftsman or shop, as both shop owners and craftsmen began to hire out for piecework. The very craft system was changing at this time—market demands in the late eighteenth century necessitated a reorganization of furniture-making shops. Rather than the older system of a master craftsman training an apprentice or working with a journeyman, the master craftsman became the shop owner and hired specialists to complete only a section of a piece of furniture, while the relationship between the maker and the buyer had changed to one of marketer and consumer. And it also changed the way the craftsman/owner advertised his wares. Because of increased production and less contact between the maker and the buyer, labeling became standard practice. Manufacturers wanted to be associated with their pieces and their workshops. Many pieces were now being

sold at auction or abroad (as venture cargo) and needed to have identifying marks (Krill 2001, 105).

Importation of Luxury Goods

Luxury goods from abroad helped spread the new style throughout the young country. Men like Jefferson, Franklin, and Monroe observed first-hand the new style of furniture and design in Europe and brought back both knowledge and examples to America, while the immigration of English and French craftsmen brought their skill in producing these luxury items. After the Treaty of Paris was signed in 1784, the importation of goods from England, Europe, and China only increased. With new consumers, merchants from abroad found a wealth of customers for their wares.

Ceramics

With the opening of trade with China in 1785, Americans were no longer dependent on England for their ceramic wares. Fine porcelain pieces had made their way to the colonies earlier, but usually through England and were obtained by only the wealthiest of colonists. Early examples of export porcelain from China were usually smaller items, such as bowls, teapots, or small cups. Tea drinking increased in popularity throughout the eighteenth century, and China teawares were highly sought after. Small rococo patterns and floral or animal motifs were common in the early eighteenth century. Once Americans became steady customers of Chinese porcelains, the designs changed to reflect the tastes of the new citizens of the nation. As with other forms, rococo styles with vivid decorations were no longer favored. Instead, repetitive borders with central designs were more suited to American tastes. Many porcelain pieces were ordered with family crests or specific patterns; punch bowls with monograms or particular images of western culture, such as battles, cityscapes, or hunting scenes, were especially popular.

Chinese export porcelain often copied scenes from Western printed sources, hoping to appeal to affluent consumers. This punch bowl, which featured a panoramic view of figures on horseback, displayed the motto "Success To the Southern Hunt" on the interior. Winterthur Museum.

After 1760, ceramics became more common in American households, edging out pewter, which had dominated the scene. European ceramics such as Meissen and Sèvres were also exported, but it was England and China who were the main suppliers of ceramics to most Americans. By the 1770s, Staffordshire potteries created their own version of porcelain, a China glaze, or creamware. Common creamware was produced in many forms, creating matching sets of ceramics where none had existed before. Washington himself purchased a set of creamware—one with 250 items total—in 1770 (Krill 2001, 166). The earthenware bodies proved quite good at holding transfer-printed designs, and by 1776, transfer-printed wares were available in America, a definite cost improvement over hand-painted wares. Transfer prints al-

lowed for mass production of like pieces and were an excellent vehicle for designs in the Federal taste, particularly border patterns in popular styles such as Greek key, acanthus leaf, or egg-and-dart. Patriotic designs of battles, war heroes, or the new national bird, the eagle, could easily be printed onto wares destined for America. And the affordability of such cheaply manufactured wares meant that more Americans were able to obtain them, even if only a single piece.

Wedgwood

Josiah Wedgwood was the "quintessential entrepreneur" of the late eighteenth century (Krill 2001, 160). His innovative marketing techniques, as well as his invention and production of unique ceramic wares, transformed the dining tables, sideboards, and display shelves of early Americans. His creamware gradually replaced older stonewares and tin-glazed earthenwares in American markets by the 1790s. Wedgwood had a strong feel for the aesthetic trends in consumers, which, at the time, was a love of antique and classical motifs and styles. Numerous experiments with clay led to several different types of ceramics, all well suited to being produced in the latest and most fashionable styles of the Federal era. Wedgwood's addition of cobalt to a white body resulted in pearlware, a highly glazed creamware with a bluish tint. Pearlware began to appear in America in the 1780s, and by 1810, it was the most popular common ware. Another of Wedgwood's creations was Jasperware, a stained white body, usually blue, with white molded and applied decoration. This was well received in the new nation—any number of designs or scenes could be molded and attached to display pieces as well as other nonceramic objects, such as oil lamps, table clocks, or even as plaques or panels in looking glasses or on mantelpieces. America produced its own stonewares and earthenwares, but was unable to compete with the production of finer tablewares from abroad. Even a middling home might have one piece of ceramic ware from abroad, perhaps one with a decorative transfer print on it, or a small item of Jasperware, which would be displayed rather than used.

Luxury Textiles

Other luxury import items were wallpapers, carpets, and fine textiles. Wallpapers in particular lent themselves to the display of fashionable Federal era motifs. Papers were usually imported from France and advertised by American merchants as "suitable for every part of a house" (Sweeney 1963, 121). Styles ranged from geometric repeating patterns that mimicked exterior embellishments, to typical classical motifs of floral swags, medallions, or urns, and even classical columns or buildings. One popular design in wallpapers was the Etruscan style of palmettes, anthemions, and grotesques, a direct influence of Adamesque design. By the early 1780s, block and roller printing enabled faster production of favored designs on imported textiles. Typical motifs were classical busts, urns, eagles, even battle scenes. Though America had the technology for textile production, factories were unable to compete with English and European production until the 1830s.

Imported carpets were also a luxury item that only affluent citizens could afford in the early years after the Revolution, and before the 1750s, carpets of any kind on the floors of colonial homes were rare, usually being displayed

instead on walls or tables. In fact, before 1800, a *rug* referred to a bed cover rather than a floor covering (Krill 2001, 279). Oriental carpets were also known as Turkey carpets and were usually of a smaller size because of the expense. Their patterns did inspire French and English designs in the seventeenth and eighteenth centuries, though these carpets also began to display more rococo styles in the early eighteenth century, in keeping with the concurrent style of furniture and decoration. Brussels and Wilton carpets, which were both made in Wilton, England, were a bit more accessible to the American market, though still mainly available to the affluent. These had to be laid by professional upholsterers, which only added to the final cost. Axminster carpets were also another luxury textile imported from England, and because they were made by hand, like Oriental carpets, they were more expensive than Brussels or Wilton carpets. However, small textile factories had been producing carpets and rugs for the domestic market since the late 1790s, and power looms were being used for weaving by the 1810s in Waltham, Massachusetts. After the War of 1812 and the inevitable flood of imported goods, a protective tariff was placed on woolen goods coming into the country; at 25 percent, such a tax was a large impetus to the rise of the textile manufactories in America (Seale 1979, 80).

Middle-class Americans now had the opportunity to own new pieces of furniture or decorative objects—if not as well made or highly decorated as wealthy Americans could afford, then at least a reasonable facsimile. The rise in consumerism helped fuel the need for low-cost alternatives for high-style objects. Shop owners now needed increased capital to keep their shops running, and mass production of lower-quality goods helped offset the costs.

Craftsmen

The dissemination of style throughout the young country was not only helped by returning diplomats from abroad, but also by the immigration of foreign craftsmen. Duncan Phyfe (1768–1854) from Scotland and Charles-Honoré Lannuier (1779–1819) from France both set up furniture-making shops in New York City, while two sets of brothers, the Seymours from England and the Finlays from Ireland, became well known for their high-style furniture in Boston and Baltimore, respectively.

Duncan Phyfe established himself early on as a cabinetmaker of no small talent. Arriving in New York City in 1791, he quickly set up workshops and a showroom to display his wares. Phyfe interpreted the designs of Sheraton and Thomas Hope, whose *Household Furniture and Interior Decoration* was published in 1807. Phyfe's manner was light and delicate, in keeping with the Federal style of the time. A trademark motif of his became the lyre, which he incorporated into chair backs, sofa backs, legs, and inlaid surface design. He also used thin reeding on his arms and legs, which only served to heighten the sense of delicacy. Phyfe took advantage of the growing consumer market and distributed many cards and advertising bills to potential customers. Lannuier immigrated to New York in 1803, where he first produced furniture in the more severe French Directoire style. He soon began to incorporate Federal style elements into his designs, however, to compete with other cabinetmakers that were working in the more restrained English style. Lannuier also used different marketing techniques to gain more clients, such as continuing the French

tradition of affixing a maker's mark or stamp to his pieces, as well as a trade label (Kenny and Thurlow 2004).

The demand for furniture and other objects in the Federal period was high, and cabinetmakers and other craftsmen had to compete fiercely for work. Well-established or well-known craftsmen such as Phyfe and Lannuier produced mainly special order items for loyal customers, but they too needed to reach further out for business. Some craftsmen would ship their wares to other parts of the country, like the Mid-Atlantic or the South, in addition to destinations in the Caribbean. The items they shipped this way were usually larger lots of lesser quality and were destined for auction houses or warerooms. Lesser quality also meant lesser cost, so more middle-class consumers could afford objects that resembled more high-style pieces. Of course, for many Americans in the Federal period, a Phyfe chair was not a possibility, and for their furniture they turned to local craftsmen. Some had apprenticed with a master craftsman and were able to produce wares of fairly good quality for the middle and lower classes. Others were self-taught and usually began making objects for themselves out of necessity until starting to produce for others. These local artisans, however, had something in common with craftsmen such as Lannuier or Phyfe—the pattern book. Because they were being published at a rapid rate during the Federal period, everyone could be inspired by the designs of Sheraton, Heppplewhite, or Hope.

Reference List

Bushman, Richard L. 1992. *The Refinement of America: Persons, Houses, Cities.* New York: Alfred A. Knopf.

Calloway, Stephen. 1991. *The Elements of Style.* New York: Simon & Schuster, Inc.

Eighteenth-Century English Pattern Books Used in America

During the eighteenth century, nearly 40 furniture pattern books were published in England, and these were the chief source for dissemination of style to the former colonies. Most pieces directly copied from such publications were the expensive, special-ordered pieces, only available to the most affluent during the eighteenth century. Master craftsmen from abroad, such as Charles-Honoré Lannuier and Duncan Phyfe, settled in America and produced furniture from such publications. As these books made their own way west, however, and were republished in smaller, cheaper versions, local craftsmen could make forms similar to them, capturing the basic stylistic features, using less costly materials, and few ornaments, rather than direct imitation.

Thomas Chippendale's *Gentleman and Cabinet-Maker's Director* (1755) was the most influential pattern book for most of the eighteenth century. Even after the rococo style, which he promoted, had faded, it was still being seen in the American colonies; and after the Revolution, furniture was still being made that followed Chippendale's curving forms. Many furniture styles from the Mid-Atlantic and the South showed direct influence from Chippendale's *Director.* William Ince and John Mayhew's *Universal System of Household Furniture* (1762) was in direct competition for Chippendale's audience, and most furniture illustrated in this publication was also in the French rococo fashion, though not many examples taken from their *Universal System* were found in America. Later on, however, Ince and Mayhew produced pieces more in the neoclassical style for many of Robert Adam's patrons. John Crunden's *Joyner and Cabinet-Maker's Darling* (1765) and Robert Manwaring's *Cabinet and Chair-Maker's Real Friend and Companion* (1765) also were highly influenced by Chippendale's rococo style, and Manwaring's designs seemed especially popular in the Boston region. George Hepplewhite's *The Cabinet-maker and Upholsterer's Guide* (1788) was more devoted to the neoclassical style from the later eighteenth century, and many Federal period furniture examples from the Mid-Atlantic and New England areas can be related back to Hepplewhite's illustrations. Thomas Sheraton's *The Cabinet-Maker and Upholsterer's Drawing Book* (1793) also displayed neoclassical designs and was just as highly influential in Federal period America furniture styles as was Hepplewhite's book. Sheraton's motifs for chair backs were particularly seen in examples from Baltimore, Philadelphia, and New York (Heckscher 1994).

Fales, Martha Gandy. 1973. *Early American Silver.* New York: Dutton.

Foley, John P. 1900. *The Jefferson Cyclopedia.* New York and London: Funk & Wagnalls. Accessed from The University of Virginia Library Electronic Text Center. Available at: http://etext.virginia.edu/toc/modeng/public/JefCycl.html.

Garrett, Elisabeth Donaghy. 1989. *At Home: The American Family, 1750–1870.* New York: Abrams.

Garrett, Wendell, ed. 1998. *George Washington's Mount Vernon.* New York: Monacelli Press.

Heckscher, Morrison H. 1994. "English Furniture Pattern Books in 18th c. America." Accessed from American Furniture, 1994. The Chipstone Foundation. Available at: http://www.chipstone.org/publications/1994AF/Hechscher94/1994Heckschertext.html.

Ierley, Merritt. 1999. *Open House: A Guided Tour of the American Home, 1637–Present.* New York: Henry Holt & Co.

Kenny, Peter M., and Matthew Thurlow. 2004. "Duncan Phyfe (1768–1854) and Charles-Honoré Lannuier (1779–1819)." Accessed from Timeline of Art History. The Metropolitan Museum of Art, 2000–2007. Available at: http://www.metmuseum.org/toah/hd/phla/hd_phla.htm.

Kimball, Fiske. 1966. *Domestic Architecture of the American Colonies and of the Early Republic.* New York: Dover Publications.

Krill, Rosemary. 2001. *Early American Decorative Arts.* Walnut Creek, Calif.: Alta Mira Press, with Winterthur Museum, Garden & Library.

MacArthur, John D. 2008. "The Eagle, Ben Franklin, and the Turkey." Accessed from The Great Seal. Symbols. Available at: http://www.greatseal.com/symbols/turkey.html.

Morris, Anne Cary, ed. 1970. *The Diary and Letters of Gouverneur Morris.* New York: Da Capo Press.

Schaefer, Elizabeth Meg. 2006. *Wright's Ferry Mansion: The House.* Columbia, Penn.: The von Hess Foundation.

Seale, William. 1979. *Recreating the Historic House Interior.* Nashville: American Association for State and Local History.

Sweeney, John. 1963. *The Treasure House of Early American Rooms.* New York: W. W. Norton & Co.

"Washington to Morris." 1890. *The Century Illustrated Monthly Magazine* (May), p. 20.

Landscaping and Outbuildings

In the seventeenth century, American gardens were for basic subsistence; rare was it to find a plot of land set aside for purely ornamental use. The eighteenth century brought some leisure with it, and money, particularly during the Federal period, which enabled some (though a small minority) to have both land for work and play. As the growing middle class became wealthier, even the smallest of homes attempted to have some type of pleasure garden in addition to a vegetable garden. Both farmers and merchants found time on their hands and began to garden for pleasure as well as profit.

This chapter discusses the different types of gardens found in the Federal period in America. Working gardens, or gardens for subsistence, are examined, both rural and urban examples. The use of fences, so important for protecting property both in town and in the country, is also looked at. The republican values that were being promoted by the early leaders of the country had an impact on all facets of life, particularly on the agrarian lifestyle favored by Thomas Jefferson. The role of the gentlemen farmer, as well as the gardening books they used, is discussed. The rise of the early nurseries and seedhouses was also an important feature of the Federal period. Finally, pleasure gardens, or gardens for mere enjoyment, are studied—both rural and urban examples, as well as a special look at the role and configuration of outbuildings on a rural country estate.

WORKING GARDENS

The most elemental gardens in the eighteenth century were utilitarian, as they had been from the start. The early settlers to this country found fertile land

in abundance, but it had not been easy to tame. A garden was not a matter of comfort but one of life and death for so many colonists in the seventeenth and eighteenth centuries. At the beginning of the Federal period, nearly 94 percent of Americans were still engaged in farming, with only a few commercial farmers, mainly along the coast; most farmed merely to live (Favretti and Favretti 1977, 15). Of the remaining population, such as tradesmen, artisans, or the clergy who were located in more settled areas, even they had vegetable gardens for their own use and perhaps a cow or pig if space or finances allowed for it.

Rural Working Gardens

The layout of gardens and farmsteads for the middling and poor classes in rural areas was much as it had been at the beginning of the colony's history and remained so until the late nineteenth century. Any gardens were mostly functional and situated to take advantage of certain conditions, with little relationship to the house. A farmstead might consist of a few acres; larger crops, such as wheat or corn, were planted in fields further away from the house, while smaller vegetable plots were located closer. And as was common on most rural farmsteads, the women would work the smaller, closer plots, while the men took care of the larger fields; everyone, however, was involved in growing. Good soil was, of course, essential to any cultivation and would determine the location of the vegetable gardens. Sun exposure was also a consideration, and most gardens were planted on a southern slope, if possible, to take advantage of the early spring sunlight (Favretti and Favretti 1977, 20). Vegetable gardens were laid out much as they had been for centuries before, various-sized raised beds of like plants in an enclosed area. Small crops, such as onions, carrots, and peas, could be planted close to the house, while vegetables such as potatoes, corn, beans, and turnips, which needed more space, were located further away. Herbs were usually not grown separately from the other plants, but placed in the kitchen garden where they could be gathered easily while picking vegetables. Fruit trees, if present, were usually planted in the dooryard for convenience and shade.

Many Federal period farmhouses and single-room homes had yards that were indistinguishable from the farmyard surrounding them. While homes of the gentry and affluent classes sought to remove their dwellings from the immediate work area and keep service buildings at a distance from the house, others were not so lucky with their land and continued to live and work in the same space. The space between the grouping of outbuildings and the house was usually referred to as the dooryard, and it was here that most farm activity took place: clothes washing, butchering, soap making, candle making, or wood chopping. The dooryard was a busy place, as well as a sheltered one, situated in between the house and its buildings.

The idea of the *yard* has the deepest possible roots in the English language. The Old English word *geard* (YAY-ard) meant an enclosure, but it carried also the sense of world, and it is closely related to the word *earth*. At its broadest meaning, in the term *middan-geard* (middle enclosure or middle earth), *geard* meant the known world of humankind, the horizon of human existence and endeavor. The word gave us not only our modern English term for the enclosed space around a home, but also words like *guard*—words implying bounded-ness, security, and defense. (Garden, incidentally, comes from the same Indo-European root as *geard*/yard, but via the French *jardin*.) In America,

the idea of a yard came to mean the area immediately in front, back, or to the side of the dwelling. If there were gardens, the flower garden would be located on the front or side, where it could be seen by passersby, and the vegetable garden was located in the back (Leighton 1987, 81n1).

As for any outbuildings connected with a rural farmstead, they were generally placed for maximum efficiency, rather than design. In New England, outbuildings were usually placed to the northwest of the main house, to shield from cold winter winds. Barns, too, were sited in a location where any breezes might move odors away from the house. In the South, where there was more land and less harsh weather, farm buildings could be placed at further distances from the main house and from each other, because sheltered space was less of a necessity.

For the poor or middle-class farmstead, however, outbuildings were not numerous. A barn was a necessity for any livestock there might be. Another possible outbuilding found on rural farmsteads was a smokehouse, a great help for any homeowner who raised their own meat, particularly pigs. The smokehouse was usually brick or wood and could be small, but it was indispensable for the preservation of food for family consumption. Smokehouses were found throughout the South, on both poor and affluent homesteads, because southerners tended to preserve meat by smoking rather than salting, which was done more often in northern areas (Hill 1998, 37). Depending on the finances of the homeowner, a corncrib, woodshed, cow shed, tool shed, or forge might also be found on a larger rural farmstead, as well as a poultry house, though many farmers let the poultry have free rein of the barnyard.

A staple in most Federal period gardens, of course, was the outhouse, or privy. The placement of the privy in the garden was not a chance thing. It must be close enough for convenience, yet far enough away for propriety's sake. The form of the privy varied, again depending on the location, size, and finances of the homeowner and his property. The privy of most poor and middle-class families was a simple wooden shack with a door. In New England, privies were often connected to the house by a covered walkway, close enough for comfort on cold winter evenings, but far enough away for privacy. For the poorest of homes, of course, even a *necessary* was a luxury.

For middle- and upper-class rural homes, more land meant that gardens and cultivated land could be farther removed from the main living areas, particularly in the South. The strong agriculturally based economy there required more land and naturally moved most of the working areas some distance away from the main dwellings. On a large southern plantation there might be several farmsteads located in different areas, all contributing to the income of the household. Kitchen gardens, however, with small-crop vegetable and herb beds, would be located, as the name suggests, next to the kitchens. This would be the domain of the dedicated kitchen staff and, sometimes, of the lady of the house (McGuire 1992, 13).

Urban Working Gardens

Urban gardens for the middling class were not much different from the rural examples, though space was at a premium and some concessions were made as to layout. Literature of the time stated that one and a half acres of land would suffice for a kitchen garden for a small family, while four to five

acres was needed for a larger one. It was also important for it to be located in a sunny spot and not overshadowed by neighboring buildings, though close proximity to stables would help in the application of fertilizer. Except for the most affluent, economy of scale was essential for town gardens. For many, crops were the most important feature of their garden and took precedence over any ornament. Tightly aligned vegetable beds were planned to make the most use of small areas, and strict, orderly plantings were a common and necessary feature to urban gardens. There was little wasted space; fences or walls of some sort enclosed most spaces, and those surfaces could also be used for training vines of vegetables or fruits. The walls could absorb the heat from the sun and allow the produce to ripen quicker than it would on freestanding trees.

Most urban dwellings, even affluent examples, were built close on the street, so any growing space was relegated to the back and, if possible, the sides of the house. However, there were urban homes in New England, particularly Boston, where front flower gardens were popular. They were small, just the width of the house, with a path cut through the middle leading to the front door. For upper-class houses that had both working and pleasure gardens, the kitchen garden would be closest to the house, with the flower garden midway between it and the service buildings, usually located at the back of the property. However, unlike rural outbuildings, which could be placed some distance away from the main dwelling, most urban homeowners did not have the luxury of such space, and structures were placed where there was room. Often they were set on the very edge of the property line, with the stable, if there was one, situated farthest from the house. Most walkways to the outbuildings were laid out in the most convenient manner possible, and showed little of the strict geometrical design that was seen in the kitchen and flowerbeds. Privies, like their rural counterparts, were located on the boundaries of the garden (The Colonial Williamsburg Foundation 2007). In New England towns, outbuildings were often connected to the house by walkways or roofed passageways, while in the South, hot summers made the circulation of air vital, so buildings were set as far apart as space would allow.

A working area, much like the rural dooryard, was a needed feature for the urban garden, yet it was a luxury for the lower-class homeowner with little space. Like the poorer rural farmsteads, many urban gardens had no separate area for outside household chores, and work was done wherever there was room. For affluent urban homes, however, there was room for a separate work yard, which was usually laid with brick or fieldstone that, like kitchen floors, needed frequent and easy cleaning.

FENCES

One important feature of both rural and urban homes was a fence; they were a necessity. As Israel states, the three main incentives for fencing in colonial America were guardianship, proof of possession, and privacy (1999, 101). And it was not until, as Leighton says, "homeowners ceased to worry about being surprised by Indians and began to fancy a small sitting area near the house and in the garden," that fences took on a more decorative aspect (Leighton 1987, 3).

The earliest fences in America were used by seventeenth-century settlers as protection from the larger world (Indians) and the smaller (roaming livestock). Fences were made with whatever materials were close to hand, typically wood, which was in abundance. The earliest fence design was the simplest: palings or palisades surrounded early settlements, and with each stake usually six feet high or more, the palisade construction form could be a formidable barrier. Within the stockades, smaller plots of land were fenced as well to protect precious crops and flowers from domestic animals. These smaller fences for interior protection were usually of the post-and-rail type design. The rails needed to be close enough together to keep out dogs, cattle, or chickens, yet still allow for the circulation of air into the garden.

Pickets were found to be sturdier, as well as more impenetrable, and began to replace the post-and-rail design by the eighteenth century, particularly within the city. These early fences were wooden, usually upright stakes with two horizontal crossbars for support—the ever-popular picket fence. Wood was plentiful, and the fence was easy to construct. It needed to be painted and repaired frequently, but the basic materials were near at hand.

Most urban gardens were enclosed; not only were their owners anxious to keep out straying animals or humans, but many towns began to pass laws requiring land to be enclosed. There was even a "Viewer of Fences" in seventeenth-century New England who had the power to fine homeowners for inadequate fencing (Israel 1999, 101). And in Williamsburg, an act passed by the General Assembly in 1705 required that all homeowners build a fence around any new dwelling, at a minimum height of 4-1/2 feet, which would

Picket fences were sturdier than the earlier post-and-rail style and could be easily constructed and cheaply repaired. Courtesy of the Library of Congress.

"enclose the said lots, or half acres, with a wall, pales, or posts and rails, within six months after the building" (The Colonial Williamsburg Foundation 2007).

Animals still roamed freely in Federal period cities, and picket fences worked quite well to protect crops and houses. However, with the increase in street traffic in front of city homes, aesthetics also became a consideration, and neat rows of white, shaped pickets marching across the front of a dwelling had definite eye appeal. Most gardens, particularly those of the tradesmen and middle class, were bordered by wooden fences, usually painted white, although sometimes the gate would be painted a bright, eye-catching color, such as red (Sarudy, 4). Fancy wooden pickets could be bought that were cut in the latest styles, such as various Chinese-inspired designs. These were usually reserved for more affluent homes, while the other classes made do with plain upright stakes. Surrounding the homes of more prosperous merchants might be brick walls or perhaps a combination of brick and wood, imitating the stone and iron fence construction built on English estates at this time. The basic purpose of fences for protection was still the main reason for building them, and many city homes usually had more utilitarian board fences surrounding the sides and back of the house.

There were, of course, broad differences between urban fencing and rural fencing, namely a matter of utility. Simple but strong fences were used for agrarian purposes, while the decorative designs were favored in the city. Wooden fencing was used extensively outside of the city—on farms as well as estates of the Federal gentry. For agricultural uses, a version of the post-and-rail fence, the snake or zig-zag fence, was used extensively in the eighteenth and nineteenth centuries, predominately in the mid-Atlantic states and the South. The advantage of the snake fence was its ease in construction—there were no postholes to dig, and the fence itself could quickly be taken apart and relocated as needed. The amount of wood used for such fencing, however, was enormous when compared to other methods. One source calculated 15,000 rails were needed to enclose 160 acres with a snake fence, compared to only 8,800 rails for a post-and-rail design (Kulik 1996, 22). Nevertheless, it continued to be the dominant fence form for large agricultural enclosures well into the nineteenth century, when it began to be replaced with barbed wire.

Wrought iron was slow to be introduced in fence construction. The Hammersmith iron foundry was active from the 1640s–1670s in Lynn, Massachusetts (Southworth and Southworth 1992, 27). Though it produced mainly household items, the knowledge gained from this venture allowed the firm to begin to produce large-scale ironwork for gates and fences in the following century. The southern cities of Charleston, Savannah, and New Orleans seemed to have the highest output of wrought iron gates, as many European craftsmen had settled there and passed on their knowledge. The high cost, however, made such fences available only to the very wealthy. Some gate and fence elements were imported from England in the eighteenth century, and those that were produced here followed along the same lines—usually monumental stone piers flanking intricately designed gates, often with gilded lead ornaments such as eagles, urns, or balls on top. The malleability of wrought iron lent itself well to the intricate designs of the eighteenth century, but the output

was small. And though the cast iron process was not perfected until the 1830s, there were manufactories in New York that were offering cast-iron fencing at a cheaper price. In 1802, the Cupola Iron Furnace was able to advertise "Cast-Iron Railing of elegant patterns…which are handsomer, more durable, and much less expensive than wrought-iron," while another foundry promised "elegant and Fancy and Plain Cast Iron Railing for Fronts of Houses…superior to Wrought Iron" (Israel 1999, 105).

REPUBLICAN IDEALS IN AMERICAN GARDENS

Ancient Rome was a strong influence in the philosophy and ideals of the early leaders of the new country. And because the large majority of these men were, at the very least, landowners of some size, their thoughts concerning gardens, agriculture, and the pastoral life were influential in the cultivation of the nation's landscape. Classical texts by Virgil, Horace, Cicero, and Pliny the Younger extolled the virtues of the pastoral life; and many Federal period thinkers, such as Thomas Jefferson, took this philosophy as their own: "Ours are the only farmers who can read Plato," he said (Sarudy, 142). For some, the landscape of

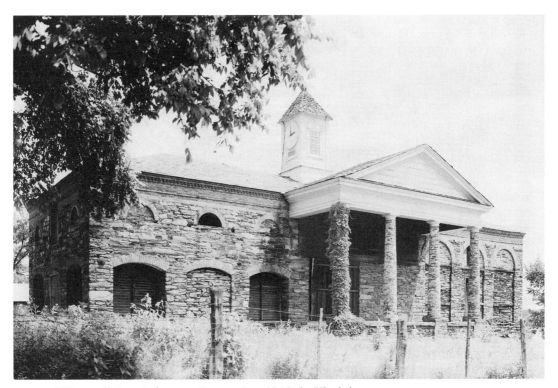

General Hartwell Coxe's barn at Bremo (ca. 1819) in Virginia, was a two-story stone structure with a hipped roof, a cupola, and a massive portico with Tuscan columns. Courtesy of the Library of Congress.

The Society of Cincinnati

In 1783, General Henry Knox founded the Society of the Cincinnati, the oldest military hereditary society in the United States. The Society was created on patriotic, fraternal, and financial principles (Hoey 1968). It was hoped that its members, former officers of the Revolutionary War, could use the group as a way of keeping in touch with fellow soldiers, as well as providing charitable resources for veterans of the war and their families. It was well known that Congress had been quite lax in paying officers of the Continental Army, and many did not have the private resources of someone like George Washington, who once famously told Congress that "the patriotism and long-suffering of this army are well-nigh exhausted" (Hoey 1968).

In keeping with the Republican fervor of the Federal period, the Society took its name from Lucius Quintus Cincinnatus, a fifth-century Roman farmer who twice left his fields to lead Rome—once in battle and once as temporary dictator. Both times, Cincinnatus voluntarily gave up his power to return to his farm. The basic motto of the Society, "He relinquished everything to serve the Republic," reflected the beliefs of the members that all was done for the good of the country. Washington, who was elected first president of the Society, was repeatedly compared to Cincinnatus, the civilian soldier, for his voluntary resignation from military duty after the war (The Hereditary Society Community 2003).

The formation of the Society alarmed many during the Federal period, who saw the very existence of a hereditary society in a country just freed from an oppressive rule as a dangerous one. Thomas Jefferson was one such critic, thinking it went against the republican principles that were the basis of the young country's revolution, while other leaders chafed at the idea of the use of government money for a private society. In the end, it was the Constitutional Convention that caused the furor to die down. Many members of the Convention were also members of the Society, and a general feeling of well being toward the group was restored once the Constitution was approved. Even Jefferson's attitude toward the Society mellowed over time, and he wrote to them to obtain funds for Central College, which would later become the University of Virginia. (The Society, however, had not mellowed toward Jefferson, and his request was denied.)

the young nation took on almost spiritual connotations—the land *was* America, and how it was laid out, cultivated, and managed would determine its future success.

One idea from abroad that had a small impact on some landscapes in the Federal period was the concept of the *ferme ornée*—the ornamented farm. Mainly an English conceit, it took the principles of a working farm and added the idea of an Arcadian landscape. Cupolas on cattle barns or Chinese-style fencing around kitchen gardens were little decorative touches that could be added to what were essentially work areas. General John Coxe placed the outbuildings to his plantation at Bremo, Virginia, over a rise at a distance from the house. Nevertheless, on his barn, which was an enormous stone structure with massive classical columns, Coxe added 10-foot-long wrought iron straps to the barn door and placed a clock tower, complete with bell, at the summit. Washington's kitchen and flower gardens had four pepper-pot-shaped houses within the walls, which were white with red roofs. They were very decorative and meant to be seen, even though two of them were used as seed and tool sheds, while the other two were necessaries. Jefferson's own privies at Poplar Forest were set on either side of ornamental mounds, built in a similar domed and octagonal shape like the house itself. Some Federal period homeowners even extended the decoration to include the cabins of their slaves. Rosalie Calvert designed her plantation's slave cabins to resemble small rustic huts with thatched roofs. One cabin was even redone as a little Roman temple with columns (Sarudy, 61). Some landowners in the Federal period, however, saw such embellishments as impractical and frivolous. While President, John Adams was concerned about "expensive ornaments" that were to be

added to his barn, though his wife insisted that his horses would be the "best-housed creatures in the town" (Bushman 1992, 247).

Gentlemen Farmers

Just as they had done with architecture, many men of leisure devoted themselves to agricultural experimentation, including Washington, Jefferson, and Madison, to name just a few. Some of them saw it as their duty to improve the lives of others. Washington wrote in 1788: "Experiments must be made, and the practice of such of them as are useful must be introduced by Gentlemen who have leisure and abilities and wherewithal to hazard something. The common farmer will not depart from the *old* road 'till the *new* one is made so plain and easy that he is sure it cannot be mistaken" (Leighton 1986, 150). Crop rotation was a large concern for many gentlemen planters, especially in the tobacco farming areas, where the harsh crop leeched vital nutrients out of the soil within a number of years, making the land useless for growing. Crop rotation had been known since ancient Rome, but it was not practiced by all. The four-field crop rotation of wheat, barley, turnips, and clover was popularized by British agriculturalist Charles Townshend in 1715 (Burchill et al. 2007). In America, Washington's experimental farm and promotion of crop rotation helped pave the way for greater agricultural strides in the country during the nineteenth century, as did Madison and Jefferson's experiments with soil composition and farming equipment.

Throughout the eighteenth century, gentlemen with a botanical interest participated in exchanging seeds and cuttings across the Atlantic. Englishmen were fascinated with American plants, and unusual flora from Europe was also sought for gardens in America. Exotic specimens, particularly tulips, were a favorite of the Federal period, and many varieties were named after classical thinkers (e.g., Cicero, Cato, and Archimedes) and American heroes (e.g., General Washington, General Harry Lee, and Dr. Franklin), which highlighted the strong connection between the present and the past (Sarudy, 147). Here, however, it was far more likely that an American gardener would show off his vegetable garden with just as much pride as an English landowner would display his collection of exotic flowers from all over the world. A visitor to a Boston garden in the 1790s remarked on being shown "elegant arrangements for amusement and philosophical experiment" (Sarudy, 152). Jefferson, Madison, and Franklin all corresponded with botanists abroad and helped disseminate horticultural knowledge throughout the young country. Earlier in the eighteenth century, Franklin and botanist John Bartram had started the American Philosophical Society in Philadelphia for the promotion of "Useful Knowledge, especially as it respects Agriculture, Manufactories, and the Natural History of North America" (American Philosophical Society 2007). And, most notably, Jefferson's purchase of a large expanse of land west of the Ohio Territories in 1803, and the subsequent expedition to the Pacific, brought a myriad of new plant material to the notice of gardening enthusiasts worldwide.

Jefferson himself experimented with a great many plants at Monticello. He attempted to grow olives from seeds that he had obtained while in Europe, and he and James Madison both tried their hand at growing rice on their plantations, though neither crop was successful. Jefferson believed, however, that it was "the greatest service" to introduce a useful plant to a culture, "especially a

bread grain; next in value is oil" (Hobhouse 1992, 264). His commitment to the agricultural advancement of the new nation did not stop him from trying, but his farms rarely, if ever, showed a profit.

Gardening Books

English and French treatises on ornamental gardening and landscape design were used by Americans to plan their own gardens, albeit on a much smaller scale. And just like architectural books, gentlemen on a tour abroad would often do so with a landscape book in hand. Both Jefferson and Adams carried *Observations on Modern Gardening* by Thomas Whatley during their travels through England in 1786. Jefferson seemed to prefer French gardens (and culture) to the English, while Adams's comments on his visits to some of the most famous gardens in England could be seen as wholly American, one that distrusts what he sees as artificiality: "It will be long, I hope, before Ridings, Parks, Pleasure Grounds, Gardens and ornamented Farms grow so much in fashion in America. But Nature has done greater Things and furnished nobler Materials there" (Leighton 1986, 359).

Washington owned *The Universal Gardener and Botanist* by Mawe and Abercrombie (1778), as well as Philip Miller's *Gardener's Dictionary,* which was on its 8th printing by 1768 (Leighton 1986, 254–255). He also owned Batty Langely's *New Principles of Gardening* (1728) and followed some of the author's suggestions in laying out areas of Mount Vernon, such as a serpentine entrance drive and informal groupings of trees (he also used Langely's *Builder's and Workman's Treasury of Design* at Mount Vernon as well). Jefferson, of course, had an enormous library of horticulture books, including Philip Miller's *Gardeners Dictionary* and Bernard M'Mahon's *The American Gardener's Calendar.*

Many circulating libraries, such as the ones in Annapolis, Baltimore, and Philadelphia, could provide the interested amateur gardener or botanist with a variety of texts to help in his improvements. Before the Revolution, books such as these were imported from London by the affluent, oftentimes in exchange for regular tobacco shipments or other goods exported by the colonies. The war curtailed much of the trading between booksellers and book buyers, but the decrease in tobacco production also had an impact on the importation of books from abroad. Coupled with a rise in a literate middle class, lending libraries began to appear more frequently. Booksellers realized the popularity of such a scheme and also started to lend books to readers for a nominal fee. The Library Company of Baltimore, which started in 1796, had 60 subscribers and 1,300 books. By 1809, however, the list had grown to more than 400 members and a stock of 7,000 volumes.

Nurseries

The earliest commercial nursery was the Prince nursery at Flushing, Long Island. Established in 1730 by Robert Prince, it originally stocked fruit trees brought to New York by Huguenot emigrants, but later added ornamental trees and shrubs. The nursery was well known for having the most exotic examples in the colony. Washington was a customer, traveling to Flushing soon after his election to the presidency. And when the British occupied Long Island during the Revolution, they posted guards around the nursery to keep

scavengers away. Many samples of flora from Lewis and Clark's journey found their way back to Prince's nursery (DeWan 2007).

Catalogues published by English nurserymen in the eighteenth century were also owned and read by American gardeners, collectors, and botanical enthusiasts. Bernard M'Mahon, an Irishman who immigrated to Philadelphia in 1796, was one of the most influential nurserymen during the Federal period. Though it might be legend that the Lewis and Clark Expedition was planned at M'Mahon's home, he was appointed by Jefferson to be in charge of all plants brought back from the trip, some of which ended up in M'Mahon's own garden. His *American Gardener's Calendar* of 1806 was highly influential well into the latter half of the nineteenth century. Like Asher Benjamin's builder's guide, the *Gardener's Calendar* was the first to offer advice specifically designed for the American gardener, taking into account soil and climate, just as Benjamin's guide examined native building materials. It was M'Mahon's intention to tender much-needed advice to the young country "which has not yet made that rapid progress in Gardening, ornamental planting, and fanciful rural designs which might naturally be expected from an intelligent, happy and independent people" (Leighton 1987, 68). M'Mahon's nursery was enormous, with his catalogues listing 3,700 plants, including ornamentals, vegetables, fruits, and trees (Leighton 1986, 320). His business paved the way for a flood of other seedsmen from abroad, many of whom had worked on large estates in England; most set up shop in Philadelphia or New York. David Landreth, an English plantsman, settled in Philadelphia shortly after M'Mahon. His seedhouse was one of the earliest in America, and he had nurseries in Philadelphia as well as Charleston, South Carolina (Howlett 1968). Other immigrants became traveling seed dealers, bringing stock with them from Europe to sell directly to customers rather than the large commercial nurseries. Some found it difficult to sell seeds or bulbs to ordinary gardeners, as opposed to amateur botanists, as the former might not know what the final product would resemble. One enterprising nurseryman would open his own garden in the spring, when his bulbs were in full bloom, and invite customers to mark the plants whose bulbs they wanted after the blossoms had faded (Sarudy, 68).

Seed and plant catalogues by nurserymen were also read by Federal period gardeners, many of whom sought to cultivate more useful plants and trees than merely ornamental specimens. As was seen in the case of decorative outbuildings, it was a need to maintain a balance between the useful and the decorative, to distance themselves from the aristocratic pleasure gardens of England, and to show they were knowledgeable of the natural as well as the physical world.

PLEASURE GARDENS

In Europe, particularly England, from which many ideas came to the young Republic, the three basic components for a successful landscape were space, trees, and water; America had all three in abundance (Leighton 1986, 361). And though many eighteenth-century English gardens were designed to recall one's classical studies, American pleasure gardens were instead for one's own private enjoyment. If one wished to design a formal garden along the lines of the English landscape style, it was remarked by many contemporary writers that little

needed to be done. Jefferson wrote that the countryside needed little induce-ment to beauty: America "is the country of all others where the noblest gardens can be made without expense. We have only to cut out the superabundant plants" (Hill 1998, 28). However true this may be, affluent homeowners did spend a great deal on beautifying their surroundings. Theodore Lyman, a Bos-ton merchant, laid out a garden at his house, The Vale. The house was designed by local builder Samuel McIntire in 1793 and was set on a hill with an open lawn that spread down to the canal below. Behind the house was a brick-enclosed garden with flowerbeds and fruit trees, with a hot house built into the side of the hill for the over-wintering of exotic plants. A summerhouse with col-umns was built into the brick wall, while another acted as a terminal point to a curved walk that led from the main house. Other pretty summer houses featured bell-shaped roofs.

In the early decades of the eighteenth century, most homes did not have the space—nor homeowners the income or inclination—to set aside large plots of land for pleasure gardens. After 1750, however, many homes aspired to have a courtyard or front garden of some sort. A visitor to Worcester, Massachusetts, in 1794, remarked: "Most of the houses have a large court before them, full of lilacs and other shrubs, with a seat under them, and a paved walk up the middle" (Bushman 1992, 135).

Ornamental gardens on rural farmsteads were very rare; because they took extra time and care, most poor and middle-class homeowners had little desire to have one. Sometimes, however, a small patch was set aside, usually on the side opposite the dooryard, for the planting of a few flowers or herbs, though most space was given over to subsistence crops. However, as the growing

Light and airy summerhouses were often used for training flowering vines. The Hodges-Peele-West summerhouse (ca. 1804) in Salem, Massachusetts. Courtesy of the Library of Congress.

middle class became wealthier, they found they had more leisure time, and even the smallest of homes would attempt to have some type of pleasure garden in addition to a vegetable garden. Both farmers and merchants found time on their hands and began to garden for pleasure as well as profit.

Urban Pleasure Gardens

Ornamental city gardens in the Federal period followed much of the same trends as had been popular in England in the seventeenth century. The strong geometric lines of Stuart England translated well to the compact and boxy lots that surrounded most urban dwellings. In the early eighteenth century, boxwood had been used for edging beds found within such rigid plots, and it continued to be the plant of choice for gardens to keep their geometric beds in place. Even toward the end of this period, when larger gardens were following a more natural, picturesque style, city gardens remained more or less as they had been throughout the eighteenth century. A major component of an urban garden was a central walkway. This usually connected to the house at one end, traveled through the garden, and ended at a distinct feature. The pathway could be from 4 to 15 feet in width, depending on the overall size of the plot (Favretti and Favretti 1977, 34). Gravel was the most common material used for garden pathways. In the North, flat fieldstone was also used, while brick was often seen in the South. When building up a gravel path, lime rubbish and large flint stones were placed down 8 to 10 inches thick, which would discourage any weeds from growing up on the path. Then gravel was laid 6 to 8 inches thick. Rolling the path was also recommended, particularly after hard rains, to settle the surface and bind it (Favretti and Favretti 1977, 12–13).

Larger gardens would have cross paths intersecting at angles with the main path, with beds for flowers and small shrubs located in-between the paths. As mentioned previously, the path usually began at the house and ended at a distinct feature, which could be as simple as a small bench or chair, an urn, or perhaps a more elaborate feature such as a summerhouse, an arbor, or a wellhead. Space permitting, a central feature was sometimes placed on the main axis, such as a sundial or armillary, or even a fountain.

Ornamental gardens of this sort would usually only contain flowers, and perhaps herbs, rather than vegetables, which would be in a different location, space permitting. However, fruit trees were often planted at the edges of ornamental city gardens, along the outside walls or perhaps in the corners; pear and peach trees were especially popular (Favretti and Favretti 1977, 35). If there were a kitchen garden as well as an ornamental garden for an urban house, the ornamental garden would most likely be found in front of the house, while the vegetable garden would be placed in a more private location to keep crops safe from poachers.

Many urban gardeners had more delicate plants in earthenware pots or even wooden half-barrels. Except in the South, harsh winters would destroy all but the hardiest of plants and much care was taken to protect delicate, rare, and certainly expensive plants from the weather. Additionally, potted plants could be moved about, facilitating a quick and easy change in the layout of the garden.

Although not every urban garden was used for relaxing as well as sustenance, many did have some form of seating—if not for comfort, then to aid

in working in the garden. Sometimes it was little more than a stump or grassy hillock. Lightweight chairs, such as Windsor chairs, were often taken out into the garden for temporary use. "Garden seats," however, were being made and advertised in many cities during the Federal period; one particular workshop in Baltimore had chairs for sale that were "made and painted to particular directions" (Sarudy, 12).

Urban gardens were almost always enclosed by wooden fences or stone or brick walls, depending on the availability of materials and the finances of the homeowner. Fences around ornamental gardens usually contrasted with those around utilitarian gardens. Even wooden pickets might be whitewashed to give the plot a more graceful air, while rough-hewn boards or rails might suffice for the vegetable garden and certainly were used for fields or larger areas of land that needed enclosing. Wooden pickets were one of the easiest and cheapest types of enclosures; the stakes were placed close enough to keep animals out but far enough apart to allow air to circulate through them. Stone or brick walls, of course, gave more privacy, but they were also more expensive to build and maintain. A brick wall surrounding a property was a clear sign to passersby of the owner's wealth. These enclosed gardens could also be found on country estates of a certain size, located in the back of the main dwelling. An enclosed garden such as this would afford a great deal of privacy, just like the medieval *hortus conclusus* that inspired it.

Though arbors were found in country landscapes of the affluent, they were quite popular with urban dwellers. Arbors were constructed in some gardens for both decorative and useful purposes. Flowering vines could be trained to wind their way up the supports and over the arches, providing a shady and private place to walk or sit, as well as a screen for undesirable views, such as from a back street or a privy. They also could hold fruit or vegetable vines. In the eighteenth century, arbors were usually painted green, as were many other garden structures, such as seats, rails, and fences; it was thought that green most easily blended in with the surrounding environment (Hill 1998, 16).

Rural Pleasure Gardens

Federal period gardens in country homes of the wealthy began to move away from the older style of rigid lines and became more naturalistic, in keeping with the latest landscaping ideas from England. Whether it was through word-of-mouth, books, or first-hand knowledge, some affluent homeowners either changed the landscape around their dwellings or built gardens from scratch that tried to mimic the sweeping and curving layout that was popular in England. Instead of a main path laid on an axis with the main house, garden paths were now supposed to curve and meander, following the lines of the beds, which had also lost their straight edge. Hills and depressions were used to give texture to the sweeping lawn, and clumps and belts of trees and shrubs were scattered throughout the landscape to act as visual markers.

It must be noted, of course, that many gardens during the Federal period, like architectural styles, were a combination of many different ideas. Older landscapes might take on new features in the latest styles, but rarely would they be completely replaced. And in other cases, the older style remained in strong evidence. One such feature was the entrance to the country home.

Many affluent Federal period country homes kept the original straight avenue, lined with single or double rows of trees, as the main approach to the house. Some landowners building from new also set the main road on an axis with the house.

The whole business of creating a *natural* feel to the garden was, in fact, quite complicated. The ha-ha, a feature from mid-eighteenth-century English gardens, was used in several notable Federal period country gardens including Mount Vernon and The Highlands, in Whitemarsh, Pennsylvania. Giving the impression of vast amounts of land stretching far into the distance without intervening barriers was helped by the invisible trench of the ha-ha, which would allow livestock to seemingly wander free within the view of the visitor, without coming close enough to spoil the illusion. Water was also seen as an essential part of a naturalistic garden. Unlike the rectangular pieces of water laid out in European gardens of the seventeenth century, pools, streams, and cascades were fashioned to add a touch of wildness to the surroundings (Favretti and Favretti 1977, 41). Both Jefferson and Washington, as well as other affluent men in the Federal period, succumbed to the English natural style and cut winding paths through their gardens. Monticello's serpentine walk around a lawn was one example. Jefferson also planned at one point to add some temples, a grotto, and a cascade to his landscape, all quintessential elements of the English style of landscape gardens (Favretti and Favretti 1977, 35).

Another conceit of the natural landscape style was the wilderness, which was a planting of trees informally grouped, rather than in the rigid lines still seen following the avenue to some older homes. Woodlands and Solitude, both located near Philadelphia, had a wilderness on their grounds, and a plan from 1787 shows two clumps of loosely grouped trees on either side of the main house at Mount Vernon. The new American landscape was, of course, filled with natural wilderness; however, the lure to follow English style, even after the Revolution, stayed with many people.

Though terraced gardens were also from an earlier age, they remained popular for some during the Federal period. For the affluent homeowner who had enough land to spare, a series of terraces falling away from the main house gave a sense of grandeur to the landscape. The level parts of the terraces could be planted with flowers or vegetables, with the slopes or falls covered in grass. At Montpelier, Dolley Madison arranged for a series of terraces to be built in her walled garden, with fruit trees to border the sides.

Though change was slow to come to all things, there was a clear difference in the design of flowerbeds during the first half of the eighteenth century when compared with the latter part of the century. Previously, many flowers were laid out in complicated designs; knot gardens had been around for centuries and continued to be favored by many. However, during the Federal period, many flowerbeds began to be laid out by type or variety. Botanical interest in different species piqued a greater attention to the form rather than the style of a flower. Seed merchants helped foster this interest in exotic plants, and many specimen gardens were planted in small plots for an affluent gentleman's enjoyment.

Gardens in general during the late eighteenth and early nineteenth centuries had basic designs: flowerbeds were usually planned in small squares, while vegetable gardens were placed in rows. If the landscape were of a size to warrant it, a path or drive to the house would be curved, with clumps of trees and shrubs

placed at appropriate locations to break up the view from and to the house. Long views were sought and encouraged.

Like the grand gardens of England, affluent homeowners in America had visitors to their estates and showed off their landscapes and crops with enthusiasm; many visitors also wrote of their impressions. Abigail Adams described an estate at Richmond Hill, near New York City, in 1789. The house itself sat on a hill, which afforded it rich views of the Hudson as well as the city. Clumps of trees and hills were scattered about the ground, "which serves to heighten the beauty of the scene, by appearing to conceal the part," which was a basic element in English landscape gardens at the time. Behind the house was the ornamental garden, "a large flower-garden, enclosed with a hedge and some very handsome trees. On one side of it, a grove of pines and oaks fit for contemplation" (Leighton 1986, 378). The influence of English landscape gardening and the emotional impact it tried to convey was very present in ornamental gardens in late eighteenth-century America. At another grand home, that of Bush Hill in Philadelphia, Adams writes of a grove situated behind the house, with a "spacious gravel walk, guarded by a number of marble statues" (Leighton 1986, 379). In both instances, the land beyond the gardens was given over to the growing of crops.

Statues were sometimes seen in pleasure gardens of the gentry. Originally imported from England and Europe by only the wealthiest colonists, statues were being produced in the Federal period in places such as Philadelphia. An ad from 1796 described "six elegant carved figures, the manufacture of an artist in this country, and made from materials of clay dug near the city, they are used for ornaments for gardens" (Sarudy, 44). Figures from Greek and Roman mythology were popular, as were philosophers and poets; all were calculated to show that the homeowner was a man of taste and learning. Important figures from the young country's own history were also produced. The historical portrait bust, which had been used since classical times, began to portray more contemporary figures. Another ad from Philadelphia, also from 1796, promised busts of "Gen. Washington, Marquis La Fayette, [and] Doctor Franklin" (Israel 1999, 44). Vauxhall Gardens in New York City was mentioned as having a statute of Washington by 1805, only six years after his death (Sarudy, 45). Both marble and stone continued to be used for statuary, though cast-iron and cast-stone, such as Coade stone, began to appear in America after the Federal period. Lead, which was used in England, was not seen very often in America.

As mentioned, seating in the garden usually took the form of lightweight chairs, such as Windsor chairs, which could easily be moved about the garden as needed and then returned to their spot, which was usually on the front porch or in the center hall. Washington had several dozen Windsor chairs positioned on the piazza at Mount Vernon, ready to be moved to the garden if needed. While some garden seats were quite plain, like the Windsor style, others mimicked more substantial and costly furniture found inside the house. Chinese fretwork, as was depicted in many pattern books, such as William Halfpenny's *Rural Architecture in the Chinese Taste* from 1755, was a popular choice for a decorative bench; one such pattern was called "Open Gates with Dutch Battend Pannels and Chinese Barrs" (Israel 1999, 78). On the whole, however, garden seating was more common in England, where there were many pattern books

that gave examples of seats and other decorative features for the outdoors. Charles Middleton's *Decorations for Parks and Gardens: Designs for gates, garden seats, alcoves, temples, baths, etc.* (1800) and Charles Over's *Ornamental Architecture in the Gothic; Chinese and Modern Taste* (1758), both published in England, show the range of designs and forms available for English estate owners. Such furniture was not that common in America until later in the nineteenth century, and cast iron chairs and benches, so familiar to the nineteenth-century garden, were not seen very much during the Federal period (Hill 1998, 40).

Besides sitting in the garden, enjoying the views, a few affluent homeowners provided entertainment areas for themselves and their guests. Arbors, like in urban gardens, were popular in rural pleasure gardens as well. They were seen most frequently in the South, where they provided a welcome respite from the hot sun. Mount Vernon had a bowling green in the center of a large expanse of lawn for outside activities, as well as a serpentine path for leisurely strolls around the garden. Celebrations were held in the garden—dances, dinners, and weddings; a French visitor to Virginia remarked on a wedding he attended with "at least a hundred guests, many of social standing, and handsome, well-dressed ladies. Although it was November, we ate under the trees" (Sarudy, 112).

Outbuildings

Many Federal period homes of the affluent class linked various outbuildings to the main house by wings, or *hyphens,* as was done before the Revolution. The Lyman house and the Gore house, both in Waltham, Massachusetts, used wings to connect service rooms. Sometimes the wings were two rooms deep, such as with Tudor Place, in Washington, D.C., which had principal rooms on the back or garden side and service passageways on the front. Other designs used open terraces or colonnades to bring the outbuildings into the main structure. At Bremo, in Fluvanna County, Virginia, as well as at Jefferson's Monticello, the outbuildings were situated below grade and were linked with terraces (Kimball 1966, 189).

Much like rural homes of the middle class, affluent homes of the Federal period also had unattached

Dovecotes were a common feature in many Federal period gardens and were a useful as well as decorative addition to the grounds. Courtesy of the Library of Congress.

Influential Eighteenth-Century Gardening Books of the Period

1711: *The Dutch Gardener, or the Complete Florist* (Hendryck Van Oosten)
Gardener and author Van Oosten wrote important treatises on the methods of growing delicate fruit trees, such as oranges and lemons, in a harsh, northern climate.

1712: *The Theory and Practice of Gardening* (John James)
British architect James translated early French and Italian architectural treatises as well as an edition of d'Argenville's *Theory and Practice of Gardening*, introducing an English audience to European designs.

1715: *The Nobleman, Gentlemen, and Gardener's Recreation* (Stephen Switzer)
Gardener and garden designer Switzer wrote several horticultural volumes, including books on kitchen gardens and orchards; he also developed an irregular style of garden design that ran counter to the contemporary formal layout.

1725: *A Survey of the Ancient Husbandry and Gardening* (Richard Bradley)
A Fellow of the Royal Society, Bradley wrote numerous books on garden history, animal husbandry, and planting improvements.

1726: *A New System of Agriculture* (John Laurence)
Laurence, an English clergyman, published work on the "pleasures" of gardening for gentlemen, as well as fruit cultivation.

1728: *New Principles of Gardening* (Batty Langely)
Langely, a garden designer and architect, promoted the use of Gothic and medieval elements in garden architecture, particularly the addition of picturesque ruins.

1731: *The Gardener's Dictionary* (Philip Miller)
The Gardener's Dictionary became the standard reference work in the eighteenth century and went through many editions. As well as being an author, Miller is also credited with introducing nearly 200 American plants.

1736: *Fundamenta Botanica* (Carolus Linnaeus)
Considered to be the "Father of Botany," Linnaeus introduced clear and systematic descriptions

outbuildings arranged around the main dwelling. But with more space, the buildings could be placed with an eye toward aesthetics as well as utility. In addition to the main dwelling and stable, outbuildings might also include a carriage or *chaise* house, a smokehouse, icehouse, milk house, springhouse, poultry houses, washhouses, a forge, and a summer kitchen. This is in addition to any structures that might be found in the garden, such as privies, well house, tool shed, greenhouse, dovecotes, and summerhouses or gazebos. Jefferson designed a brick summerhouse of his own to sit on top of the wall enclosing his vegetable garden at Monticello. It was a simple cube with a pyramid-shaped roof, double-sash windows, and a Chinese fretwork railing; it looked out onto his kitchen garden and down the hill to the vineyard, orchard, and rolling hills below his home.

Icehouses were found on affluent country estates in the South and Mid-Atlantic. Usually built on top of a mound or hill, a chamber was dug in the hill with an entrance on the side for loading blocks of ice packed in straw. Some homeowners would build small decorative structures such as summerhouses on top of icehouses, which would economize the land while also lending decoration to an otherwise utilitarian object. At Montpelier, James Madison placed a rotunda (supposedly designed by Thomas Jefferson) atop his icehouse, with a stone hatch located in the center of the floor. The structure itself was circular, with freestanding columns that supported a dome. Hampton, near Baltimore, had an elaborate icehouse, with a domed brick ceiling, fieldstone walls, and an underground vaulted passageway, all disguised as a turf-covered mound. The ice chamber itself was nearly 34 feet deep, which would insure that the straw-packed ice would survive much of the summer to cool liquids and foods for the family (Sarudy, 60).

Another less mainstream style that appeared in American gardens was the rustic style, which again had been used in England for some time. Elias Derby's house in Peabody, Massachusetts, was designed by Samuel McIntire in 1794, and in addition to an elaborately classical, two-story teahouse, the garden also boasted a hermitage covered in bark (Hill 1998, 34). The teahouse, like many other ornamental buildings in affluent gardens, also doubled as a practical object; in this instance, the ground floor was used as tool storage. Another instance of practicality and beauty was found in a stone garden house in Pennsylvania, built in 1790. The owner of The Highlands, Anthony Morris, built the ornamental house over a spring, and it had shelves on its lower level to hold perishable foods.

Practicality combined with style was something many Federal period homeowners strove for. Those inspired by Enlightenment thinking, such as Jefferson, felt it important to try and balance beauty with utility; rational ideals would applaud the usefulness of an object, while at the same time, appreciating the aesthetics of something well made. Dovecotes and fishponds could be attractive, but they could also provide food, while brick walls surrounding a garden would show a man's wealth and style and protect his crops. As Sarudy states, there was an "implicit moral sanction" that required ornamental gardens to be more than just pleasure grounds. A visitor to a Maryland plantation during the Federal period wrote that the grounds were "so judiciously disposed that utility and taste are everywhere" (Sarudy, 62).

Dovecotes, or pigeon houses, were often a feature in Federal gardens, both urban and rural. Birds were raised for consumption by the family and, in the cases of urban settings, often for use in a restaurant or tavern. Dovecotes were

(continued)

of plant life, which later evolved into the present system of scientific classification.

1737: *Systema Naturae, Critica Botanica, and Genera Plantarum* (Carolus Linnaeus)

1747: *The Natural History of Carolina, Florida, and the Bahama Islands* (Mark Catesby)
Catesby, an English naturalist, published the first accounts of North American flora and fauna and collected plant samples on his travels, which he sent back to England for study.

1749: *Histoire Naturelle, Générale et Particulière* (Georges-Louis Leclerc, Comte de Buffon)
Buffon was a French naturalist and author who also wrote on mathematics, the environment, and the solar system and was an early proponent of possible links between humans and apes.

1750: *Philosophia Botanica, and Species Planatrum* (Carolus Linnaeus)

1769: *Every Man His Own Gardener* (Thomas Mawe and John Brown Abercrombie)
Abercrombie, the son of a market gardener, wrote books that became the standard gardening manuals during the later-eighteenth and early nineteenth centuries.

1770: *Observations on Modern Gardening* (Thomas Whately)
Whately wrote one of the earliest treatises on the practice of English landscape gardening; both Jefferson and John Adams toured Britain with their own copies of Whatley's *Observations on Modern Gardening.*

1775: *Arboretum Americanum, The American Grove* (John Bartram)
Bartram, called "the greatest natural botanist in the world," was Botanist to the King for the American colonies, as well as friend to many prominent early Americans. He had one of the largest collections of trees in the country and was among the first in America to perform hybridization experiments.

1780: *The History of the Modern Taste in Gardening* (Horace Walpole)
Politician and author Walpole wrote *History of the Modern Taste* as an essay on garden design, especially regarding what he saw as a particular English invention, the landscape garden.

(continued)

1780: *Letters from an American Farmer* (Michel-Guillaume St. Jean de Crevecoeur)

Letters was one of the seminal texts written on American husbandry in the eighteenth century, a collection of essays that described the life on the American "frontier" to a European audience.

1780: *Historie Naturelle* (Georges-Louis Leclerc, Comte de Buffon)

1783: *Dictionnaire de Botanique* (Jean Baptiste Lamarck)

French naturalist Lamarck traveled extensively, studying different types of flora and fauna, before working in the French Royal Gardens as a botanist and zoologist.

1788: *Les Epoques de la Nature* (George-Louis Leclerc, Comte de Buffon)

1791: *Travels through North and South Carolina* (William Bartram)

The son of botanist John Bartram, William was one of the earlier plant explorers; he recorded his findings and influenced later generations of gardeners, botanists, and naturalists.

1792: *Remarks on Forest Scenery and Other Woodland Views* (William Gilpin)

Artist and author Gilpin published several essays on the depiction of nature in art and was the first to use the term *picturesque* when describing a certain type of natural scene; the word was used in both art and landscape design.

1792: *The Farmer's Almanac* (Robert B. Thomas)

Now known as *The Old Farmer's Almanac*, it has been in continuous publication since the first issue.

1794: *Sketches and Hints on Landscape Gardening* (Humphrey Repton)

Repton followed in the footsteps of garden designer Lancelot "Capability" Brown to become Britain's leading landscape gardener, a term he was credited with inventing.

1797: *Essays and Notes on Husbandry and Rural Affairs* (John Beale Bordley)

Bordley, an agriculturalist and surveyor from a prominent Maryland family, experimented with crop rotation, planting improvements, and animal husbandry at his plantation on Wye Island in the Chesapeake Bay.

made of wood, stone, or brick, depending on local materials and the finances of the homeowner. Many were built to be decorative as well as utilitarian, but they did not need to be substantial and were often nothing more than a wooden box mounted on a pole. While other domestic birds needed to be fenced or caged to keep them from wandering, pigeons rarely roamed far from the dovecote.

While many ponds built by affluent homeowners were in keeping with the new naturalistic style of landscape coming from England, the practicality of them was apparent. Like dovecotes, fishponds were used to store food for the family's consumption, but they could also double as a place for recreation and relaxation. Jefferson had fishponds at Monticello, as did many other rural homeowners during the Federal period.

Beehives were also a common feature in Federal period gardens, both urban and rural. Traditionally, a beehive (or bee skep, a skep being a coiled grass basket) was made of straw, which would disintegrate over time. Wooden beehives, usually of pine, were a sturdier alternative, though sometimes a beehive was nothing more than a hollow log (Sarudy, 13). As with other garden fixtures, such as a dovecote, a beehive was both practical and decorative.

Privies or necessaries were, of course, a vital component to any garden. Some privies were highly decorated, with peaked roofs and white walls, even designed to match other garden structures, such as tool sheds or dovecotes. At Mount Vernon, small wooden garden houses were located inside the walls of the flower and vegetable gardens, two of which Washington referred to as the "new necessaries" (Leighton 1986, 253).

Reference List

American Philosophical Society. 2007. "About the APS." Accessed from The American

Philosophical Society, 2008. Available at: http://www.amphilsoc.org/about.

Burchill, Shirley, Nigel Hughes, Peter Price, and Keith Woodall. 2007. "The Four Field System." Accessed from The Open Door Web Site, 2008. Available at: http://www.saburchill.com/history/chapters/IR/003f.html.

Bushman, Richard L. 1992. *The Refinement of America: Persons, Houses, Cities.* New York: Alfred A. Knopf.

The Colonial Williamsburg Foundation. 2007. "A Williamsburg Perspective on Colonial Gardens." Accessed from Colonial Williamsburg. Experience the Life. Available at: http://www.history.org/Almanack/life/garden/garintro.cfm.

DeWan, George. 2007. "The Blooming of Flushing." Accessed from Newsday, Inc., 2008. Available at: http://www.newsday.com/community/guide/lihistory/ny-history hs329a,0,6961092.story.

Favretti, Rudy, and Joy Favretti. 1977. *For Every House a Garden: A Guide for Reproducing Period Gardens.* Chester, Conn.: The Pequot Press.

Garofalo, Michael P. 2002. "The History of Gardening: A Timeline." Available at: http://www.gardendigest.com/timel18.htm.

The Hereditary Society Community. 2003. "History of the Society of the Cincinnati." Available at: http://www.hereditary.us/cin_history.htm.

Hill, May Brawley. 1998. *Furnishing the Old-Fashioned Garden: Three Centuries of American Summerhouses, Dovecotes, Pergolas, Privies, Fences, & Birdhouses.* New York: Harry N. Abrams, Inc.

Hobhouse, Penelope. 1992. *Gardening through the Ages: An Illustrated History of Plants and their Influence on Garden Styles From Ancient Egypt to the Present Day.* New York: Simon & Schuster.

Hoey, Edwin A. 1968. "A 'New and Strange Order of Men'." *American Heritage Magazine* 19(5). Available at: http://www.americanheritage.com/articles/magazine/ah/1968/5/1968_5_44.shtml.

Howlett, Freeman S. 1968. "History of Horticulture." Accessed from The Ohio State

(continued)

1801: *History of the Oaks of North America* **(Andre Michaux)**
Michaux, a French botanist, traveled widely throughout the world and made extensive studies of plant life along the eastern seaboard of America.

1802: *Encyclopedia of Plants* **(John Claudius Loudon)**
Loudon, a well-known landscape designer and garden writer, produced several books on garden design, as well as publishing a monthly periodical, *Gardener's Magazine.*

1803: *Flora Boreali and America* **(Andre Michaux)**

1803: *Observations on the Theory and Practice of Landscape Gardening* **(Humphrey Repton)**

1805: *A Short Treatise on Hothouses* **(John Claudius Loudon)**

1806: *The American Gardener's Calendar* **(Bernard M'Mahon)**
M'Mahon was a highly influential nurseryman; his *Gardener's Calendar* was the standard text for aspiring horticulturalists for much of the nineteenth century.

1806: *An Inquiry into the Changes of Taste in Landscape Gardening* **(Humphrey Repton)**

1808: *Pomona Britannica* **(George Brookshaw)**
Brookshaw's paintings of flowers and fruit were praised for their beauty as well as their botanical exactness.

1812: *A Concise and Practical Treatise . . . of the Carnation* **(Thomas Hogg)**
Hogg was a well-known London florist who developed many important cultivars and wrote about methods of cultivation.

1813: *Elementary Theory of Botany* **(Augustus Pyramus de Candolle)**

Swiss botanist de Candolle developed a new classification of plants according to the natural system while Director of the Botanic Garden at the University of Montpelier in France.

1817: *Fragments on the Theory and Practice of Landscape Gardening* **(Humphrey Repton)**

(continued)

1817: *A View on the Cultivation of Fruit Trees* **(William Coxe)**

One of the earliest American pomologists, Coxe wrote the first American book on the cultivation of fruit trees and orchard management.

1818: *Genera of North American Plants* **(Thomas Nuttall)**

An English botanist and zoologist, Nuttall traveled extensively throughout the Great Lakes region, as well as the Missouri, Arkansas, and Red Rivers, collecting plant specimens for study and resulting in his published collection *Genera of North American Plants.*

(Garofalo 2002; Howlett 1968)

University Horticulture and Crop Science in Virtual Perspective, 2002. Available at: http://www.hcs.ohio-state.edu/hort/history/153.html.

Israel, Barbara. 1999. *Antique Garden Ornament: Two Centuries of American Taste.* New York: Harry N. Abrams, Inc.

Kimball, Fiske. 1966. *Domestic Architecture of the American Colonies and of the Early Republic.* New York: Dover Publications.

Kulik, Gary. 1996. "The Worm Fence." In *Between Fences,* ed. Gregory K. Dreicer. Washington, D.C.: The National Building Museum and Princeton Architectural Press.

Leighton, Ann. 1986. *American Gardens in the Eighteenth Century: "For Use or For Delight."* Amherst: The University of Massachusetts Press.

Leighton, Ann. 1987. *American Gardens of the Nineteenth Century: "For Comfort and Affluence."* Amherst: The University of Massachusetts Press.

McGuire, Diane Kostial. 1992. "Early Gardens Along the Atlantic Coast., In *Keeping Eden: A History of Gardening in America,* ed. Walter T. Punch. Boston: Massachusetts Historical Society.

Sarudy, Barbara Wells. 1998. *Gardens and Gardening in the Chesapeake, 1700–1805.* Baltimore, Md.: The John Hopkins University Press.

Southworth, Susan, and Michael Southworth. 1992. *Ornamental Ironwork: An Illustrated Guide to its Design, History, and Use in American Architecture.* New York: McGraw Hill.

Glossary

acanthus: A decorative embellishment in the form of a long, stylized leaf.

Adamesque style: An architectural and interior design style based on the works of English architect Robert Adam. Popular in England and later, to a smaller extent, in America, the style was based on classical Greek, Roman, and Egyptian forms.

anthemion: A decorative element in the form of a stylized honeysuckle flower.

arcade: A row of arches supported by columns.

architrave: The lowest part of an entablature above a column.

baluster: A turned element used as a support feature, such as on a railing.

balustrade: A low, ornamental railing used around a roof, usually surrounding a walk or balcony.

bay: Vertical sections of a façade, usually consisting of a window over a window or a window over a door.

bond: The pattern in which bricks are laid, for both strength and design.

broken pediment: A pediment form with a gap in the top.

Brussels carpet: a machine-made carpet that has an uncut looped pile.

capital: The top part of a column.

chair rail: A molding that marks the top of the dado on a wall surface.

Classical orders: Formal style of columns used in architecture, based on Greek and Roman examples: Doric, Ionic, and Corinthian, Tuscan, and Composite.

Formal style of columns used in architecture, based on Greek and Roman examples, Corinthian. Courtesy of the Library of Congress.

Composite order: One of the Classical orders; the column usually combines acanthus leaves from the Corinthian order with volutes from the Ionic order.

Corinthian order: One of the Classical orders; the column is usually fluted with acanthus leaves on the capital.

cornice: The highest part of an entablature above a column; also a decorative element found on top of a window, interior ceiling, or exterior wall.

course: A thin, continuous band, usually of brick or stone, encircling the façade of a dwelling.

crumb cloth: A cloth laid on top of a rug, under a table, to protect from spills.

cupola: A small dome that sits on top of a roof.

Formal style of columns used in architecture, based on Greek and Roman examples, Doric. Courtesy of the Library of Congress.

dado: The lower part of a wall surface between the chair rail and the baseboard.

dentil: A series of square, block-like ornaments used as embellishment on cornices, roofs, mantels, or other decorative elements.

Doric order: One of the Classical orders, the column is usually fluted with no base.

double-hung window: A window with two sashes that can be slid up and down in tracks; they are kept in place by counterweights attached to hidden cords in the frame.

dovecote: A building used for raising doves or pigeons for food.

dooryard: An open space between a dwelling and its outbuildings, usually reserved for daily chores, such as washing clothes, soap making, butchering, or shoeing horses.

drugget: A tough fabric used to protect expensive floor coverings.

egg-and-dart: A decorative element of alternative ovals and triangular shapes.

English bond: A type of brickwork pattern that alternates headers (the short side of the brick) and stretchers (the long side of the brick) on separate courses.

entablature: The top of a column, consisting of the architrave, frieze, and cornice.

fanlight: A fixed window over a door; usually of semicircular or oval shape.

Federal style: A style of architecture and interior design that emerged in America during the late eighteenth to early nineteenth centuries. Federal style architecture resembled the preceding Georgian (or Colonial) style in its classical symmetry, but presented more delicate detailing in exterior features and restrained ornamentation inside. The Federal style also resulted in new architectural elements, such as fanlights and sidelights around the entryway, and new furniture forms, such as the sideboard and lady's writing desk.

Flemish bond: A type of brickwork pattern that alternates headers (the short side of a brick) and stretchers (the long side of the brick) on each course.

floor cloth: A canvas cloth usually painted or stenciled, used to protect floors.

Formal style of columns used in architecture, based on Greek and Roman examples, Composite. Courtesy of the Library of Congress.

A fine example of a column with entablature, consisting of the architrave, frieze, and cornice. Courtesy of the Library of Congress.

flute: A decorative channel on supporting elements, such as a column or furniture legs and arms.

French doors: A pair of glazed doors, hinged on the sides, and opening in the middle.

frieze: The middle section of an entablature above a column.

gable roof: A roof with two triangular ends on either side of a pitched roof.

gambrel roof: A roof with a double pitch, or where each side has two different slopes.

Georgian: A style of architecture that emerged in England during the eighteenth century and was based on classical forms from ancient Greece and Rome. The architecture featured symmetrical façades with classical elements such as pillars or columns, hipped roofs, and porticos. In the American colonies, Georgian style is also referred to as Colonial, though earlier Colonial homes were simpler in form than later, more elaborate Georgian examples.

glazing bars: The bars that hold the panes of glass in a window.

glazing: Window glass.

gougework: Ornamental woodwork that is made with a rounded chisel.

Greek key pattern: A decorative element that consists of geometrical, repeating right-angled lines.

guilloche: A decorative element of interlaced bands.

ha-ha: A sunken fence consisting of a ditch with a sloping slide that acts an invisible barrier for animals.

header: The short side of a brick.

Formal style of columns used in architecture, based on Greek and Roman examples, Ionic. Courtesy of the Library of Congress.

hipped roof: A roof where four slopes met at the top along a ridgeline.

I-house: In vernacular architecture, a house two stories high, one room deep, and at least two rooms wide.

in-grain carpet: A flat-weave carpet with a pile, such as a Scotch or a Axminster carpet.

Ionic order: One of the Classical orders; the column has a spiral scroll, or volute, at the capital.

keystone: The central stone in an arch.

lintel: A horizontal beam over a door or window that carries the weight of the wall.

lunette: A semicircular-shaped window.

mantle: The frame surrounding a fireplace opening.

medallion: A decorative element, circular or oval, used as a surface embellishment.

mullion: A vertical bar that divides a window or other opening.

muntin: The vertical bar separating windowpanes.

nogging: Masonry rubble used as insulation in-between timber frame in a structure.

overmantle: The decorative element above the fireplace opening.

palladian window: A window consisting of three parts, usually an arched center window flanked by two smaller rectangular windows.

papier mâché: A mixture of paper pulp used to form decorative elements.

parapet: A low wall on top of the exterior wall of a building.

paterae: A decorative element, usually round or oval, used as a surface embellishment.

pediment: A low-pitched gable, or triangular space, on top of an opening, such as a portico, window, fireplace, or door.

pilaster: A flat pillar or pier attached to a surface, such as a wall.

portico: A roof that projects outward from a wall, with a roof and supporting columns.

post-and-beam: A construction method that involves joining heavy vertical posts with horizontal beams, usually with a mortise-and-tenon joint.

quoins: A vertical line of decorative blocks found on the corners of a building.

row house: One of a group of attached houses.

sash: The moveable part of the window that contains the glass.

stretcher: The long end of a brick.

stucco: Plaster covering for walls, or architectural ornaments.

rosette: A decorative element, in the form of a stylized flower.

side-gabled roof: A roof where the gable end is above the front door.

swag: A decorative element, in the form of a garland of flowers or fabric.

sidelights: A vertical window, usually containing small panes, found on either side of the front door.

terracotta: An unglazed, unfired clay mainly used for tiles.

tongue-and-groove: A wood joint where the edge of one board, with a lip, fits into the groove of another.

trompe l'oeil: A decorative feature that is used to create an effect of an illusion.

Tuscan order: One of the Classical orders; the column is like the Doric order, but with a simple base and capital.

transom: A window above a door or window that can open.

triple-hung window: A window with three moveable sashes.

Formal style of columns used in architecture, based on Greek and Roman examples, Tuscan colonnade. Courtesy of the Library of Congress.

veranda: A balcony or porch, covered by a roof, but open on the sides.

vernacular: A type of regional or rural architecture that comes from a more academic or formal style.

volute: A decorative element in the form of a spiral scroll.

weatherboard: Covering for a dwelling made of long, narrow boards overlapped to form a weather-tight seal.

Wilton carpet: A machine-made carpet with a cut-looped pile.

wrought iron: Low-carbon iron that is hammered into shape by hand.

Resource Guide

PRINT RESOURCES

Books

Andrews, Wayne. 1978. *Architecture, Ambition and Americans: A Social History of American Architecture*. New York: Free Press.

Baker, John Milnes. 1994. *American House Styles: A Concise Guide*. New York: W. W. Norton.

Barley, M. W. 1986. *Houses and History*. London and Boston: Faber & Faber.

Bealer, Alex. 1980. *The Tools that Built America*. New York: Bonanza Books.

Beard, Geoffrey. 1978. *The Work of Robert Adam*. New York: ARCO.

Bergeron, Louis. 2000. *Industry, Architecture, and Engineering: American Ingenuity, 1750–1950*. New York: Harry N. Abrams.

Blumenson, John J.-G. 1981. *Identifying American Architecture*. Nashville, Tenn.: American Association for State and Local History.

Boyd, Sterling. 1985. *The Adam Style in America*. New York: Garland Publishers.

Briggs, Martin. 1974. *The Architect in History*. New York: Da Capo Press.

Brownell, Charles E., Calder Loth, William M. S. Rasmussen, and Richard Guy Wilson. 1992. *The Making of Virginia Architecture*. Richmond: Virginia Museum of Fine Arts.

Burchard, John, and Albert Bush-Brown. 1961. *The Architecture of America*. Boston: Little, Brown.

Note: This is the Resource Guide for Part II of the volume. For the resource guide to Part I (1492–1780), see page 107.

Bushman, Richard L. 1992. *The Refinement of America: Persons, Houses, Cities.* New York: Alfred A. Knopf.

Calloway, Stephen, ed. 1996. *The Elements of Style: A Practical Encyclopedia of Interior Architectural Details from 1485 to the Present.* New York: Simon & Schuster.

Carley, Rachel. 1994. *The Visual Dictionary of American Domestic Architecture.* New York: Henry Holt and Company.

Carson, Cary, Ronald Hoffman, and Peter J. Albert, eds. 1994. *Of Consuming Interests: The Style of Life in the 18th c.* Charlottesville: University Press of Virginia for the U.S. Capitol Historical Society.

Carter, Thomas, and Elizabeth Collins Cromley. 2005. *Invitation to Vernacular Architecture: A Guide to the Study of Ordinary Buildings and Landscapes.* Knoxville: University of Tennessee Press.

Chambers, S. Allen. 1999. *National Landmarks, America's Treasures: The National Park Foundation's Complete Guide to National Historic Landmarks.* New York: John Wiley & Sons, Inc.

Ching, Francis D. K. 1996. *A Visual Dictionary of Architecture.* New York: John Wiley & Sons, Inc.

Clark, Clifford Edward. 1986. *The American Family Home, 1800–1960.* Chapel Hill: University of North Carolina Press.

Condit, Carl. 1982. *American Building: Materials and Techniques from the First Colonial Settlement to the Present.* Chicago: University of Chicago Press.

Cooper, Wendy A. 1993. *Classical Taste in America, 1800–1840.* New York: Abbeville Press.

Department of Interior. 2004. *Preservation of Historic Architecture: The US Government's Official Guidelines for Preserving Historic Homes.* Guilford, Conn.: The Lyons Press.

Di Valmarana, Mario, ed. 1984. *Building by the Book.* Charlottesville: The University Press of Virginia for the Center for Palladian Studies in America.

Donnelly, Marian C. 2003. *Architecture in Colonial America.* Eugene: University of Oregon Press.

Dooley, Patricia L. 2004. *The Early Republic: Primary Documents on Events from 1799 to 1820.* Westport, Conn.: Greenwood Press.

Dunbar, Michael. 1986. *Federal Furniture.* Taunton, Mass.: Taunton Press.

Du Vall, Nell. 1988. *Domestic Technology: A Chronology of Developments.* Boston: G. K. Hall.

Eberlein, Harold Donaldson. 1938. *Colonial Interiors, Federal and Greek Revival, third series.* New York: Bonanza Books.

Eggener, Keith L., ed. 2004. *American Architectural History: A Contemporary Reader.* New York: Routledge, Taylor & Francis Group.

Fairbanks, Jonathan, and Elizabeth Bidwell Bates. 1981. *American Furniture: 1620 to the Present.* New York: Richard Marek.

Favretti, Rudy J., and Joy Putman Favretti. 1978. *Landscapes and Gardens for Historic Buildings: A handbook for reproducing and creating authentic landscape settings.* Nashville, Tenn.: The American Association for State and Local History.

Fitzgerald, Oscar. 1995. *Four Centuries of American Furniture.* Radnor, Penn.: Wallace-Homestead.

Fleming, Dolores A., Barbara J. Howe, Emory L. Kemp, and Ruth Ann Overbeck. 1987. *Houses and Homes: Exploring Their History.* Nashville, Tenn.: American Association for State and Local History.

Fleming, John, Hugh Honour, and Nikolaus Pevsner. 1999. *The Penguin Dictionary of Architecture and Landscape Architecture.* London: Penguin.

Foley, Mary Mix. 1980. *The American House.* New York: Harper & Row.

Foster, Gerald L. 2004. *American Houses: A Field Guide to the Architecture of the Home.* Boston: Houghton Mifflin.

Foster, Michael, ed. 1982. *Architecture: Style, Structure, and Design.* London: Quill Publishing.

French, Leigh. 1923. *Colonial Interiors: The Colonial and Early Federal Periods, first series.* New York: Bonanza Books.

Gardiner, Stephen. 2002. *The House: Its Origins and Evolution.* Chicago: New Amsterdam Books.

Garrett, Elisabeth Donaghy. 1980. *The Antiques Book of American Interiors: Colonial and Federal Styles.* New York: Crown.

Garrett, Elisabeth Donaghy. 1984. *The Arts of Independence.* Washington, D.C.: National Society, Daughters of the American Revolution.

Garrett, Elisabeth Donaghy. 1990. *At Home: The American Family, 1750–1870.* New York: Harry N. Abrams, Inc.

Garrett, Wendell. 1996. *Classic America: The Federal Style and Beyond.* New York: Universe Publications.

Garvan, Beatrice. 1987. *Federal Philadelphia: The Athens of the Western World.* Philadelphia: Philadelphia Museum of Art.

Garvin, James L. 2001. *A Building History of Northern New England.* Hanover, N.H.: University Press of New England.

Gelernter, Mark. 1999. *A History of American Architecture: Buildings in their Cultural and Technological Context.* Hanover, N.H.: University Press of New England.

Gilje, Paul A. 2006. *The Making of the American Republic, 1763–1815.* Upper Saddle River, N.J.: Pearson Prentice Hall.

Glassie, Henry H. 1968. *Pattern in the Material Folk Culture of the Eastern United States.* Philadelphia: University of Pennsylvania Press.

Glassie, Henry H., George Jevremovic, and William T. Sumner, eds. 1999. *Vernacular Architecture.* Bloomington: Indiana University Press.

Gowans, Alan. 1976. *Images of American Living: Four Centuries of Architecture and Furniture as Cultural Expression.* New York: Harper & Row.

Gowans, Alan. 1992. *Styles and Types of North American Architecture: Social Function and Cultural Expression.* New York: HarperCollins.

Greenberg, Allan. 2006. *The Architecture of Democracy: American Architecture and the Legacy of the Revolution.* New York: Rizzoli.

Hafertepe, Kenneth, and James F. O'Gorman, eds. 2001. *American Architects and Their Books to 1848.* Amherst: University of Massachusetts Press.

Hammett, Ralph Warner. 1976. *Architecture in the United States: A Survey of Architectural Styles since 1776.* New York: Wiley.

Handlin, David P. 1979. *The American Home: Architecture and Society, 1815–1915.* Boston: Little, Brown.

Handlin, David P. 2004. *American Architecture.* London: Thames & Hudson.

Hardyment, Christina. 1992. *Home Comfort: A History of Domestic Arrangements.* New York: Viking Press.

Harmon, Robert B. 1982. *Georgian Architecture in America: A Brief Style Guide.* Monticello, Ill.: Vance Bibliographies.

Harris, Cyril. 1998. *American Architecture: An Illustrated Encyclopedia.* New York: W. W. Norton.

Harrison, Peter Joel. 1993. *Fences.* Richmond, Va.: Dietz Press.

Harrison, Peter Joel. 1995. *Gazebos.* Richmond, Va.: Dietz Press.

Headley, Gwyn. 1996. *Architectural Follies in America.* New York: John Wiley & Sons.

Heckscher, Morrison H. 1994. "English Furniture Pattern Books in Eighteenth-Century America." In *American Furniture 1994*, ed. Luke Beckerdite. Milwaukee, Wis.: Chipstone Foundation, Distributed by the University of New England Press.

Hedrick, U. P. 1988. *A History of Horticulture in America to 1860.* Portland, Ore.: Timber Press.

Henretta, James A. 1987. *Evolution and Revolution: American Society, 1600–1820.* Lexington, Mass.: D.C. Heath.

Herman, Bernard L. 2005. *Town House: Architecture and Material Life in the early American city, 1780–1830.* Chapel Hill: Published for the Omohundro Institute of Early American History and Culture, Williamsburg, Va., by the University of North Carolina Press.

Hill, May Brawley. 1998. *Furnishing the Old-Fashioned Garden: Three Centuries of American Summerhouses, Dovecotes, Pergolas, Privies, Fences, & Birdhouses.* New York: Harry N. Abrams, Inc.

Hilowitz, Beverley, and Susan Eikov Green. 1980. *Historic Houses of America.* New York: Simon & Schuster.

Hitchcock, Henry Russell. 2003. *American Architectural Books: A List of Books, Portfolios, and Pamphlets on Architecture and Related Subjects Published in America before 1895.* Mansfield Centre, Conn.: Martino Publishers.

Howe, Jeffrey, ed. 2002. *The Houses We Live In: An Identification Guide to the History and Style of American Domestic Architecture.* London: PRC Publishing, Ltd.

Hunt, William, Dudly, Jr. 1980. *Encyclopedia of American Architecture.* New York: McGraw-Hill.

Hurst, Ronald L., and Jonathan Prown. 1997. *Southern Furniture, 1680–1830: The Colonial Williamsburg Collection* Williamsburg, Va.: Colonial Williamsburg Foundation, in association with Harry N. Abrams.

Ierley, Merritt. 1999. *Open House: A Guided Tour of the American Home, 1637–Present.* New York: Henry Holt & Co.

Israel, Barbara. 1999. *Antique Garden Ornament: Two Centuries of American Taste.* New York: Harry N. Abrams, Inc.

Johnson, Paul E. 2007. *The Early American Republic, 1789–1829.* New York: Oxford University Press.

Kennedy, Roger. 1983. *Architecture, Men, Women, and Money* New York: Random House.

Kornwolf, James D. 1967. *A History of American Dwellings.* Chicago: Rand McNally.

Krill, Rosemary. 2001. *Early American Decorative Arts.* Walnut Creek, Calif.: Alta Mira Press, with Winterthur Museum, Garden & Library.

Lamton, Lucinda. 1978. *Temples of Convenience.* London: Gordon Fraser.

Lane, Mills. 1993. *Architecture of the Old South.* New York: Abbeville Press.

Lanier, Gabrielle M., and Bernard L. Herman. 1997. *Everyday Architecture of the Mid-Atlantic: Looking at Buildings and Landscapes.* Baltimore, Md.: The Johns Hopkins University Press.

Larkin, Jack. 1988. *The Reshaping of Everyday Life, 1790–1840.* New York: HarperCollins.

Larkin, Jack. 2006. *Where We Lived: The American Home from 1775–1840.* Newtown, Conn.: Taunton Press.

Leighton, Ann. 1986a. *American Gardens in the Eighteenth Century: "For Use or For Delight."* Amherst: The University of Massachusetts Press.

Leighton, Ann. 1986b. *Early American Gardens: "For Meate or Medicine."* Amherst: University of Massachusetts Press

Leighton, Ann. 1987. *American Gardens of the Nineteenth Century: "For Comfort and Affluence."* Amherst: The University of Massachusetts Press.

Library of Congress. 1995. *America Preserved: A Checklist of Historic Buildings, Structures, and Sites.* Recorded by The Historic American Buildings Survey/Historic American Engineering Record. Washington, D.C.: Library of Congress, Cataloging Distribution Service.

Little, Nina Fletcher. 1952. *American Decorative Wall Painting, 1700–1850.* Sturbridge, Mass.: Old Sturbridge Village.

Lockwood, Charles. 1972. *Bricks and Brownstones: The New York Row House, 1783–1929, Architectural and Social History.* New York: McGraw-Hill.

Lowenthal, David. 1985. *The Past is a Foreign Country.* Cambridge, Mass.: Cambridge University Press.

Lynn, Catherine. 1980. *Wallpaper in America.* New York: W. W. Norton.

Madigan, Mary Jean, and Susan Colgen, eds. 1983. *Early American Furniture.* New York: Billboard Publications.

Massey, James C., and Shirley Maxwell. 1996. *House Styles in America: The Old-House Journal Guide to the Architecture of American Homes.* New York: Penguin Studio.

Mayhew, Edgar deN., and Minor Myers, Jr. 1980. *A Documentary History of American Interiors from the Colonial Era to 1915.* New York: Charles Scribner's Sons.

Maynard, W. Barksdale. 2002. *Architecture in the United States, 1800–1850.* New Haven, Conn.: Yale University Press.

McAlester, Virginia, and Lee McAlester. 1991. *Field Guide to American Houses.* New York: Alfred A. Knopf.

McGaw, Judith A., ed. 1994. *Early American Technology: Making and Doing Things from the Colonial Era to 1850.* Chapel Hill: University of North Carolina Press.

McKee, Harley, J. 1973. *Introduction to Early American Masonry: Stone, Brick, Mortar and Plaster.* Washington, D.C.: National Trust for Historic Preservation Press.

McMurry, Sally. 1988. *Families and Farmhouses in 19th c. America: Vernacular Design and Social Change.* New York: Oxford University Press.

Millar, John Fitzhugh. 1968. *The Architects of the American Colonies; or, Vitruvius Americanus.* Barre, Mass.: Barre Publishers.

Montgomery, Charles F. 1966. *American Furniture: The Federal Period in the Henry Francis du Pont Winterthur Museum.* New York: Viking Press.

Montgomery, Florence M. 1970. *Printed Textiles; English and American Cottons and Linens, 1700–1850.* New York: Viking Press.

Montgomery, Florence M. 1984. *Textiles in America, 1650–1870: A Dictionary.* New York: W. W. Norton.

Morgan, William. 2004. *The Abrams Guide to American House Styles.* New York: Harry N. Abrams.

Morrison, Hugh. 1987. *Early American Architecture: From the First Colonial Settlements to the National Period.* New York: Dover Publications.

Moss, Roger W. 1994. *Paint in America: The Colors of Historic Buildings.* New York: John Wiley & Sons, Inc.

Mouzon, Stephen, and Susan Henderson. 2004. *Traditional Construction Patterns: Design and Detail Rules-of-Thumb.* New York: McGraw-Hill Professional.

Mumford, Lewis. 1955. *Sticks and Stones: A Study of American Architecture and Civilization.* New York: Dover Publications.

Nelson, Christina H. 1984. *Directly from China: Export Goods for the American Market, 1784–1930.* Salem, Mass.: Peabody Museum of Salem.

Nylander, Jane C. 1994. *Our Own Snug Fireside: Images of the New England Home, 1760–1860.* New Haven, Conn.: Yale University Press.

Nylander, Richard C., and Jane C. Nylander. 2005. *Fabrics and Wallpapers for Historic Buildings.* Hoboken, N.J.: John Wiley & Sons, Inc.

O'Dea, William. 1958. *Social History of Lighting.* London: Routledge and Kegan Paul.

Peterson, Harold L. 1971. *American Interiors from Colonial Times to the Late Victorians.* New York: Charles Scribner's Sons.

Phillips, Steven J. 1989. *Old-House Dictionary: An Illustrated Guide to American Domestic Architecture, 1600–1940.* Lakewood, Colo.: American Source Books.

Pierson, William H., Jr. 1986. *American Buildings and Their Architects,* vol. 1. New York: Oxford University Press.

Pillsbury, Richard, and Andrew Kardos. 1970. *A Field Guide to the Folk Architecture of the Northeastern United States.* Hanover, N.H.: Dartmouth College, Department of Geography.

Punch, Walter T., ed. 1992. *Keeping Eden: A History of Gardening in America.* Boston: Little, Brown.

Purcell, Sarah J. 2004. *The Early National Period.* New York: Facts on File.

Quimby, Ian. 1978. *Material Culture and the Study of American Life.* New York: W. W. Norton & Company.

Reiff, Daniel D. 2000. *Houses from Books: Treatises, Pattern Books, and Catalogs in American Architecture, 1783–1950.* University Park: Pennsylvania State University Press.

Reps, John William. 1965. *The Making of Urban America: A History of City Planning in the United States.* New Haven, Conn.: Princeton University Press.

Rifkind, Carole. 1980. *A Field Guide to American Architecture.* New York: Plume.

Rosenstiel, Helene von, and Gail Caskey Winkler. 1988. *Floor Coverings for Historic Buildings.* New York: John Wiley & Sons, Inc.

Roth, Leland M. 1979. *A Concise History of American Architecture.* New York: Harper & Row.

St. George, Robert Blair, ed. 1988. *Material Life in America, 1600–1860.* Boston, Northeastern Press.

Scully, Vincent. 1988. *American Architecture and Urbanism.* New York: Henry Holt and Company.

Seale, William. 1979. *Recreating the Historic House Interior.* Nashville, Tenn.: The American Association for State and Local History.

Smith, G. E. Kidder. 1996. *Sourcebook of American Architecture: 500 Notable Buildings from the 10th Century to the Present.* New York: Princeton Architectural Press.

Sokol, David M. 1976. *American Architecture and Art: A Guide to Information Sources.* Detroit, Mich.: Gale Research Co.

Southworth, Michael, and Susan Southworth. 1992. *Ornamental Ironwork: An Illustrated Guide to Its Design, History, and Use in American Architecture.* New York: McGraw-Hill, Inc.

Stilgoe, John R. 1982. *Common Landscape of America, 1580–1845.* New Haven, Conn.: Yale University Press.

Sweeting, Adam. 1996. *Reading Houses and Building Books.* Hanover, N.H.: University Press of New England.

Thorndike, Joseph J., Jr. 1981. *Three Centuries of Notable American Architects.* New York: American Heritage Publishing Co., Scribner and Sons.

Thornton, Peter. 1998. *Form and Decoration: Innovation in the Decorative Arts, 1470–1870*. London: Weidenfeld & Nicolson.

Ulrich, Laurel Thatcher. 1995. "Furniture as Social History: Gender, Property, and Memory in the Decorative Arts." In *American Furniture 1995*, ed. Luke Beckerdite. Milwaukee, Wis.: Chipstone Foundation, Distributed by the University of New England Press.

Upton, Dell, and John Michael Vlach, eds. 1986. *Common Places: Readings in American Vernacular Architecture*. Athens: University of Georgia Press.

Vlach, John Michael. 1991. *By the Work of Their Hands: Studies in Afro-American Folklife*. Charlottesville: University of Virginia Press.

Vlach, John Michael. 1993. *Back of the Big House: The Architecture of Plantation Slavery*. Chapel Hill: University of North Carolina Press.

Walker, Lester. 1997. *American Shelter: An Illustrated Encyclopedia of the American Homes*. Woodstock, N.Y.: Overlook Press.

Ward, Gerald W. R., ed. 1991. *American Furniture with Related Decorative Arts*. New York: Hudson Hills Press.

Whiffen, Marcus. 1993. *American Architecture Since 1780: A Guide to the Styles*. Cambridge, Mass.: MIT Press.

Whiffen, Marcus, and Frederick Koeper. 1981. *American Architecture, 1607–1976*. Cambridge, Mass.: MIT Press.

Wood, Joseph S. 2002. *The New England Village: Creating the North American Landscape*. Baltimore, Md.: The Johns Hopkins University Press.

Wood, Rodger H., and Richard J. Wood. 2000. *American Domestic Architecture, 1600–1990* [electronic resource]. Mobile, Ala.: Infosential Press.

Wright, Gwendolyn. 1981. *Building the Dream: A Social History of Housing in America*. New York: Pantheon.

Articles

Barka, Norman F., Cary Carson, William M. Kelso, Garry Wheeler Stone, and Dell Upton. 1981. "Impermanent Architecture in the Southern American colonies." *Winterthur Portfolio* 16: 135–196.

Cooke, Edward S., Jr. 1980. "Domestic Spaces in the Federal Period Inventories." *Essex Institute Historical Collections* 116 (4): 24–25.

Griswold, Ralph E. 1970. "Early American Garden Houses." *Antiques* 98 (July): 82–87.

Matusik, Joe-Ellen. 1996. "Period Garden Plans." *Old-House Journal* 24 (March–April): 28–31.

Nylander, Jane C. 1980. "Keeping Warm: Coping with Winter in Early 19th c. New England." *Early American Life* 11 (5): 46–49.

Nylander, Jane C. 1980. "Summer Housekeeping in Early 19th c. New England." *Early American Life* 11 (2): 32–35, 56–57.

Sherrill, Sarah B. 1976. "Oriental Carpets in 17th and 18th c. America." *The Magazine Antiques* (January): 142–167.

Upton, Dell. 1984. "Pattern-Books and Professionalism, Aspects of the Transformation of Domestic Architecture in America, 1800–1860." *Winterthur Portfolio* 19 (Summer/Autumn): 107–150.

Scholarly Journals

Early American Studies: An Interdisciplinary Journal. University of Pennsylvania Press. http://muse.jhu.edu/journals/early_american_studies_an_interdisciplinary_journal/.

Eighteenth-Century Life. Duke University Press. http://www.dukeupress.edu/ecl/.

Eighteenth-Century Studies. The Johns Hopkins University Press. http://www.press.jhu.edu/journals/eighteenth-century_studies/.

Journal for Early Modern Cultural Studies. Indiana University Press. http://muse.jhu.edu/journals/journal_for_early_modern_cultural_studies/.

Journal of the Early Republic. University of Pennsylvania Press. http://muse.jhu.edu/journals/journal_of_the_early_republic/.

Journal of the Society of Architectural Historians. Society of Architectural Historians. http://www.jstor.org/journals/00379808.html.

Winterthur Portfolio: A Journal of American Material Culture. Winterthur Museum. http://www.jstor.org/journals/00840416.html.

Museums and Repositories

Archives of American Gardens
Smithsonian Institution, Washington, D.C.
http://www.nmnh.si.edu/naa/siasc/american_gardens.htm
The archives contain a collection of over 60,000 photographs documenting historic and contemporary American gardens.

The Art Institute of Chicago, Thorne Miniature Rooms
http://www.artic.edu/aic/collections/thorne/index.php
The Thorne Miniature Rooms, named after their creator, Mrs. James Ward Thorne, were created in 1932–1940 to display European and American interiors from the thirteenth century to the 1930s. Sixty-nine rooms in all, they were constructed on a scale of one inch to one foot.

The Athenaeum of Philadelphia, Architectural Archives
http://www.philaathenaeum.org/menu.html
The Athenaeum is a special collections library founded in 1814. In addition to material culture resources, the Athenaeum has architectural records from 1800–1945, consisting of 180,000 architectural drawings, over 350,000 photographs, and extensive manuscript holdings of nearly 1000 American architects. The institution focuses mainly on the history of American architecture and building technology.

Baltimore Museum of Art
Baltimore, MD
www.artbma.org
The museum's furniture collection represents historic cabinetmaking from Baltimore, Philadelphia, New York, and Boston. They also have a large collection of Maryland silver from the late eighteenth to early nineteenth centuries, as well as English silver owned by Maryland families in the Federal period.

Columbia University Libraries, Avery Architectural and Fine Arts Library
New York City
http://www.columbia.edu/cu/lweb/indiv/avery
Avery Library houses an extensive collection of early American architectural books, particularly those published before 1800, as well as trade catalogs, engravings, and period guide books.

The Connecticut Historical Society
Hartford, CT
http://www.chs.org
The Connecticut Historical Society's Barbour Collection has an extensive range
of eighteenth-century furniture produced by local Connecticut craftsmen, as
well as a large collection of eighteenth- and nineteenth-century clocks, from
handcrafted tall clocks to mass-produced timepieces.

Connecticut State Library, White Pine Series of Architectural Monographs
Hartford, CT
http://www.cslib.org/whitepine.htm
The White Pine Series is also known as *The Monograph Series: Recording the
Architecture of the American Colonies and the Early Republic* and consists of 98
separate monographs. Published bimonthly from 1915–1940, the series was an
early source of drawings, photos, and data for eighteenth- and early nineteenth-
century homes.

Decatur House
Washington, D.C.
http://www.decaturhouse.org
A historic house museum designed by Federal period architect Benjamin
Latrobe in 1818; the house has a large collection of Federal period furniture
owned by the original family.

Dumbarton House
Washington, D.C.
http://www.dumbartonhouse.org
A Federal period historic house museum located in the Georgetown section of
Washington, D.C.; the collection contains a large amount of decorative objects
from 1790–1830.

Gore Place
Waltham, MA
http://www.goreplace.org
This 1806 estate belonged to Massachusetts Gov. Christopher Gore. One of the
most significant Federal period homes in New England, it is often called the
"Monticello of the North." It is furnished with period pieces and has a small
farm.

Historic American Buildings Survey (HABS)
National Park Service, Washington, D.C.
http://www.cr.nps.gov/hdp/
The U.S. Government's oldest preservation program, the archives contain rec-
ords on 40,000 sites throughout the country with photographs, measured draw-
ings, and historical reports.

The Metropolitan Museum of Art
New York, NY
http://www.metmuseum.org

The large collection of American eighteenth- and nineteenth-century furniture housed at the Met includes furniture from regional cabinetmakers in New England, the Mid-Atlantic, and the South, as well as silver, glass, pewter, ceramics, and textiles from the same period.

Monticello
Charlottesville, VA
http://www.monticello.org
The home of America's 3rd president, Thomas Jefferson was also, among other things, an architect, farmer, inventor, philosopher, and was incredibly influential in all aspects of the Federal period.

Montpelier
Orange, VA
http://www.montpelier.org
The restoration project of America's 4th president will take the home of James and Dolley Madison back to the late Federal period, complete with furniture and decorative arts from that time. A Federal period garden, complete with a temple/ icehouse, is also being restored.

Mount Vernon
Mount Vernon, VA
http://www.mountvernon.org
Home of America's 1st president, the house and grounds display a combination of Colonial and Federal period artifacts from Washington. The newly opened Reynolds Museum has other vignettes from Washington's life, as well as an interactive learning center.

Museum of Early Southern Decorative Arts (MESDA)
Winston-Salem, NC
http://www.mesda.org
The extensive furniture, decorative arts, and archives at this museum, located at Old Salem Historic Town, focuses on arts and crafts from the seventeenth to the early nineteenth centuries from the Chesapeake, the Low Country, and the Backcountry regions of the southeastern United States.

Museum of Fine Arts, Boston, American Decorative Arts and Sculpture Collection http://www.mfa.org/collections
The decorative arts collections contain 1,500 examples of furniture from cabinetmakers in the seventeenth through the nineteenth centuries, particularly from Salem, Boston, and Newbury. Major Boston silversmiths from the eighteenth and nineteenth centuries are also part of the collection, as is early American-made glass and ceramics.

Nathaniel Russell House and Aiken-Rhett House
Charleston, SC
http://www.historiccharleston.org
Two restored Federal period townhouses, the Nathaniel Russell House (1803–1808) and the Aiken-Rhett House (1817) are both excellent examples of typical

Charleston homes, with the main rooms and open piazzas located on the side of the dwelling, overlooking the gardens.

The Octagon Museum
Washington, D.C.
http://www.archfoundation.org/octagon
This is the oldest museum devoted to architecture and design in the United States. Built by William Thornton between 1799–1801, it is a unique experiment in Federal period architecture. The building is now owned by the American Architectural Foundation.

Old Sturbridge Village
Sturbridge, MA
http://www.osv.org
Old Sturbridge Village has a wide-ranging collection of artifacts made and used by rural New Englanders between 1790–1840. Furniture, lighting, ceramics, glass, and other household implements, as well as agricultural equipment and vehicles, present an extensive array of late eighteenth- and early nineteenth-century material culture.

Peabody Essex Museum
Salem, MA
http://www.pem.org
This museum has an extensive and eclectic collection of world art. Their American decorative art collection showcases mainly New England art and culture over a 300-year period, with both elite and vernacular examples.

Rhode Island School of Design, the Charles L. Pendleton Collection
Providence, RI
http://www.risd.edu
The Pendleton Collection contains examples of eighteenth-century furniture from Boston, New York, Philadelphia, and Newport cabinetmakers, as well as Rhode Island silver, Chinese export porcelain, and English pottery.

Strawbery Banke
Portsmouth, NH
http://www.strawberybanke.org
The former seaport is now an open-air museum of restored houses, landscapes, and gardens that interpret the history of the community from the late seventeenth century to the mid-twentieth century. Many of the restored houses reflect the lives of their former occupants, mostly artisans and merchants, and are good examples of both middling and prosperous dwellings during the Federal period.

Tudor Place Historic and Garden
Washington, D.C.
http://www.tudorplace.org
A Federal period historic house museum located in the Georgetown section of Washington, D.C., the house was designed by noted architect William Thornton

for the granddaughter of Martha Washington. The collection is strong in Federal period decorative arts.

University of Pennsylvania Architectural Archives
Philadelphia, PA
http://www.design.upenn.edu/archives
The Architectural Archives at the University of Pennsylvania preserves the works of more than 400 architects from the eighteenth century to the present, including Robert Adam, William Chambers, Sir John Soane, Humphrey Repton, and William Russell Birch.

University of Virginia Libraries, Fiske Kimball Fine Arts Library
Charlottesville, VA
http://www.lib.virginia.edu/fine-arts/index.html
The Fiske Kimball Fine Arts Library at UVA has an extensive manuscript and image collection of vernacular Virginia architecture from the eighteenth and nineteenth centuries.

Winterthur Museum and Library
Winterthur, DE
http://www.winterthur.org
The museum has an extensive collection of early American furniture from 1640–1860, as well as a library with more than 80,000 sources on American cultural history.

Yale University Art Gallery, American Decorative Arts Collection
New Haven, CT
http://artgallery.yale.edu
The art gallery features nearly 18,000 silver, glass, wood, porcelain, and textile objects, predominantly from the Colonial and Federal periods. The silver collection is particularly strong in examples from New England, New York, and Philadelphia.

Useful Web Sites

http://andromeda.rutgers.edu/~jlynch/18th/
Web resource for eighteenth-century studies on literature, history, art, music, religion, economics, etc.

http://decorativearts.library.wisc.edu/index.html
Digital library for American material culture and decorative arts from UW-Madison

http://departments.umw.edu/hipr/www/vafbib.htm
Vernacular Architecture Forum, Newsletter Bibliography archives

http://digital.nypl.org/mmpco
New York Public Library Online Image Collection

http://www.greatbuildings.com
General image database for world architecture

http://libraries.mit.edu/rvc/kidder
Kidder Smith Architecture Slide Archives, MIT

http://memory.loc.gov/ammem/index.html
American Memory site from Library of Congress

http://oieahc.wm.edu/
Omohundro Institute of Early American History and Culture

http://www.aia.org/
American Institute of Architects, Washington, D.C.

http://www.archives.gov
U.S. National Archives and Records Administration

http://www.bc.edu/bc_org/avp/cas/fnart/fa267/

Digital archives of American architecture, seventeenth century to the twentieth century

http://www.brynmawr.edu/Acads/Cities/imgb/digcapt2.html
Society of Architectural Historians Image Exchange, American Architectural Survey

http://www.getty.edu/research
Art and Architecture online thesaurus, The Getty Research Institute

http://www.mip.berkeley.edu/query_forms/browse_spiro_form.html
Visual resources slide library from UC-Berkeley

http://www.nbm.org/
National Building Museum, Washington, D.C.

http://www.nps.gov/history/nr/index.htm
National Register of Historic Places

http://www.rlg.org/en/page.php?Page_ID = 168
Avery Index to Architectural Periodicals

http://www.sah.org/
Society of Architectural Historians, Chicago, IL

http://www.uen.org/Centennial/08BuildingsA.html
Illustrated glossary of architectural terms

http://www.washington.edu/ark2
Cities/Buildings Image Archive, University of Washington

Index

About the Editor and Authors

WILLIAM E. BURNS is a historian who lives and works in Washington, DC. He is the author of *Science and Technology in Colonial America* (2005) and *Witch Hunts in Europe and America* (2003), both published by Greenwood Press. He is also the author of *An Age of Wonders: Prodigies, Politics and Providence in England, 1657–1727* (2002).

MELISSA DUFFES is the coordinator of publications for the Allen Memorial Art Museum at Oberlin College in Oberlin, Ohio. Before that, she was an exhibition writer and editor for the Smithsonian Institution, as well as curator of Historic Green Spring in Alexandria, Virginia. Duffes received an M.Phil in the History of Decorative Arts from the University of Glasgow, Scotland.

OLIVIA GRAF is a graduate of the University of Southern California School of Architecture and claims citizenship in both Switzerland and the United States. Currently a practicing designer in California, Graf has also contributed to *The Greenwood Encyclopedia of Homes through World History* (2008).

THOMAS W. PARADIS is Director, Office of Academic Assessment, and Associate Professor of Geography and Planning at Northern Arizona University. He has taught and written on historic preservation, cultural geography, urban design, and assessment of student learning.